The Wellness
Bucket List

First published in the United States of America
in 2024 by
Rizzoli Universe, a Division of
Rizzoli International Publications, Inc.
300 Park Avenue South
New York, NY 10010
www.rizzoliusa.com

ISBN: 978-0-7893-4558-5
Library of Congress Control Number: 2024933945

2024 2025 2026 2027 / 10 9 8 7 6 5 4 3 2 1

Printed in Malaysia

Conceived, designed, and produced by
The Bright Press, an imprint of the Quarto Group
1 Triptych Place
London SE1 9SH
United Kingdom
www.quarto.com

Publisher: James Evans
Editorial Directors: Isheeta Mustafi, Anna Southgate
Managing Editor: Jacqui Sayers
Art Director: James Lawrence
Senior Editor: Joanna Bentley
Project Editor: Julie Brooke
Design: Anna Gatt
Picture Research: Anna Gatt, Susannah Jayes

Visit us online:
Facebook.com/RizzoliNewYork
X (formerly Twitter): @Rizzoli_Books
Instagram.com/RizzoliBooks
Youtube.com/user/RizzoliNY

It is recommended that you seek professional medical
advice before embarking on any new treatment, therapy,
or product use. The authors and publishers disclaim
liability for any outcomes that may occur as a result of
any of the experiences described in this book.

The Wellness Bucket List

1000 escapes and experiences to enrich your mind, body, and soul

NANA LUCKHAM

WITH CIARA TURNER-EWERT, JANE WILSON,
KATH STATHERS, SOLANGE HANDO, AND
COLLEEN O'NEILL MULVIHILL

RIZZOLI UNIVERSE

HOW TO USE THIS BOOK

This book is divided into six chapters—North America, South America, Europe, Africa and the Middle East, Asia, and Australasia. Within each chapter, entries are arranged by country, with a more specific location, such as town or area, provided at the beginning of each. Specific locations can also be searched for using the index on page 406.

COLOR CODE

Each entry number in the book has been given a color that relates to one of six categories, as shown below, allowing you to select activities based on the type of experience you're interested in.

Relax and indulge

Explore and thrive

Renew and recharge

Savor and nourish

Heal and balance

Reflect and connect

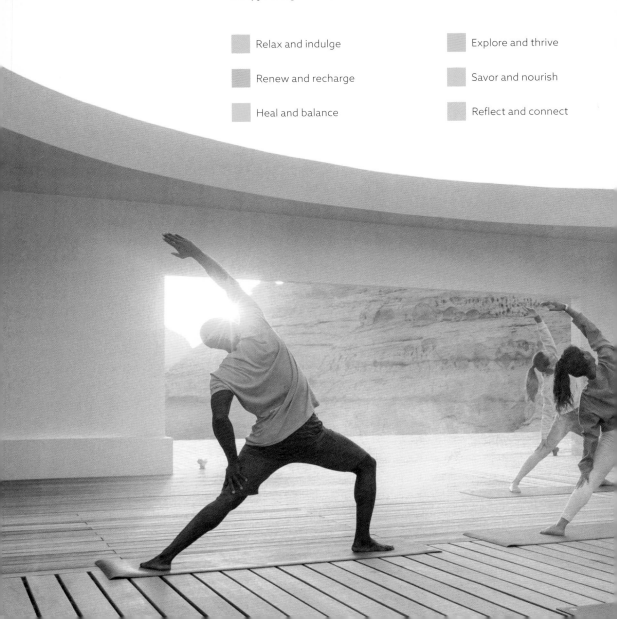

CONTENTS

Introduction 6

1 NORTH AMERICA 8

2 SOUTH AMERICA 122

3 EUROPE 166

4 AFRICA AND THE MIDDLE EAST 258

5 ASIA 304

6 AUSTRALASIA 364

Index 406
Image credits 414
About the authors 416

INTRODUCTION

In a world where so many of us are busy, stressed, and time poor, wellness travel is booming. We're increasingly looking for uplifting trips that restore, reset, and revive us both mentally and physically, rather than spending our vacations on a crowded beach or cramming in as many sights as possible. And with health and wellness options permeating every type of travel, it's easier than ever to prioritize your well-being while you're away from home.

When you hear the phrase "wellness travel," you might think of yoga classes, spa treatments, and healthy eating regimes. And while this book does include plenty of those—from ashrams and luxury spa resorts to boot camps and vegan retreats— wellness travel encompasses a whole lot more. Traditional healing practices, for example, or personalized programs designed to help you deal with everything from trauma to exhaustion to insomnia.

Like me, you might find that your biggest highs come from spending time in nature—swimming in the Scottish seas in winter, perhaps, or feeling goose bumps rise while watching the stars above the Sahara Desert. Or you might get that wellness boost through mastering a new creative skill, forming connections with people from different cultures, or tending to your spiritual needs at a monastery retreat or on an ancient pilgrimage trail.

To help you get started, we have researched and chosen one thousand experiences across six continents to suit your travel needs and preferences. Whether you're traveling as a couple, as a family, or going it solo, we've included plenty of ideas to help you work on your mental and physical well-being, experience the healing power of the wilderness, or just relax, kick back, and indulge. At the time of writing, some of the destinations in this book are, or have recently been, in conflict zones. We didn't want to exclude any wellness destinations based on the current situation in their region, but it does mean some entries might not be accessible—or advisable—now or in the future. Please check relevant government guidelines before traveling.

We hope that you enjoy reading this book and that it gives you plenty of inspiration for happier, healthier, and more meaningful travels.

NANA LUCKHAM

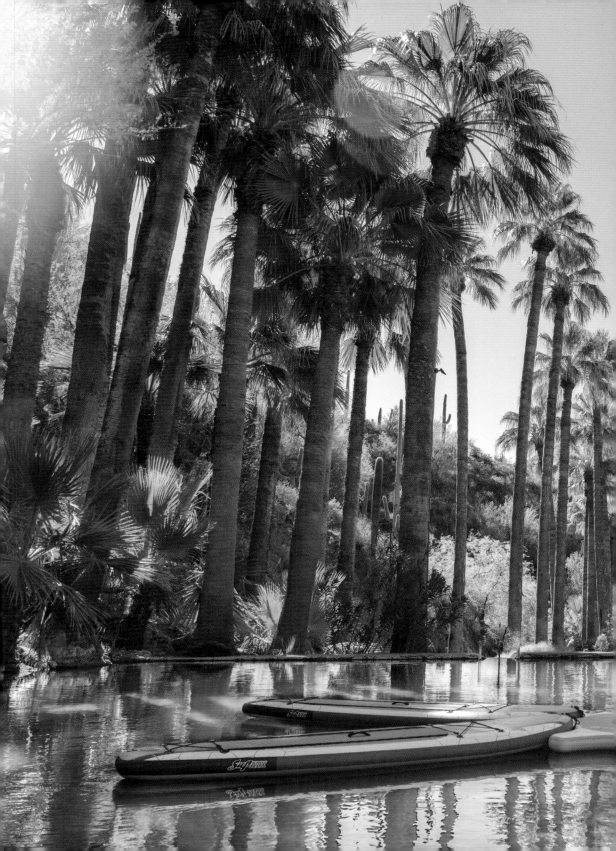

1
NORTH AMERICA

CANADA

1 Head into the wild for some natural sound healing

If you want to alleviate stress, improve your sleep, or soothe anxiety, turn to the ancient art of sound healing. The sound of birdsong, the wind through the trees, and the gentle rush of a river are all known to calm the nervous system and can have profound health and well-being benefits. The fewer human-made noises the better, so get as far into the wilderness as you can and sit or walk in silence, taking in the sounds around you.

CANADA

2 Experience frozen wilderness along Canada's ice roads

In the winter there are nearly 1,200 mi. (1,931 km) of ice roads in Canada, carved through terrain that's often impassable in summer. Follow them to visit remote communities, view frozen landscapes, and be energized, uplifted, and connected to the land and its people. Arctic Range Adventure can help you make the most of this terrain, taking you in the footsteps of First Nation traders from the Yukon to the Arctic Circle.

CANADA, NORTHWEST TERRITORY

3 Kayak to an idyllic wilderness spa

Set on the banks of the South Nahanni River, Kraus Hot Springs is a popular rest stop for kayakers. In fact, the only way to get here is by paddle. Ignore the pungent smell of sulfur and concentrate on soaking up the mountain views, allowing the high concentration of minerals, including chloride, sodium, and sulfate, to relax your muscles and smooth your skin. But steer clear during the summer: black bears and grizzlies are common in August and September.

1 Sound healing

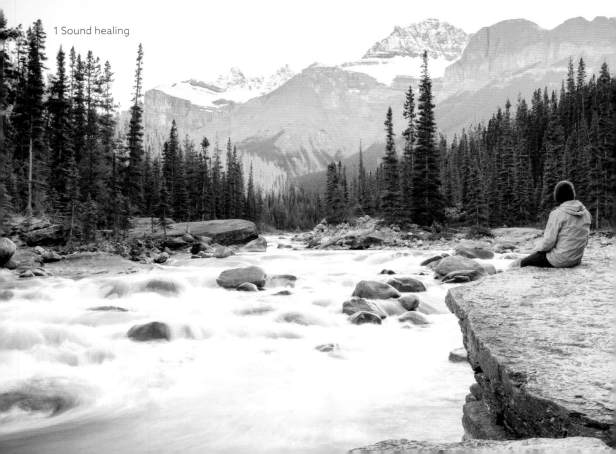

4 Improve your zen by learning the basics of meditation

Young people keen to discover Vipassana—a meditation technique from India that focuses on cleansing the mind by observing your thoughts—are welcome at the Vipassana Meditation Centre near Montebello. The result is a spirit filled with self-love, peace, and compassion. The course is suitable for those aged twelve to eighteen years. All meditators are expected to observe silence as it's key to a successful, zen-filled experience.

5 Bundle up for a one-of-a-kind winter experience

Made entirely of snow and ice, the Hôtel de Glace is newly constructed each winter in the countryside outside Québec City. You'll get a buzz just from staying in this frozen wonderland, which draws inspiration from medieval architecture and has rooms complete with ice beds, fur throws, and ice-sculpted walls. The magic continues with access to an outdoor Nordic area, which comes complete with hot tubs and a sauna under the stars.

6 Dare to dream and share at a creative retreat

In the serene Gatineau Hills you'll find a safe space for creative souls looking to de-stress and reconnect with their potential. The workshops at Crow's Rest are designed to help you form a deeper connection with your creative passion. The activities change every year, but the goal is the same—the chance to release stress and express yourself through art.

7 Discover new perspectives on a creative art and food weekend

When art and food collide for a restorative moment, you'll find a creative weekend to nourish your soul and belly. Offered by These Hands, this art and food retreat will challenge your emotions and help you tap into all the feelings you're experiencing while learning skills such as pastry making.

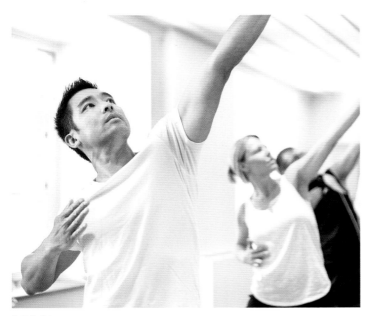

8 Tai chi

8 Feed your soul at a tranquil monastery retreat

It's easy to feel at peace during a stay at Le Monastère des Augustines, set within the walls of a seventeenth-century building in the heart of Old Québec. Still home to a dozen Augustinian sisters, it's a wellness haven that welcomes guests from around the world. Activities include tai chi, guided meditative walks, and spa treatments, and nights are spent in the restored former cloister, with breakfast taken in silence.

9 Learn to quiet your mind with a silence retreat

Creating intentional moments of silence can be a type of spiritual immersion and may profoundly benefit your health. While being silent is a key focus of the silence retreat held at the International Art of Living Centre, it follows a structured format of breathing techniques, yoga, and guided meditations. It is based on the Sudarshan Kriya technique, which is said to lower stress levels, alleviate depression, and elevate feelings of positivity.

10 Contemplate at Les Jardins de Quatre-Vents

Soak up the vitamin D from the sunshine and watch your mood improve from being outdoors in this soothing landscape created by investment banker Francis H. Cabot. The elaborate gardens in Charlevoix feature grassy lawns, waterfalls, pools meant for quiet moments of reflection, and exotic Asian plants.

11 Kick back in a rooftop hot tub at a stunning design hotel

Set on one of Newfoundland's most remote and beautiful islands, Fogo Island Inn is renowned for its striking modern architecture, its emphasis on social and environmental responsibility, and its panoramic views. But it also has a secret: a rooftop deck housing saunas and wood-fired hot tubs. The island also offers activities such as berry picking and the chance to enjoy the work of local artists.

11 FOGO ISLAND

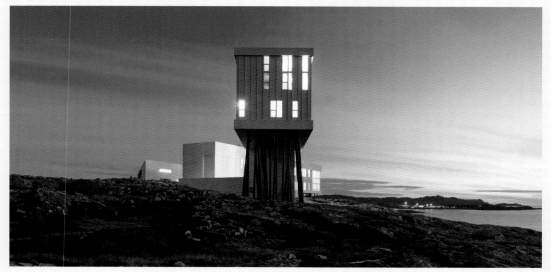

Modern architecture

Berry picking

Summer art workshop

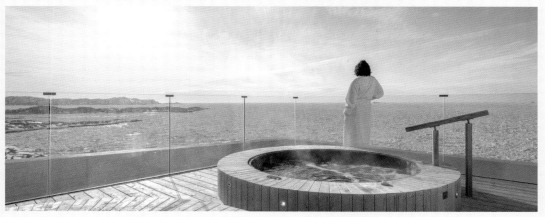

Rooftop hot tub

CANADA, PRINCE EDWARD ISLAND

12 Meditate among the sand dunes overlooking the Northumberland Strait

Choose a spot to meditate in Cedar Dunes Provincial Park and you'll get twice the benefit. Being at the beach should increase your overall well-being and elevate your mood, but these rewards may increase with the addition of meditation. The coastal park has views of West Point Lighthouse, or you can sit on top of a sand dune overlooking the Northumberland Strait and enjoy views for miles.

CANADA, NOVA SCOTIA

13 Boost your immune system on a thermal journey at a hydrothermal spa

Hydrothermal experiences can easily become the highlight of any spa trip as they are said to be loaded with health benefits. They may release toxins, increase circulation, improve immunity, support heart health, and more. At Oceanstone Resort, you can choose a one-of-a-kind seaside journey ranging from an arctic plunge pool and salt-inhalation hammam to a soak in the vitality pool.

CANADA, NEW BRUNSWICK

14 Find peace at an Indigenous-run wilderness lodge

Built and run by the Metepenagiag Mi'kmaq Nation, Red Bank Lodge sits by the Miramichi River, and you can walk to Metepenagiag Heritage Park, where you can learn about Mi'kmaq history and culture. Follow peaceful walking trails, watch local wildlife, and learn how to make traditional food including hot tea made from teaberry leaves.

CANADA, NEW BRUNSWICK

15 Have a therapeutic massage then soak in a wood-fired hot tub with ocean views

Whether you're looking to release tension in your muscles or calm your nerves, a trip to Nattuary Nordic Spa Retreat gives you permission to take in the panoramic views of the Bay of Fundy while soaking in the wood-fired hot tub or enjoying the cedar barrel sauna, spend time immersed in nature to elevate your mood, and then cozy up in the beautiful guesthouse for a peaceful night's rest.

15 Cedar barrel sauna

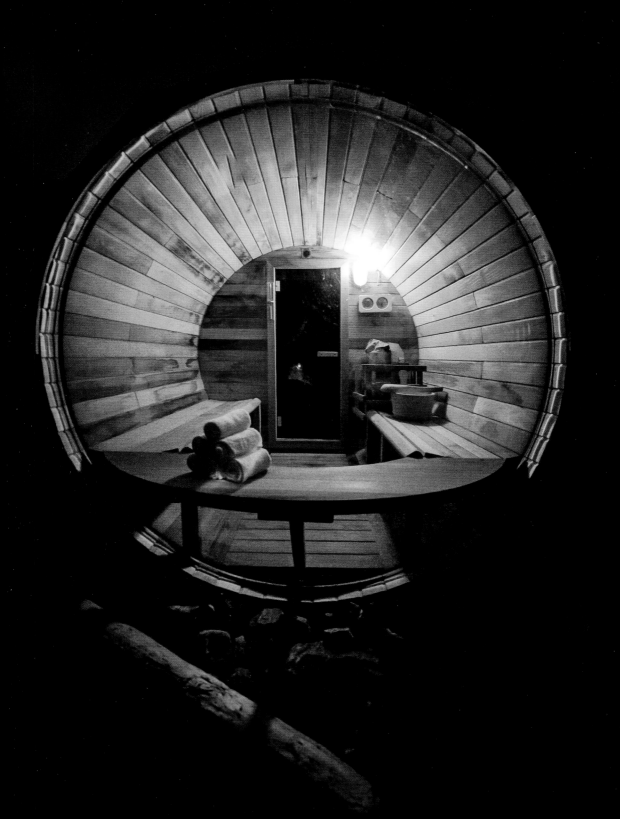

19 CABINSCAPE

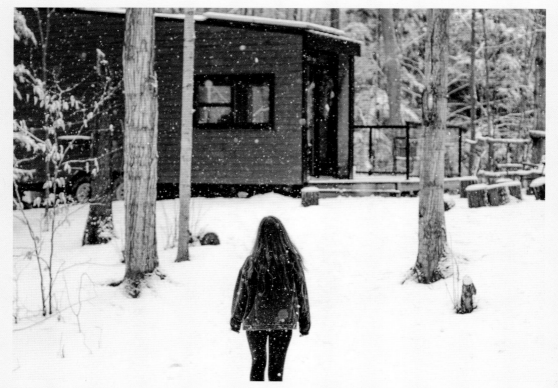

Rustic cabin

Cabin lodgings

Off-grid living

CANADA, ONTARIO

16 Discover the wonders of night on a Canadian cross-country train

It's a long rail journey from Toronto to Vancouver, but when night falls you can unwind in your private sleeper and gaze at the universe all around. Twinkling stars as far as you can see, millions of trees passing by slowly, a placid lake glistening blue under the moonlight—absorb every detail in deep mindfulness. Then all is silent and, lulled by the train, you'll fall into a heavenly sleep.

CANADA, ONTARIO

17 Experience the healing powers of spring-fed Chalice Lake

Set next to spring-fed Chalice Lake, Grail Springs is an adult-only resort that takes a holistic, nonclinical approach to well-being. Guests benefit from the alkaline-based lake water, which is used both for cooking and drinking, as well as in the outdoor hot and cold water immersion treatments. It's said to reduce muscle pain and stiffness, boost the immune system, and even improve mental well-being.

CANADA, ONTARIO

18 Find your balance at the Ontario Vipassana Center

You'll need to set aside ten days to attend a Vipassana meditation course at the Ontario Vipassana Center. A form of mindfulness meditation that stems from the teachings of the Buddha, it teaches you to focus on your breath and other physical sensations, becoming calmer and more focused in the process. You'll meditate for ten hours a day, spend your time in silence, and eat simple vegetarian food.

CANADA, ONTARIO

19 Retreat to an off-grid cabin in the woods

You'll find Cabinscape's collection of tiny cabins scattered throughout Ontario in remote locations. Set within easy reach of hiking trails and wild swims, they're designed to help you reap the benefits of being in the great outdoors, and come with equipment such as kayaks and snowshoes. What's more, they're off-grid and ecologically sound, complete with solar power and composting toilets.

CANADA, ONTARIO

20 Book a self-guided wellness experience at an eco-cabin in the woods

Smart design, nature, and well-being come together at Arcana, set in a secluded forest a short drive north of Toronto. Stylish cabins blend seamlessly into the landscape thanks to clean lines and mirrored exterior walls, and guests are encouraged to do the same. You can follow hiking trails, join guided forest bathing and foraging experiences, or just soak up the silence from your private deck or waterside hot tub.

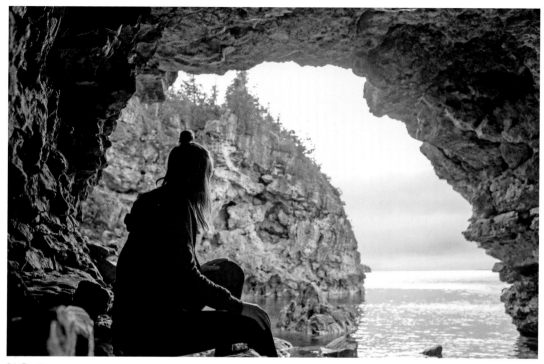

21 Grotto

CANADA, ONTARIO

21 Go for a swim in a stunning turquoise cave

Hidden along the rugged shores of the Bruce Peninsula National Park, the Grotto is a sea cave surrounded by towering rock cliffs and reached via a hike past wetlands, across rocky beaches, and along cliffs studded with orchids and ferns. Once there, take a dip, explore the cave, then head next door to Georgian Bay to swim and snorkel.

CANADA, ONTARIO

22 Explore Algonquin wilderness on horseback

The forests, mountains, and lakes of Algonquin Provincial Park are magnificent. Explore them with an equine partner and you've the makings of the ultimate mood-boosting experience. Troubles melt away as you focus on guiding your horse and looking out for the wildlife that makes this park their home—deer, moose, otters, and even wolves.

CANADA, ONTARIO

23 Feel the positive effect of negative ions at the falls

The buzz you'll get from the spectacular views is reason enough to visit Niagara Falls. But rumor has it that there's another reason why it will make you feel so good. It's said that waterfalls are a source of negative ions, molecules in the air charged with electricity that may have positive physiological effects on mood and stress levels.

24 Eat traditional Cree cuisine in the wilderness

Cree culture and nourishing local food lie at the heart of the Han Wi dining experience in Wanuskewin Heritage Park. With the help of an experienced Cree chef, you'll prepare a meal from local ingredients such as bison, foraged saskatoon berries, and chanterelles. Then you'll settle down to enjoy the results while listening to Cree myths and history.

24 Wanuskewin Heritage Park

25 Disconnect and reconnect on a retreat

It's well known that spending time in nature can improve your mood and reduce feelings of stress. At a Clay-Hike-Breathe-Sauna retreat organized by Back2Nature Wellness and Adventures, you'll get those benefits and more as you embark on a journey to reawaken your senses through hikes, and boost your circulation while sitting in the wood-burning barrel saunas.

26 Partner with horses to find empowerment and confidence

EmPower U Equine uses the power of horses to help develop life skills, communication skills, and build confidence. The organization offers several programs, ranging from a woman's wellness retreat to personal growth workshops. It even has a group program for children to help with behavior and build teamwork skills.

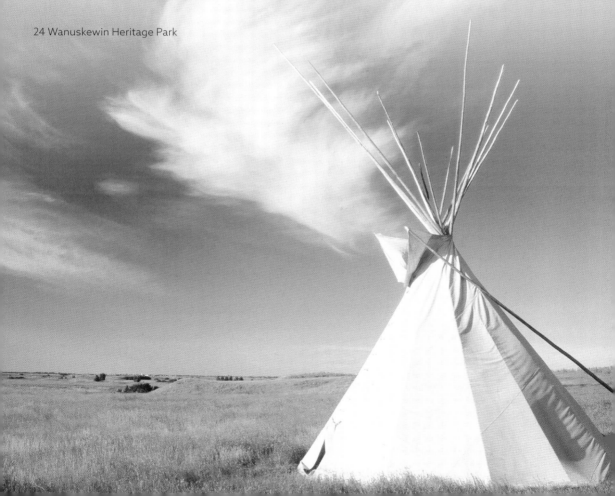

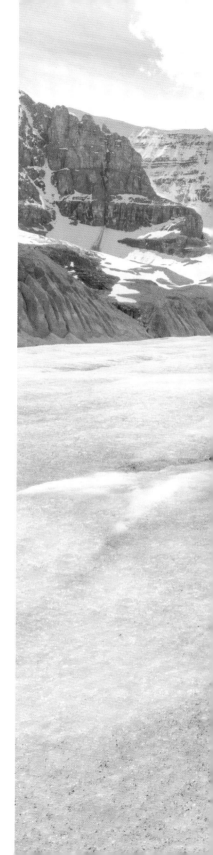

CANADA, ALBERTA

27 Explore an amazing glacier in the Canadian Rockies

Athabasca is the most accessible glacier in the vast Columbia Icefield in the Jasper National Park. Book your activities, dress warm, and at the end of the road, the power of nature will take your breath away. Start with the glass-floored skywalk, suspended 920 ft. (280 m) above the ravine, then join a guide for a challenging walk on the ice, or board the specially adapted Ice Explorer vehicle, dipping down into the glacier. Rumbling avalanche, high wind, sprinkling of snow—it's an exhilarating adventure immersed in the natural world.

CANADA, ALBERTA

28 Trek through the snow at full moon

The alpine lakes, pine forest, and hills around Kananaskis Country are stunning enough. But for the most soul-stirring experience, come after dark in winter when there's a full moon. Kananaskis Outfitters runs regular evening snowshoe tours, during which you'll explore the forest and meadows and gaze up at moonlit skies. It's a chance to work out your body and your senses as you experience the silence of the landscape after nightfall.

CANADA, ALBERTA

29 Sign up for an Indigenous cooking class

Visitors can expand their horizons and connect with Indigenous culture with a cooking class. Making bannock (bread) and berry jam, a staple in many Indigenous households, is the most popular choice at Pei Pei Chei Ow, in Edmonton/ Amiskwaciwâskahikan. Alternatively, an "honor the whole animal" class teaches guests how to cook using every part of a duck—learning valuable lessons about waste and sustainability in the process.

27 Columbia Icefield

CANADA, BRITISH COLUMBIA

30 Slow travel on the Rocky Mountaineer

Take a slow, mindful journey across Canada by train, following the historic first passage to the West. Allow your carriage to transport you on a live-in-the-moment adventure through passages only accessible by rail and leave your stress trackside. The Rocky Mountaineer travels by day, with a route from Vancouver, through Kamloops to Banff. After a day of contemplative sightseeing, passengers check in to a hotel for a night of restorative sleep.

CANADA, BRITISH COLUMBIA

31 Challenge body and mind along the West Coast Trail

Winding through Vancouver Island's Pacific Rim National Park Reserve, the multiday West Coast Trail is far removed from roads, homes, and tourist traffic and is a must-do if you're seeking adventure and solitude along the Canadian coastline. Follow the 75-mi. (120-km) track across cliffs and deserted beaches, spotting marine wildlife as you travel, and you'll find an adventure that's as good for your soul as it is for your thighs.

CANADA, BRITISH COLUMBIA

32 Experience the wilderness with Klahoose First Nation guides

Set within Desolation Sound and reached by a thrilling water taxi or seaplane ride, this off-grid wilderness outpost is owned and operated by the Klahoose First Nation. A stay at the Klahoose Wilderness Resort combines the chance to explore rock art sites said to go back to the time of the mammoths, and experience spiritual drum ceremonies with modern facilities such as a wood-fired floating sauna.

31 West Coast Trail

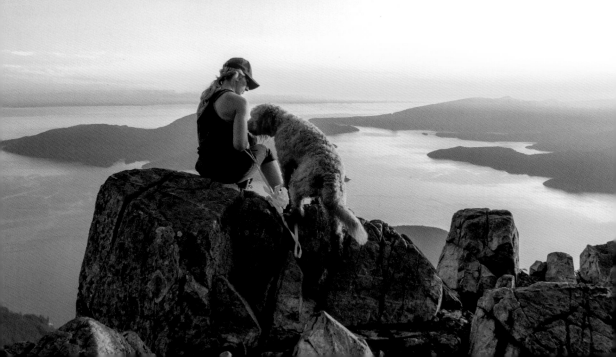

CANADA, BRITISH COLUMBIA

33 Search for wildlife in a magical rainforest

Sometimes called the Amazon of the North, the Great Bear Rainforest is the largest coastal temperate rainforest on Earth. It's also the only place where you can find cream-colored spirit bears, which the native Kitasoo/Xai'xais people believed held supernatural powers. There are fewer than four hundred of the bears left in the wild, and seeing them is an uplifting experience.

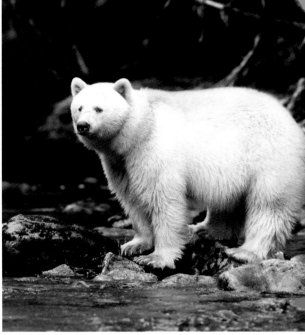

33 Spirit bear

CANADA, BRITISH COLUMBIA

34 Follow a hot springs trail through the mountains

The outdoor wonderland that is the Kootenay Rockies has an extra special bonus—a 530-mi. (852-km) hot springs circuit that offers an abundance of soothing, mineral-rich bathing spots. Try secluded and community-owned Nakusp Hot Springs, set in a bohemian campground, or Halcyon Hot Springs, which has a cold plunge pool for maximum immunity-boosting benefits.

CANADA, BRITISH COLUMBIA

35 Find peace with a forest therapy session

The wilderness around Whistler is the perfect place to embrace the quiet life among the trees. On a guided walk with Forest and Flow you'll be encouraged to get in touch with the forest using all your senses: smelling the air, listening to the birdsong, and touching bark, moss, and leaves. The therapeutic benefits include lower blood pressure, an improved mood, and better sleep.

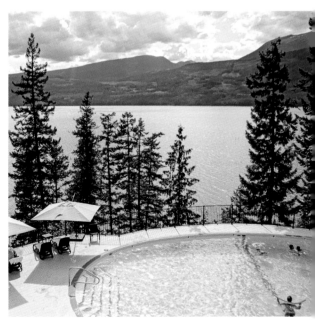

34 Halcyon Hot Springs

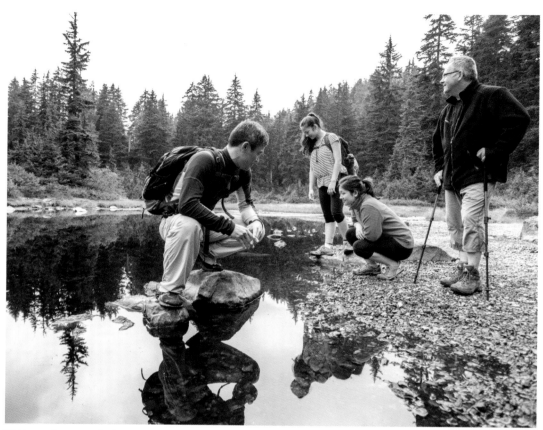

37 Mount Seymour Park

CANADA, BRITISH COLUMBIA

36 Wellness in the wilderness at a floating sauna

Tofino is known for its wildlife, forests, and wide, sandy beaches, but the newest string to its bow is a floating, wood-fired cedar sauna. Owned by Tofino Resort + Marina, it's set in a bay backed by towering evergreens. Relax in the warmth while taking in the views from the floor-to-ceiling windows, then cool off in the outdoor shower or jump into the sea.

CANADA, BRITISH COLUMBIA

37 Match the hike to your energy level

Mount Seymour Park offers a range of trails with differing lengths and difficulties so there's a route for all ages and abilities to enjoy together. If you have the stamina, hike to Mystery Lake where you can cool off in the clear water and explore a thick ring of pine forest. Views out over the valley toward nearby Vancouver round out the picture.

CANADA, BRITISH COLUMBIA

38 Connect with the worldview of the Haida people

The Haida Gwaii islands are a rugged wilderness. But the best thing about a visit is the chance to learn about First Nations culture. At Haida House you'll discover Yah'guudang—"respect for all living things and the interdependence that binds us." Visits to ancestral sites and time spent listening to myths will connect you to the people and their land.

CANADA, BRITISH COLUMBIA

39 Try a reset program based around daily hikes

Hiking is king at Mountain Trek Health Reset Retreat. A handful of clients join its week-long program, launching themselves into the wild on challenging daily hikes. A guide will teach you how to control your breath, manage your steps, and be fully aware of the sounds and smells around you.

38 Haida Gwaii

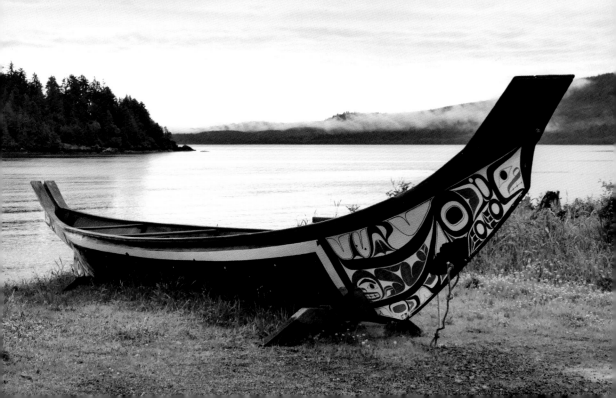

USA, ALASKA

40 Explore the à la carte wellness amenities on an Alaskan cruise

From the amazing food to live performances that leave you speechless, an Alaskan cruise is all about indulgence, excitement, and pampering. On board, you'll find everything you need to steer the stern in the direction of balance and healing on the open waters. Head to the fitness center to work up a sweat, get a total body workout by attending a fitness class such as yoga, or run laps on the jogging track to energize your body and stay active. But for the ultimate relaxation, consider booking an afternoon at the spa. Choose from aroma stone therapy to help relax those deep muscle tissues or acupuncture to enhance your overall wellness, or whatever else your cruise may offer.

40 Alaskan cruise

USA, ALASKA

41 Find your zen at the edge of the wilderness

Just a short trip across the mountain fjord of Kachemak Bay, Stillpoint Lodge is a wilderness escape with a wellness perspective. Mindfully walk the onsite labyrinth, lower stress and anxiety with a dose of forest bathing, or limber up for the day at a morning yoga class. The offering is rounded out with a locally sourced, nutritious menu to help heal you from the inside.

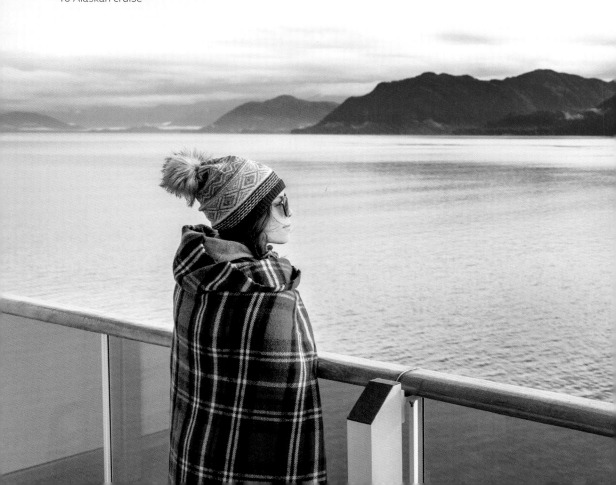

USA, ALASKA

42 Go off the grid on a remote island

Set on Fox Island, this is the ultimate place to unplug and escape modern life. The simple cabins at Kenai Fjords Wilderness Lodge come without electrical outlets, TVs, or phones, so you can concentrate on enjoying the silence and the incredible views over Halibut Cove. Spend your days hiking, kayaking, or learning about the abundant local marine wildlife.

USA, ALASKA

43 Get a workout on the Alaskan Kenai Fjords

There are few better places to feel the healing power of nature than the vast open spaces of Alaska. Join Within the Wild at its lodge in Tutka Bay and you can go a step further, improving your core strength and balance with paddleboarding sessions or exploring the coast in a kayak. You'll be nourished by locally sourced cod, sea vegetables, and foraged mushrooms and berries.

USA, ALASKA

44 Reconnect with nature at a wilderness lodge accessible only by boat

Get off the road and the beaten track at Kenai Backcountry Lodge, a collection of low-impact wooden cabins accessed by boat across the glacier-carved Skilak Lake. This wild slice of Alaska is home to moose, caribou, wolves, bears, and eagles. Add lake swims and evenings in the wood-fired sauna and it's the perfect antidote to stressful modern life.

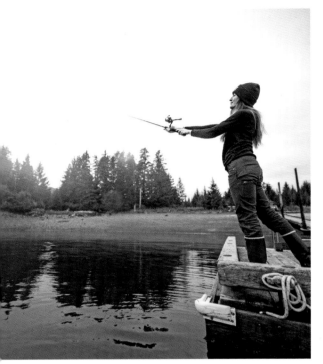

45 Freshwater fishing

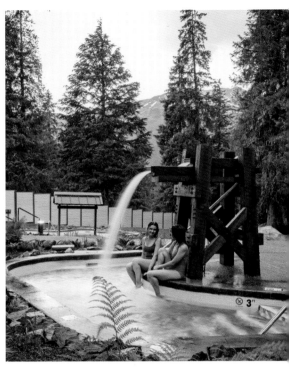

46 Alyeska Nordic Spa

USA, ALASKA

45 Make your own wilderness tea or take to the water for fish and fjords

Along Kachemak Bay there's a private cove that is home to Tutka Bay Lodge. This retreat, planted deep in the forest, features the Wilderness Tea Lounge, where guests are invited to gather herbs and flowers to make a tea to aid healing. This off-the-beaten-path destination also offers cooking classes, freshwater or deep-sea fishing, plus the chance to explore the vast wilderness of the ocean fjord or venture into Kachemak Bay State Park.

USA, ALASKA

46 Flit between saunas and steam rooms at a vast Nordic spa

It's the spectacular backdrop of northern rainforest and mountains that draws people to Alyeska Nordic Spa. That, and the equally impressive 50,000-sq-ft (4,645-sq-m) indoor-outdoor wellness space. After enjoying a guided glacier hike or spending the day skiing, you can kick back in one of many saunas and steam rooms and alleviate aches and pains as you move between the hot and cold pools.

USA, ALASKA
47 Relax in isolation in Denali National Park

You'll find both frazzled city dwellers and outdoor enthusiasts at Denali Backcountry Lodge, a property that's so remote it's only accessible by helicopter. The main draw is outstanding hiking, biking, and kayaking, and the facilities ensure you'll get the soundest of sleeps after a day in the wild. Plus the spa offers everything from antimigraine treatments to posthike massages.

USA, ALASKA
48 Spot the northern lights from a hot spring

It's the chance to wallow in geothermal water that pulls in tourists to this woodsy resort. You can head for some relaxation in the indoor pool and hot tubs, or try the outdoor Rock Lake, said to relieve conditions such as psoriasis and arthritis. For some extra magic visit from fall through spring, when after dark you can soak while the northern lights dance above your head.

USA, ALASKA
49 Forage for ingredients then transform them into a traditional Alaskan dish

This off-the-grid wilderness destination offers boundless opportunities for adventurers, from guided fly fishing to foraging for delicacies such as herbs and berries. Connect with nature at Winterlake Lodge on the historic Iditarod Trail and join a cooking class where locally sourced ingredients are turned into an Alaskan meal.

47 Denali Backcountry Lodge

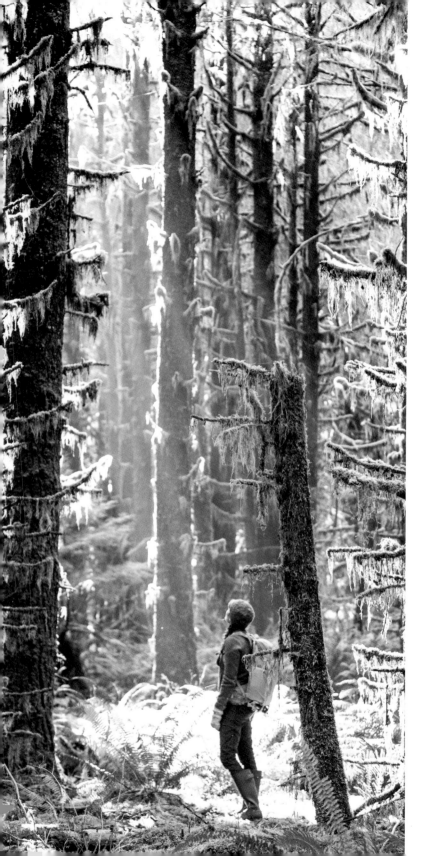

50 Bathe in the forest at Olympic National Park

Spending mindful time in the woods is good for the body and soul, boosting the immune system, lowering blood pressure, reducing stress, and even aiding sleep. Head to the Hoh Rain Forest and you can do so in a temperate environment with a unique ecosystem that hasn't changed for thousands of years; and where moss-covered trees reach up to 300 ft. (91 m) tall and 7 ft. (2 m) wide.

51 Soak up solitude under canvas

The beauty of North Cascades National Park lures hikers to explore its primeval rainforest, subalpine meadows, and glacier-clad peaks. And with only around 2,500 visitors a year, it's one of those rare places where you can fully immerse yourself in nature for days on end. There are drive-in campgrounds here, but for true isolation and a low-impact experience, head for one of the simple backpackers' camps.

50 Hoh Rain Forest

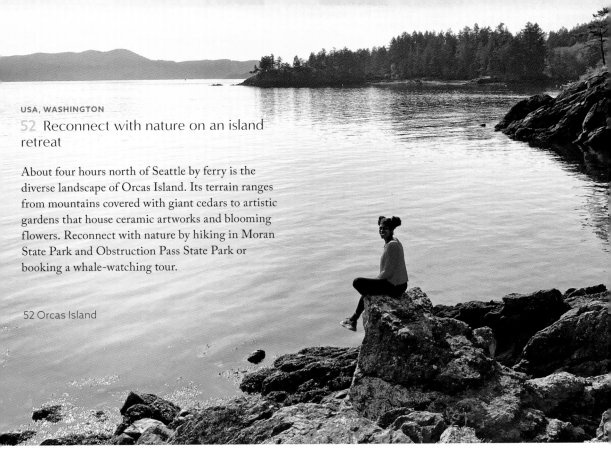

52 Reconnect with nature on an island retreat

About four hours north of Seattle by ferry is the diverse landscape of Orcas Island. Its terrain ranges from mountains covered with giant cedars to artistic gardens that house ceramic artworks and blooming flowers. Reconnect with nature by hiking in Moran State Park and Obstruction Pass State Park or booking a whale-watching tour.

52 Orcas Island

USA, OREGON

53 Take a mindfulness and self-compassion retreat

Give yourself the gift of healing and self-love at an off-the-grid wellness retreat center. Breitenbush Hot Springs aims to help others awaken and grow their spirits, and it allows you to craft the best itinerary to support your wellness journey. Enjoy vegetarian meals, find inner peace on a meditative walk in a labyrinth, or learn a new wellness practice.

USA, OREGON

54 Book a day with an adventure coach or relax with a spa treatment

The adventure coaches at Headlands Coastal Lodge offer experiences to fit your mood and energy levels. Whether you choose a beach bonfire or a heart-pumping experience, you'll be left feeling more connected to nature. Also on offer is the chance to forage for ingredients then bake a loaf of bread, or increase your joint mobility with a fat tire bike tour.

USA, OREGON

55 Meditate and contemplate the labyrinth at Portland's Grotto

Since 1924, Portland's Grotto—a nature sanctuary for peace and prayer—has been a haven for anyone seeking to deepen their connection with God. Built on 62 ac (25 ha) of land, people of all religions are welcome to meditate in the outdoor labyrinth, or tour the gardens and contemplate the redemptive quality of light and dark.

57 Craters of the Moon

56 Be your own guide in the Rocky Mountains

For eighty years, this charming ranch has called the Rocky Mountains its home. As a guest of Idaho Rocky Mountain Ranch, get ready to experience expansive views straight from the porch. Wake up to birds chirping as you step outside, inhale the clean air, then take on some of the 700 mi. (1,126 km) of trails in Sawtooth National Recreation Area. Finally, end your day in the soothing natural hot springs for a muscle-relaxing soak.

57 Feel a sense of wonder

Awe is an uplifting human emotion and a balm for a troubled mind—and it won't be in short supply at Craters of the Moon, a vast volcanic landscape straight out of science fiction. Hike around the twisted plain of ancient lava flows, cinder cones, and eerie sagebrush and you'll feel wonderfully insignificant. Camp overnight and the wonder continues—brace yourself for brilliant constellations in this International Dark Sky Park.

58 Connect with nature and your steed

Going for a horse ride helps reduce stress, release serotonin, and develop trust and connection with another living being. It's also a chance to explore the natural world in a way that's not possible on four wheels or on foot. Saddle up at the Ranch at Rock Creek and you can explore 6,000 ac (2,428ha) of wilderness. It has a herd of over seventy horses and offers everything from beginner lessons to full-day rides through the mountains.

USA, MONTANA

59 Feel the thrill of winter sports at Glacier National Park

If you're craving a snowy adventure, you can get your kicks in Glacier National Park's awe-inspiring winter landscape. Explore on cross-country skis or snowshoes and the thrill increases further. You'll work out your muscles, test your endurance levels, and improve your coordination skills while soaking up the fresh country air and topping up vitamin D levels with bursts of winter sun.

USA, MONTANA

60 Soothe body and mind at Feathered Pipe Ranch

Celebrated experts on yoga, meditation, wellness, and health have passed through the gates of Feathered Pipe Ranch. It's like a summer camp for yogis, offering fresh spring water and wholesome food, all wrapped up in the silence and beauty of the Rocky Mountains. Week-long retreats feature yoga, meditation, and a "mindful unplug experience," which teaches you to recover your natural rhythm away from the grip of modern technology.

60 Feathered Pipe Ranch

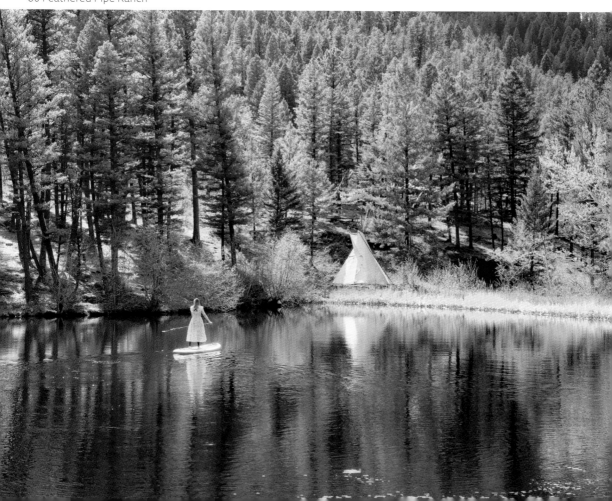

61 Relieve stress on the slopes at Jackson Hole

There is no denying the exhilarating feeling of swishing down the snow on skis, so it's not surprising that winter sports can be good for your mental as well as your physical health. Exercise such as skiing and snowboarding reduces stress hormones and boosts endorphins, while being out in nature has mood-improving benefits too. Hit the slopes at Jackson Hole Mountain Resort and you'll have plenty of runs to test your mettle, as well as an abundance of dramatic scenery to bring on that top-of-the-mountain feeling of awe.

62 Find solitude on a women-only llama trek

Spend three or four days with Wildland Trekking meandering through meadows and forests until you reach Dunanda Falls— a waterfall in Yellowstone National Park. You'll be joined by your own llama companion and be part of a small group of women as you challenge your muscles on the trail, embrace solitude in the quiet forest, and relax in the hot springs.

63 Forest bathe and wade in the hot springs

Feel your mind and muscles relax during a soak in the Granite Hot Springs Pool as you breathe in the fresh air of the Gros Ventre mountains. You'll also enjoy astonishing views of the Bridger-Teton National Forest. The pool, which is only open in the winter and summer, beckons wellness travelers for a day of relaxation and forest bathing in the steamy warm waters.

64 Rejuvenate in the mountains on a pack trip

Unplugged and untamed adventures are what set Diamond 4 Ranch apart from the typical ranch. It's nestled in the heart of the Wind River Mountain Range where guests can take in the vast wilderness and cling to the silent solitude that comes with it. Pick from a variety of specialty trips, such as a women's wellness retreat, to join solo or with loved ones. Each one includes horses, wranglers, and options based on your needs.

64 DIAMOND 4 RANCH

Horses on the range

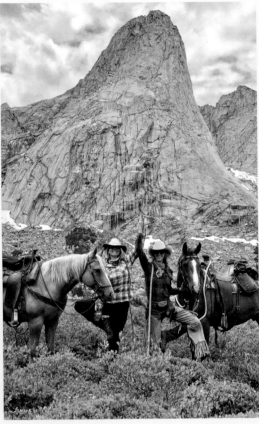

Women's Wellness Pack Trip

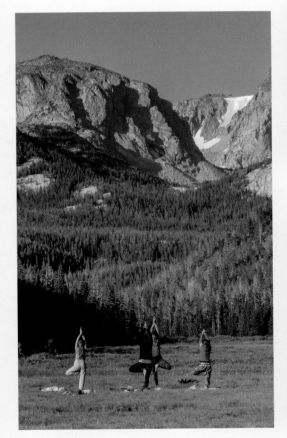

Yoga retreat

The Art of Wilding retreat

USA, NORTH DAKOTA

65 Bird-watch and spend the night on a working farm

The prairies of North Dakota are home to many unique birds, and visitors come from far and wide to spot Nelson's sharp-tailed sparrow, Baird's sparrow, chestnut-collared longspur, and Sprague's pipit. A stay at Pipestem Creek Garden Lodging and Nature Retreat is a chance to spot one or more of them while staying on a working family farm.

USA, NORTH DAKOTA

66 Plan a crafting or quilting getaway

Embrace the slower pace of life at a quilting or crafting getaway at the Coteau des Prairie Lodge in Rutland. Choose your favorite spot for a private quilting experience, or book the whole lodge for an inspirational crafting getaway. During these quiet moments, make space for self-expression through your art and give yourself the gift of peace.

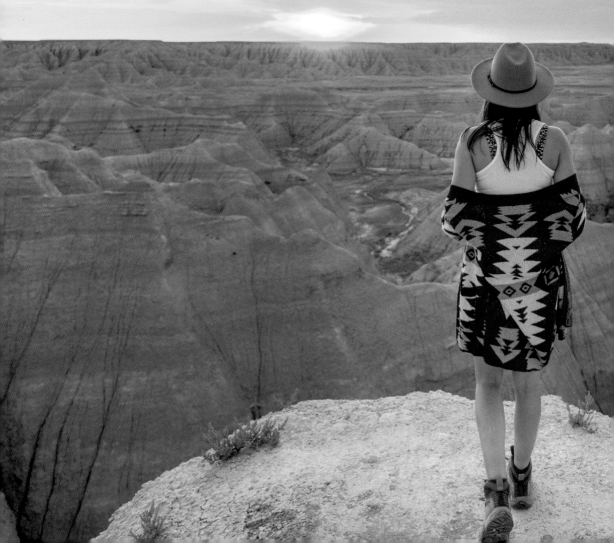

USA, SOUTH DAKOTA

67 Float your problems away in hot mineral waters

Honor the past and the present with a soak at Moccasin Springs. Historically, the healing waters at the hot springs were used by the Indigenous people. Then, in 1890, the first bathhouse was built. The property was restored in 2019 so locals and tourists alike could experience the high-quality minerals the water provides.

USA, SOUTH DAKOTA

68 Feel the power of nature at the otherworldly Badlands National Park

Hiking can help keep you physically and mentally healthy, especially in an area as stunning as Badlands National Park. It's full of striking pinnacles, spires, and jagged canyons that feel almost as if they've been transported from another planet. You'll experience plenty of "wow" moments as you explore.

68 Badlands National Park

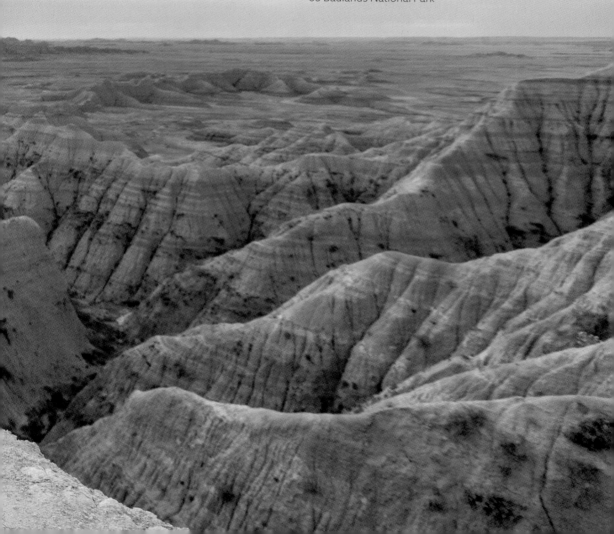

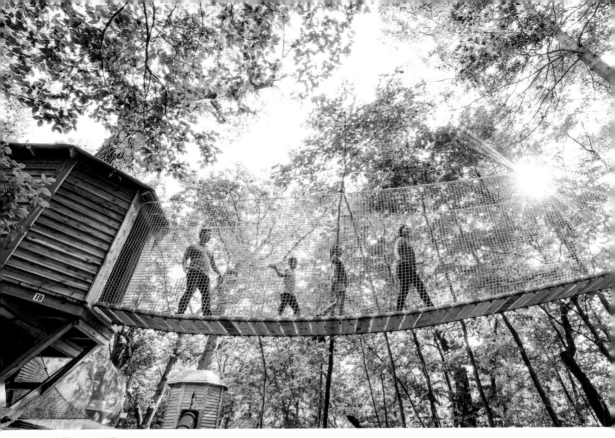

69 Treetop Village

USA, NEBRASKA
69 Explore the treetops to get close to nature

Fulfill your dreams of life in the treetops with a trek through the Treetop Village at Arbor Day Farm Lied Lodge. The village sits high above the forest canopy, and there's natural beauty around every corner. Channel your inner child to explore the wooded walkways and fascinating bridges that connect the eleven uniquely crafted tree houses together.

USA, NEBRASKA
70 Take artistic inspiration from the prairie

Set by the Mountain Pine Ridge Forest Reserve and Oglala National Grasslands, Our Heritage Guest Ranch is a prime destination for artistic discovery. The diverse beauty helps guests to open their hearts and minds to endless creative pursuits. As a retreat, you can book lessons and create your own masterpiece, whether it's a chair, painting, or photograph.

USA, MINNESOTA
71 Get tactile and learn the art of ceramics

Getting your hands dirty in a ceramics class is a great creative outlet and a form of self-expression. It will also help focus your mind. The Northern Clay Center in Minneapolis offers various types of ceramic classes for adults as well as a youth-friendly class. From beginner workshops and wheel classes to art educator workshops, there is something for every skill level.

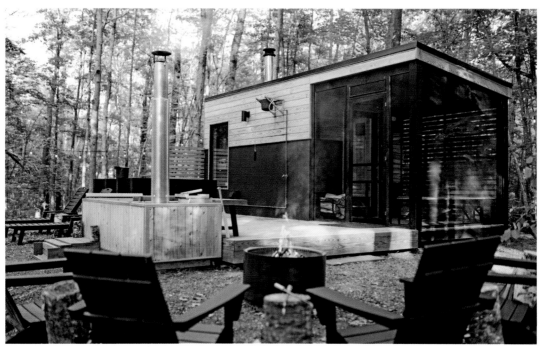

72 Forest bathing

USA, MINNESOTA

72 Immerse yourself in nature with forest bathing

Forest bathing is a deep sensory experience that awakens all the senses. Silvae Spiritus offers guided walks to help you lean into the tactile sensations of nature and move slowly along the paths for a meditative approach. The outcome is a repaired relationship with nature that is said to reduce stress, enhance immunity, and boost attention.

USA, IOWA

73 Spend a day meditating in solitude

Ancient wisdom used labyrinth walking as a tool for meditation, prayer, and quiet moments of contemplation. While many spiritual or meditation centers are accompanied by towering wooded areas, the Prairiewoods Franciscan Spirituality Center is also home to a meadow with an outdoor labyrinth. As you zigzag across the labyrinth, use this time to clear your mind and listen to any revelations.

USA, IOWA

74 Take an Ayurvedic menopause program

Ayurvedic medicine is an ancient Indian system that looks at health through a holistic lens. Experts at the Raj have used it to design a program of treatments specifically for menopause to bring balance to the body. It works by cleansing impurities that build up in the body and boosting metabolism and digestion to help alleviate menopause symptoms.

75 Attend a natural building workshop

Building your own eco-home doesn't have to be challenging—sign up for a natural building workshop at the Dancing Rabbit Ecovillage and you'll be set for success. You'll gain insight into how construction materials such as straw bales, earthen plasters, clay, stone, recycled concrete, and sand work together to build a solid foundation for a sustainable home.

76 Be still and find peace in the Ozarks

The Hermitage Spiritual Retreat Center is a sacred space for restoration, silence, and connection with God through nature. Its goal is to help guests find spiritual renewal in the lush foothills of the Ozarks. Take a meditative walk, discover the shores of Lake Pomme de Terre, or spend the afternoon painting, and find stillness in this secluded destination.

77 Find your spiritual practice at a retreat

Anyone looking for a secluded getaway to find spiritual renewal will be spoiled for choice at the Timber Creek Retreat House. The focus of all its retreats, whether for couples, individuals, or those seeking silence and more, is spirituality. Choose from a meditative hike in the forest, prayer in the chapel, spiritual mentoring, or a movie that will inspire your soul.

78 Learn to see things differently on a night hike

At the tip of Door County Peninsula lies Newport State Park. It's home to the darkest skies in the state and has been designated a Dark Sky Park by DarkSky International. Stargazers can embrace the grandest of the dark skies during a night hike that winds through the forest to a sandy beach—the viewing area—for a transcendent sky-watching experience.

79 Experience the wilderness off-grid

Deep in River Wildlife's nature reserve, and disconnected from modern amenities such as electricity and running water, Tomczyk Cabin allows you to unplug, recharge, and experience the restorative power of the wilderness. The cabin has been lovingly restored into a simple retreat where time can be spent relaxing by the fire, walking in the woods, and rediscovering the simple pleasures of peace and solitude.

80 Learn new skills in nature at a folk school

Set within 128 ac (51 ha) of Door County forests and meadows, the Clearing Folk School has one purpose—to "clear one's mind" by reconnecting with nature and one another. Today, adults with an interest in the creative arts or nature visit to learn and reflect in a noncompetitive and hands-on way. Week-long programs foster a sense of community, with guests taking classes in everything from drawing to basketmaking to pottery.

78 Newport State Park

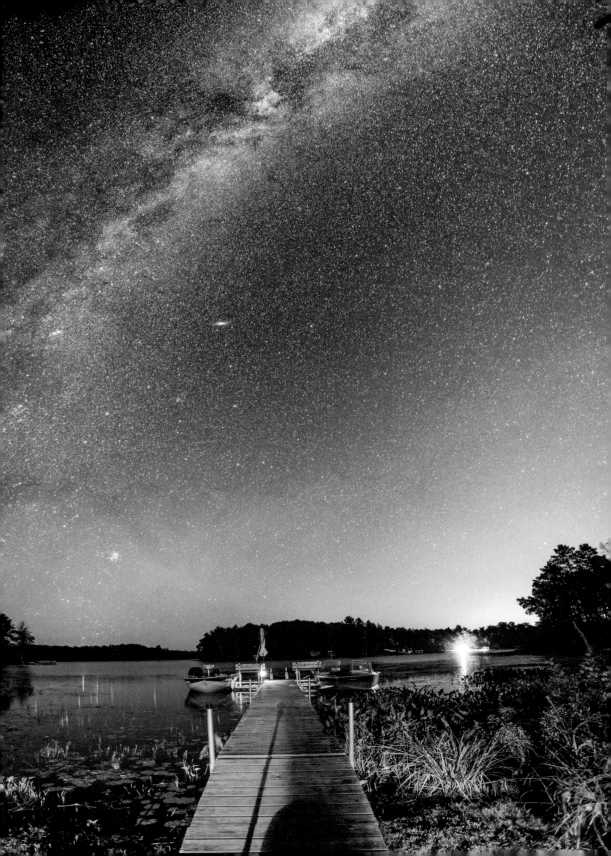

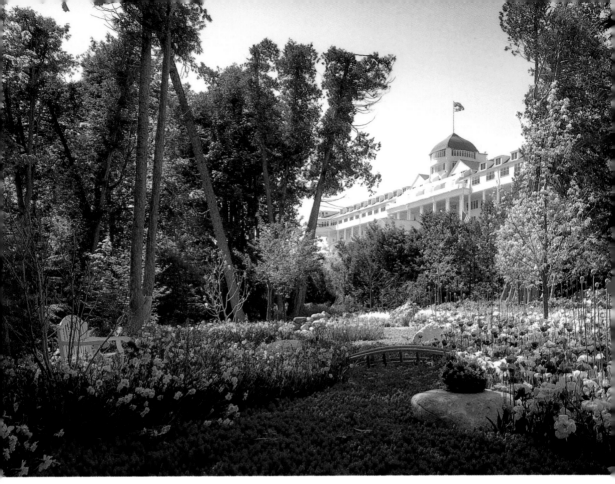

84 Grand Hotel gardens

USA, ILLINOIS

81 Spend the night in peace at a monastery

Visitors are welcome to experience a slice of serenity in the city at Chicago's Monastery of the Holy Cross. Rooms and apartments are available, and you can join the monks at mealtimes to share their solitude and silence. It's the chance to rebalance your life with peace, quiet, and hospitality.

USA, ILLINOIS

82 Stretch your body in the beautiful plains of the Midwest

Yoga, horses, and nature collide in a retreat at Soul Farms. Wake up to a morning yoga flow designed to help center your mind while lengthening your muscles. Then enjoy a farm-to-table meal, followed by mindful activities that aim to nourish your mind and bring more clarity and awareness to your life.

USA, MICHIGAN

83 Improve your circulation with bio-electromagnetic energy regulation

Sometimes a spa-cation is what your body needs to realign and heal, and at the Spa at Boyne Mountain, BEMER (Bio-Electromagnetic Energy Regulation) therapy may help do just that. The therapy uses pulses of an electromagnetic field that are said to improve blood flow, increase energy levels, boost circulation, and promote healing.

USA, INDIANA
85 Hike mindfully across shifting sand dunes

Spanning 15 mi. (24 km) of Lake Michigan shoreline, Indiana Dunes National Park is made up of oak savannas, swamps, rivers, and dunes. Take on the three-dune challenge and climb the tallest dunes on the shore, or try the dune ridge trail, a path along a completely forested sand dune.

USA, INDIANA
86 Unwind and test your chakras at a country retreat

Journey to Crown Point for a peaceful country retreat offering the chance to understand your chakras and enjoy body treatments to promote relaxation. Organized by Wellness & Retreats, guests examine the energy centers of their body and then make adjustments for optimal well-being.

USA, KENTUCKY
87 Attend a leadership retreat at a horse ranch

A ranch retreat that combines learning leadership and communication skills, wellness, and relaxation sessions is what many medical professionals need. A course organized by Wild Med Adventures enables medics to earn hours toward their AMA PRA Category 1 CME (TM) and dive into discussions around how to increase wellness in the workspace.

USA, KENTUCKY
88 Strengthen your body in a salt cave

Salt caves release tiny salt particles into the air that are believed to improve respiratory issues, ward off infection, reduce stress, and boost the hydration of the skin. At Be Happy Yoga & Salt Cave yoga is added into the mix to allow you to receive all these benefits while strengthening and lengthening your muscles. Thanks to the low light and comfortable temperature, it's a relaxing yoga experience.

USA, MICHIGAN
84 Weekend wellness retreat on a car-free island

Adopt a slower pace of life on an island where travel is by foot, bike, or golf cart. Mackinac Island has been car-free since 1898, resulting in a quieter, less hectic enviornment. This in turn may lead to a healthier lifestyle, lower stress, and improved relationships. While you're there enjoy a carriage ride, try a Reiki session at the Grand Hotel, or spend time in the hotel's garden.

91 and 92 **THE LODGE AT WOODLOCH**

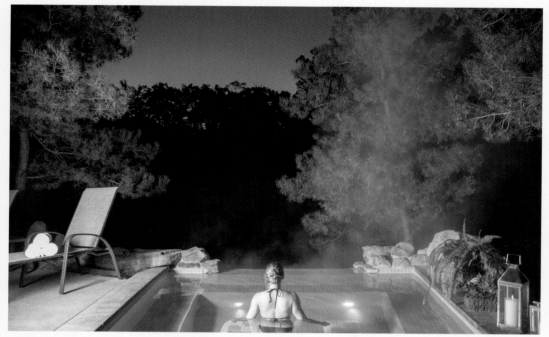

91 Whirlpool at dawn

91 Stand up paddleboarding

92 Art class

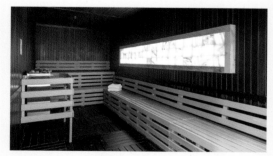

91 Himalayan salt spa

USA, OHIO
89 Book an all women's restorative self-care retreat

Designed to foster renewal and a deep sense of purpose, the goal of Native Wellness + Co all-women's retreat is to leave participants feeling empowered and connected. Through restorative yoga flows to boost your mood, guided forest hikes to awaken your senses, and wellness workshops to discover what self-care practices light you up, you'll be able to embrace the peace in the lush Hocking Hills.

USA, OHIO
90 Relax at a hidden green-certified inn

Indulge in a romantic getaway for two (or the family) at a property that features unique stays ranging from luxurious yurts and contemporary geodomes to rustic log cabins and cottages. The green-certified Inn and Spa at Cedar Falls takes its inspiration from the natural attractions such as waterfalls and caves in the park that surround it. You'll also find a spa with body treatments so you can unwind even further.

USA, PENNSYLVANIA
91 Relax body and mind and try something new

For a sauna with a difference, head to the Lodge at Woodloch, where you can feel the heat in a Himalayan salt sauna. The hot salt is said to release negatively charged ions to purify the air and allow the body to reap the health benefits. Afterward relax in the outdoor whirlpool, or try beekeeping, paddleboarding, or vibrational sound therapy.

USA, PENNSYLVANIA
92 Try your hand at watercolors and coloring

Tap into your inner artist at a creative discovery class run by the Lodge at Woodloch. Guests are encouraged to let go of the everyday routine and release stress as they foster moments of personal, deep connection and mindfulness with every stroke of their brush. Besides watercolor painting and mandala coloring, other creative classes offered are henna art, acrylics on canvas, and art for stress management.

USA, PENNSYLVANIA
93 Find holistic care to meet your health goals

Curate a wellness experience that caters to your health goals at Nemacolin Holistic Healing Center and Woodlands Spa. Among the treatments on offer is float therapy, a technique that is said to activate your parasympathetic nervous system to deliver your body into a state of relaxation. Energy work further promotes relaxation and healing on all levels—physically, spiritually, and emotionally.

USA, PENNSYLVANIA
94 Take a class in farm-to-table cooking

Nourishing meals, fresh farm produce, and recipes from different cuisines are what you'll find at the culinary retreats hosted by Honey Hollow Farm. In other words "food is medicine" reigns true on the green rolling lawns of this property. Choose from gut-healing, Ayurvedic, or plant-based recipes, or try your hand at tea making to support your body's natural digestion efforts.

95 Shou Sugi Ban House

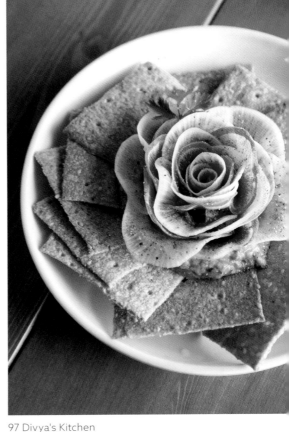

97 Divya's Kitchen

95 Experience holistic healing in the Hamptons

Holistic wellness treatments are the specialty of Shou Sugi Ban House, an intimate thirteen-room sanctuary in the Hamptons, set across a series of beautifully decorated modernist barns. There's a regularly changing program of sound journeys, energy balances, shamanic healing, yoga, and nutrition workshops, led by visiting holistic experts and healers.

96 Design a personalized wellness treatment

YO1 Wellness Center sits amid 1,300 ac (526 ha) of lakes and woodlands and offers guests customized well-being retreats. Choose the area you wish to target, from anxiety to weight management, and then design a program that works for you with the help of practitioners and therapists. Yoga, physiotherapy, massage, and acupuncture will likely all play a part.

97 Nourish your body at an Ayurvedic restaurant

Food is all about wellness at Divya's Kitchen, a Lower East Side restaurant that's based on the principles of Ayurveda—an ancient holistic medicine system with roots in India. Chef-owner Divya Alter cooks up modern, healthy, and delicious plant-based dishes such as an avocado dip garnished with a watermelon radish rose and crackers made in-house with freshly ground organic spelt flour.

100 Boram Postnatal Retreat

USA, NEW YORK

98 Experience a Russian oak leaf treatment

A *platza* is a traditional Russian treatment that improves circulation, exfoliates, and purifies the skin. Give it a go at the Russian-style Wall Street Bath and Spa. Relax in the sauna while a platza master scrubs you all over with fresh oak leaves, said to contain an astringent that opens your pores and removes toxins. Follow up with a dip in the cold plunge pool.

USA, NEW YORK

99 Breathe and reconnect to motherhood at a mama-child retreat

This retreat aims to honor the connection between mother and child in a supportive environment. Run by Wanderwild Family Retreat, it encourages mamas to show up as they are and carve out space to breathe and be. They can bond with other mothers and de-stress in nature while their child is cared for.

USA, NEW YORK

100 Join a nourishing postnatal retreat

Becoming a parent can be overwhelming, but a postpartum retreat can help you get back on your feet. Boram Postnatal Retreat will give you time to rest, recover, and bond with your baby, and you'll have access to a nursery and physical and mental wellness support. The team advise on everything from diapering to lactation to infant CPR.

USA, NEW YORK

101 Take the waters at the US's original spa capital

The healing properties of the mineral-rich, naturally carbonated waters at Saratoga Springs have been known for centuries. Mohawk and Iroquois people drank and bathed in the water—making it the original spa capital of the US—to benefit from its healing properties. Today, the tradition continues, and the waters are used to ease ailments and improve health.

USA, NEW YORK

102 Spend a weekend meditating in the mountains

Nestled in the Catskills, Zen Mountain Monastery promotes the ancient tradition of Buddhist monasticism. There's a program of full-time training for the monks, but you can join the Sunday morning beginners meditation program and its introductions to Zen training. There are also open sessions on poetry and the teachings of the Buddha.

USA, NEW YORK

103 Take part in a mindfulness and stress management program

Aman NY may be an urban spa, but its mindfulness and stress management retreat could be just as refreshing as getting out of the city. Its wellness concierge will use assessments and cutting-edge research to help you design a program to suit your needs. You could then find yourself working with a sporting legend or being treated in a private spa.

USA, NEW YORK

104 Join a silent meditation retreat at the Finger Lakes

If you seek silence and meditation without any religious affiliation, head to Springwater Center, set among rolling hills in the Finger Lakes region. Each retreat has a daily schedule including meditation periods, talks, and private meetings with teachers, and you're free to join them all or to spend private time wandering the peaceful grounds. The only requirement is that you participate in silence and contribute an hour of work at the center each day.

USA, NEW YORK

105 Recreate summer camp memories in the Adirondacks

You can recreate carefree childhood memories at Timberlock, a laid-back family resort set on the shores of a lake in the Adirondack Mountains. The setup is like summer camps of old. You wake up to the sound of birdsong and days are spent out in the fresh air either swimming, canoeing, hiking, biking, or fishing. Meals are served communally in an open-air dining area overlooking the lake, and guests gather around the campfire after dinner to swap stories, play music, and sing songs. Best of all, there's no television, Wi-Fi, or electricity, so guests can concentrate on family, friendships, and enjoying the wilderness without electronic distractions.

USA, NEW YORK

106 Hike, bike, and kayak yourself to health

Valley Rock Inn & Mountain Club is a small hotel that's big on fitness. Its intensive Mountain Club Boot Camp takes place on weekends, and activities including hiking, kayaking, and mountain biking make the most of the surrounding trails, lakes, and parkland. Healthy food is part of the offering.

105 Adirondack Mountains

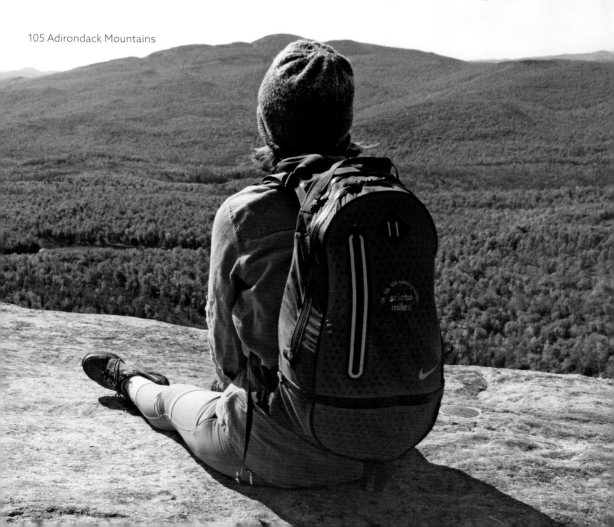

USA, VERMONT

107 Balance body and mind

When you combine a resort spa with Vermont's natural beauty, the result is the perfect place to unplug, unwind, and recharge. Spa technicians at Equinox Golf Resort and Spa customize treatments for individual skin types while massages at this mountain oasis include the spirit of Vermont, which combines Reiki and reflexology.

USA, VERMONT

108 Experience a wellness pool with a waterfall

At the Stoweflake Mountain Resort and Spa there is more than one way to enjoy the water. Book a spa treatment and you can use the indoor pool, outdoor whirlpool with a heated deck (ideal in the winter), and the mineral spa within the women's locker room area. If you want some fresh air, go to the waterfall at Bingham Falls or walk or bike the Stowe Recreation Path.

USA, VERMONT

109 Indulge in a two-story relaxation room

The two-story, sunlight-filled alcove at the spa next to the Woodstock Inn encourages visitors to begin loosening tight muscles as they enjoy views of outdoor greenery. You can soothe away stress with essential oils or hot stones, then stroll through the garden and visit the year-round outdoor whirlpool spa. Or you can complete your day sitting in an Adirondack chair on the lawn.

USA, VERMONT

110 Practice yoga in a farm setting

This legacy farm near Woodstock hosts a yearly wellness retreat that will have you feeling vibrant, connected, and on your way to living your best life. The five-day Feel Alive Yoga event at OQ Farm includes daily Bikram yoga sessions, meditation, and onsite massages, while the hiking and walking trails right outside your door will beckon you to reconnect with nature.

USA, VERMONT

111 Improve your physical and mental well-being with lifestyle coaching

If you're ready for some holistic healing, head for the hills where Sētu Vermont promotes the traditions of Indian medicine, yoga, and meditation. Among these is Ayurveda, which can help to rebalance your health by incorporating lifestyle changes and herbal therapies with a wholesome diet. You'll receive expert guidance to help kick-start your journey.

USA, VERMONT

112 Follow a natural path to well-being

This 300-ac (121-ha) resort offers plentiful paths to natural well-being, thanks to an idyllic rural setting and clean country air. At Twin Farms you can enjoy yoga, spend your time hiking, biking, fly fishing, and canoeing in summer, and skiing, snowshoeing, and even ice-skating in winter, with deep-tissue massages on hand to soothe any aches and pains. You'll be able to restore a sense of physical and spiritual balance.

112 TWIN FARMS

Canoeing on Copper Pond

Fall colors

Biking

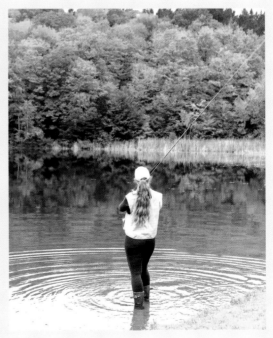

Fly fishing

113 Be soothed with traditional New England botanicals

For over one hundred years, travelers have visited the White Mountains for their pristine beauty and fresh mountain air. With the forest right outside its doors, the Omni Mount Washington Spa is the place for an exquisite mountainside escape. Inspired by its setting, the spa brings the outdoors inside to treatment rooms with sweeping mountain views. Miles of hiking trails and sweeping vistas make this a true wellness destination.

114 Experience a natural approach to beauty and well-being

The charming Christmas Farm Inn & Spa celebrates the simple pleasures of life. The spa uses all-natural products from sustainable sources to create deep relaxation and spiritual renewal. Its mountain-air body wrap blends detoxifying clay with essential oils to draw impurities from the skin, while a chakra balancing massage combines deep tissue strokes with reflexology to balance the body's energy.

USA, CONNECTICUT
125 Attend an immersive Jewish wellness retreat

Set among the forests and meadows of the South Berkshires, the Isabella Freedman Jewish Retreat Center is a year-round, farm-to-table, kosher escape that puts on educational workshops, yoga retreats, and religious services. There's a glass-walled synagogue overlooking a lake, and Shabbat and prayer services are offered; but anyone, regardless of religion and background, is welcome to come and enjoy the organic farm, hiking trails, and lakeside setting.

USA, CONNECTICUT
126 Explore your senses in a sensory garden

Home to ten unique gardens, the 250-acre (101-ha) Wickham Park was once owned by Clarence and Edith Wickham. The couple's love of nature is deeply infused into the Sensory Garden. Here you can explore and connect with nature. Breathe in the uplifting flowery scents and listen to the water gently flowing in the fountains for a moment of contemplation.

USA, NEW JERSEY
127 Join a program for those in recovery to let go of the past

Harmony Hollow is a retreat center that follows a twelve-step immersion program designed to help individuals wanting to embrace sobriety recover through forest bathing, equine therapy, and mindfulness activities. This conscious contract gives retreat-goers permission to analyze their strengths and weaknesses with a personal sober coach to understand their "why" and achieve emotional sobriety.

USA, NEW JERSEY
128 Take time for yourself among azalea and rhododendron

Known for its diverse range of trees and extensive azalea and rhododendron planting, Laurelwood Arboretum is the perfect setting for a walk in nature. It has a number of specialty gardens, including Azalea Way that overlooks the calming waters of Laurel Pond. The Sensory Garden is the perfect spot for quiet contemplation, where you can clear your mind and notice your responses to the nature around you. The planting is designed to awaken all five senses, with wide paths and raised beds making this experience accessible to all.

128 Laurelwood Arboretum

USA, DELAWARE

129 Improve your well-being living with a disability

Whatever your age, equine-assisted therapy can help to improve your confidence, balance, flexibility, and more. Southern Delaware Therapeutic Riding helps those living with a disability to foster emotional well-being through therapeutic riding sessions. Its mission is to allow everyone to experience the healing powers of horses and improve the lives of those living with disabilities.

USA, DELAWARE

130 Pamper yourself with LED light therapy, acupuncture, and more

Take a moment to relax and ease tension in your body with one of the holistic wellness treatments offered by Oceanova Spa at Ocean View. Acupuncture may help to improve circulation, reduce stress, elevate your mood, and improve the energetic flow in your body. Meanwhile LED light therapy is said to boost skin tone, lower inflammation, reduce wrinkles, and smooth out skin texture for a beautiful glow.

USA, MARYLAND

131 Recharge on a women's resilience retreat

Get ready to find and channel your inner strength through mindfulness practices, resilience classes, hiking, and gentle yoga flows at Haley Farm Inn and Retreat Center. You'll also complete a resilience journal to support your growth when it's time to return home. The farm is surrounded by hills and located near Deep Creek Lake, a popular destination to view Swallow Falls, the tallest free-falling waterfall in Maryland.

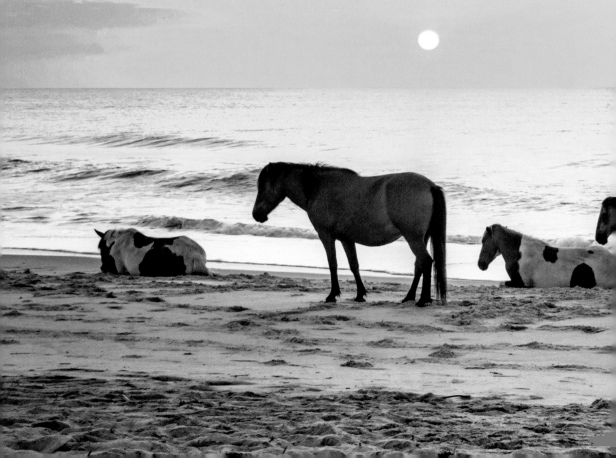

USA, MARYLAND

132 Try a gentle aerial (or hammock) yoga flow

Yoga is well-known for being an excellent exercise to help release muscle tension and boost flexibility. At Ridgely Retreat you can add a hammock or swing into the mix to suspend your body in the air, allowing more space for it to lengthen. With this technique, known as aerial yoga, deep stretching becomes easier and your spine can decompress even more.

USA, MARYLAND

133 Camp among wild horses on Assateague Island

Assateague Island is an animal lover's dream, known for the herd of one hundred wild horses that roam freely around its forests, meadows, and beaches. Make for one of the island's campsites where you can put your tent between the dunes and watch as the horses run and play. The feeling of joy you'll get from viewing them in a natural habitat will give you the well-being boost you need.

133 Assateague Island

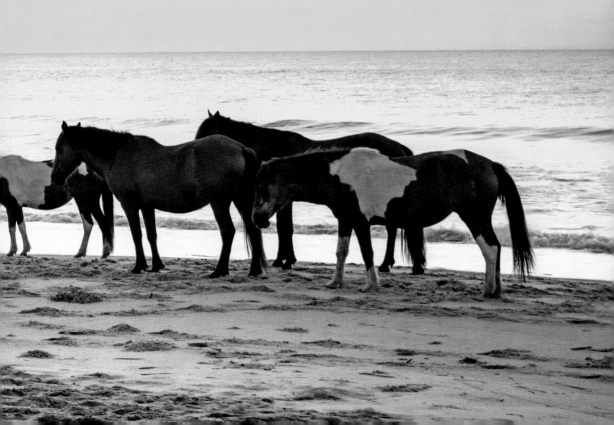

USA, WEST VIRGINIA

134 Country roads and whitewater rafting

In the Appalachian Mountains country roads lead through acres of forests, mountains, waterfalls, and an American Heritage River. The Mountain State lends itself to heart-thumping adventures such as whitewater rafting and the New River Gorge Bridge walk, which is one of the tallest in the US. For a calmer experience, relax in cozy cabin hideaways or at the legendary Greenbrier resort with its underground bunker.

USA, WEST VIRGINIA

135 Check out one of America's earliest spas

The warm mineral waters of Berkeley Springs State Park have been used for their medicinal and restorative powers for centuries, first by Native Americans and then by European settlers who, in the eighteenth and nineteenth centuries, used the waters to treat everything from gout to epilepsy. A public bath was opened in 1930, and today people visit the Roman-style bathhouse and soak their stresses away.

USA, WEST VIRGINIA

136 Go back to basics at a rustic pioneer cabin

You'll find true rest and relaxation at Kumbrabow State Forest, home to six fully furnished but rustic wooden cabins deep in the wilderness. You won't find Wi-Fi, electricity, or running water, but you will have gas lights, a wood-burning fireplace, an outdoor toilet, and a well for water. It's the perfect opportunity to slow down, connect with your surroundings, and spend time with loved ones free from modern distractions.

USA, VIRGINIA

137 Follow a transformative program

Acquire a renewed wellness lifestyle in the heart of the Blue Ridge Mountains. Wrapped in woodland and fields, you will be able to align with nature and immerse yourself in one of the specialty programs at the Eupepsia Wellness Resort. Its retreats include the chance to detox in the Himalayan salt chalet, experience shirodhara mind-calming therapy, or take a meditative trip to restore balance.

USA, VIRGINIA

138 Taste historic waters favored by presidents

Bathe in history—and spring water—at the Omni Homestead Resort in Hot Springs. The spa's stone basin was the first spa structure to be built in the US (back in 1761) while its iconic bathhouses date from the mid-1820s (for male spa-goers) and mid-1870s (for female guests). Over the years, twenty-three American presidents have come here to relax and take a dip in the warm springs pools.

USA, VIRGINIA

139 Reset with an equine adventure

You can de-stress and reset with equine experiences at Salamander Resort, which sits deep in Virginia's horse and wine country. There are plenty of opportunities to get out on horseback, but it's the equine communication program that's unforgettable. These sessions explore the bond between horse and human, and teach the importance of communication, body language, and energy.

137 EUPEPSIA WELLNESS RESORT

Himalayan salt chalet

Massage

Labyrinth

USA, **NORTH CAROLINA**

140 Learn to adult at a young adult retreat

When it comes to finding a safe space for young people to thrive, a retreat may be just the thing. At Skyterra Young Adult, participants learn how to incorporate positive change and the importance of a consistent routine to help with time management. Therapists help with strategies for goal setting and emotional regulation to support a healthy lifestyle.

USA, **NORTH CAROLINA**

141 Learn the secrets of happiness

The Art of Living Retreat Center focuses on happiness and positivity in its extensive wellness program. During its signature happiness retreat, you'll learn Sudarshan Kriya Yoga, a breathing meditation technique that helps reduce stress, depression, and anxiety, as well as improve sleep. The offering is rounded out by guided nature walks, Ayurveda cooking demonstrations, and creative workshops including pottery.

USA, **NORTH CAROLINA**

142 Reset your relationship with a couples wellness retreat

According to research, taking a vacation as a couple boosts happiness and increases relationship satisfaction. Choose a dedicated couples wellness escape and you'll ramp the benefits up even further. At Art of Living Reset Center, all-inclusive couples' packages include everything from relaxation therapy to guided meditation to walks in the fresh mountain air, so you can strengthen your partnership bond while reinvigorating your body, mind, and soul.

USA, SOUTH CAROLINA

143 Join a jump-start weight-loss program

Home to sandy white beaches and pleasant walking trails, Hilton Head Island is a charming coastal getaway off the shores of South Carolina. Kick your wellness routine up a notch by booking a sustainable weight-loss program at Hilton Head Health. Each retreat offers cooking demos, health coaching, or individual counseling.

USA, SOUTH CAROLINA

144 Embrace the healing sacred sites in Springbank

The history of Springbank dates to 1782 when it was a plantation. It has been developed into a retreat with a mission to provide spiritual renewal through healing activities such as basketmaking, pottery, ecological education, and more. You can honor the past enslaved inhabitants with a visit to the cemetery, or take a meditative walk in the labyrinth.

143 Hilton Head Island

USA, FLORIDA

145 Spa with your dog at The Betsy Miami

A graceful historic hotel in the heart of South Beach, The Betsy pulls in a stylish crowd to its Rooftop Wellness Garden, which welcomes four-legged visitors. Join the daily rooftop yoga or enjoy a dip in the pool, safe in the knowledge that your pooch is also being treated to luxury canine nibbles and chilled water. And then you can reunite for a starlit after-hours walk on the beach.

USA, FLORIDA

146 Learn from physicians, registered dietitians, and exercise physiologists

Pritikin is a medically based wellness retreat with healthy eating and fitness firmly at its heart. One-on-one consultations and expert assessments form the basis of treatment, and you'll go through everything from exercise-tolerance tests to heart-rate monitoring to dietitian consultations and even sleep studies in order to develop a plan to help you reach your well-being goals.

USA, FLORIDA

147 Meditate with wolves in Florida

Don't cry wolf—meditate with them. This unique approach to energy healing and relaxation techniques allows visitors to the Shy Wolf Sanctuary in Naples to interact with these exotic creatures under the guidance of trained experts. The refuge—which has rescued more than 1,260 animals—conducts educational and therapeutic programs such as meditation with wolves, where guests experience a therapeutic animal and human connection and its effect on hope, healing, and peaceful coexistence with wildlife.

USA, FLORIDA

148 Create a road map for longevity at Carillon Miami Wellness Resort

Many modern spas are all about preventative action, and the Carillon Miami Wellness Resort is no exception. Visit the resort's biostation and you'll have diagnostic tests on over one hundred biomarkers such as serum glucose and cholesterol, followed by nutrient-therapy treatments and a curated set of wellness experiences. To keep the momentum going, you'll leave with a set of personalized health goals, as well as access to ongoing monitoring from the resort's medical team.

USA, FLORIDA

149 Red light therapy at Carillon Miami

Cutting-edge wellness techniques are a given at the Carillon Miami Wellness Resort, and among the treatments on offer are the latest innovations in whole-body red-light therapy. Its prism light pod can be used for everything from speeding up recovery from injury, to easing muscle and joint fatigue, to slowing skin aging. It's believed to work by producing a biochemical effect in cells that strengthens the mitochondria.

145 The Betsy

USA, FLORIDA

150 Book a trip on a yoga yacht

Want to elevate your yoga experience? How about practicing your asanas on board a luxury catamaran? Based out of Miami, the Yoga Yacht includes everything from cushioned sundecks for the perfect yoga flow, bespoke yoga and Pilates programs, and sound-healing sessions. All with the benefit of ocean breezes and salty sea air.

USA, FLORIDA

151 Spend the night under canvas at Biscayne National Park

You'll need a boat to access the campgrounds at Biscayne National Park, a watery island wonder that's part of the Florida Keys. A night or two spent camping by the ocean, away from the noise of the city and with clear, starry skies above, will help you to switch off, de-stress, and rediscover the joys of nature, as will the warm subtropical waters, marine wildlife, and endless opportunities for kayaking, sailing, and snorkeling, all right on your doorstep.

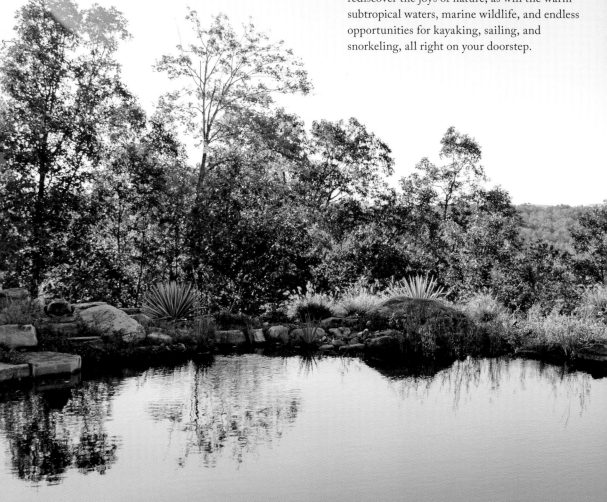

USA, GEORGIA

152 Get in touch with your inner goddess

Women discover how to tap into their most fulfilled, free lives by stripping any unwanted narratives on an unleash-your-inner-goddess retreat in the majestic Blue Ridge Mountains. The Elohee retreat center provides a space where transformational healing energy can thrive in a nature sanctuary that allows you to escape, unwind, and tune in to the healing properties of nature.

152 Elohee retreat center

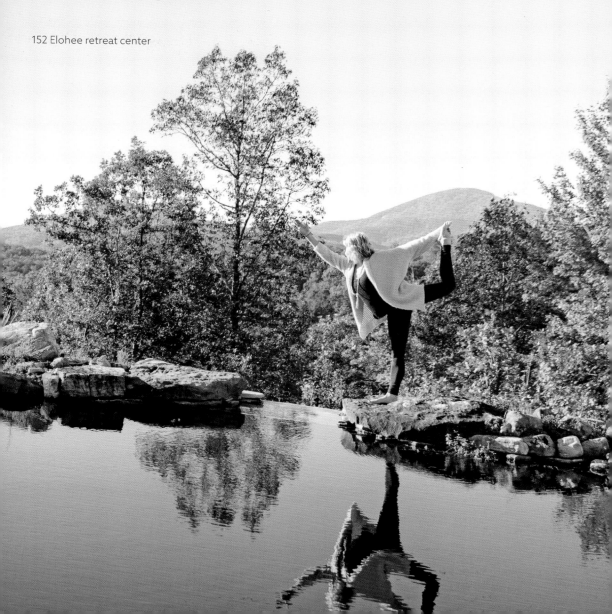

USA, GEORGIA

153 Camp in a Wi-Fi-free blackwater swamp perfect for stargazing

Take a break from Wi-Fi and embrace the dark skies of the biggest blackwater swamp in North America. Okefenokee Swamp is also home to one of the most famous reptiles—the American alligator. The Georgia Department of Natural Resources estimates that nearly twelve thousand reptiles live in the swamp, as well as black bears, wood storks, deer, turtles, and herons. Beyond the abundance of wildlife be warned—parts of the swamp are remote.

USA, GEORGIA

154 Discover the culinary heritage of the Gullah Geechee people

Isolation led the people of the Golden Isles—four barrier islands off the coast of Georgia—to develop their own culture. Today, these are still embraced by many of the Gullah Geechee people, descendants of the enslaved Africans who worked on the cotton plantations. Educate yourself about the community at the Pin Point Heritage Museum and support it by dining at a Gullah Geechee–owned restaurant, and enjoy traditional dishes such as shrimp and grits.

153 Okefenokee Swamp

USA, TENNESSEE

155 Take a break with float therapy meditation

At New Day Healing and Wellness in Memphis, services centered around easing pain, reducing stress, increasing energy, or improving immunity are given a boost with the addition of meditative flotation therapy. While you float in the tank you'll seem weightless and be able to feel the stress melt away.

155 Flotation therapy

USA, TENNESSEE

156 Honor the new moon and solar eclipse in a yurt

Get ready for a soulful adventure as you bathe in the moonlight and immerse all your senses in nature. This restorative experience is based at the Seven Springs Retreat Center, nestled at the base of the Great Smoky Mountains National Park. The New Moon Yoga + Yurt, Nature + Nurture Retreat encourages participants to pause, disconnect from daily life, and honor the new moon.

USA, TENNESSEE

157 Get mindful with ceramics

Unleashing and harnessing your creativity can be as good for your mental health as any meditation session. And at Blackberry Mountain, arts and crafts are an integral part of the wellness schedule. Sign up for a pottery class and you'll be encouraged to work mindfully and intuitively with clay, with the freedom to create whatever's in your imagination.

158 ONSITE

Healing workshops

Local farm

Sharing experiences

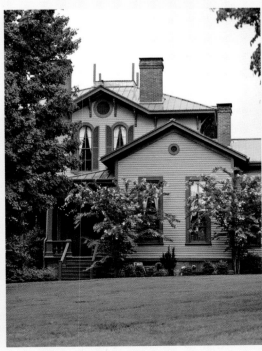

Boutique accommodation

USA, TENNESSEE

158 Take the path that will help you transform your life

Whether you're in a challenging season or just want to learn and grow, Onsite's six-day emotional wellness workshop will help you transform your life by allowing you to step away from your routine and dive into a journey of self-love and self-discovery. Expert therapists will help you find relief from anxiety, stress, and burnout by healing what hurts, learning new practices and embracing who you are.

USA, TENNESSEE

159 Explore yoga and meditation

The Isha Institute of Inner-Sciences is based on the teachings of visionary yogi Sadhguru, and guests come here to deepen their mental and physical well-being. Ayurveda treatments and daily programs in yoga and meditation are on offer, and days are often rounded off with live music around a bonfire, when guests come together to laugh, share stories, or just revel in the joy of shared experience.

USA, ALABAMA

160 Take a mountaintop meditation retreat

Since 1995, the Mentone Mountains in Alabama have been a home base for a meditation and yoga retreat. Run by the Cottages of Mentone, this is a charming and romantic escape in the quiet countryside. Each cottage is perfectly placed for sweeping mountaintop vistas of the canyon and tender moments of rest and renewal.

USA, ALABAMA

161 Gently detox your body

Discover a holistic approach to learning how to safely detox your body and promote healing. Living Springs Retreat follows the NEWSTART method—nutrition, exercise, water, sunshine, temperance, air, rest, and trust in God—for health issues such as obesity, hormonal imbalances, and more. There are wellness lectures to teach self-care habits and morning worship to renew your soul and heart.

USA, MISSISSIPPI

162 Try Fin & Zen yoga at the Mississippi Aquarium

Tap into your nirvana in a beautiful underwater setting at the Mississippi Aquarium in Gulfport. Twice a month, the facility, which is home to more than two hundred species of marine life, invites you to visit the Aquatic Wonders exhibit to find your ease and flow. Become one with the fishes as you flow through a vinyasa sequence, syncing your body and breath with the help of a yoga instructor.

USA, MISSISSIPPI

163 Learn how to achieve your core desires

Over the course of three days, Hearts of Beauty hosts a restorative retreat to help women unlock three core desires—adventure, beauty, and romance. Through self-reflection, workshops, sisterhood, and inspirational films and music, consider exploring what really makes your heart sing.

USA, LOUISIANA

164 Embrace your inner artist at a museum workshop for over fifty-fives

A museum is the perfect place to practice your creativity—and make life more colorful. New Orleans Museum of Art helps adults fifty-five and up to thrive with creative aging workshops that take a deep dive into color theory, helping participants understand the relationship between color perception and how colors convey emotions.

USA, LOUISIANA

165 Take a yoga detox retreat with nutritious Cajun food

Based in New Orleans, Diaita Yoga's Cajun-inspired retreat combines Southern hospitality with a focus on implementing lifestyle practices that promote detoxification and rejuvenation so your body can heal. Retreat-goers can expect nourishing meals that support healing, inspirational workshops for motivation, daily meditation, and yoga flows.

USA, ARKANSAS

166 Discover the waters at Hot Springs National Park

What do you get when hot springs meet a vibrant forest? Hot Springs National Park. But while it's famous for its thermal springs, the park's hot springs are not open for a soak. Instead, they are touch pools for a relaxing hand bath. For a fully submerged water experience visit one of the bathhouses and relax in the mineral waters.

USA, ARKANSAS

167 Dig for your own healing crystals on a mining retreat

Quartz crystals are said to bring harmony and mental clarity. Spend a weekend digging for these fabled stones while you bond with nature and experience the feelings of peace that it brings. In addition, Angelic Roots retreat at Hot Springs offers gong baths and meditations, all of which are used to boost overall well-being.

USA, KANSAS

168 Find your favorite bathing ritual

Bathing rituals can be more than just a rose-petaled soak. At Spa Rock Haven in Hays, they include a relaxing outdoor whirlpool, a visit to a steam room, which is infused with different aromas to help settle the mind, a revitalizing hair treatment, and a face and body scrub.

USA, KANSAS

169 Life coaching and gentle yoga

Relax in a hammock on the veranda, write a book, or explore that inner healing your body has been wanting on a Fairchild Wellness Retreat. Through gentle hatha yoga classes, designed to help improve balance and flexibility, and thoughtful life coaching sessions, meant to awaken your sense of purpose, you will feed your soul on your own terms.

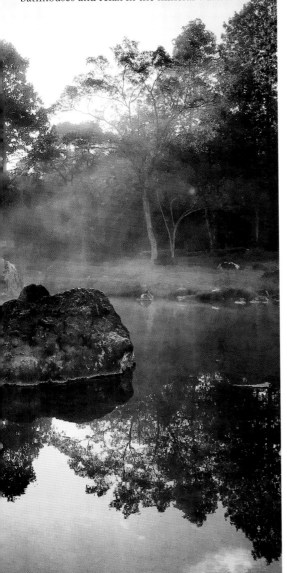

166 Hot Springs National Park

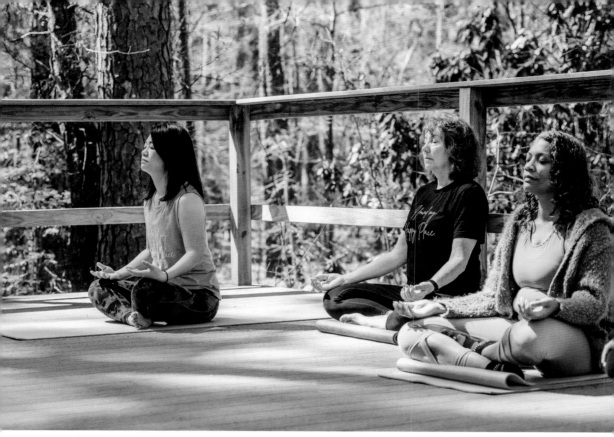

172 The Retreat in the Pines

USA, OKLAHOMA
170 Meditate and contemplate in the forest

The stillness of the forest is the perfect space for an interspiritual retreat. The Osage Forest of Peace, which sits on 45 ac (10 ha) of land outside Tulsa, is home to several hiking trails, a Zen garden, a meditation chamber called the Cave of the Mothers, a chapel, and a forest labyrinth, all of which can be used for quiet contemplation. Reconnect with nature and journey inward to refresh your spirit.

USA, OKLAHOMA
171 Take a romantic couples getaway

Take your partner to a romantic hidden gem where every morning you'll be greeted by sweeping views of the Arbuckle Mountains. From the whimsical decor and Swedish-style couples massages, to chocolate dipped strawberries and fine dining, Echo Canyon Spa Resort in Sulphur has everything couples need to unplug, relax, and reconnect with each other.

USA, TEXAS
172 Learn to love yourself at a women's retreat

Tucked away in the pine trees of East Texas, this retreat run by women, for women, embraces the beauty of all women, and welcomes them to foster heartfelt emotions surrounding mindfulness, connection, healing, and love. The Retreat in the Pines offers retreats where you'll participate in yoga flows, learn the art of acceptance, and attend self-care workshops.

USA, TEXAS

173 Set your intention on a customized break

Understand which aspects of your health need some extra TLC at a customized wellness experience. At Miraval Austin you'll be encouraged to find what will enrich and nourish your body the most. You can focus on mental well-being, relaxation, self-connection, leadership, and grief and loss among others.

USA, TEXAS

174 Choose new goals for the new year

A new year is a good time to reevaluate your life. Kick off the next one with a women's vision board retreat that allows you to work through limiting beliefs, explore your core values, and set goals so you can achieve the highest version of yourself. Hosted by the Brave Kind on a farm in Hamilton County, this retreat lets you explore the property, enjoy yoga flows, and clear out old energies.

USA, TEXAS

175 Relax and bask in the beauty of Hill Country

Why choose between luxury camping and gourmet dining when you can have both? This ultimate playground for wellness enthusiasts is filled with numerous rejuvenating health-focused activities. At this Collective Retreats event you can connect with the landscape, enjoy a yoga session, reduce stress with a sound meditation, hike, and bond with a fellow retreat-goer over s'mores.

USA, TEXAS

176 Take a break in the heart of Fort Worth Stockyards

An oasis of tranquility, the pool in the Backyard at Hotel Drover has everything you need for a day of relaxation. Hotel guests can upgrade to one of three private cabanas complete with crystal chandeliers, a refreshing fruit tray, and a selection of sodas and waters, or swap the heated pool for the hot tub or one of the Backyard's firepits.

176 Hotel Drover

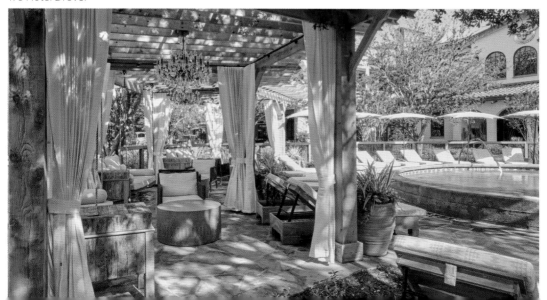

177 Discover an emblem of optimism

Back in its heyday, Winks Panorama was a famous Black-owned resort tucked away in the hilly mountains of Pinecliffe. Now it's listed on the National Register of Historic Places, and organizations such as Lincoln Hills Cares offer family educational programs and tours about this symbol of hope in the Black community.

178 Improve your horsemanship at a retreat

Saddle up for a ranch experience in the Rocky Mountains. Known as the base camp for all things wellness and adventurous, C Lazy U Ranch is a hub for travelers looking to embrace their inner rancher and find solitude. Start your day with a yoga flow, then channel your cowgirl (or cowboy) at a horsemanship clinic to connect with your horse and strengthen your leadership skills.

179 Take your yoga into the water

Would you rather practice yoga or go swimming? At Springs Resort you can choose both! Say hello to aqua yoga. It uses powerful vinyasa flow in the water, so you can strengthen and lengthen your muscles in the refreshing and comfortable environment of the pool. It will also take the pressure off your joints as you sync your breath with the movements.

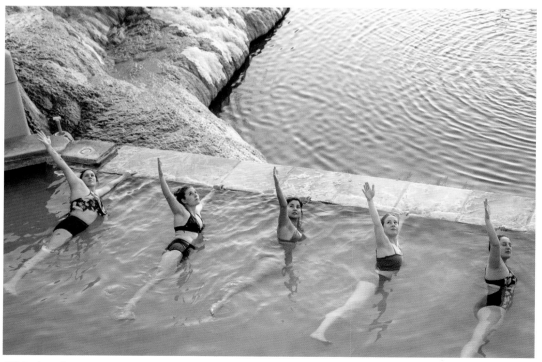

179 Springs Resort

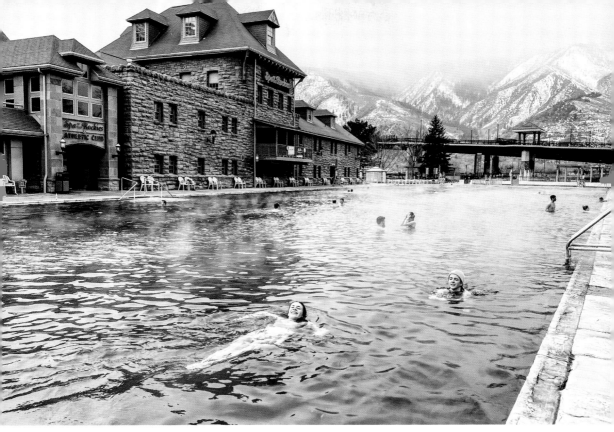

182 Glenwood Hot Springs

USA, COLORADO
180 Try a moonlit soak in a therapeutic copper tub

Six luxurious tents are the setting for the full-service Lazy You Spa, open from mid-May to mid-October along the banks of Willow Creek in Granby. Have a massage in one of its overwater tents, which comes complete with a glass floor, or go for a cowboy soak by moonlight and take in the views of the Continental Divide as you relax in a therapeutic copper tub.

USA, COLORADO
181 Catch live music from an outdoor soaking pool

Set in the San Juan Mountains, Durango Hot Springs Resort + Spa sits atop a natural spring, which feeds a sprawling outdoor complex of forty-one mineral-rich soaking pools. As well as feeling the soothing effect on your joints and muscles, you can catch live performances from the many musicians who perform here, taking in the action from the comfort of your tub.

USA, COLORADO
182 Bathe in the world's largest mineral hot spring

Opened in 1888, Glenwood Springs is home to the world's largest mineral hot springs pool. The geothermal heated water comes from the Yampah spring and features fifteen minerals said to soothe mind, body, and spirit. The water is cooled to different temperatures before flowing into a number of pools. Other facilities include a stone grotto.

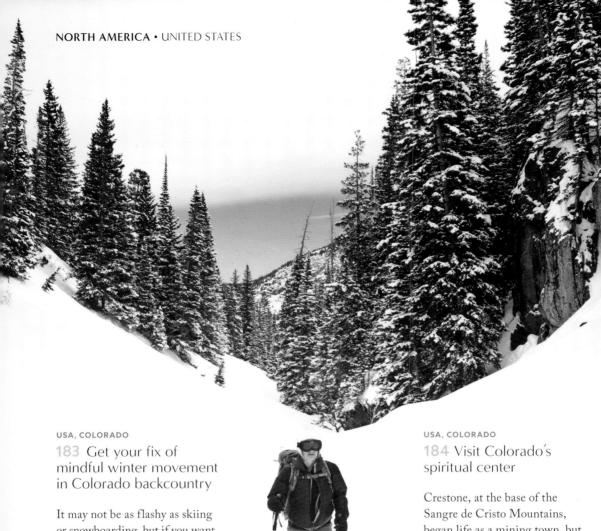

USA, COLORADO

183 Get your fix of mindful winter movement in Colorado backcountry

It may not be as flashy as skiing or snowboarding, but if you want to move slowly, take in your surroundings, and soak up all the sensations of being out in the winter wilderness then try snowshoeing through the Rocky Mountains. Take things easy as you look out for elk and coyotes on the Gem Lake Trail, or get a little sweatier on the Deer Mountain Trail, where views across the Continental Divide will take your breath away.

USA, COLORADO

184 Visit Colorado's spiritual center

Crestone, at the base of the Sangre de Cristo Mountains, began life as a mining town, but has become a spiritual center that is home to Bhuddist venues including the Chamma Ling Colorado retreat center, which focuses on the ancient Bon tradition from Tibet, and the Crestone Mountain Zen Center. Hindu, New Age, and other practices also have a home here.

183 Rocky Mountains

USA, NEW MEXICO
185 Experience the power of desert hot springs

Ojo Caliente in Taos County opened its doors as a bathhouse in 1868, but the natural desert hot springs around which it is based have attracted travelers for centuries. Today it offers nine communal hot spring baths, which feature naturally sulfur-free waters containing four healing minerals: lithia, soda, iron, and arsenic.

USA, NEW MEXICO
186 Heal through creativity at Ghost Ranch

The towering rock walls, vivid colors, and vast skies surrounding Ghost Ranch were made famous as a site of paleontological discovery, and by painter Georgia O'Keeffe, who owned a studio here. The area continues to draw artists from across the world, and retreats here are all about unleashing creativity and making the most of the dramatic landscape. Classes are available for beginners and professionals.

USA, NEW MEXICO
187 Find wellness in the desert

Find your Zen in the wilderness with the help of guides who will make sure you slow down, take stock, and appreciate both the solitude and the sweeping landscape. At Ghost Ranch a retreat is about more than the hiking trails. The retreat center, which is run by the Presbyterian Church, promotes spiritual development, creativity, and well-being through nature.

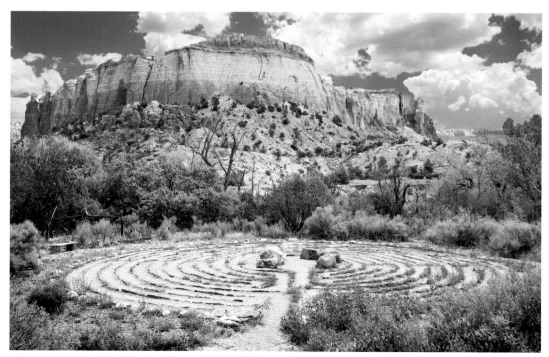

186 Ghost Ranch

193 Sensei Lanai

USA, NEW MEXICO

188 Hike among ancient Puebloan ruins

Quietly contemplate those who came before you at Bandelier National Monument. Here you can walk among age-old Pueblo dwellings, pictograph images, and petroglyph engravings; visit the original fourteenth-century pueblo on the canyon floor; and climb alongside the cliff face, where short ladders help you to clamber into caves and alcoves where people once made their homes.

USA, NEW MEXICO

189 Reap the mental health benefits of animal interaction

Mood-enhancing animal therapy—as well as a spa—are on offer at Ojo Santa Fe. Studies have shown that time spent with animals can lower blood pressure and melt away stress and anxiety. The resort fosters rescue pups at a local shelter, which guests are welcome to visit. A daily chicken chat invites guests to feed and pick up the friendly silkie hens.

USA, NEW MEXICO

190 Try Japanese-style massage and hot springs

You'll feel as if you've been transported to Hokkaido when you visit Ten Thousand Waves, an atmospheric spa inspired by Japanese hot springs resorts. Settle down in one of the outdoor soaking tubs, and enjoy the fragrance of cedar and the sound of falling water. Or try a Japanese shiatsu massage, which uses rhythmic pressure to disperse tension and pain.

USA, HAWAII
193 Take part in sleep and stress analysis

Reset and recover on an individual tailored program that aims to restore balance to your life. At Sensei Lanai, a luxury wellness enclave located among the pine-covered mountains on the secluded island of Lanai, guests are offered a personalized, curated wellness journey based on their health data. Staff analyze their current physical and mental health condition, then create itineraries featuring stress management techniques and rest practices to encourage a revised lifestyle.

USA, HAWAII
191 Attend a relationship retreat with your partner

If your relationship needs a reboot, a retreat could be the answer. A personalized program at Maui Healing Retreat includes relationship coaching sessions, couples sound healing, meditation sessions, and even guided beach walks with a counselor who'll teach you how to de-stress, appreciate your surroundings, and be present in the moment.

USA, HAWAII
192 Cocoon yourself in the natural algae of Hawaii

Wrap yourself with spirulina in Maui. This blue-green algae is packed with vitamins and minerals and usually used as a food supplement. But the Hana-Maui Resort utilizes it in a body wrap designed to detoxify and improve skin tone. The treatment includes an antioxidant sea salt and eucalyptus exfoliation followed by a hydrating massage using Hawaiian aloe vera gel and ti leaves from its garden to rehydrate and nourish the body.

USA, HAWAII

194 Connect to the land and discover native plants

It's no wonder that Kauai is known as the the Garden Isle. It is home to mountains, waterfalls, and several botanical gardens. You can also reconnect with nature when you explore the island's native plants and its agricultural terraces filled with taro—a staple food across Hawaii. Taro is an endangered species, but organizations across the islands are working to reverse this.

194 Taro growing on Kauai

USA, HAWAII

195 De-stress using aroma, sound, and color therapy

Oahu's Sullivan Estate is a private wellness retreat that takes a maximum of six guests and offers a wealth of wellness experiences. Its signature treatment uses aroma, sound, and color therapy while participants float in a warm saltwater pool. It relaxes the muscles, reduces stress, and ensures that you'll have the best sleep you've had in a very long time.

USA, HAWAII

196 Focus on experiential learning, personal growth, and well-being

If you want to improve your well-being while picking up a new skill, it doesn't get much better than Lumeria Retreat, a historic Maui compound surrounded by lush tropical gardens. Here you can learn to meditate, practice healing arts, take an aromatherapy class, or learn about the land through its horticulture programs.

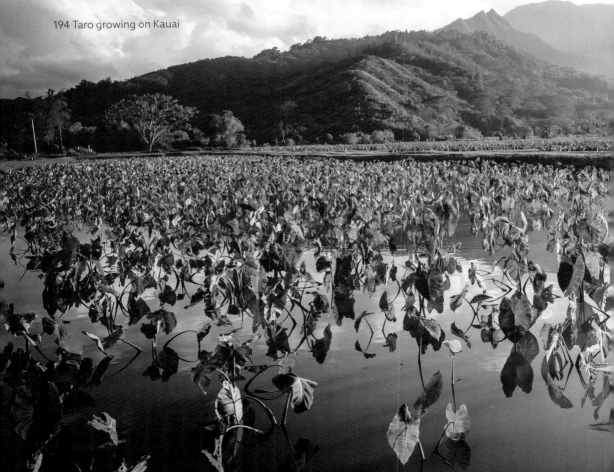

USA, HAWAII

197 Learn about harvesting and cooking with wild plants

Join an immersive experience that teaches about land stewardship and the cycle of giving and receiving with Mother Nature on a wild food and farm tour hosted by Sunny Savage. Guests learn to identify plant species that are native only to Hawaii, see the crops used to make Hawaiian canoes, and take a closer look at the wild foods found on the island.

USA, HAWAII

198 Try traditional *pohaku* hot-stone therapy

A traditional Hawaiian healing practice, in the past pohaku massage was a privilege bestowed on the Hawaiian *alii* (royalty). Warmed and oiled basalt lava stones (*pohaku*) are placed on the body's energy points and passed slowly over the skin, allowing the heat to relax muscles and relieve aches and pains.

USA, HAWAII

199 Experience a lomi massage treatment

Meaning "rub" in the Hawaiian language, lomi is a traditional massage that uses broad, flowing strokes along with macadamia, palm, and coconut oils to restore energy and soothe the body. A therapist may say a blessing before they start, to ask for help in the healing process, or hum to amplify their energy. The treatment helps to instill a sense of well-being.

USA, ARIZONA

200 Experience the energies of Sedona's vortex sites

People seeking healing and self-exploration, or the ideal place to meditate, often choose the subtle, swirling power of the seven vortex sites in the city of Sedona. Each of these sacred, powerful energy centers is said to have its own unique energy and to vibrate and accentuate the inner being of every visitor. Take in the raw beauty of the natural landscape—the red rocks, cacti, and silence provoke spiritual awakenings.

USA, ARIZONA

201 Share in sacred Native American desert culture

Share in the wisdom of Native American teachers in personal classes focused on reflection and renewal. At the Mii amo Spa, treatments inspired by local traditions include stone massage energy clearing. Alternatively, sign up for a connection ceremony, try sound resonance therapy, learn aura photography, or discover the influence of celestial cycles.

USA, ARIZONA

202 Gaze at starry skies above ancient ruins

You'll feel a connection to both the land and its ancient peoples at Wupatki National Monument, a sprawling desert park that preserves the remnants of ancient Native American dwellings and ceremonial sites. A designated Dark Sky Park, it's free of light pollution, so after a day spent exploring you can take in the vast expanse of constellations and contemplate your place in the world.

USA, ARIZONA

203 Switch off and stargaze

Quiet the mind and enjoy the solitude and stillness of the dark sky at Oracle State Park—a recognized Dark Sky Park. This remote area in the foothills of the Catalina Mountains is a place to switch off and join the natural nocturnal wildlife. Connect with nature, capture the celestial phenomena, and gaze at the stars and sky above. Depending on the time of year, you may catch a view of the Milky Way without the need for a telescope.

USA, NEVADA

223 Cool off with a refreshing body scrub at Green Valley Ranch

While Las Vegas is renowned for its vibrant nightlife, it's also home to some amazing wellness experiences. The spa at Green Valley Ranch, which lies just outside the city, offers innovative collagen-infused facials and energizing body scrubs, which use a powerful combination of exfoliating and brushing to boost circulation, remove toxins, and encourage lymphatic flow.

USA, NEVADA

224 Try paddle yoga on Lake Tahoe

Most people understand the health benefits of yoga, but how about yoga on a paddleboard? Lake Tahoe Yoga organizes paddle yoga sessions designed to help with balance, flexibility, and coordination. The poses allow you to dive deeper into these benefits since your surface is, well, rocking. It tests your balance even further while also encouraging you to find ease in your body and tune into the energetic flow of Lake Tahoe's waters. Paddle yoga takes place early in the morning, before the crowds arrive, and so you get to experience the lake at its most serene. Afterward you might find that your body moves more easily—on and off the water.

224 Lake Tahoe Yoga

USA, CALIFORNIA

225 Express yourself through creative play

A judgement-free space meant for expression, self-love, and compassion is on offer at a creative play workshop at the Stanford Inn by the Sea. You will reconnect to your inner wisdom and gain more clarity about your life as you paint outside the lines.

USA, CALIFORNIA

226 Heal from the inside with plant-based food

Set on a hillside on the rugged Mendocino coast, homely Stanford Inn by the Sea will give you a taste for salty sea air and delicious plant-based food. Healthy eating and cooking are at the heart of the hotel's wellness ethos, and you can sign up for cooking classes as well as nutrition and healthy living workshops.

USA, CALIFORNIA

227 Forget your troubles with animal therapy

Have you ever wanted to cuddle a cow or rub a pig's tummy? If you're secretly nodding "yes, that's me!" then the Gentle Barn in Santa Clarita provides the opportunity to do just that. With a goal to inspire compassion and kindness, the barn provides a haven to help individuals to heal and balance their mood. Tour the grounds, hold a chicken, and watch as your mood lightens.

USA, CALIFORNIA

228 Learn more about your gut health

The gastrointestinal system—aka the gut—is one of the most diverse systems in your body. Classes at the We Care Spa are designed to help support immune and digestive health, aid food preparation and kitchen organization, or offer seven steps to rejuvenation. The sacred energy of the desert is at the core of the spa's philosophy.

USA, CALIFORNIA

229 Support your lungs and mental health with a cycle ride

Pedaling to your heart's content in the great outdoors can reap major heart-healthy benefits. Take your cycling experience to the next level by renting a bike at Pedal Forward to ride in Yosemite National Park. Here you'll experience paved bike-friendly roads smack dab in the middle of the national park's gorgeous meadow.

USA, CALIFORNIA

230 Soak and relax in a private mineral hot pool

Unlike most mineral hot springs, Sycamore Mineral Springs Resort & Spa offers an intimate soaking experience to nurture your body and soul. An open-air, hillside hot tub is tucked beneath a canopy and naturally heated to the optimum temperature. You'll unwind and breathe in the fresh air as your muscles loosen up from the heat and minerals.

229 Cycling in Yosemite National Park

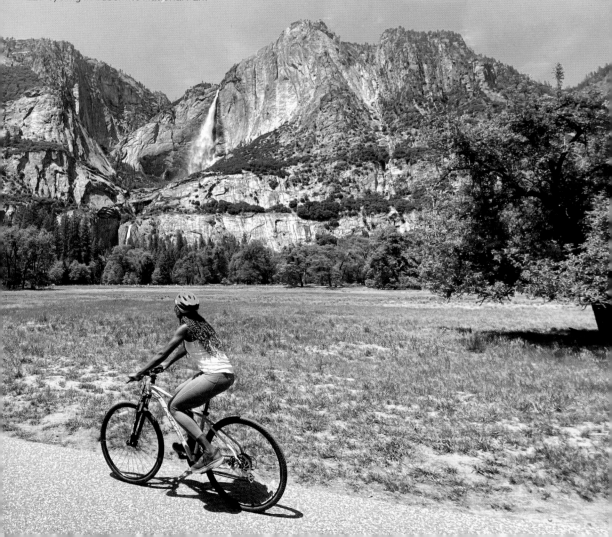

USA, CALIFORNIA

231 Reset through the power of sound bathing

It's known that the vibrations of sound have healing properties. Sound baths use sound to de-stress and decompress, while Tibetan singing bowls may improve spiritual well-being and lower feelings of anxiety, tension, and depression. And what better way to experience these healing vibrations then in the desert oasis of Joshua Tree, where sessions are offered by a number of organizations and therapists.

USA, CALIFORNIA

232 Desert bath in Joshua Tree National Park

Desert bathing is very similar to forest bathing and focuses on connecting and immersing yourself in the desert terrain surrounding you. The mood-boosting effects may help energize your body while simultaneously calming your mind. Joshua Tree National Park offers this experience to anyone who dares to embrace the endless sunshine and answer the call of the desert.

232 Joshua Tree National Park

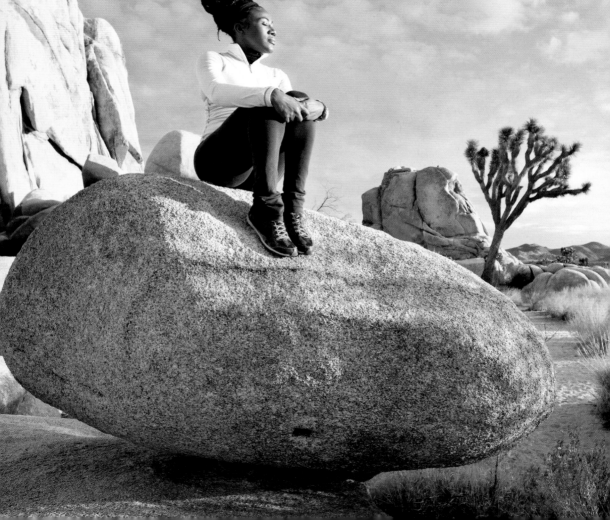

USA, CALIFORNIA

233 Attend a music festival with a difference

A family-friendly weekend of yoga and spiritual music, Bhakti Fest is the antidote to traditional rock music festivals. This transformational experience of nonstop yoga, meditation, spiritual study, and, of course, music ranging from gospel to rock is held at the Joshua Tree Lake RV and Campground each September. All food is vegetarian, and there's a welcoming, inclusive ethos. This isn't a place to party, however: it's strictly alcohol and drug free.

USA, CALIFORNIA

234 Try a hypnotherapy session in the desert

Hypnotherapy can help ease a range of physical, emotional, and psychological issues, inducing a natural state of relaxation to help you deal with the stresses of daily life. Sign up with Desert Reset, the world's first hypnotherapy-based retreat, and you have the bonus of finding your zen in the silence and beauty of Joshua Tree National Park. It's the perfect chance to retreat from the world and turn your attention inward.

USA, CALIFORNIA

235 Sign up for a wilderness retreat

Tap into the healing power of nature when you join Hiking My Feelings, a wilderness wellness program that aims to make lasting improvements to people's mental, physical, and spiritual health. As well as hiking, camping, and exploring an area of incredible beauty, you'll learn how to move mindfully and experience the thrill of pushing your body to accomplish things you didn't believe were possible.

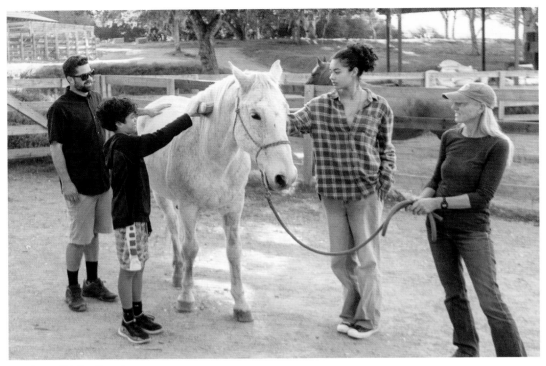

238 Carmel Valley Ranch

236 Try a health retreat without restrictions

Surrounded by lavender fields and vineyards, Cal-a-Vie Health Spa is full of French charm. In addition to yoga classes and fitness assessments you can check out its observatory, where a state-of-the-art Takahashi telescope allows you to gaze up at the cosmos. Eschewing a restrictive approach, this resort is as much about pleasurable experiences as it is about wellness. You can also indulge your taste buds with top-class French dining.

237 Get a natural "high" amid the trees

Perched on a cliff above the ocean, Post Ranch Inn is a collection of tree houses and grass-roofed cabins surrounded by forest and pasture. The focus is on making the most of your surroundings. Try a stress-reducing forest meditation session or a treatment using lotions made from flowers and herbs picked in the chef's garden.

238 Explore the special bond between humans and horses

Set in the peaceful foothills of the Santa Lucia Mountains, Carmel Valley Ranch is a place where visitors can learn to communicate with horses through vocal and body cues to achieve equestrian mindfulness. There's also the chance to mingle with the herd, giving you the chance to explore humanity's connection with horses.

USA, CALIFORNIA

239 Feel the energy of a sacred mountain

Outdoor adventures come with a side of spirituality at Mount Shasta. According to legend, this soaring peak is a sacred site. Go on a tour with a company such as Shasta Vortex Adventures and you can trek to sacred springs, join mountainside meditations, or undertake a guided vision quest—all with the aim of feeling the region's powerful energy.

USA, CALIFORNIA

240 Soak up the glamour of Palm Springs's spas

One of California's most spa-heavy destinations, Palm Springs has seen everyone from Frank Sinatra to the Kardashians enjoy its desert charms. Think mid-century modern architecture, luxury design hotels, and warm natural mineral waters known to reduce pain and increase metabolism. Go for full-on indulgence at the Yacht Club at Parker Palm Springs where treatments include tailor-made massages and regenerating facials.

240 Parker Palm Springs

242 **GOLDEN DOOR**

Japanese-style architecture

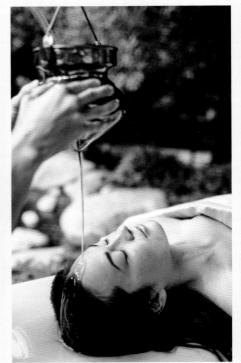

Shirodhara

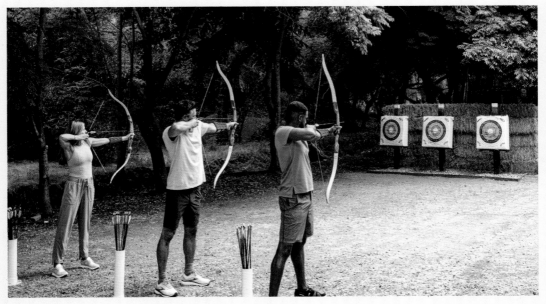

Archery

USA, CALIFORNIA

241 Reconnect with your loved ones

An interactive family wellness retreat at NewTree Ranch is the perfect opportunity to strengthen your bond in the clean country air. Your family will be guided through activities including Wim Hof ice baths, gardening and healthy cooking classes, and sessions in the outdoor spa bath. During downtime you can enjoy peace, fresh air, and the ranch's onsite animals, including Highland cows and dwarf goats.

USA, CALIFORNIA

242 Meet your fitness goals at a celebrity haunt

You'll discuss your individual health goals before arriving at the Golden Door, a retreat favored by celebrities and VIPs. Tailor-made itineraries include a personalized fitness program, a range of spa treatments such as the shirodhara where warm oil is poured over the scalp, and a meal plan featuring local ingredients. In your downtime you can make use of the grounds, which include Zen gardens and hiking trails.

USA, CALIFORNIA

243 Sweat out your stress in the mountains

An icon in the wellness world, the Ranch Malibu attracts a cast of celebrities, businesspeople, and fitness obsessives looking to meet their health goals in the Santa Monica Mountains. This is no laid-back program of gourmet food and gentle yoga classes. Its "no options" week includes a daily four-hour hiking excursion, afternoon strength training class, and a 1,400-calorie-a-day organic, plant-based diet.

USA, CALIFORNIA

244 Relax to the max with a mud treatment

You'll be asked to select a fragrance for Spa Solage's signature "mudslide"—a three-part detoxifying treatment using mineral-enriched mud and essential oils. The process involves slathering yourself in thick, white mud, letting it soak for twenty minutes, then rinsing it off before relaxing in a tub of geothermal water. Not relaxing enough? It's followed by a session in a state-of-the-art sound chair.

USA, CALIFORNIA

245 Give your system a break and prepare a cleansing mono-diet

The mono-diet is billed as a gentle way to detoxify the body, support tissue regeneration, and increase circulation. These diets come in various forms, but all follow the same rule—only one ingredient (i.e. broccoli, grapefruit, or watermelon) can be consumed. Creative Cleansing suggests you cleanse for no more than three days and that a twenty-four-hour cleanse can be very beneficial for the body.

USA, CALIFORNIA

246 Help preserve some of the tallest trees on Earth

Do something good for yourself and the planet by volunteering with Save the Redwoods, an initiative aimed at preserving California's iconic redwood forests, home to some of the tallest trees on Earth. Not only will you reap the mental and physical health benefits of spending time among these ancient trees, you'll work toward ensuring that they will be around for generations to come.

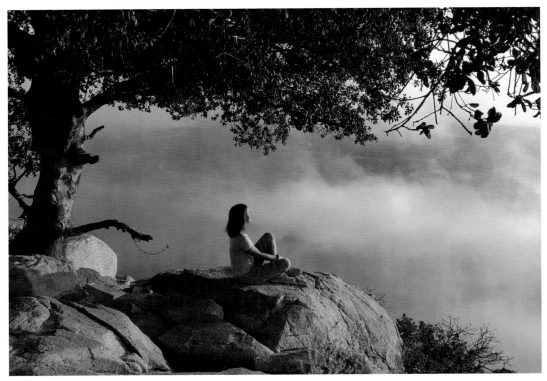

247 Mount Kuchumaa

MEXICO, BAJA CALIFORNIA

247 Connect with nature or engage your brain with a creative workshop

Located at the base of Mount Kuchumaa, Rancho La Puerta is set within thousands of acres of wild landscape, allowing guests the opportunity to find solitude and solace in the natural world. If you find that acquiring a new skill boosts your health and happiness, then learning is a part of the well-being offering. Sign up for workshops including landscape sketching, or attend lectures by leaders in their fields. You'll leave feeling engaged and refreshed.

MEXICO, BAJA CALIFORNIA

248 Sign up for fitness-based healing programs on a private reserve

Set amid fields, hills, and flower-filled gardens, and visited by the likes of Oprah Winfrey and Kate Winslet, Rancho La Puerta is a haven for people seeking peace, privacy, and a lifestyle reboot. Fitness-based programs are popular here, with more than seventy activities on offer, from dance classes to guided hikes. The idea is not to exhaust yourself, but to understand how best to care for your body.

249 Be soothed by birdsong at a tree house spa

An eco-resort nestled in the foothills of San José del Cabo, Acre Resort's unique selling point is modern tree houses—and its spa is no exception. Treatments take place at palm-tree level, with the sound of birdsong and the ocean as a backdrop. Whether you go for a neuromuscular massage to relieve deep tension or a body scrub made from locally grown organic nopal cactus, your proximity to the treetops will help you unwind even further.

249 Acre Resort

250 Rid yourself of negative energy in a Maya sweat lodge

Locals have understood the benefits of temascal ceremonies for centuries. You can take part in them at venues across Mexico where there are regional differences. A temascal is an igloo-shaped hut heated by volcanic stones doused with water and herbs to create a purifying steam. A two-hour session may include shaman-led rituals and chanting, with participants encouraged to focus on an area of their life they wish to improve. It's said that they aid blood flow and release mental burdens.

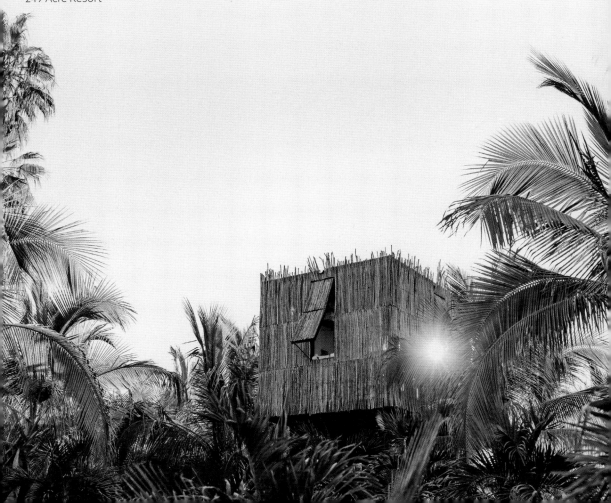

254 Monarch butterfly migration

251 Relax in a resort that champions biophilic design

An upscale tented resort spread over 48 ac (19.4 ha) of jungle, Naviva in Punta Mita is a fantastic example of biophilic design, an approach that aims to connect physical spaces and their inhabitants with the natural world. The tents are equipped with everything you need to unplug and immerse yourself in the surrounding ecosystem.

252 Enjoy a sensorial dinner with an Ayurvedic menu and music

A sensorial dinner allows you to replenish your soul and nourish your body at the same time. At El Santuario's Na-Ha restaurant, which lies deep in the forest, guests can embark on an electrifying culinary experience that couples healing and melodic tunes with yummy Ayurvedic dishes. It is believed that eating this diet may ward off unwanted food cravings, aid in weight loss, and balance the gut microbiome.

253 Immerse yourself in nature at a dreamy Mexican hideaway

A private estate that was once the holiday home of a British billionaire, Casa Cuixmala is an opulent mix of Mexican, European, and Moorish design, set on a private beach and backed by a nature reserve. A stay here is all about being out in the wild, walking the beaches and hiking trails, doing yoga at sunrise, exploring the resort's coconut plantation, and even visiting its animal sanctuary.

254 Wonder at the spectacle of the monarch butterfly migration

Each fall, black-and-gold eastern monarch butterflies travel up to 2,500 mi. (4,023 km) from the US and Canada to central Mexico to hibernate. Visit Michoacán's Monarch Butterfly Reserve between January and March, when up to a billion of them cluster together, turning the trees orange and bending branches under their weight.

MEXICO, GUERRERO

255 Celebrate your connection with the natural world at a wild eco-resort

You'll feel your stress levels begin to fall as you arrive at Playa Viva, a wild 200-ac (81-ha) site including an estuary, ancient Aztec ruins, and a coastal forest and mangrove ecosystem along Mexico's Pacific coast. This laid-back eco-hotel teaches guests to treasure the environment and their connection with the natural world. You can stay in a tree house or cabin, eat wholesome farm-to-table cuisine, visit the onsite sea turtle sanctuary, and do yoga on a deserted beach, safe in the knowledge that you're doing something positive for the planet too: Playa Viva runs on a 100 percent off-grid, solar-powered system, uses smart water design to conserve water, and was constructed using renewable building materials harvested onsite.

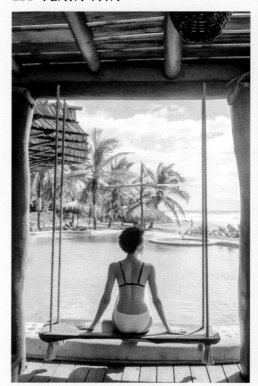

Pool view

Baby sea turtle release

Tree houses

Farm tour

Farm-to-table meal

MEXICO, YUCATÁN

256 Go for a swim in a magical cenote

The Yucatán Peninsula is known for its stunning beaches, but head away from the shore and cool off in a cenote (freshwater sinkhole). Formed by underground rivers, these mineral-rich swimming holes vary from atmospheric caves full of clear, pristine water to wide, open pools. There are more than six thousand of them in Yucatán alone.

MEXICO, YUCATÁN

257 Learn how to cook ancestral Maya cuisine

For the chance to learn about healthy, traditional food, join a class with Mayan Immersion Tulum. Lessons take place in a family home, where you'll be introduced to traditional Maya staple masa, a corn dough used to make tortillas, tamales, and other specialties. Then share a meal and make connections with newfound friends.

256 Yucatán cenote

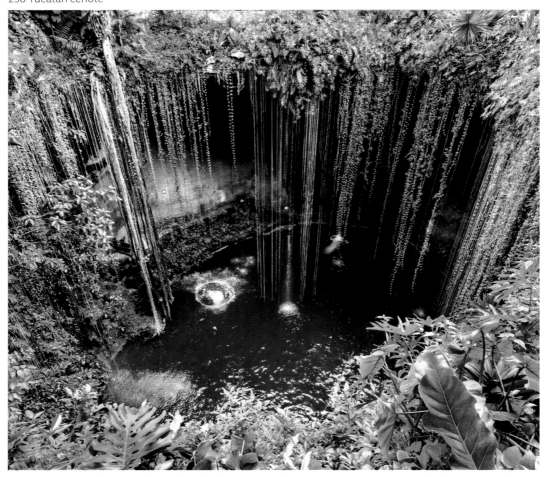

MEXICO, YUCATÁN

258 Take part in traditional Maya rituals

The hotel and spa at Chablé Yucatán combines advanced therapies and traditional Maya rituals. Plus it's the only spa in the world that is built on and around a natural cenote. After a traditional welcome ritual, guests can enjoy spiritual therapy with a Maya elder and meditation sessions after dark on lawns lit by fireflies.

258 Chablé Yucatán

MEXICO, QUINTANA ROO

259 Experience a shamanic session

The chance to consult with the resident shaman brings people to the Naum Wellness & Spa. Visitors can use the ancient energies of past civilizations to pay homage to themselves using an ancient form of healing. The shaman also leads guests through a spiritual ritual that involves a guided Maya meditation and breathwork to enable healing.

MEXICO, QUINTANA ROO

260 Gorge on nutritious plant-based cuisine

Wholesome, inventive vegan and vegetarian cuisine is on the menu at Palmaïa, the House of AïA, a sprawling luxury wellness resort in Playa del Carmen. Plant-based dining options include Ume, a chic Asian-themed restaurant, and El Caminante, the resort's onsite food truck that specializes in Mexican street food favorites.

MEXICO, QUINTANA ROO

261 Take a stress-busting meditative jungle walk

Just outside San Miguel de Cozumel you'll find Xkanha, a junglelike wellness center. Sign up for a meditative walk and you'll learn how to focus on the smells, sights, and sounds of nature, as well as on your body. It's stress-busting, mood-boosting, and a reminder that mindfulness doesn't have to be a still or solitary activity.

THE CARIBBEAN, THE BAHAMAS

262 Swim in a healing freshwater spring accessible only by boat

You'll need to hire a boat and a knowledgeable guide to reach East Bimini's Healing Hole, which sits inside thick mangrove swamps where freshwater and saltwater meet. Jump in and you'll benefit from the healing powers of lithium, sulfur, and magnesium, a triple wellness whammy said to improve mood, muscle function, and energy levels. For the best experience, come during high tide in the spring and summer.

THE CARIBBEAN, THE BAHAMAS

263 Try a mindful eating experience

Practice mindful eating as you slow down and savor every bite at Kamalame Cay, a resort on the private Andros Island, which is framed by the Andros Barrier Reef. Guests can indulge in farm-fresh seasonal Bahamian dishes ranging from green vegetable curry made with fresh coconut milk to oven-roasted sea bass complete with a miso glaze. It's the ideal destination to discover a way to support your digestion, curb cravings, and help you enjoy your food more.

THE CARIBBEAN, DOMINICAN REPUBLIC

264 Explore a wellness retreat at this eco-lodge

When yoga and nature collide, you get Caribeyoga, an eco-lodge featuring seventeen bungalows surrounded by lush greenery, a pool, and easy access to the secluded beaches where you can step into solitude. Its location easily fosters an environment of blue and green spaces, which are said to offer many mental health benefits such as reducing stress and elevating one's mood.

THE CARIBBEAN, DOMINICAN REPUBLIC

265 Realign your chakras at an island retreat

The human body has seven chakras: the crown, third eye, throat, heart, solar plexus, sacral, and root. At a Heal Through the Chakra Retreat, hosted by Ki-Ra Holistic Living, participants activate each chakra through mindful experiences that help them to move energy, release trauma, and heal. For instance, chanting and Ayurvedic cooking open up the throat chakra.

THE CARIBBEAN, TURKS AND CAICOS

266 Stay on a private island at the edge of a barrier reef

A secluded private island on the edge of a barrier reef, Pine Cay is an idyllic spot to kick off your shoes and do little more than sunbathe and swim in the startling blue sea. Just being in the sunshine and fresh air will do wonders for your well-being, but don't forgo the spa, which offers massages using potions made from island-grown ingredients.

266 Pine Cay

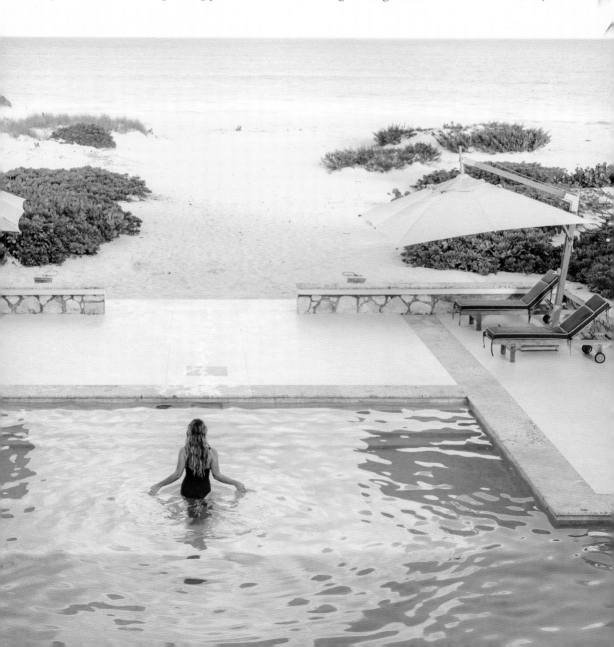

268 Hix Island House

THE CARIBBEAN, PUERTO RICO

267 Join a rooftop cacao ceremony to unlock peace

Sip your way to serenity and release tension as you commune beneath the moonlit sky with other cacao ceremony–goers at Casa Alternavida. These events are perfect for anyone looking for a quiet moment to improve their overall health as this warm, chocolatey drink is said to help reduce blood pressure levels, inflammation, and stress, and even improve brain health.

THE CARIBBEAN, PUERTO RICO

268 Immerse yourself in the wild at a minimalist eco-lodge

There are no televisions or phones and limited Wi-Fi at Hix Island House, a modernist eco-hotel set among palm groves and the ultimate place to drop off the grid and unwind. Spend your days swimming, biking, hiking, and exploring Vieques island—you'll return home recharged, relaxed, and ready to take on the challenges of everyday life.

THE CARIBBEAN, PUERTO RICO

269 Recharge on a retreat for one

If you're looking for a personalized escape, then Casa Alternavida may have what you're looking for. This hotel will help you craft the best itinerary for your needs. From quiet teatime and rooftop movement sessions overlooking the forest, to guided nature adventures, downtime for journaling, and organic meals, you'll feel recharged after your retreat.

270 Cool off in the water

271 Bomba dancing

THE CARIBBEAN, PUERTO RICO

270 Hike and swim in a tropical rainforest

Trek the Angelito Trail in El Yunque National Forest and enjoy a dip in Las Damas pool, a refreshing, crystal clear swimming hole. The forest is the only tropical rainforest in the US's national forest system, and it has 24 mi. (39 km) of hiking trails. Alternaively, hike the Mount Britton Tower trail for scenic views of the lush forest from the tower itself.

THE CARIBBEAN, PUERTO RICO

271 Discover the healing powers of bomba

Release your emotions through the rhythmic drumming and bomba, a Puerto Rican dance created by enslaved Africans in the seventeenth century. Travelers and locals alike can join the dance at small group workshops throughout Puerto Rico, but on a Monday night, La Terraza de Bonanza in San Juan is the place to be.

THE CARIBBEAN, PUERTO RICO

272 Swim in glittering bioluminescence

You'll reignite a sense of childlike wonder when you swim in Mosquito Bay. This beautiful cove is bioluminescent—it's full of microscopic organisms called dinoflagellates that produce a glow-in-the-dark effect. Add a lack of light pollution and, with each movement in the water, you'll set off a trail of bright glitter below the surface.

273 Aerial BVI

274 Redemption Ranch

THE CARIBBEAN, BRITISH VIRGIN ISLANDS

273 Experience a slice of paradise with a purpose

With a glorious setting on a pristine Caribbean island, Aerial BVI has all the trappings of an indulgent resort, but this is paradise with a purpose—to help burned-out execs find their best selves. Come for one of its regular semisilent retreats or "elevate presence summits" and you'll experience inspirational talks and coaching sessions, healing food and drink, and two days of guided serene silence, all alongside a tribe of like-minded people.

THE CARIBBEAN, BRITISH VIRGIN ISLANDS

274 Heal through animal connection

Rescued animals from across the world arrive at Redemption Ranch ready to be rehabilitated. Visitors are encouraged to view and interact with the residents, which have all been through their own healing process, feeding the zebras, riding the horses, or taking part in equine therapy sessions, proven to be an effective means of reducing stress and healing trauma.

THE CARIBBEAN, DOMINICA

275 Soak aching muscles in a hot water sulfur spa

Set deep in the Dominican rainforest, the hot water sulfur spa at Ti Kwen Glo Cho has pools, tubs, and waterfalls ranging from steaming hot to refreshingly cold, all tucked into lush, landscaped gardens. The springs have been used by islanders for generations to soothe and relax the body, treat aching muscles, and reduce skin complaints.

THE CARIBBEAN, DOMINICA

276 Join a retreat at one of the Caribbean's largest yoga centers

Set on a hillside overlooking the ocean, Jungle Bay Resort is a dream setting for a wellness retreat—and it's well-equipped for the job. The on-site yoga center is the largest in the region, offering daily classes and week-long retreats in its two open-air studios. Alternatively, you can carry out your practice in the gardens, surrounded by plants that contribute more than one hundred spices, healing herbs, and exotic fruits to the resort's organic vegan and vegetarian menu.

276 Jungle Bay Resort

277 Climb the highest volcanic peak on Saint Lucia's island

Something different in the Caribbean? Start early to avoid the heat and follow a guide to the spectacular summit of Gros Piton on a well-maintained but demanding trail. There are no technical requirements for those joining this climb, but as you clamber up high steps and rocks for three hours or more, a hiking pole might help. Look out for rare trees, birds, and tropical plants, and from the summit, see the luminous sea, islands, fishing villages, pretty Soufrière, and lush coconut groves. Enjoy the reward—you deserve it.

277 Gros Piton

278 Enjoy a week of fitness and healthy eating at the BodyHoliday

The BodyHoliday's name says it all. This resort revolves around physical well-being and has a daily program of spa treatments and fitness classes. There are also a tennis center, a scuba center, a sailing club, and a spa complete with a thalassotherapy pool and Ayurvedic temple. If it's on your wellness agenda, you'll find it here.

2
SOUTH AMERICA

GUATEMALA

294 Reflect on the ancient Maya civilization in Tikal National Park

Temples, palaces, pyramids, and more—the ancient Maya city of Tikal has around three thousand remains scattered in the Petén jungle. Some rise high above the trees, beautifully restored, others cling to old rocks and stumps while "voices of the spirits" echo in remote areas. Listen for a while, and as you connect with the past, you may feel the strong creative aura. Two thousand years ago the Maya developed astronomy, hieroglyph writing, the calendar system, and the most elaborate architecture. Explore as far as you can and carry water.

GUATEMALA

295 Rejuvenate your mind and body with a chocolate massage

Guatemala is often deemed the birthplace of chocolate, as this sweet-smelling artisanal treat floods many of this country's streets. While chocolate is widely distributed nowadays, ancient Maya believed it was a gift from above. At Casa Santo Domingo in Antigua, you can experience its divine quality from a different perspective—a massage with cacao butter. This anti-inflammatory, rich food may help scrape off dead skin cells, lower stress, heal the skin, and encourage a radiant glow.

GUATEMALA

296 Soak your feet in the natural hot springs found at a high-altitude lake

The pristine blue waters of Lake Atitlán lie deep in the Sierra Madre mountains. This natural wonder was formed as a result of a volcanic eruption and the Atitlán volcano is among the hills that surround it. Because of its terrain, areas of the lake form steamy natural hot springs that are great for a foot soak.

296 Lake Atitlán

GUATEMALA

297 Work on your well-being at a sacred lake

Considered by many to be the most beautiful lake in the world, Lake Atitlán is a sacred place according to traditional Maya belief, and people from across the country and beyond flock here in search of meaning and well-being. Visit tranquil San Marcos, the area's wellness hub, for spa treatments and meditation sessions. Soak in volcanic hot springs in the surrounding mountains, or try a Maya fire ceremony in sacred caves located 1,200 ft. (365 m) above the lake.

GUATEMALA

298 Practice yoga in a mountain forest

To combine the benefits of yoga with the healing power of nature you can't do much better than the Yoga Forest, which perches on a hillside with dramatic views of Lake Atitlán. Studios are built to take in the views, and when you're not immersed in your practice, you can soak in hot springs. The simple lodgings are off-grid, solar powered, and built using sustainable materials.

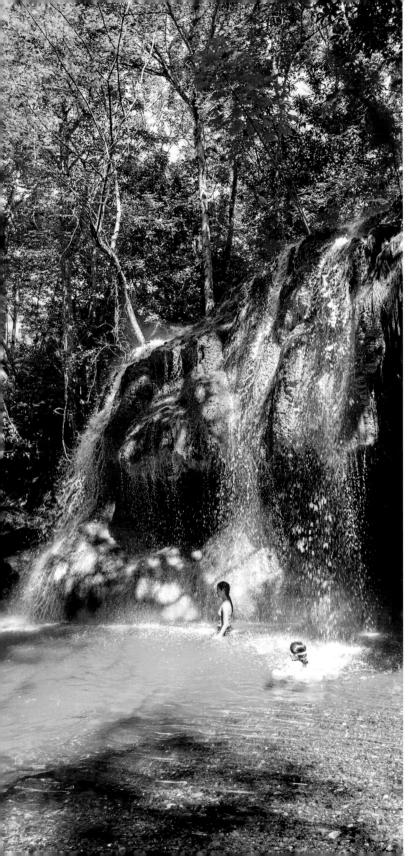

299 Bathe under a hot spring waterfall

Head out from the waterfront town of Rio Dulce and follow a path through the forest to Finca el Paraiso, a beautiful waterfall that tumbles into a rocky pool. It's fed by volcanic hot springs, so the water is warm and full of healing minerals. Clamber up the falls and you can have a hot shower under the spray, and then cool off with a swim in the clear waters below.

300 Take a transformative hike into the ATM cave

Maya believed that the Actun Tunichil Muknal (ATM) cave, and the hundreds of others that surround it, were gateways to their gods and the underworld. Today, visitors to this sacred archeological site near the quaint city of San Ignacio come to see the fascinating rock formations, stalactites and stalagmites, ancient artifacts, and the bones of those who were sacrificed.

299 Finca el Paraiso

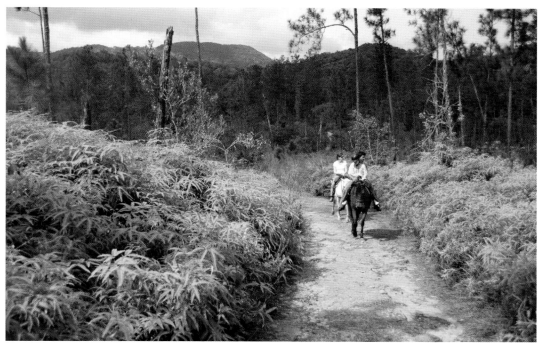

301 Horseback riding

301 Hide away under the rainforest canopy

Disconnect to reconnect with Mother Earth in the unspoiled, subtropical landscape of Mountain Pine Ridge in the Maya Mountains. Wake up to the sound of monkeys, open your mind to new experiences on expeditions to witness the wildlife and colorful vegetation on mountain bike, foot, or horseback, then relax in an eco-spa, tree house, or jungle lodge.

302 Revive body and mind in a kayak

Take to the Moho River by kayak and the only sounds you'll hear are your paddles pulling through the water and the hubbub of the birdlife in the rainforest. Go slowly and navigate the river over two or three days with Maya and mestizo guides who'll teach you about the ecology of the rainforest and local folklore. This immersive journey will leave you feeling connected with nature.

303 Take a tour of a medicinal garden

The small village of San Antonio in the Cayo district is home to the García Sisters who run a self-sustaining farm, museum, and herb garden where people come to learn about rainforest herbs and their uses. With advance notice, the sisters also offer Maya ceremonies, blessings, and massage treatments using produce from their lush grounds.

304 Have an alfresco massage in the rainforest

You can have an outdoor massage in the rainforest at the Lodge at Chaa Creek, an eco-retreat set in a nature reserve. Choose from naturally mineral-rich mud treatments, herbal wraps, and botanical massages as you tune in to the background music of tropical birds and take in the views across the winding Macal River and the Maya Mountains.

305 De-stress amid the jungle and Maya ruins

Adventurers, animal lovers, and those in search of some natural healing will adore Pook's Hill, a remote rainforest lodge in the Cayo district. There are just a handful of thatched cabanas here, and a visit is all about getting out in the great outdoors. Head down to the Roaring River to swim in hidden pools, wander the ancient ruins of a Maya site, or simply imbibe the silence of this slice of jungle paradise.

306 Commune with the underwater world

Free from tourist hordes, laid-back Roatán is one of the best places to go underwater thanks to the diverse coral of the reef system there. Studies show that proximity to the ocean reduces stress, promotes relaxation, and makes us feel connected to nature. Get into the water and the benefits increase—the breathing practiced by scuba divers promotes a sense of calm, often compared to meditation.

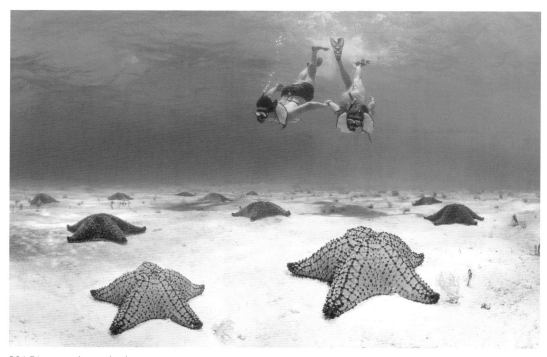

306 Discover the seabed

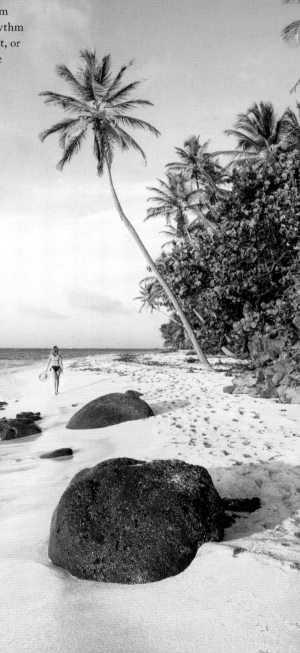

NICARAGUA

307 Revel in Robinson Crusoe vibes at Little Corn Island

The thick forest, powdery sand, and colorful seas of Little Corn Island are the stuff that Robinson Crusoe fantasies are made of. And once you've made the long journey here from the mainland, it's easy to slip into the slow, meditative rhythm of island life. Spend days swimming, walking in the forest, or just sitting on a balcony taking in the ocean views. It's the perfect tonic for busy urban life.

307 Little Corn Island

308 Jicaro Island

308 Practice salutations on a floating yoga deck

You'll find breathtaking views and secluded wooden casitas at Jicaro Island—a private island eco-lodge, which sits quietly in the middle of Lake Nicaragua. The well-being ethos is strong here, and you can enjoy an array of treatments in its breezy, waterside massage rooms, or practice your asanas on the lodge's incredible floating deck, which overlooks the volcanoes of Ometepe Island.

309 Ramp up your adrenaline

Adventurous travelers regularly throw themselves down the sooty slopes of Cerro Negro, an active volcano an hour's drive from León. After an hour-long hike to the top, you'll need to put on a jumpsuit, goggles, and a helmet before sliding down the slopes on a rectangular board at speeds of up to 37 mph (60 km/h). It's messy, thrilling, and life-affirming, and the buzz you'll get from completing the challenge will last all day.

310 Combine surfing and spa treatments

Nourishing food, well-being, and nature are at the heart of Costa Dulce, a community-run lodge on Nicaragua's wild southern coast. Get a natural high with beginner-friendly surf lessons, meditate on the beach at sunrise or sunset, and unwind with yoga classes at one of three ocean-view yoga *shalas*, which come with 360-degree jungle views. Add relaxing spa treatments and farm-to-table meals and you'll be radiating health inside and out.

311 Practice yoga and meditation at a beachside sanctuary

Cultivating a yoga or meditation practice can be very beneficial to your health, and when they're practiced at the beach, those health benefits intensify. Feeling the sand between your toes can help ground you with the earth, increase your energy levels, and further challenge those yoga postures since you're balancing on an uneven surface. A retreat at Jai Wellness will give you these benefits and more.

312 Use the rainforest as your alarm clock on the Osa Peninsula

Waking up to the sounds of nature—rather than getting jolted out of your sleep by harsh, robotic noises—is the best way to start the day. And there's no need for a digital wake-up call when you visit the Osa Peninsula. Instead your alarm call may include the cries of distant howler monkeys, birdsong, the buzz of insects, and the gentle rush of wind through the trees. Now you're awake, all you need to do is explore the rainforest.

312 Osa Peninsula

313 Vegan lasagna

314 Tabacón hot springs

COSTA RICA

313 Experience and learn the healing powers of Ayurveda

The Retreat Costa Rica is a wellness resort and spa that caters to anyone looking to surrender their past, reset their energy with nourishing meals, and adopt a simplicity mindset. One of its customized health approaches to help achieve these lifestyle goals is an Ayurveda retreat. You'll learn how to improve your longevity, prevent disease, and increase your happiness through personalized cleanses, guided hikes, and more.

COSTA RICA

314 Soak sore muscles in Tabacón hot springs

Costa Rica's cloud forest hides a network of bubbling hot springs whose thermal water is naturally heated by the Arenal Volcano and slowly mineralized underground. Some of these hot spring pools, rivers, and waterfalls are part of spa resorts, which offer overnight stays and day passes. At Tabacón Thermal Resort & Spa guests can enjoy natural hydrotherapy at a range of temperatures.

COSTA RICA

315 Attend a surf retreat for women

Head to the beach town of Santa Teresa for a "soulful surf" experience at A Week Awake and you'll be taught a simple, mindful way of living by inspirational female coaches and trainers. Days are spent practicing restorative yoga, gaining confidence in the ocean, exploring conscious breathwork, and nourishing your body with organic food.

317 Pacuare Lodge

COSTA RICA
316 Discover a natural way to longevity

The Nicoya Peninsula is one of five blue zone regions around the world with the most centenarians. For a glimpse into the secrets of longevity, Hotel Nantipa invites guests to immerse themselves in the microculture to explore natural ways to enjoy enhanced physical health, minimal stress, active days, and fulfilling encounters on a blue zone wellness program inspired by the lifestyle traits of local elders.

COSTA RICA
317 Arrive at a stunning eco-lodge on a whitewater raft

If it's a remote escape you're looking for, Pacuare Lodge, set next to a river and swathed in thick jungle, is an excellent bet. In fact, it's so isolated that the best way to get there is by raft. The thrilling ninety-minute journey across Pacuare River's class I through IV rapids, spotting monkeys and birds in the rainforest, will get your heart racing and your soul soaring. When you come back down to earth, there are plenty of pampering perks to smooth any bumps left by the journey, from riverside yoga to spa treatments among the trees.

COSTA RICA

318 Go on a digital detox in the jungle

Guests are asked to leave their cell phones at check-in to make the most of the sights and sounds at Nayara Springs, where curated wellness programs take place within the rainforest. They include meditation sessions among the trees, candlelit massages at dusk, and a signature volcanic detox treatment, using volcanic mud sourced from the nearby Arenal Volcano.

COSTA RICA

319 Dine in a glass box among the treetops

You'll be wowed by both the food and the setting at the San Lucas Treetop Dining Experience. Each table is set in a private glass cube on a hillside with a bird's-eye view of the cloud forest and its inhabitants. Multicourse menus champion local, organic ingredients and are an inventive introduction to Costa Rican history and culture.

318 Nayara Springs

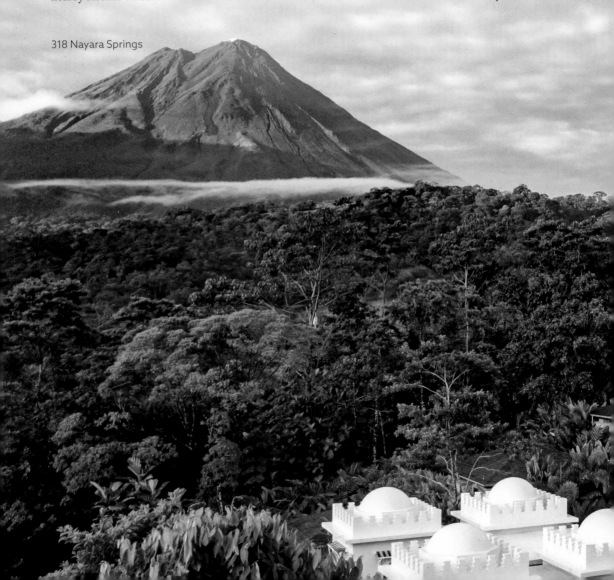

COSTA RICA

320 Achieve equilibrium through food

Benefit your *doshas*—the three life forces that make up your individual nature in Ayurvedic medicine—by cooking meals that will keep them in balance. At Pura Vida you'll also learn how to cook meals that keep your doshas as they should be, as well as the physical, mental, emotional, and spiritual facets of food preparation.

COSTA RICA

321 Relax in a water treatment pool

There are all kinds of treatments on offer at the mountaintop retreat of Pura Vida, but for the most restorative treatment try a session in its Watsu pool. For this gentle body therapy you'll float in a pool of warm water with a therapist who'll relax your body using massage, shiatsu, and muscle stretching. A session can reduce pain, relax muscles, and improve your sleep.

322 ISLA PALENQUE

Casita

Outdoor soaking tub

PANAMA

322 Unwind at a tiny island resort

Feel like running away from everyday life to live wild on an island sanctuary? Isla Palenque might just be the right pick. Its eight casitas are enclosed by rare primary forest that's home to hundreds of species of flowers, animals, and birds, and there are plenty of secluded spaces in which to meditate or practice yoga, whether on deserted beaches or private platforms among the coconut groves. If you'd rather chill out at your casita, each has its own outdoor soaking tub looking out over the ocean.

PANAMA

323 Join a luxury island yoga retreat

You can take over the whole island or join in a group retreat at Islas Secas. Yoga is a specialty here, and alongside world-class guest instructors, there's a host of beautiful spaces in which to practice—the lush, flower-filled garden, for example, or a platform floating in the ocean. You can even join a sunset session on the island's jungly airstrip.

COLOMBIA

324 Wallow in a mud volcano

One of the world's smallest volcanoes, the 49-ft.-tall (15-m) El Totumo mud volcano, just north of Cartagena, spews up mud instead of lava and ashes. Visitors can lower themselves into the crater and slather themselves with the warm, thick substance, before rinsing it all off in the nearby lagoon. The mud's mineral content is said to soothe muscles and help skin complaints such as psoriasis.

COLOMBIA

325 Head for the stars in the Tatacoa Desert

Between our cell phones, laptops, and smart watches, it's rare to have a chance to disconnect from the digital world. Heading into the Tatacoa Desert could be the perfect opportunity to switch off. Explore the ethereal landscape by day, and after dark turn your focus to the stars. Thanks to a lack of light pollution, the nightly show is awe-inspiring.

325 Tatacoa Desert

COLOMBIA

326 Slip into laid-back Colombian beach life

Depart Cartagena by speedboat and you'll be transported to a palm-fringed island that's a popular escape from the chaos of the city. Have beach massages, use the yoga mats and stand-up paddleboards, or join one of Blue Apple Beach hotel's connect and reset weeks, where you'll be embraced by the community with yoga, breathwork, and fireside chats on Colombian culture.

COLOMBIA

327 Boost your brain health

Lie back and let the low electrical currents of neurostimulation therapy help your brain to relax. Treatments at Las Islas can be tailored for your needs whether you're looking to deal with stress, break negative behaviors, or find more energy to bring to life.

326 Blue Apple Beach

328 View over Guatapé

COLOMBIA

328 Climb the rock of El Peñón de Guatapé

Towering above the land, the monolithic El Peñón de Guatapé offers a stunning backdrop for photographs and a workout. Climb the 740 concrete steps, stopping halfway to visit the shrine, then feel a sense of achievement when you reach the summit. From there you can enjoy incredible views of the glistening water far below and the mountains around you.

VENEZUELA

329 Wake up to birdsong and connect to nature

The song of the birds welcoming in a new day at Orinoco Delta Lodge will help you connect with nature even when your eyes are still closed. Nature connection works best when you use all your senses, so listen out for the sounds while you feast on the sights and inhale the scents of this isolated but beautiful spot on the banks of the Orinoco River.

VENEZUELA

330 Let your mind find stillness watching fish

There is nothing quite like the peace of being underwater, your hearing muffled, watching the fish going about their lives. At Los Roques National Park you'll become absorbed watching them peck at the colorful coral. Los Roques has been a national park for more than fifty years, and its coral reefs and white-sand beaches reflect its status.

SURINAME

331 Spot wildlife in peace at a remote eco-lodge

If you get to Suriname, a country with 93 percent forest cover, you'll be rewarded with the chance to disappear into the jungle. Many of the tribal and Indigenous communities host tourists in everything from high-end eco-lodges with swimming pools to basic shelters. Wherever you stay, you'll spot wildlife, swim under waterfalls, and find peace in the fact there's nothing to disturb you but the sounds of the rainforest.

BRAZIL

332 Explore the Human Design System

Developed in the late 1980s by Canadian Alan Krakower after an eight-day mystical experience, the Human Design System claims to offer you an insight into your own psychology based on the time and place of your birth. At Ecovila Paraiso an analyst guides guests so they can use this knowledge to make the most of their energy.

BRAZIL

333 Feel restored in a minimalist spa

Feel the benefits of being well and truly pampered in the expansive spa at the Hotel Fasano Boa Vista, just two hours from São Paulo. From the minimalist decor to the treatment rooms with country views and loungers, and the pools, whirlpool baths, showers, and steam rooms, everything is set up to make you feel fabulously indulged.

BRAZIL

334 Hunker down at a chic beachside spa hotel

Escape the chaos of Rio de Janeiro and head down the coast to Hotel Fasano Angra dos Reis, a sleek wellness hotel squeezed between ocean and jungle. Find some headspace in nature on rainforest walking and running trails, swim in pools fed by waterfalls, or kick back on the private beach. Rooms face the ocean or the forest so there's plenty to see even if you don't want to venture out and about.

BRAZIL

335 Learn from the wisdom of elders

Travel deep into the heart of the Amazon rainforest to Cruzeiro do Sul to spend time with Indigenous communities and learn about their culture as well as the deep connection to the plants and land around them. Soak up their wisdom through powerful painting sessions and healing ceremonies.

BRAZIL

336 Feel a sense of awe under the stars

The feeling of awe—witnessing something far greater than ourselves—has been shown to reduce stress and increase feelings of altruism toward others. Few things are quite as awe-inspiring as a dark sky filled with stars. Desengano State Park is a Dark Sky Park where you can see thousands of stars with the naked eye.

BRAZIL

337 Move effortlessly from the beach to the spa

Txai Resort, on the stunning Chocolate Coast, nestles among palm trees just yards from the Itacarezinho's white sandy beach. Its rustic bungalows quietly whisper luxury, while its spa offers extra routes to relaxation including Watsu—underwater shiatsu massage.

337 Txai Resort

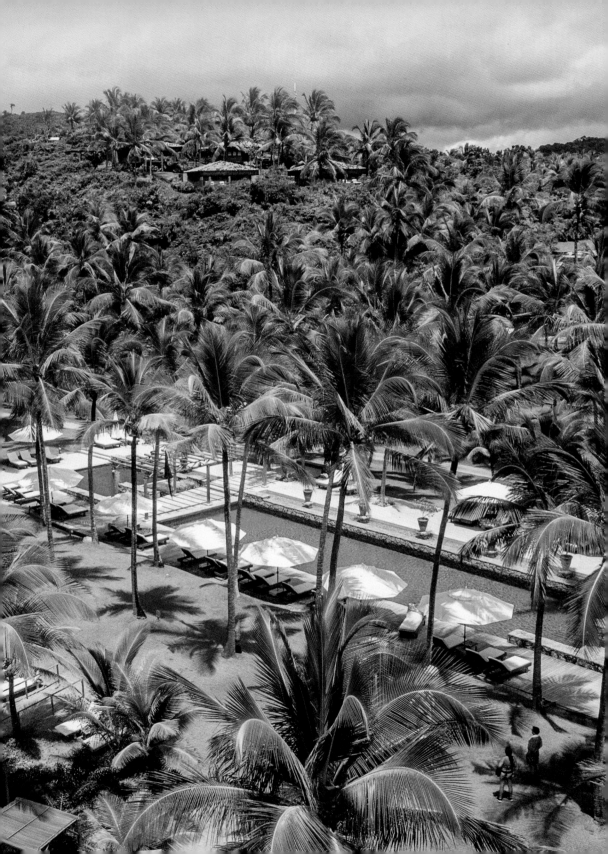

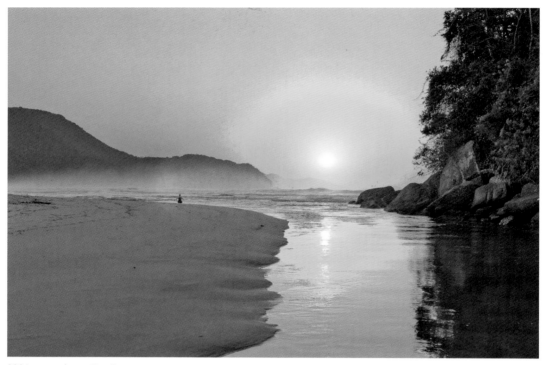

339 Itamambuca Eco Resort

338 Feel the healing affection of dogs

At Retreat Bela Natureza, group meditation sessions take place in the company of the retreat's family of dogs. The hounds' companionship and unconditional love help visitors express their own feelings and connect with their own intuitive ability to communicate.

339 Move peacefully through nature

Set on the edge of the Serra do Mar State Park, Itamambuca Eco Resort is perfectly positioned between the sea, the river, and the Atlantic rainforest. Put on your running shoes and jog along the beach. Alternatively, a kayak or a stand-up paddleboard excursion will let you move through nature at a pace that gives you time to reflect on everything you see.

340 Experience the healing power of nature

Reconnect with your roots on a nature immersion retreat. Terra Brasilis Retreats educate guests on sustainable living and encourage an appreciation of the natural rhythms and cycles of nature. From their peaceful bases in different regions of Brazil, guests can enjoy activities such as guided nature walks, yoga, surfing, and healing ceremonies.

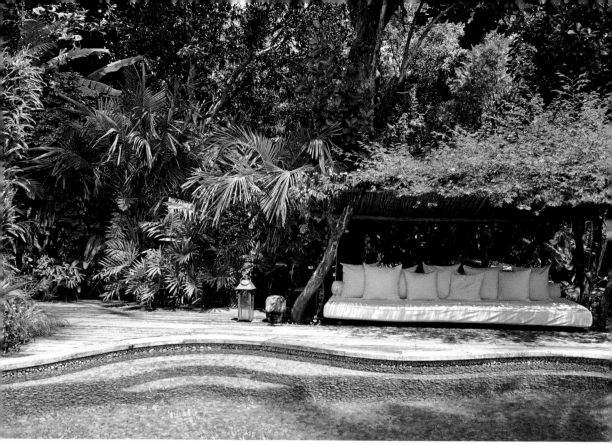

343 Uxua Casa

341 Go off the grid on a digital detox

Enjoy the slower pace of the simple life at one of the Houses in Nature at Fazenda Catuçaba. Everything on this estate is designed to enable you to appreciate nature. Leave your cell phone behind, tune in to the birdsong, watch the sunset, and then sit under the stars around the firepit.

342 Have a massage with oils from local trees

While you lie back and inhale the musky scent during an almíscar oil massage, the restorative qualities of this indigenous plant will rejuvenate your skin. The oil is made on-site at the Vida Lab, and you can find almíscar trees growing in the extensive gardens of the beautiful Uxua Casa Hotel and Spa.

343 Take a dip in a healing crystal pool

Set among a series of characterful casas in Trancoso's historic main square, Uxua Casa is home to a one-of-a-kind crystal pool. It's lined with green aventurine quartz, a native Bahian stone thought by some to possess powerful healing qualities, such as the ability to soothe skin conditions, reduce inflammation, and help allergies and migraines.

BRAZIL

344 Find your inner calm at an ashram

Connect with your spiritual side with meditation and a calmer way of life in the Ecovila Goura Vrindávana, a Hare Krishna ashram and spiritual sanctuary. Hare Krishna is part of India's oldest religion, Vaishnavism, and has long touted the benefits of understanding our own spiritual nature, and meditation is a core part of this.

BRAZIL

345 Leave tension behind at a pristine island paradise

You'll feel the stresses and strains of everyday life begin to fade as you approach the Fernando de Noronha archipelago, a group of tiny islands. Exclusive, pristine, and protected, it offers some of the best snorkeling in the world, near-deserted beaches, and the Baía de Golfinhos, where huge pods of spinner dolphins put on regular displays.

BRAZIL

346 Take the time to connect with your senses and the world around you

Stay at Unique Garden in Terra Preta and you'll be surrounded by the exotic plants grown in the hotel's gardens. The unforgettable view—and the scent of the blooms—create a calm backdrop to your visit. Add in therapies at the Pandora Spa, detox experiences, and meals made from ingredients grown on the grounds and you have a sustainable, revitalizing trip.

346 Unique Garden

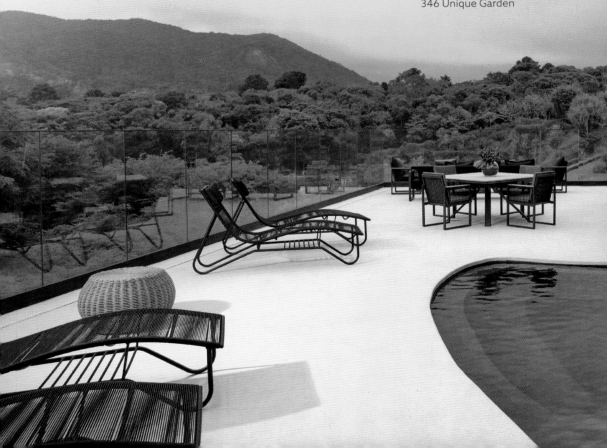

BRAZIL

347 Discover a personalized diet to keep your gut healthy

Certified by the Mayr Clinic in Austria, staff at the Lapinha Spa look at each guest individually and create a care program just for them. This includes an eating plan specifically designed to improve gut health and prevent disease.

PARAGUAY

348 Draw positive energy from a powerful waterfall

As water crashes down from the Saltos del Monday waterfall, its power and energy are indisputable. Sit at the bottom and watch the rainbows bounce across the horseshoe-shaped falls, or head to the top and feel the inevitability of the water heading to the precipice. Either way, let nature invade your soul.

PARAGUAY

349 Bathe in a lake full of legends

There are geological reasons for the existence of the Ojo de Mar (Eye of the Sea) lake, but no apparent water source. So it's easy to see why the origin story is that it was formed from the tears of a princess separated from her true love. The clear waters reflect the lush green landscape, and a swim in them is revitalizing.

PARAGUAY

350 Inhale the fresh air of a biodiverse park

The wetlands of Ypoá National Park are rich in biodiversity, which in turn creates clean, fresh air. You'll connect with nature as you breathe it deep into your lungs, looking out over the wilderness. If you're lucky, you might catch the life-affirming mating dance of rheas— Latin America's largest birds.

351 Clean your body from the inside out

Headaches, stomach pain, and tiredness can all have their roots in diet, which is why the Alive Health Spa Resort looks at what you eat as an essential part of its wellness programs. Its alkaline detox program cuts acidic food from your diet, eating fruit and vegetables at first, then adding meat, cereals, and grains to find the balance between acidity and alkalinity that works for you.

352 Wake up your sense of smell

Take a moment of mindfulness in the center of Montevideo with a visit to the Rosedal del Prado—the Uruguayan capital's rose garden. Established in 1912, it is full of romantically picturesque architecture and thousands of roses. Sit awhile and engage all your senses.

352 Rose garden

URUGUAY

353 Swim in a pool with a view

Where better to place a hotel than at the top of the highest hill in the area so you can enjoy the views all around? Add to this a swim in the pool on the roof of the Hotel & Spa Art Las Cumbres and you can feel your stress ebb away. This architect-owned hotel is filled with art from around the world that will feed your mind as your body relaxes.

URUGUAY

354 Relax with a mineral bath

Just outside of the town of Salto is an underwater hot spring that provides naturally heated, mineral-rich water year-round. A number of spas, hotels, and leisure facilities offer different ways (and prices) to experience it. Whether you're in a shared swimming pool or a private whirlpool bath, you will feel revitalized and relaxed.

URUGUAY

355 Take it slow in a village that's off-grid

There are no roads into Cabo Polonio, a former pirate hideaway, so you'll arrive in a 4x4 that travels over sand dunes and a beach. The slow way of life here is a nod back to simpler times, and it is the perfect place to drop in, tune out, and escape your troubles for a while. There are fewer than one hundred permanent residents here, and there's nothing to do but surf, wander the sand dunes, and spot sea lions bathing on the rocks.

URUGUAY

356 Work on your surfing and yoga skills on a blissful beach

Mix yoga, surfing, and uncrowded white-sand beaches on a week-long vacation in Maldonado put together by Swarupa Retreats. The days begin and end with yoga and meditation classes, with time for the surf in between, helped by instructors who are equally adept at teaching beginners and experts. Healthy meals are included, and "fire-camp" dinners, held outdoors, are a retreat favorite.

355 Cabo Polonio

358 CAVAS WINE LODGE

Spa treatment

Horseback riding

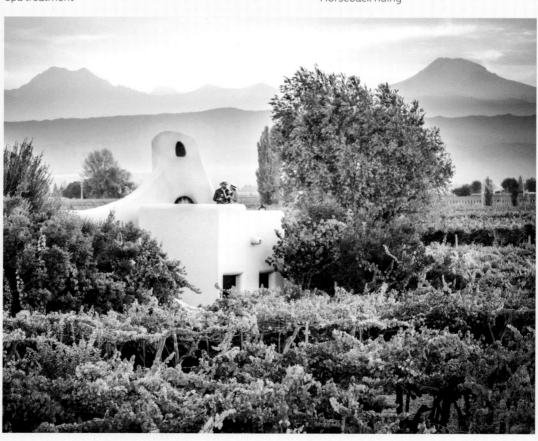

Private villa

357 Find empowerment on an immersive yoga retreat

By combining the more active vinyasa yoga with the more posed style of Yin yoga, a retreat at Cabañas Hacia El Sur in the Patagonian mountains requires you to dig deep within yourself. The yoga is complemented by guided journaling and hikes, which aim to give you a clarity of purpose and leave you feeling empowered for the future.

358 Discover why grapes are good for your skin

In a way that will truly connect you to where you are staying, the spa treatments at the Cavas Wine Lodge are based on vine and grape-seed extracts. These are rich in polyphenols, which act as antioxidants, neutralizing the harmful effects of free radicals and reducing inflammation. Discover the vineyards on a horseback tour and stay in one of the villas.

359 Get lost amid the otherworldly silence of the puna

The puna in northwest Argentina offers a myriad of places to soak up the silence. Head out on an expedition and you'll be almost alone in a high-altitude plain of ethereal salt desert, abandoned mining towns, and vast lagoons home to thousands of James's flamingos. The chance to be immersed in a landscape far removed from anything in your everyday life is an unforgettable experience.

360 Find a peaceful moment of zen in a busy capital city

The Japanese Garden has been a beacon of peace in the center of Buenos Aires since the late 1960s. Walk over the traditional red bridges, follow the koi carp swimming in the lake, admire the cherry blossoms in July, and reflect on the balance and serenity of the garden as a whole, just as Japanese garden designers have been doing for centuries.

361 Protect the rainforest for the future

When you act to protect a place for the future, it gives you a sense of purpose and commitment that can link you to that place forever. At Margay Natural Reserve, you are encouraged not just to enjoy the surrounding jungle, but also to visit a local nursery with plant seedlings. The mindful activity of touching the soil and caring for the tiny trees will make you feel engaged and connected.

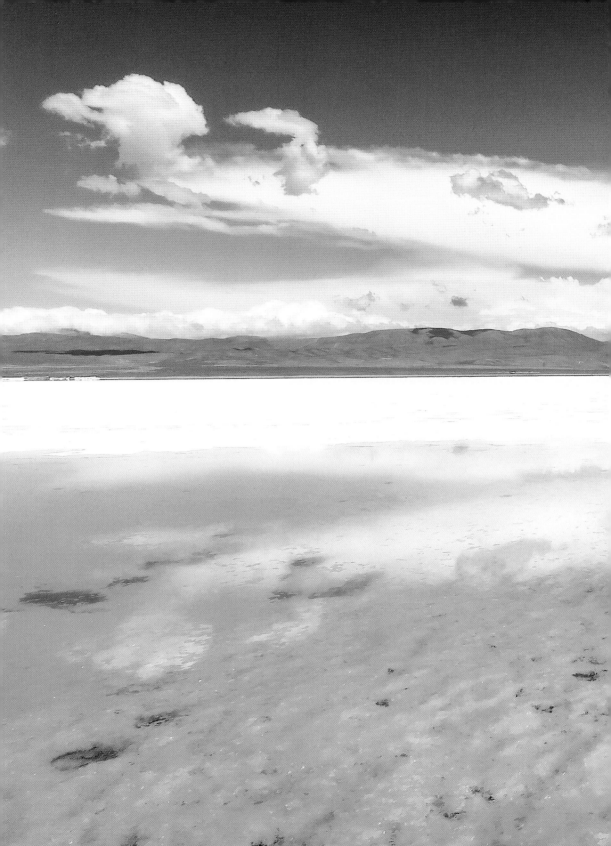

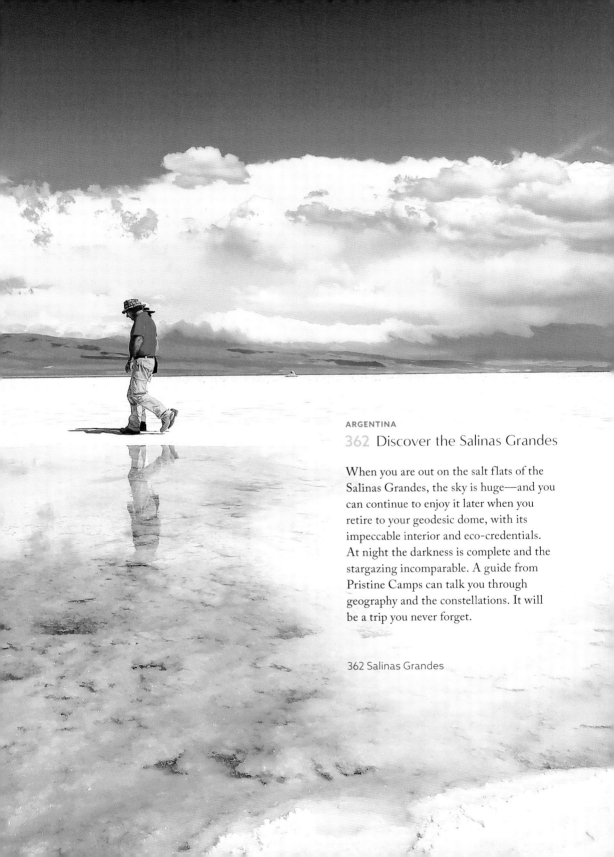

ARGENTINA

362 Discover the Salinas Grandes

When you are out on the salt flats of the Salinas Grandes, the sky is huge—and you can continue to enjoy it later when you retire to your geodesic dome, with its impeccable interior and eco-credentials. At night the darkness is complete and the stargazing incomparable. A guide from Pristine Camps can talk you through geography and the constellations. It will be a trip you never forget.

362 Salinas Grandes

ARGENTINA

363 Take a thermal bath with a view of the mountains

Wherever you go to enjoy the thermal waters at Cacheuta, you will also enjoy mountain views peppered with cacti and wildflowers. The resort is home to hotels, spas, and public baths, and you can move from pool to pool to enjoy the varying water temperatures, which together with the minerals will relax your muscles and boost your energy levels.

ARGENTINA

364 Let yoga, meditation, and nature restore your inner balance

Time spent high in the Andes on a Utopia Yogashala retreat at La Paya will leave you feeling relaxed and refreshed. With twice daily yoga sessions, meditation, and healthy organic food, the focus is on finding balance. Add to this plenty of opportunity for walking in nature and swimming in the pool, and you'll leave feeling calm and rejuvenated.

ARGENTINA

365 Take a bath in the treetops

All the cabins at Awasi Iguazu are built on stilts, so your view out is pure treetops. We all know that immersing yourself this firmly in nature is good for the soul. Combine it with lying back in your cabin's personal plunge pool and your relaxation is complete. What better way to connect with nature.

ARGENTINA

366 Connect to the land at a spa that draws on Indigenous knowledge

At the Hotel Termal Los Cardones at Santiago del Estero, you can enjoy water from the Rio Hondo hot springs and draw on the wisdom of the people who have lived there for generations. Treatments are based on essential oils distilled from plants and herbs grown on the local mountains. The warm thermal water is used throughout the spa.

367 Find your way to mindfulness through Zen meditation

The slopes of Uritorco are infamous within Argentina for apparent UFO sightings, but come for those and you may be disappointed. Instead, connect to the real world and the beauty within it by practicing Zen Buddhism at the Shobogenji Zen Temple, where you can learn the art of meditation.

368 Feel cleansed by Latin America's first ever hammam and spa

Hammams date back to the time of the ancient Greeks and Byzantines. Although these public baths originated in the Middle East, you can find them around the world. Argentina's first is at the Entre Cielos Wine Hotel Spa. With two steam rooms, two forms of exfoliation, hot stones, and a heated pool, it provides a wonderfully relaxing way to deep clean your skin. Afterwards, enjoy the view from your loft suite.

368 Loft suite

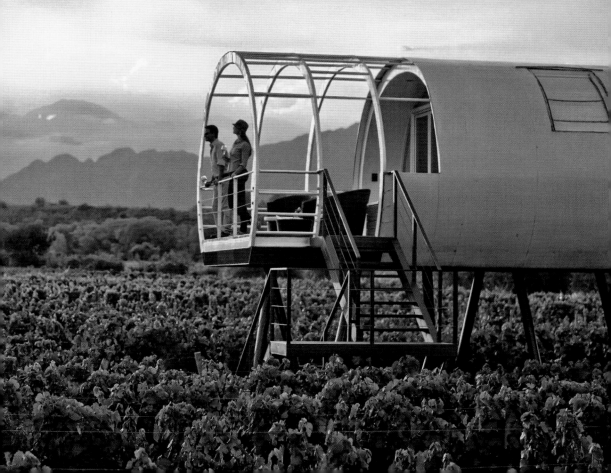

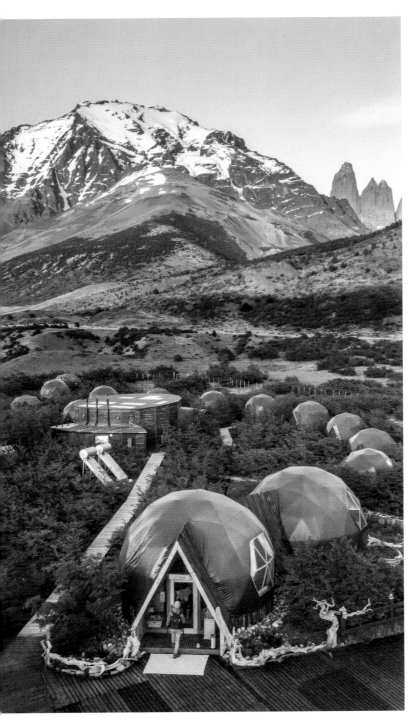

369 Refresh body and soul in the wild

A true trailblazer in responsible and remote tourism, EcoCamp Patagonia sits in Torres del Paine National Park and is known for its eco-friendly policies and edge-of-the-world atmosphere. Accommodation is in mindfully built geodesic domes designed for minimum impact and to make the most of the awe-inspiring views. Fall asleep while gazing through your skylight at the night sky, and wake up early to an incredible sunrise as the Paine massif is shrouded in a Technicolor glow.

370 Meet the horses at a heritage ranch

You can saddle up anytime you like at Estancia La Bamba de Areco, a sprawling country estate steeped in gaucho tradition that's home to two of the country's best polo fields and a stable full of championship ponies. Attend a horse-whispering show to witness the strength of the bond between horse and rider, then sign up for a horseback excursion.

369 EcoCamp Patagonia

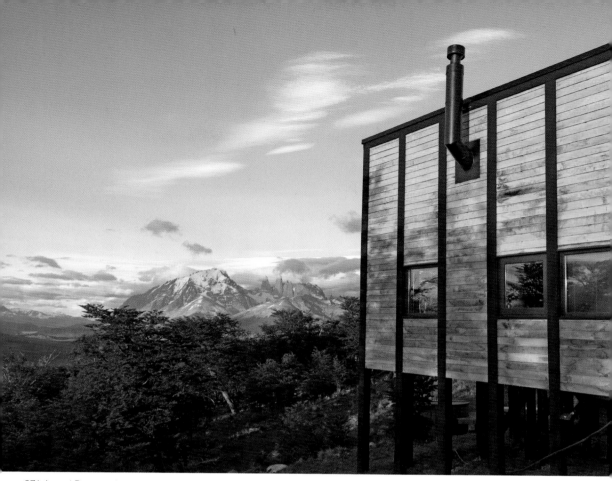

371 Awasi Patagonia

371 Spend time in glorious isolation in Torres del Paine National Park

Opened on the former campground of adventurer Florence Dixie, who pitched her tent beneath the twisted peaks of Torres del Paine in 1878, Awasi Patagonia is a collection of cabins with views so spectacular you'll want to do little more than sit and stare. Lucky, then, that you've got floor-to-ceiling windows and an outdoor hot tub from which to watch Mother Nature unfold. Should you want to explore, a private guide and 4WD will get you out at your own pace into a landscape so wild and remote you'll be filled with the joys of being alive.

372 Find the alternative therapy for you

Whether you can spare one hour or one week, the Pranic Soul wellness center in Pucón offers a wide range of healing therapies. Whether you want to try flower therapy, quartz bed therapy, biomagnetism, Reiki, or more, it gives everybody the chance to find some peace and healing, whatever their schedule.

374 Moai

CHILE
373 Marvel at the stars in the Elqui Valley

The Elqui Valley is one of the best places in the world for stargazing thanks to its remote location, high elevation, and cloud-free skies. No wonder, then, that it was declared the world's first International Dark Sky Sanctuary in 2015. The village of Vicuña makes an ideal base for exploring, and several observatories offer guided viewings of the night sky. Alternatively, you can head out on your own and contemplate your connection with the cosmos.

CHILE
374 Feel a sense of wonder at the moai

People who journey to Rapa Nui (Easter Island) report that this tiny speck of land has a magnetic, undefinable pull. It's famous for the moai—colossal stone statues with oversized heads that spring up from the earth or sit on stone pedestals called *ahus*. While fanciful myths and sci-fi theories surround their origins, evidence shows that they were carved in honor of ancestral chiefs. It's a real privilege to be able to contemplate these powerful testaments to an enigmatic past.

CHILE
375 Spoiling treatments and stunning views

Isla Grande de Chiloé is the second-largest island in South America and offers visitors contrasting landscapes—rolling green hills on one side and a rocky coastline on the other. At Tierra Chiloé guests can unwind in the tranquil setting of the Uma Spa while enjoying treatments such as shiatsu and deep-tissue massages. Alternatively, they can gaze at the wildlife-rich Pullao wetland from the heated infinity pool or try nature bathing.

375 TIERRA CHILOÉ

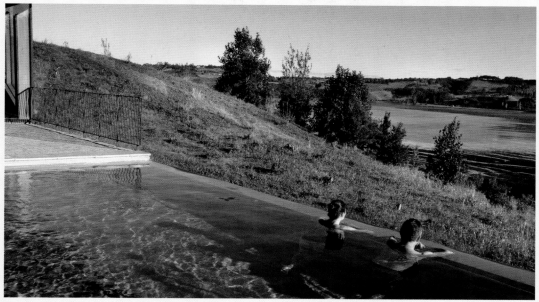

Heated infinity pool

View of the bay

Spa sauna

Nature bathing

CHILE

376 Embrace the silence of the desert

You'll be hit with a natural high in the otherworldly Atacama Desert, where geological wonders including lunar-like valleys, snow-capped volcanoes, and dazzling salt flats will leave you in slack-jawed awe. The vastness of the landscape means that solitude is easy to find. Stand still and listen to the primordial silence—it almost feels like traveling back in time.

BOLIVIA

377 Learn about the local healers

The Kallawaya people have worked as healers for more than one thousand years. They wander the Andes treating patients and collecting medicinal plants. Meet them in Charazani to learn about their belief that the natural and spiritual worlds come together in the human body, and that illness is the result of a disconnection between a person and their surroundings.

BOLIVIA

378 Watch the sunset from a hot spring

The setting of the Polques Hot Springs, on the edge of Salar de Uyuni, is pleasingly rustic with views over the salt flats to volcanoes. And the water here is healing, full of minerals that can help relieve the pain of arthritis and rheumatism or just leave you feeling wonderfully relaxed.

378 Polques Hot Springs

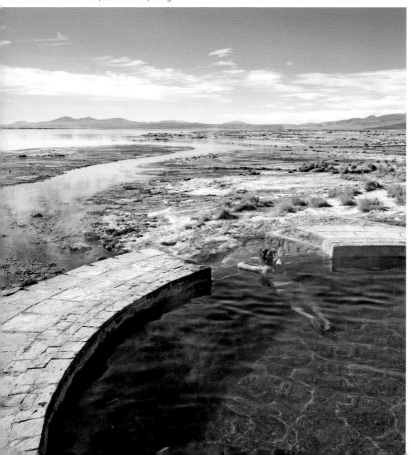

379 Have a salt treatment . . . in a salt hotel

On the outside, the Palacio de Sal is a hotel built from salt blocks set on the shores of the Salar de Uyuni salt flat. On the inside, you can indulge in a spa treatment that covers you in salt to remove dead skin cells, then uses water taken from the local salt flats to cleanse you and mineral mud from the nearby Tunupa volcano for a back treatment to relax you.

380 Walk on a blanket of stars

Gazing up at brilliant night skies is always good for the soul. Do so at Salar de Uyuni—the world's highest and largest salt flats— and it takes on a new dimension. During the December to April rainy season, water accumulates on the surface of the salt flats and they transform into a magical reflection of the sky. Come on a clear night and it feels as if you are walking on the stars.

381 Stay on an island and lap up nature

It doesn't get much more peaceful than an island in the middle of the world's largest lake that's a four-hour boat journey from the nearest town. At Isla Suasi on Lake Titicaca you can lie back in a hammock in the hotel's gardens and let the healing power of nature wash over you.

380 Milky Way at Salar de Uyuni

382 Visit Iquitos, the global capital of healing ceremonies

Reconnect with your roots through plant medicine in a place renowned for its traditions to heal and help cure past traumas by focusing on ancient spiritual practices and cosmological insights. Retreats include guided ceremonies led by shamans to facilitate holistic healing, profound spiritual realization, and dynamic personal empowerment, and include purifying herbal baths to dissipate negative energies and massages using the sacred coca leaf.

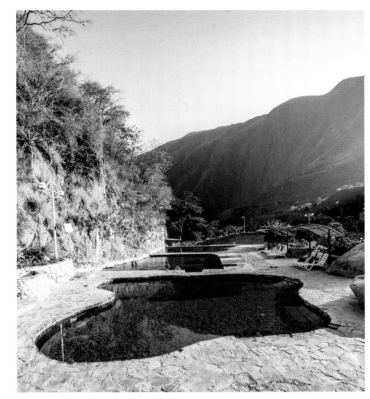

385 Cocalmayo hot spring

PERU

383 Bathe in the "laughing waters" of a natural waterfall

You'll need to take a hike through verdant rainforest, looking out for some of Peru's best birdlife, to reach the Ahuashiyacu Waterfall—the name that translates from the Quechua as "laughing waters." The water falls 114 ft. (35 m) into a natural plunge pool. Jump into the water and enjoy an invigorating bath in nature.

PERU

384 Experience healing in the Sacred Valley

You can rejuvenate, relax, and work on your well-being at Willka T'ika Wellness Retreat, an eco-friendly haven located between the ruins of Machu Picchu and the Inca capital Cuzco. Staff, including Indigenous Quechua people, ensure that stays are influenced by their relationship with Pachamama—Mother Earth. Local healers lead traditional Andean healing ceremonies.

PERU

385 Soothe your body in the waters of Cocalmayo hot springs

The hot springs of Cocalmayo are the ideal place to relax after an adventure in the Inca citadel of Machu Picchu. Surrounded by jungle and made up of three large pools, these mineral-packed waters are said to help heal skin problems, rheumatism, and joint pain. Come at night and you'll elevate the experience with starlight and a soundtrack of frogs and cicadas.

384 Willka T'ika Wellness Retreat

386 Posada Amazonas

PERU

386 Connect with the native community at an Amazon lodge cooperative

You can delve into native heritage at Posada Amazonas, a riverside Amazon eco-lodge owned by the Indigenous Ese Ejja community and managed in partnership with Rainforest Expeditions. Join a fire circle to hear local legends and histories, tour the jungle to learn about the ecosystems, and eat food based around Indigenous gastronomy, using ingredients such as cocona fruits. Not only will you feel a connection to the land and its people, your visit will have a meaningful, direct impact on the native community.

PERU

387 Learn about the medicinal power of plants

The most biodiverse region in the world, the Amazon is the perfect place to discover the medicinal uses of plants. Tour the ethnobotanical Ñape center with Rainforest Expeditions and you'll learn all about the local flora and its ingenious uses, from twigs that work against mosquitoes and inflammation to leaves that provide a temporary natural anesthetic.

PERU

388 Try the healing properties of cacao

Built on a former rubber and cacao plantation deep in the Amazon, Inkaterra Hacienda Concepción is an eco-lodge with a stylish spa. Located on the banks of the Madre de Dios River, NUA Spa champions the use of natural, local ingredients in all its therapies. The cacao treatment uses fruit from the hotel's plantation and includes a cacao exfoliation to rejuvenate the skin, a rubdown with white chocolate milk, and a massage to stimulate the lymphatic system.

389 Splurge on spa treatments in the Andes

There can be few more magical settings for a spa than Inkaterra Hacienda Urubamba, a contemporary hacienda-style hotel in the Sacred Valley of the Incas, surrounded by imposing green mountains and decorated with antique furniture and Inca masks. The spa is home to a healing garden—an outdoor space where travelers can pick medicinal herbs and plants to be used in their treatments.

390 Taste your way across Peru

To fully experience Peru, you can't just visit it, you need to taste it. A ten-day tour with Amazonas Explorer will help you nourish your body with wholesome food—and connect with the culture while doing so. You'll sample a *pachamanca*—a traditional Peruvian feast cooked underground using hot stones— and visit Indigenous farmers to learn about traditional crops and farming techniques, among many other highlights.

391 Stimulate your senses as you travel by canoe

A trip by *peke peke*—traditional dugout canoe—through the Pacaya-Samiria National Reserve allows you the opportunity to experience the wild up close, in all its splendor. Without an engine to drown out the sounds of the rainforest, the only noises you'll hear are the rippling of the canoe, the chirping of birds, the buzz of insects, and the sudden splash as a river turtle slips into the water. You'll be immersed in an environment that has remained unaltered for centuries.

389 Inkaterra Hacienda Urubamba

ECUADOR

392 Visit the world's first Wilderness Quiet Park

In a world where it seems there is never peace, it is fortunate that organizations such as Quiet Parks International are committed to saving quiet places for the benefit of all. Walk along the Zabalo River in the world's first Wilderness Quiet Park and let the sounds of nature fill your soul with happiness.

ECUADOR

393 Feel the benefits of eco-therapy in virgin cloud forest

Visits to Mashpi Lodge maximize the therapeutic benefits of being in the wilderness: you can get muddy on jungle trails, swim under waterfalls, engage your brain by learning about native plants and wildlife, and generally soak up the lost world atmosphere of Ecuador's Chocó rainforest. The modern steel and glass frame of your home base might seem a bit incongruous, but its minimalist decor is designed to make the most of the views, and you can do so from the spa, expansive yoga deck, or outdoor hot tub.

393 Mashpi Lodge

394 Taste nutritious cuisine made from indigenous flora

The restaurant at Mashpi Lodge is inspired by native ingredients and the flavors of the rainforest, including wild garlic and *chillangua*, a relative of cilantro. You'll find these herbs in dishes including Andean *locro de papa* (a creamy soup) and *maito de pescado* (fish in banana leaves). Many of the servers come from local communities and they're happy to give guests the lowdown on Ecuador's food culture.

395 Take a transformative journey into the Amazon

A trip with Pachamama Alliance is a journey unlike any other, based at a lodge that can only be reached by light aircraft. It's owned and operated by the Achuar and Sápara people, who are keen to teach visitors about their way of life. Not only is this an unforgettable learning experience, but you'll also be contributing funds to communities who defend the Amazon from oil companies, logging, and mining.

396 Traditional Andean healing ceremonies at a mountainside resort

Immerse yourself in local healing traditions at Sacha Jí, a mountainside resort with a focus on Andean culture and sustainable design. Sessions with Mama Rosa, an expert in traditional medicine and wellness, aim to restore your balance, while guided walks through the gardens will help you learn about medicinal plants. The pure mountain air and serene setting add to the sense of well-being.

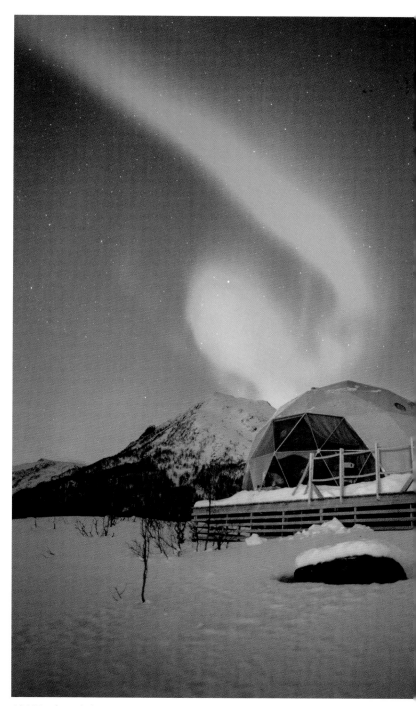

NORWAY
404 Sleep under the northern lights

There are few natural wonders that capture the imagination quite like the colorful natural light display of the aurora borealis, and it's well worth the effort, cost, and time it takes to see them. You can appreciate these radiant displays while out in the cold, but they look just as beautiful from the comfort of your own bed. Maximize the light-spotting potential through the panoramic windows of a private igloo at Isbreen the Glacier, or bed down in an aurora dome at Sorrisniva Igloo Hotel.

NORWAY
405 Go on an exhilarating sea safari

If careering along the coastline is your idea of a good time, try a sea safari with 62°NORD exploring the coastline outside Ålesund in a high-speed boat. Not only is racing over the waves a thrilling way to travel, you'll have the privilege of getting up close to some of Norway's most fascinating creatures, including a seal colony and Runde's famous bird colonies, which are home to eagles and puffins.

404 Northern lights

NORWAY

406 Stay in luxury at a wolf enclosure

The Wolf Lodge at Polar Park is the ultimate place
to reconnect with nature. Set inside a wolf enclosure
at the world's northernmost wildlife park, it offers
unparalleled access to the resident wolf pack.
Private encounters with the wolves can be arranged,
or you can sit in the lodge and watch them through
the panoramic windows. Sleep with the curtains
open and you might spot one howling at the moon.

NORWAY

407 Go on a women-only wild weekend in the fjords

You'll fully embrace Norwegian winter and the
company of like-minded women on a long weekend
with Gutsy Girls in Lysefjord. Days are spent
kayaking, snowshoeing, and hiking in perfect peace,
while your waterside cabin provides the opportunity
for energizing swims in the fjord's icy waters.
Evenings are spent cooking over an open fire with
local ingredients such as fish, deer, and seaweed.

NORWAY

408 Challenge body and mind at the Frozen Lake Marathon

Runners from all over the world compete in the
Frozen Lake Marathon, an experience like no other
that takes place on Lake Tisleifjorden in March.
A course is laid out across the frozen lake on ice
that's about 31 in. (80 cm) thick. Running on the
ice across a vast, snow-covered wilderness, cheered
on by your fellow runners, is both a magical and
heartwarming experience.

NORWAY

409 Explore local food traditions at an authentic fjord farm

Guests at Storfjord Hotel are invited to learn
about the region's cultural heritage through its
food traditions. Trips can be arranged to a fjord
farm and café in the village of Glomset, where
the owners hunt, grow, and fish everything
they serve. Food tastings, baking classes, and
storytelling will help you feel connected to the
local culture.

409 Storfjord Hotel

NORWAY

410 Visit the largest wellness center in Scandinavia

A short drive south of Oslo you'll find well-being megastar the Well. The largest wellness center in the Nordic region, it's home to a huge range of treatment options—eleven pools, fifteen saunas and steam baths, more than one hundred showers, a Japanese bathhouse, and a Turkish hammam.

DENMARK

411 Immerse yourself in historic Nordic principles

Light, air, water, nutrition, rest, and exercise were the Nordic principles for health, according to Dr. Carl Ottosen. The Nordic health sanatorium he founded in 1898 exists today as the Kurhotel Skodsborg. It offers extreme-temperature experiences in a labyrinth of grottoes, pools, and saunas. Treatments include the Skodsborg Flow, which consists of eight hot and cold experiences.

DENMARK

412 Join a mood-lifting winter swimming festival

Danes have extolled the virtues of cold water swimming since the late nineteenth century, when the first winter bathing center appeared in Copenhagen. Today, you can take part in their favorite outdoor pursuit at Skagen Ice Swimmers Festival. Each morning, you can join more than 350 winter swimmers as they pad down to the beach to take a naked dip in the sea.

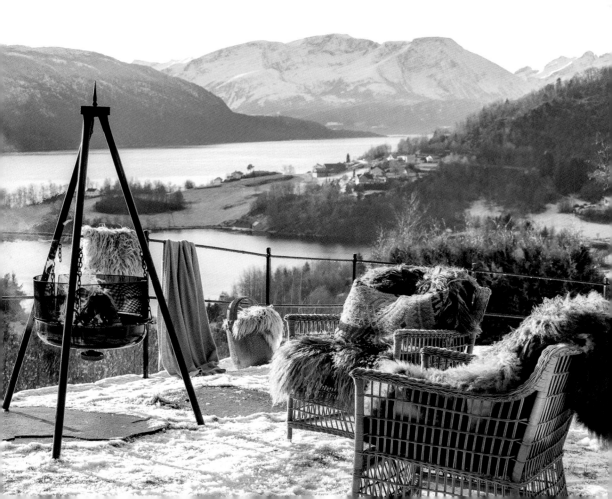

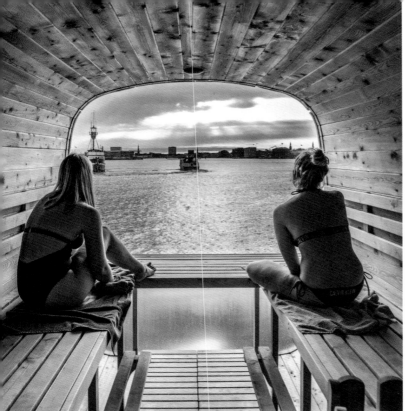

413 CopenHot

DENMARK
413 Sauna, hot tubs, and ice baths with a view

Offering a mixture of shared and private hot tubs and saunas, CopenHot is an understated city spa with a wilderness feel, where baths and tubs are fueled by fresh seawater and firewood, and the views out to sea make you forget all about busy Copenhagen life. If you'd rather be on the go, book the Sailing Hot Tub and soak as it cruises the harbor.

414 Open-air living

DENMARK
414 Discover the Danish concept of *friluftsliv*

Spending time outside is such an important part of Danish culture that they have a word for it—*friluftsliv*, which translates as "open-air living." It's about reveling in the joys of nature in all weathers and seasons, and can include anything from swimming in lakes in winter, to camping in one of the country's many wild shelters, to commuting to work on cross-country skis. Visit and you'll find opportunities to get outside and bond with the Danes while doing so.

DENMARK

415 Take a dip in a harborside swimming complex

Designed by renowned Danish architect Bjarke Ingels, the Harbor Bath in Århus is a floating temple to swimming, including a 164-ft. (50-m) pool, a diving pool, and two saunas. Come in summer and you can sunbathe on the wooden promenade while looking out at the ocean. In winter, take an ice bath in the diving pool before warming up in a steamy sauna—it'll invigorate your senses and boost your mood.

SWEDEN

416 Go on a rewilding holiday

Escape the expectations of modern life at a forest and yoga retreat run by WildSweden. It begins with three nights at Shambala Gatherings, where as well as yoga and meditation, you'll swim in secluded lakes and take part in natural movement sessions in the forest designed to rewild your body and mind. Next are two nights camping, where you'll learn about edible plants, cook over an open fire, and meditate in the dark while wolves howl in the distance.

SWEDEN

417 Tackle the Fjällräven Classic

Join hikers from around the world for the Fjällräven Classic, a 68-mi. (110-km) hike through one of Europe's last wildernesses. You carry all your provisions, cook your own food, and set up your tent at night, while the Fjällräven team sorts out route planning and logistics. It's a chance to work on your stamina and independence, and bond with like-minded trekkers, who'll keep you motivated if the going gets tough.

416 Shambala Gatherings

SWEDEN

418 Soothe your soul at a far-flung wilderness resort

You can find your zen in fairy-tale surroundings at the Arctic Bath Resort, set in northern Europe's last remaining wilderness. Centered around a floating spa, it offers a host of holistic treatments, from Swedish Arctic massages to Julevädno sauna rituals. Plus Sámi guides can take you on adventures big and small, including moose safaris, husky sledding, and berry picking. In the evenings, fill your belly with a nourishing meal sourced from surrounding forest and farms, before retiring to your glass-fronted cabin among the birch trees. Visit during winter and you may well catch the northern lights.

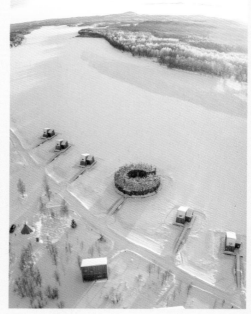

Aerial view

Snowy view

Cold bath

Spa building

419 Swim under the midnight sun on an Arctic Circle swimming race

Each July swimmers from all over the world gather for Swim the Arctic Circle, a magical freshwater swimming event that takes place on the River Torne, alongside the Finnish border. Join a 1.25-mi. (2-km) race in the afternoon, or wait until midnight, when you can swim under the glow of the midnight sun. When you're done, sit in one of the hot tubs or wood-fired saunas at the finish line and contemplate all you've achieved.

420 Live in harmony with nature at a remote eco-lodge

Just two hours by car from Stockholm, Kolarbyn Eco Lodge feels like it's in another much older, much wilder world. Surrounded by thick forest and camouflaged by mud and grass roofs are twelve back-to-basic cabins where you can fully embrace the natural rhythms of each day. You'll have to collect water from a spring, cook over an open fire, and wash in a nearby stream, but you won't miss your home comforts for long. Pick berries in the woods, search for moose and beavers, and drift off to sleep in inky blackness to the sounds of the forest—it's the perfect place to go off-grid and rekindle your ancestral connection with the wild.

422 Midnight sun

421 Travel slowly by bike in Sörmland

Forget a road trip and turn to two wheels instead. Cycling is a fantastic way to go slow and travel mindfully while you discover the lakes, forests, castles, and villages that make up the peaceful Sörmland region. This isn't about racking up the miles or exhausting yourself—go at your own pace, stop to take in your surroundings, and get to know the people and culture of this laid-back province.

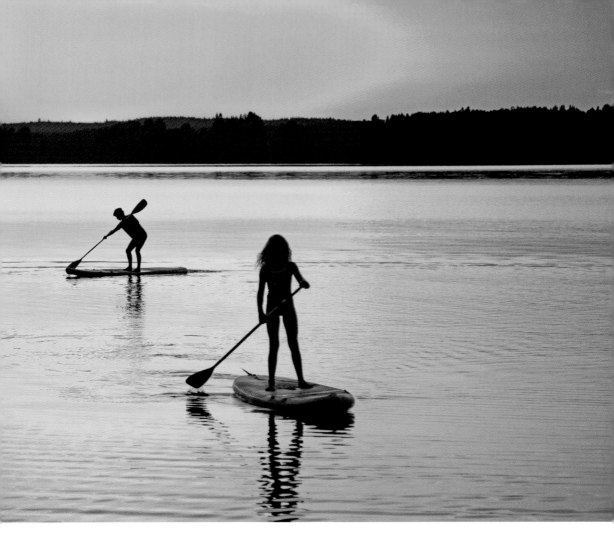

FINLAND

422 Marvel at the midnight sun

The locals say that the midnight sun is not just a
natural phenomenon but also a state of mind. And
if you visit during the summer months, you might
just adopt their mindset. The permanent daylight
from the low sun will leave you feeling energized
and ready for a host of late night adventures: you
could go on a midnight paddle, or enjoy a nighttime
picnic on the beach, bathed in golden light.

FINLAND

423 Visit the sauna capital of the world

Whether you're a first timer or a pro, Tampere is
the place to be for a slice of Finnish sauna culture.
Known as the sauna capital of the world, it has more
of them than anywhere else in the country. Try
Rajaportti sauna, the oldest working public sauna in
Finland, or the lakeside Rauhaniemi or Kaupinoja
saunas, which offer the chance for a postsauna dip
in ice-cold water come wintertime.

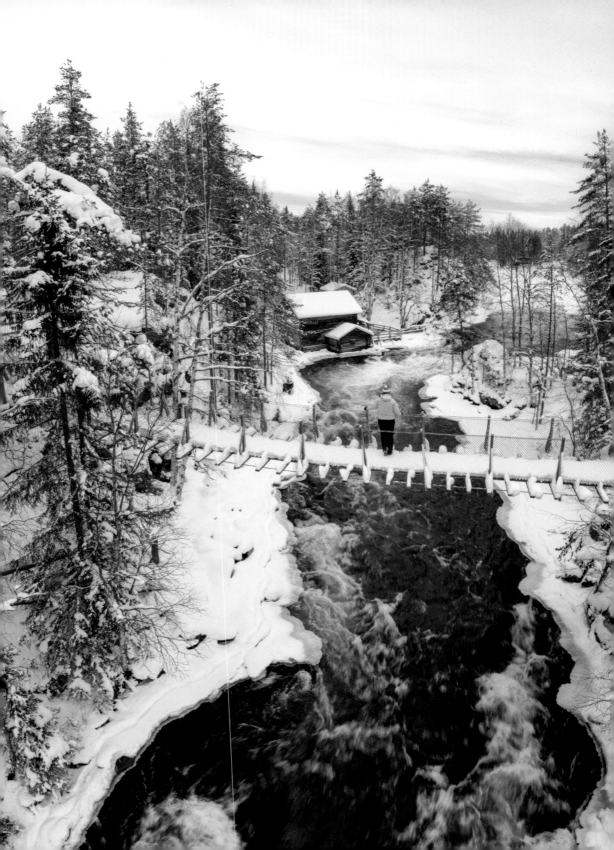

432 Try old and new spa treatments in a movie-famous hotel

The iconic Grandhotel Pupp is not only famous for its on-screen presence in the James Bond movie *Casino Royale*, but for its unique architecture and star-studded spa treatments. From organic peat baths to body rituals using twenty-four carat gold, sea minerals, and plant serums, the spa combines the healing power of water, traditional methods, and modern technologies. Afterward, relax in a spacious all-day restaurant.

433 Revitalize with a retreat in a spa town

The spas at historic Karlovy Vary—some of which are among the oldest in Europe—make the most of the town's hot springs. They combine the curative waters with wellness therapies and tailored medical programs to treat individual ailments from digestive to musculoskeletal problems. This is the largest spa complex in Europe, and in 2021 it became a UNESCO World Heritage Site.

434 Drink the mineral water of Karlovy Vary

There are eighty springs in and around Karlovy Vary, drawing water from a depth of 6,561 ft. (2,000 m), and fifteen of them are accessible to the public. If you'd like to sample the goods, don't just dive in and get started: visit a local physician to discuss your health problems, and he or she will recommend the right hot springs to visit and explain the principles behind a drinking cure.

435 Soak in the thermal waters of AquaCity

A water park built over a geothermal spring, AquaCity houses the largest spa center in Slovakia. It's crammed with saunas, whirlpool baths, and ice caves, but the main attractions are the thirteen indoor and outdoor thermal pools. The water contains more than twenty minerals said to help with movement and respiratory system problems, blood circulation, and skin complaints.

436 Attend a nature-based well-being retreat in the Tatra Mountains

Slovakia's Tatra Mountains offer fresh air, hiking trails, and plenty of dramatic views. Join a wellness retreat with Tatra Escapes and you'll make the most of this beautiful landscape, connecting with nature through walks, outdoor yoga, and forest bathing, with spa treatments to wind down after busy days. It's a chance to switch off from everyday life and soak up some positive energy in the great outdoors.

HUNGARY

437 Sample water treatments in a Turkish-style bathhouse

Budapest's Rudas Thermal Baths date back to the sixteenth century. Inside this thermal treasure are pools where you can relax in the restorative waters, and enjoy services such as aromatherapy massages to improve well-being. Keep in mind that the Turkish bath is predominately for men, but women can visit on certain days and during coed hours.

HUNGARY

438 Take a cave bath in medicinal thermal water

Cave bathing follows the same premise as forest bathing—it will awaken your senses and allow you to heal in a natural environment—but this time you're in a cave. The Miskolctapolca Cave Bath is a great place to experience this wellness phenomenon. Thanks to the heated waters and the climate inside the series of caves, it's said that the caverns may help treat inflammation and joint issues.

438 Miskolctapolca Cave Bath

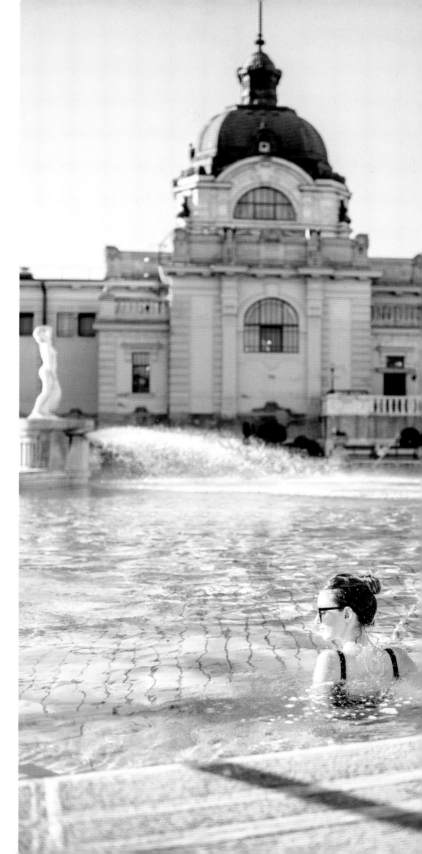

439 Visit a naturally medicinal lake

The world's largest swimmable thermal lake, Lake Hévíz, is full of minerals that are thought to have a healing effect on rheumatic and inflammatory problems. If you'd rather head indoors, try the wooden bathhouse at the center of the lake or one of several nearby spa hotels, where the treatments use the precious, mineral-rich mud from the bottom of the lake.

440 Wallow in the Széchenyi Baths

Soaking in a thermal pool is a Budapest must—the city sits over a network of thermal springs and is scattered with bathhouses, many of which have been in use for centuries. The Széchenyi Baths are the most celebrated of them all, thanks to its eighteen different pools, ten saunas and steam rooms, and a grand outdoor section with a neobaroque design, where "sparties"—parties complete with DJs and a bar—take place on Saturday nights.

440 Széchenyi Baths

441 AKASHA RETREAT

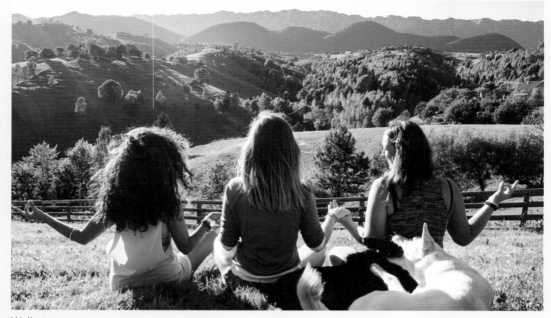

Wellness retreat

Sound healing

Spa

Plant-based meals

ROMANIA
441 Embrace the Akasha well-being experience

In the heart of Transylvania is a magical, nature-inspired wellness destination. At Akasha Retreat you can step into the power of slow travel by attending an outdoor yoga or meditation class to improve vitality, reduce stress, and support emotional health. Afterward, try a sound-healing session or a spa treatment, then indulge in herbal teas and locally sourced plant-based meals that are cooked with one intention—love—and contain ingredients foraged from the national park that surrounds the retreat.

BULGARIA
442 Float and soak in the mineral hot spring at Therma Kostenetz

Set within the Rila Mountains and fed by hot springs, Therma Kostenetz is home to a heated indoor pool equipped with hydromassage equipment designed to ease muscle pain and improve circulation. Outside, there's a thermal pool that is perfect for anyone looking to soak and meditate in the fresh mountain air. Alternatively, a short hike through the trees takes you to a waterfall.

BULGARIA
443 Enjoy a high-tech gym and healing therapies

Recharge your senses on an escape to Zornitza Family Estate. Hop into the salty mineral pool or steam bath to support your body's detoxification process, work up a sweat in the gym that overlooks the orchards, or experience a culinary adventure that emphasizes the flavors of the region. You'll also get to enjoy sweeping views of the vineyards and stay in traditional stone buildings.

BULGARIA
444 Walk from spa hotel to spa hotel

Book a self-guided walking and spa tour with Responsible Travel and spend a week walking in the Rhodope Mountains, with your luggage transferred for you and nights at some of the country's best spa hotels. With average daily distances of 8.6 mi. (14 km), this isn't a walk in the park, but there's plenty of time to stop and appreciate Bulgaria's forests and lakes. At the end of each day, visit a thermal pool or soothe aching limbs with a massage.

BULGARIA
445 Float in pink saline waters

It's the microscopic brine shrimp that give Lake Atanasovsko's waters their startling pink color. But the ultrasalty water is not just colorful, it's thought to have therapeutic properties too. Float for a good half an hour, before slathering yourself in thick goo from the adjacent mud pools, then rinse yourself off again. The process is said to enhance your metabolism and help with skin conditions such as psoriasis and eczema.

447 Hammam

448 Watsu session

TURKEY

446 Feel the benefits of a mud bath

Turkey is home to several thermal springs and some of those are in Afyonkarahisar, otherwise known as Afyon. This historic city is a gateway to a spa and wellness escapade. One of the region's best-known treatments is the mud bath. Many claim that minerals in the mud can increase circulation, promote relaxation, and ease joint pain.

TURKEY

447 Get a massage and scrub at a hammam

Imported by the Persians and popularized by the Ottomans, Istanbul's hammams are still going strong today, and the most popular treatment is a body scrub and soap massage. The action takes place in a *hararet* (a marble-covered steam room) and involves a scrub with a *kese* (a kind of loofah), followed by a foam massage, after which there's time to relax and drink Turkish tea.

TURKEY

448 Boost your immunity at Six Senses Kaplankaya

If you're feeling physically or mentally run down, the immunity-boosting program at Six Senses Kaplankaya could help. Its programs include wellness screening, sleep tracking, and an intestinal cleanse, as well as fitness, yoga, Watsu, and meditation sessions. It claims to combat fatigue, give an energy boost, and strengthen physical and mental performance.

449 Practice sunrise yoga at a restored monastery

Share your sun salutations as the morning light appears over the horizon in the surreal setting of the fairy chimneys rock formations in Cappadocia. Then spend the day exploring the ancient monastery in Argos and dig deeper into the restored underground tunnels and therapy cave to experience the mystical spirit of the landscape.

450 Recharge overlooking the Aegean at TheLifeCo

A pared-back wellness center just outside Bodrum, TheLifeCo attracts celebrities and highfliers from around the world to reset and recharge overlooking the Aegean Sea. Days can be as busy or laid-back as you like, and there's a host of treatments to choose from, from the relaxing (yoga, walks, and massages) to the extreme (detox cleanses).

451 Get a dose of healing minerals at a hot spring

The very sight of Pamukkale's hot springs will blow you away: a cascade of white travertine terraces filled with warm, aquamarine waters, perched high up on a hillside. Get in for a dip and you'll feel the benefits of minerals such as sulfur and silica, known to have positive effects on skin health. More mineral-rich waters can be found in the thermal pool at the ancient Greek city of Hierapolis.

451 Pamukkale hot springs

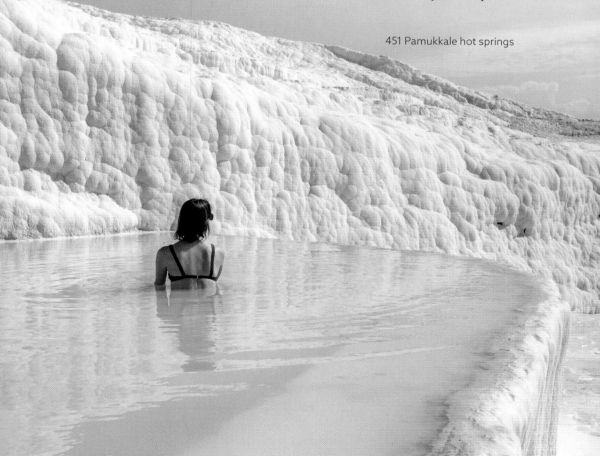

CYPRUS
452 Relax at a luxury spa in Ayia Napa

During the offseason, Ayia Napa turns into a spa paradise for beach lovers and wellness enthusiasts. From impressive gyms and picturesque views to private beaches for a moment of quietness and steam baths to support your respiratory health, there are boundless options to choose from. The Napa Mermaid Hotel & Suites is a good choice for anyone looking for a romantic spa getaway, while the Grecian Bay Hotel offers a private beach.

CYPRUS
453 Rejuvenate in nature at a secret forest retreat

Buried deep in the mountains is an enchanting forest where thermal sulfur pools bubble, and a magical rustic village exists only for adults. This wellness experience—Secret Forest—invites guests to disengage their mind and recharge their well-being battery through fresh mountain air, inspirational mindfulness workshops, the medicinal powers of the mineral hot springs, and more.

CYPRUS
454 Embrace the myth of Aphrodite

Legend says Aphrodite—the Greek goddess of love and beauty—was born on Petra tou Romiou, one of the most beautiful beaches in Cyprus. The views here are stunning, and the crystal clear waters of the Mediterranean Sea shimmer in the sunlight. Walk along the beach to take in the love energy from the goddess, or swim around to Aphrodite's rock, which, according to tradition, will bring love and beauty.

454 Aphrodite's rock

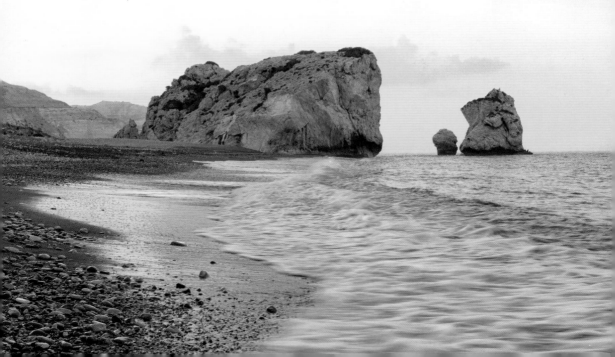

453 SECRET FOREST

Sound healing

Facial

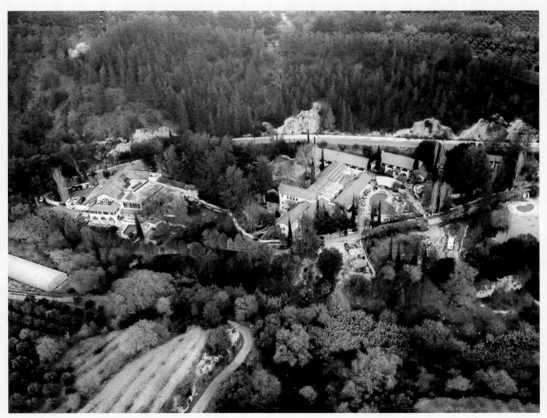

Aerial view

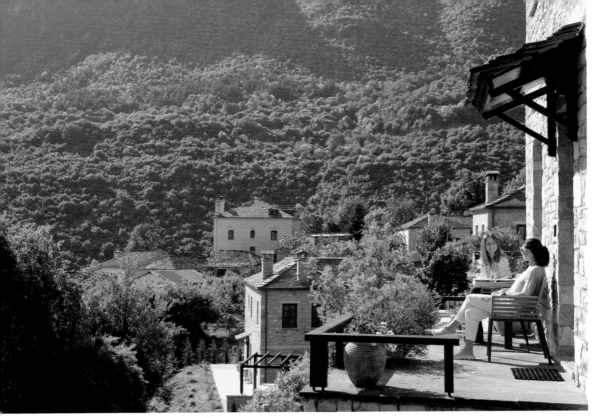

456 Aristi Mountain Resort & Villas

455 Experience a range of water therapies

Greece has many resorts dedicated to the art of thalassotherapy—the Greek word for sea and the term used for the medical use of seawater and seaweed. These therapies are designed to cleanse, soothe, and revitalize the skin and body as well as improve circulation and muscle tone using derivatives of marine and ocean algae, mud, and sand in mineral-rich hydromassages, and algotherapy wraps and baths.

456 Enjoy open-air treatments and panoramic mountain views

Gaze at the green panoramic landscape and reset your mental and physical well-being at Aristi Mountain Resort & Villas. Here, you can live fully in nature and in perfect harmony with the environment while enjoying open-air spa experiences high above the Vikos Gorge. This is a refuge for those seeking beauty and peace in nature to feel the breeze among an orchestra of birdsong.

457 Rediscover your essence on an island

Indulge in tranquility and rejuvenation at a spa that embraces the Greek philosophy of wellness and offers a sanctuary for restoring body and mind. Therapists at Ella Wellness & Spa, part of Ella Resorts collection, nestled within the Helea Lifestyle Beach Resort on the island of Rhodes, help guests find their own path to wellness, encompassing nutrition, mental health, and fitness. Treatments are design to be holistic and to renew and enhance well-being.

458 Marvel at cliff-top monasteries at Meteora

From early Christian times, the soaring cliffs of Meteora were thought to be a perfect place to achieve peace, harmony, and isolation. The first official monastery was built in the fourteenth century, leading to a total of twenty-four monastic communities by the eighteenth century. Today, only six remain, but viewing these Byzantine structures—perched on narrow stone peaks—is an inspiring, emotional experience.

458 Meteora

459 Be sure to get your beauty sleep

If you're desperate for some shut-eye, but can't seem to switch off at night, Six Senses Elounda could be the answer. Sign up for its sleep program and a doctor will design a personalized plan including sleep tracking, massages, and thalassotherapy. You should see a marked improvement in your sleep, which could boost your mood and energy levels, improve memory function, and even strengthen your immune system.

460 Yoga and creativity at the writers' lab

Meeting new people and trying new things boost brain function and creativity, and at the Writers' Lab Masterclasses at the Skyros Centre you'll do just that, taking music, art, and yoga classes alongside workshops with leading writers. Participants stay in a Skyrian village, and downtime can be spent ambling along the stunning coastline and experiencing Greek village life.

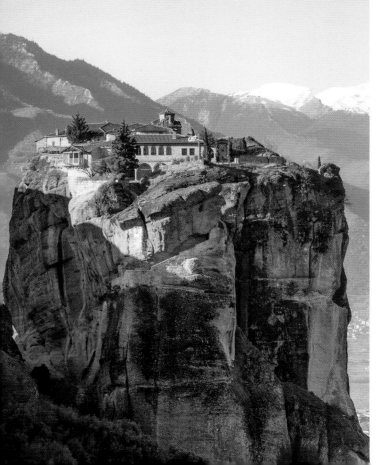

GREECE

461 Brush up on nutrition during a food holiday in the Peloponnese

This week-long food vacation led by Responsible Travel isn't just about gorging on traditional Greek cooking—it's also about discovering which foods serve your body best. Your friendly hosts will discuss the nutritional value of different Mediterranean ingredients as they guide you through tastings, market visits, and foraging expeditions, and there's plenty of opportunity to try cooking them yourself.

GREECE

462 Stay at a spa hotel built around Cretan cliffs

Acro Suites is known as much for its striking design as its upscale wellness offering. Carved into a cliff in Agia Pelagia, incorporating colors and materials seen in Crete's natural landscape, and offering endless panoramic views of the Mediterranean, it's an inspiring setting for a wellness break. Swim in the saltwater pool, join a yoga session, or experience an authentic Byzantine hammam.

462 Acro Suites

463 Artful Retreats

463 Enjoy the benefits of an art retreat

The power of art to improve physical and mental health has been known for millennia. To experience the effect for yourself, sign up for a vacation with Artful Retreats. You'll be based on a Greek estate where mornings begin with yoga or meditation, and the bulk of the day is focused on creating and discussing art. It's a powerful way to express emotions, work through problems, and understand yourself better.

464 Get your creative juices going in a restored Byzantine mansion

You can find joy through meaningful activities at Kinsterna Hotel & Spa, a plush hotel set in a Byzantine mansion. Head to the kitchens for lessons in baking country bread, sign up for a beekeeping workshop, take horseback riding classes in the hills, or learn how to make scented soaps. The chance to stimulate the body and the brain could be the well-being boost you need.

465 Focus on healing in an Ayurveda center

With its cliffs, bays, beaches, and rich cultural sites, Malta has much to offer. Add the Ayurveda Center at the Kempinski Hotel San Lawrenz and you have the setting for a restorative break. Its therapists put together personalized plans to help guests restore balance in their bodies, using techniques such as Panchakarma detoxification and massages.

MONTENEGRO

466 Combine traditions for restorative treatments for body and mind

It's worth visiting the One&Only Portonovi for its Chenot Espace spa alone. Set on the Adriatic, it combines Chinese and Western medicine, and its host of doctors and nutritionists tailor treatments to each guest. You could find yourself having anything from cryotherapy to ozone therapy, to neuromuscular activation treatment for back pain.

MONTENEGRO

467 Spa treatments inspired by ancient philosophies

The healing traditions of Bali, India, and Tibet combine at the Chedi Luštica Bay Spa. Treatments use essential oils, hot stones, deep tissue massage, acupressure, and aromatherapy to create a sense of calm. The spa's herbal poultice massage uses a combination of seaweed, orange, clove, and ginger to moisturize and nourish the skin and muscles.

CROATIA

468 Soak up the healing powers of water

Plitvice Lakes National Park is the largest national park in Croatia and the oldest in the country. This UNESCO World Heritage Site attracts adventure and nature enthusiasts who want to discover the unprecedented beauty of its sixteen emerald lakes. Contemplate life as you marvel at this aquatic ecosystem and let the mountain air fill your lungs.

CROATIA

469 Enjoy yoga on a stand-up paddleboard on a gorgeous island

While it may look intimidating, especially if you're a beginner, cultivating a yoga practice on a stand-up paddleboard may add even more health benefits—it'll improve your stability, boost your confidence, make you feel connected to the ocean, and you'll soak up some vitamin D. On the island of Vis you can do all of this with Summersalt Yoga.

CROATIA

470 Detox on Lošinj, the healing island of Europe

With its many hours of sunshine and therapeutic sea air, it is no surprise that Lošinj is thought of as the "healing island." The microclimate here creates the perfect conditions for a Sea-Tox at the Bellevue Hotel. It uses detoxifying foods, salt water, and minerals to alleviate inflammation, balance hormones, and increase energy.

CROATIA

471 Take advantage of medicinal plants

The island of Lošinj is home to around 230 varieties of plants. Oils distilled from them form the key ingredients for medicinal spa therapies at Hotel Alhambra. With a body massage using island oils, herbal poultices, and smoke smudging with herb sticks, wellness is a local affair. Try the traditional welcome: an inhalation bar—one of the world's most unusual spa experiences dating back to 1892.

468 Plitvice Lakes National Park

472 Honey massage

472 Enrich your skin with traditional honey massage

Whether acacia, spruce, or chestnut, Slovenia is one of the largest honey-producing countries in Europe. It is widely used as a traditional remedy to enrich your body, detox, and revitalize the skin. With many apiaries around the country, why not experience a honey massage in a beehive. Listen to the meditative sound of buzzing bees, and inhale the beehive air while a masseuse coats your skin with honey.

473 Experience the benefits of sleeping with bees

Imagine falling alseep to the hum and vibration of thousands of bees while enjoying the scent of honey. Staying in a beehive hotel is the place to be in Slovenia, where apitourism promotes the health benefits of bee culture. Sleep in a bed built above a hive and microvibrations from the bees act like a light massage to leave you relaxed, improve your blood circulation, and increase your energy.

474 Swim down one of Europe's warmest rivers

A four-day wild swimming adventure with Strel Swimming will take you along the Kolpa River, one of the cleanest and warmest freshwater rivers in Europe. It's blocked to motorized vehicles so you'll swim in peace alongside the occasional canoe, kayak, or raft, at a rate of 3 to 4 mi. (5 to 6 km) a day. It's an energizing break that will boost your circulation, increase mental clarity, and release those mood-enhancing endorphins.

484 Dine on locally foraged ingredients

On the southern slope of the Plose mountain, chefs at the Forestis Hotel invite you to forage for your supper on the property grounds and in the forest. Then they help you to combine your ingredients with more from local farms to create fresh, healthy, and distinctive forest cuisine. Wild herbs such as mountain basil make a classic pesto, tree-lichens are used in jus for risottos and soups, and dishes are garnished with edible local flowers.

485 Wrap in naturally ripened mud

Discover an ancient underground sea filled with mineral-rich thermal waters and naturally ripened salt-bromine-iodine mud formed millions of years ago. At Lucia Magnani Health Clinic in the medieval town of Castrocaro Terme, you can try a mud therapy, which is applied as facials, wraps, or baths. The mud is said to stimulate circulation and treat skin conditions.

484 Foraged ingredients

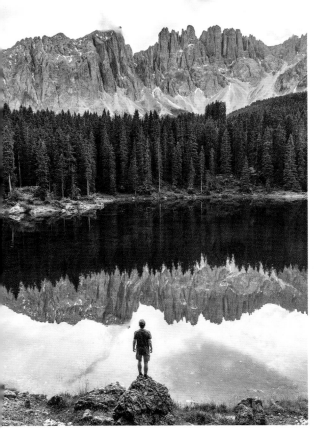

486 The Dolomites

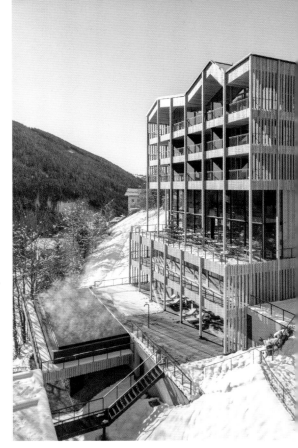

487 Engel Ayurpura

ITALY

486 Hike from hut to hut in the Dolomites

There's plenty of breathtaking drama in the Dolomites. These jagged limestone peaks have inspired walkers and writers in equal measure, and each year millions of climbers, hikers, and bikers come to bask in their beauty. The gentlest way to experience them is on foot along route AV1, which is ideal for less experienced hikers. Join a tour and you'll walk in a group accompanied by an experienced mountain guide, sleeping in comfortable *rifugios* in a variety of stunning locations along the way.

ITALY

487 Rebalance your *doshas* in South Tyrol

Engel Ayurpura is headed by Dr. Vaidya Swami Nath Mishra, one of India's leading pulse diagnosticians and a specialist in Panchakarma and Ayur yoga breathing techniques. As Italy's only Ayurveda physician, he leads a team of Ayurvedic doctors and therapists who create personalized treatment plans, diets, and exercise programs for every guest. Health-themed lectures, meditative painting, a sauna, and an outdoor saltwater pool are also on offer.

488 Sail your way to wellness

A luxurious 42-ft. (13-m) catamaran is your home for the week on a vacation through Corsica and Sardinia with Sailing 2 Wellness. As well as exploring beautiful islands, paddleboarding across stunning lagoons, and discovering a rich underwater world, there are regular guided yoga, breathwork and meditation sessions, both on board and on the beach.

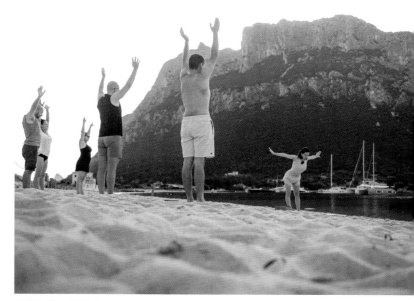

488 Sailing 2 Wellness

ITALY

489 Sweat yourself to health surrounded by hay

Hay baths are a centuries-old tradition in the Dolomites, and those at Hotel Heubad have been going since 1901. You'll be wrapped in warm, moist hay and herbs for around twenty minutes, then spend a further half an hour covered in woolen blankets to continue the process. Advocates say hay baths strengthen the immune system, stimulate the metabolism, and beautify your skin.

489 Hay bath

ITALY

490 Take in snow-capped mountains from a heated sky pool

A narrow infinity pool jutting out over an alpine meadow, Alpin Panorama Hotel Hubertus's sky pool is an incredibly stylish and inviting way to get your laps in. Heated year-round to 91°F (33°C), it's best experienced during winter, when steam rises off the water and a blanket of snow provides an inspiring backdrop.

490 Alpin Panorama Hotel Hubertus

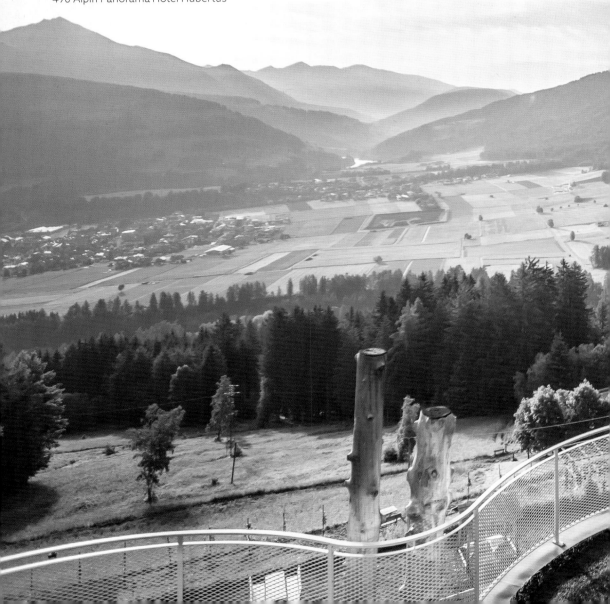

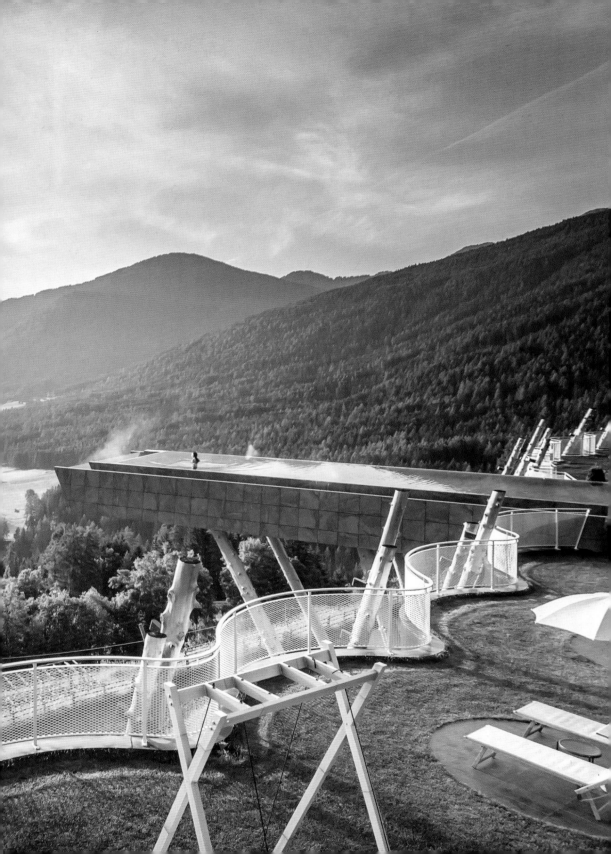

ITALY
491 Soothe your limbs in Saturnia hot springs

It was the Romans who discovered the healing properties of Saturnia's hot springs. Today, the visitors keep on coming to bask in the stunning cascading rock pools, which are full of milky-blue waters and contain precious minerals such as sulfur, calcium, and carbon. These thermal baths reach around 100°F (37°C) and are thought to reduce high blood pressure, soothe skin complaints, and relax joints and muscles.

ITALY
492 Focus on your gut health at Lefay Resort

Lefay Spa's immune system and intestine program will help you work on your gut health, said to be essential for maintaining a healthy body and mind and a strong immune system. Its five-day program includes an intestinal checkup, a consultation with a nutritionist, and a host of treatments from acupuncture to energy body scrubs to get you started.

ITALY
493 Experience the antiaging benefits of bathing in red wine

At Casale degli Erei you can sit back and relax in a bath filled with surplus red wine from the vineyard. Polyphenols in the wine are said to help detoxify skin, improve circulation, and have antiaging properties. It will come as no surprise that ancient Thracian women referred to this wine water as the "elixir of youth."

494 Make a pilgrimage to medieval Assisi

The birthplace of Saint Francis in 1181, Assisi attracts pilgrims from across the world who come to feel the spirit of Italy's premier saint and wander one of Europe's best-preserved medieval towns. You can visit his final resting place at the Basilica of Saint Francis, say Mass at the beautiful San Damiano, or just sit in the relative quiet of dusk to feel the town's beauty and spirituality to the fullest.

494 Basilica of Saint Francis

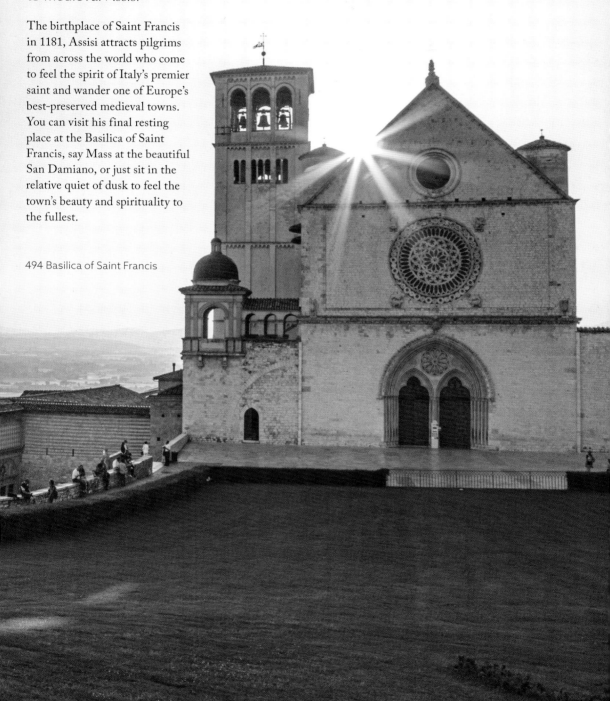

495 Take a sustainable spa treatment with a volcanic backdrop

Harness the power of nature at the Adler Spa Resort, where wellness joins forces with nature. The spa treatments rely on local sources: extracts of prickly pears, almonds, and citrus fruit nourish, condition, and moisturize the skin, while mud wraps benefit from volcanic minerals found at Mount Etna, which soars in the distance.

496 Retreat to a vegan agrivilla deep in the Tuscan countryside

Innovative, organic, and beautifully presented vegan food is on the menu at Vegan Agrivilla I Pini—a farm, guesthouse, and restaurant in rural Tuscany. As much of the menu as possible comes from the restaurant's permaculture garden, while the rest is sourced from local farmers to keep food miles low. Book one of its energy-efficient, sustainable rooms for an overnight stay.

497 Join the spring or fall fitness retreat at the iconic Sirenuse hotel

For one week each spring and fall, the Sirenuse hotel on the Amalfi coast transforms itself into a fitness retreat. Called Dolce Vitality, it prioritizes time spent in the open, breathing pure mountain air, admiring the coastal landscapes, and hiking along ancient footpaths and mule tracks. There's time for yoga and meditation too, but the support of your fellow retreat-goers could be just as beneficial for your soul.

498 Experience the power of horses at a historic Tuscan farmstead

Humans have known about the therapeutic power of horses for centuries, and at Casetta Firenze you can experience equine therapy in the heart of the Chianti Hills. It's said that horses can sense the intentions of the people around them, and guided by an experienced horse whisperer, you'll make a connection with your newfound companion that will help bring clarity to your life.

499 Find inspiration in a prince's garden

Built in the sixteenth century by Prince Vicino Orsini, the garden of Sacro Bosco is a naturalistic, architectural wonder overflowing with enigmatic sculptures, an Italian garden, and more. Many artists have found inspiration in the unique perspectives given by the different elements and sculptures. Find your own creative expression by journeying to the gardens and recharge your energy levels in the fresh air.

500 Enjoy a garden sanctuary

Villa d'Este is a cross between a stunning architectural vision and a serene garden sanctuary. The design of this UNESCO World Heritage Site near Rome was influenced by the Italian Renaissance, and the gardens feature hedge-lined walkways and grand fountains. A walk here will enable you to soak up vitamin D, contemplate life, and increase your oxygen levels in the fresh air.

496 VEGAN AGRIVILLA I PINI

Guesthouse

Vegan meals

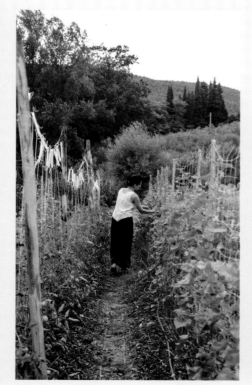

Food from the farm

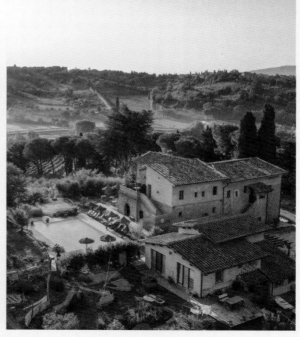

Villa view

501 Brave a cryotherapy session

Thermes-Marins in Monte Carlo was the first spa in Europe to offer whole body cryotherapy. This offbeat treatment involves exposing your entire body to subzero temperatures for two to four minutes. Proponents claim it can clear acne and eczema as well as treat muscle and ligament strains. It's no wonder that it's growing in popularity as a treatment for sports injuries.

502 Take a break in the alps

With an infinity pool overlooking Lake Lucerne, a wellness break at Bürgenstock Alpine Spa really does take place in the heart of the mountains. The complex is reached by a funicular, and treatments include hydrothermal bathing to relax, regenerate, or activate the body, and a curative heat and water program with exercise in the lap pool and lake-temperature Alpine Eco Pool, walking in the Kneipp pools, an aroma sauna, and time to relax.

502 Bürgenstock Alpine Spa

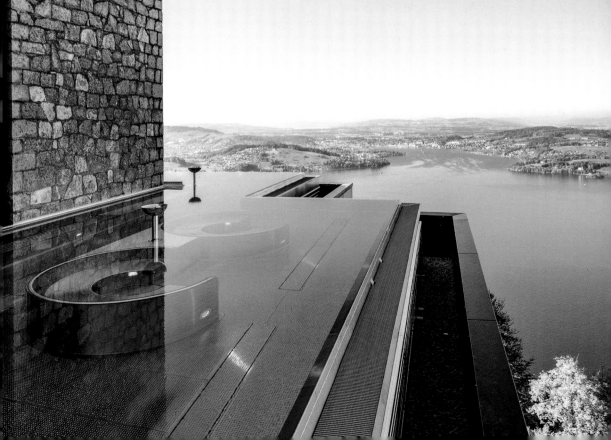

503 Connect mind and body in the Swiss Alps

Retreats provide precious time to reset goals, let go of negative chatter, and experience transformational behavior with curated programs that include personal coaching and group activities. Travelgems organize stays in the high-altitude village of Zermatt that are designed to empower personal change, push boundaries, and enable you to forge new friendships.

504 Sample après-ski treatments

After a long day on the slopes, luxuriate in the soothing spa services of the ski-in-ski-out spa at the Chedi Andermatt. Indulge in a combination of alpine- and Asian-inspired restorative therapies, chill out in the hydrotherapy area, or try a relaxing herb walk to balance your energy, body, and mind. Meanwhile your ski butler will preheat your boots, ready for your return to the slopes.

505 Discover the attraction of magnetic therapy

The therapeutic use of magnetic fields is one of the oldest forms of physical therapy. Le Mirador Resort & Spa, which overlooks Lake Geneva, uses it as part of its detox acceleration program to draw out toxins from the body. This intensive package of holistic treatments aims to fully restore the body's natural inner strength as well as create inner calm and harmony.

506 Dip into the hottest thermal baths in Switzerland

Discovered in 1831, the baths at Les Bains de Lavey are a natural site of energy and healing. The thermal waters are said to treat rheumatic, dermatological, and musculoskeletal conditions. Today, the facilities include three indoor and outdoor pools and Turkish baths, as well as a Nordic pavilion with three types of traditional and naturist saunas and relaxation areas.

507 Nourish your skin in a tub full of whey

Soaking in a wooden tub full of whey could be the beauty therapy you never knew you needed. A treatment since the time of ancient Greek physician Hippocrates, whey baths heal and nourish your skin thanks to a mixture of minerals including calcium, potassium, and phosphorus. The Grand Hotel Kronenhof organizes treatments at Pontresina's Morteratsch dairy.

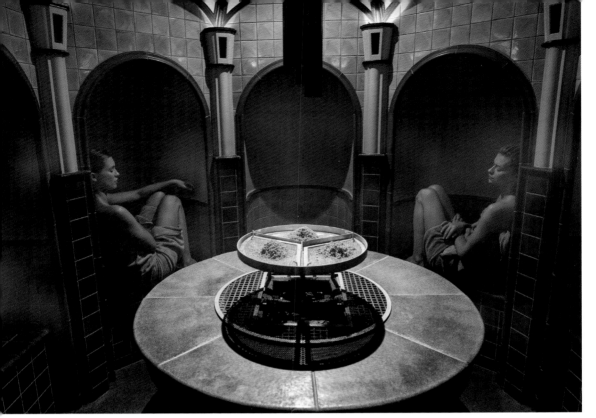

508 Le Grand Spa herbal sauna

508 Sample alpine aromatherapy and herbal saunas in Gstaad

Along the Vaud Alps is an enchanting wellness village that beckons travelers looking for luxury accommodation with a hint of holistic alpine spa treatments. At Le Grand Spa at Le Grand Bellevue, traditional saunas are replaced with herbal ones in which guests have the chance to breathe in the soothing local botanicals said to reduce stress and rejuvenate the skin.

509 Try goat yoga at Grand Hotel Kronenhof

You can take wellness in the outdoors to another level at Grand Hotel Kronenhof. Visit in the summertime and you can take part in goat yoga—an outdoor yoga class surrounded by a herd of goats. The goats nudge, lie down next to, and even clamber on participants, which can release feel-good hormones, provide an additional challenge, or at the very least give everyone a good laugh.

510 Get a full checkup for your body

Set on the shores of Lake Geneva, Clinique La Prairie has been catering for the wealthy and famous for almost a century. It aims to help people live healthier, longer lives, and that's where its multiday wellness programs come in. A five-day detox treatment, for example, comes with a full-body evaluation to get to the heart of any stress, fatigue, or general malaise that you're feeling.

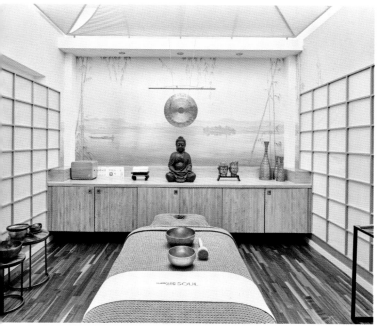

512 Grand Resort Bad Ragaz

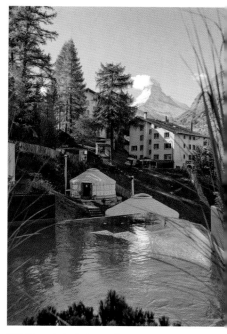

513 Mountain Ashram Spa

511 Reduce stress levels through botanical art

You'll focus on both nature and art on a break with Sukha Retreats. A botanical artist will help you develop both skills and confidence in watercolors. But this retreat isn't just about painting—it's about using art and nature to inspire positive change. You'll have time to wander mindfully through the forest, observing the forms, colors, and textures of the plants.

512 Get some thermal water action

Grand Resort Bad Ragaz is the ultimate thermal soaking palace, and its collection of indoor and outdoor pools are fed by the Tamina Gorge, which maintains temperatures of 97.7°F (36.5°C). Whether you're outside taking in the alpine views or indoors among the marble pillars and vaulted ceilings, you'll be glad to know that the mineral-rich water could benefit blood flow, lung function, and muscle relaxation.

513 Breathe in views of the Matterhorn

If the program of centuries-old body and beauty traditions doesn't get you excited, then the dramatic views of the Matterhorn from the Mountain Ashram Spa will. You can glimpse it from the sauna and treatment rooms, as well as the Japanese onsen. After exploring the mountains (hiking in summer and skiing in winter), you'll have plenty of time to recharge your batteries, whether through a mindfulness session or a massage.

FRANCE

514 Discover the benefits of Evian water at the resort's wellness spa

Pollution-free, pH-neutral, and with a low-mineral content, Evian mineral water owes its unique properties to a hydrogeological site formed thirty-five thousand years ago. Under thick layers of clay, the water is filtered and enriched to produce a formula that is known for its therapeutic benefits. In the heart of the Alps, the Evian Resort uses it for its medical spa program and range of toning, regenerating, and relaxing treatments.

FRANCE

515 Enjoy spa treatments in a landscape beloved by artists

Reconnect with your senses amid nature in the breathtaking landscapes captured on canvas by artists such as Paul Cézanne and Vincent van Gogh. Carry these visions to the Spa des Écuries, hidden behind the arches of the eighteenth-century stone-vaulted stables at the Hotel Crillon le Brave. Then blend them with the restorative powers of the natural products used in its range of body treatments and facials.

515 Hotel Crillon le Brave

FRANCE

516 Follow a curated weight-loss program

Follow the French way to lose weight at the Lily of the Valley Hotel, which offers a number of retreats adapted from the methods of international nutritionist Dr. Jacques Fricker. The spa specializes in curated programs for long-term, healthy weight loss, designed to set you on a realistic path. This is supplemented by activities such as aqua boxing, sea wading, Nordic walking, and sunset yoga.

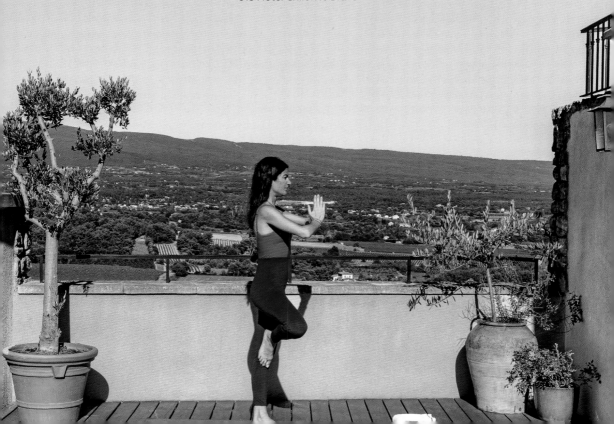

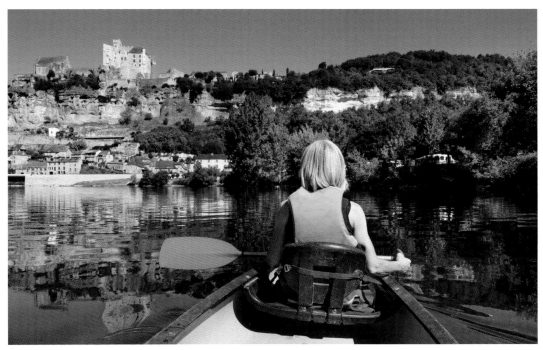

519 Kayaking on the Dordogne

FRANCE

517 Slow travel with a donkey companion

Walking through the Ardèche is a welcome change from your usual daily routine. Add an animal companion and the joy factor increases exponentially. On Safran Tours' family hiking excursion, you'll have a friendly donkey in tow as you travel through forests, gorges, and meadows. Having to tune in to the animal's natural, unhurried rhythm forces you to slow down and take in your surroundings.

FRANCE

518 Join a restorative postnatal yoga retreat

A rambling manor house in Limousin is the setting for &Breathe's Family and Postnatal Retreat, specifically designed for new moms and dads and their little ones. The venue is equipped with all the paraphernalia and toys you could ask for, and there are four hours of daily childcare provided, so not only can you pack light, you'll have time for fitness and yoga classes—or just swim, read, and snooze.

FRANCE

519 Soak up the beauty of the Dordogne by kayak

Exploring the Dordogne River by kayak is a leisurely, feel-good way to take in some of France's most stunning scenery. You'll feel the sun on your face as you paddle past ancient châteaux and honey-hued villages, stop off on sandy river beaches to picnic and dip your toes in the water, and get enough of a workout that you'll end the day with the deepest of sleeps.

525 MESA DE HOY

Fresh tacos

Meditation space

Japanese-style bouquet

Vegan cuisine

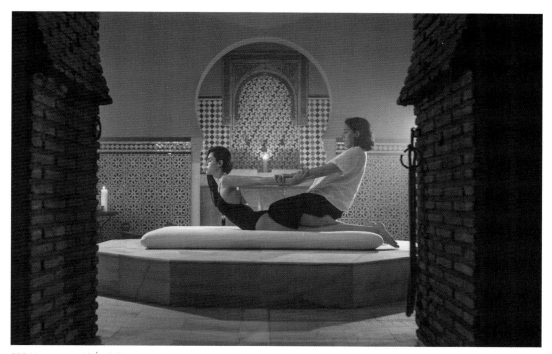

535 Hammam Al Ándalus

534 Experience the meditative power of painting

There are few better settings for a painting vacation than Andalucía, thanks to its superb light, gorgeous coastal scenery, and beautiful whitewashed towns and villages. Week-long painting holidays at Casa Ana celebrate this natural canvas and are designed to help you make the most of your abilities, whether you're a newbie or an experienced artist. They're good for the soul too—it's proven that creativity reduces anxiety and stress and provides a healthy hit of dopamine.

535 Bathe in ancient opulence

You'll feel the stress slip from your shoulders as you enter Granada's Hammam Al Ándalus thanks to the low lighting, gentle music, and scent of rose and pomegranate in the air. Housed in a grand building full of arched doorways, colorful geometric tiles, and domed ceilings, it is a wonderfully atmospheric place to spend some time. Move between the hot and cold pools, steam rooms, and massage chambers, all softly lit by candles and lanterns. Then stop to drink mint tea and congratulate yourself on finding such a relaxing environment.

536 Visit the gardens in this historic destination

Perched on a plateau surrounded by verdant trees and overlooking the city of Granada, the medieval walled city of Alhambra was once home to sultans and kings. Today, it is considered to be one of the best-preserved Islamic palaces as well as being home to notable examples of Spanish Renaissance architecture. Its gardens feature vegetables, trees, and medicinal plants such as lavender, rosemary, and sage. Breathe in these scents for their powerful relaxation and energy-lifting benefits.

537 Work on your fitness in the wild

Rustic luxury and dramatic views are part of the deal at Wildfitness retreat, set in a Menorcan farmhouse. This is no hard-core boot camp—it's all about getting fit while restoring your connection with nature. Exercise sessions make the most of the location, while workshops on nutrition and mindfulness will keep your brain in gear. Use your downtime to walk along pine-scented trails.

536 Alhambra gardens

538 Strike a yoga pose at stunning Migjorn Beach

The startling blue sea and white sand of Migjorn Beach, the longest on Formentera, make a stunning venue for those daily *ohms*. Stay right by the sand at Gecko Hotel & Beach Club and you can use the services of its in-house yogi. Daily classes range from fast-paced vinyasa yoga to meditation and pranayama, all held in gardens facing the ocean.

539 Reap the physical and mental rewards of the Body Camp

A chic farmhouse in Sencelles, Mallorca, is the setting for the Body Camp, a well-being boot camp that aims to improve fitness and instill healthy habits. Classes include circuit training, boxing, hiking, and resistance training, and you're free to explore your surroundings, do poolside yoga, or simply relax on the grounds.

540 Water therapy at an extensive aqua circuit in Ibiza

The benefits of water have been used in therapies for centuries. Plunge into the waters of the Aqua Spa at the Ibiza Gran Hotel and you can experience a heated hydromassage pool with waterfalls, warm Turkish baths, bracing ice pools, and hot Finnish saunas. Alternatively, try a saline inhalation bath then relax on a heated bed.

SPAIN

541 De-stress at a spa by the ocean

A high-end resort on Ibiza's bohemian north coast, Six Senses is the perfect place in which to rest and recharge—thanks both to its sublime spa and its idyllic setting among the rocks of Xarraca Bay. Health and well-being are paramount throughout. Try sound therapy, sanctum and meditation sessions, purification rituals, and beauty treatments, get guidance from nutritionists, and relax with an outdoor massage as you look out toward the sea. Alternatively, stretch your limbs in the pool. You'll feel even better knowing that sustainability is considered in every detail.

Facial

SPAIN

542 Head to Ibiza for a retreat that helps you find clarity

Movement and meditation are used to help participants improve their mental clarity, brain performance, and social interaction during a WiseMotion retreat. Using the latest research, the course at Six Senses Ibiza enables guests to rediscover their vitality, improve their emotional and mental wellness, feel better physically, relieve stress, and work better with others.

Purification ritual

Swimming pool

Sanctum session

Meditation

545 São Miguel lake

543 Dig into nutritious farm-to-table food

A sustainable retreat in the wild and wonderful Alentejo region, Craveiral Farmhouse prioritizes slow living, nature, and local community. This ethos bleeds through into its restaurants, Craveiral FarmTable and Craveiral Pizzeria, which champion seasonal, organic, and locally sourced ingredients, with much of the produce used on the menu coming from its own farm and gardens.

544 Connect with the outdoors

Enhance your physical fitness amid rolling hills, imposing cliffs, and forests, then rest in rocky coves before strolling along broad beaches. The secluded, private Praia do Canal Nature Resort in the heart of the Algarve will connect you with the wild nature of this unspoiled landscape—it's the perfect place for yoga and meditation.

545 Go hiking with hot springs in the Azores

The "Green Island" of São Miguel—a fairy-tale land of crater lakes, waterfalls, and ancient forest—is your destination on this week-long hiking and hot springs vacation, organized by Responsible Travel. Hikes are challenging but slow enough that you can take in the landscape to the full, and each day ends with a swim in the ocean or time in a restorative natural thermal spring.

546 Soak in mineral-rich thermal waters

Parque Terra Nostra might just be the most beautiful garden in the Azores, but that's not where the magic ends. At its heart is a sprawling, geothermal swimming pool filled with water from volcanic hot springs. The muddy brown color might not be appealing, but it is rich in iron and other minerals to treat your skin and muscles. And if you fancy bathing while gazing at the stars, it's open until 10 p.m.

547 Feel a sense of calm with a CBD massage

A chemical compound found in the cannabis sativa plant, cannabidiol (CBD) has been making its way into the wellness sphere. Often used in managing pain and tackling inflammation, it's also effective if you're suffering from sore muscles, stress, or sleep issues. Try it out at Pine Cliffs Resort's Serenity Spa, the first in Portugal to offer a CBD-oil massage treatment.

548 Join a well-being retreat for gay and queer men

Billed as a journey of self-discovery, Rainbow Journey is a retreat for gay and queer men that takes place on the Atlantic coast. Daily yoga and meditation classes are interspersed with sessions on intimacy and communication, emotional release, boundary setting, and creating art, with the emphasis on new experiences and building connections with others and yourself.

548 Rainbow Journey

PORTUGAL

549 Wellness in the Douro Valley

Foodies and spa junkies will be in their element at Six Senses Douro Valley, a sleek nineteenth-century boutique resort that cleverly marries healthy living and indulgence. One minute you're taking yoga classes, hiking in the hills, and learning how to pickle vegetables from the garden, the next you're feasting in the restaurant. It's a feel-good roller coaster that will leave you glowing for days.

PORTUGAL

550 Find your bliss in an open-air tent for two

Squeezed between sand dunes and a pine forest is Areias do Seixo, an elegant resort full of bohemian charm. The jewel in its crown is a luxury tented room with no internet access, air conditioning, or walls between you and the natural world. Fall asleep to the thrum of the ocean, wake to birdsong, and spend evenings around a firepit—it's the most restorative camping experience you'll ever have.

PORTUGAL

551 Combine surf, yoga, and meditation

Located in the Sintra region, Shamballah Yoga Retreat sits just a short walk from the stunning coastline and offers week-long immersive retreats. You'll have to commit to two yoga classes a day, as well as evening meditation sessions, but the rest of the time you're free to choose any activities. Explore the beguiling town of Sintra, take surfing lessons at the beach, or wander the hills in search of peace.

550 Tented room

552 Get sporty in Quinta do Lago Resort

A state-of-the-art fitness hub complete with a high performance gym, tennis and padel courts, a swimming pool, and cycle tracks, the Campus in Quinta do Lago Resort attracts both top athletes and tourists. Take part in group classes and personal training, or enroll the kids in one of its popular summer sports academies. Who knows? You might even spot a soccer star or two.

553 Find well-being through creativity

Wellness and creativity go hand in hand when you join a sculpting and yoga retreat at Quinta Camarena, a rustic boutique hotel. Mornings begin with an energizing yoga session in the open-air studio, then it's time to take up the tools. After time spent choosing the right stone, you'll mold it into your artistic vision over several days under the guidance of the artist in residence.

554 Join an anti-stress and mindfulness retreat

Set in a gleaming contemporary building in Alvor, the Longevity Health & Wellness Hotel is a leading medical spa, with a private hospital next door and a beach a short walk away. Join its anti-stress and mindfulness retreat and you'll be given a unique health check to help find your stress factors, followed by treatments such as sound therapy and acupuncture, as well as access to the spa.

554 Spa treatment

557 Natural pool in Madeira

555 Find a realistic way to a healthier life through food and laughter

Phone off, pajamas on—the Detox Barn's digital detox weekend has begun. Head to this stunning retreat in a nature reserve in the Algarve—look out for the flamingoes—to enjoy yoga, a vegan diet, country walks, lots of laughter, and plenty of discussion about how to embed more healthy habits into your daily life.

556 Try an Ayurvedic Panchakarma cure and detox

Ayurvedic medicine involves balancing your three *doshas*, and you can do this by eliminating the toxins that are causing the imbalance. A Panchakarma treatment involves regular massage and steam sessions to allow the toxins to move easily, followed by treatments to eliminate them from your body. Surround yourself in the peaceful setting of the Alpino Atlantico Ayurveda Hotel and allow your body to feel renewed.

558 Mindful stress reduction at a Buddhist monastery retreat

Nestled in the Belgian Ardennes, an area well known for its diverse fauna and flora and quaint villages, lies Yeunten Ling. During a retreat at this Buddhist monastery, guests are invited to deepen their mindfulness practices through restorative yoga poses that calm the nerves, boost inner awareness, and support mental health.

559 A spa with thermal baths and a Zen garden

Journey to Le Château des Thermes to recharge your inner batteries and pamper your body. Whether you prefer soaking in the outdoor or the indoor thermal bath, the waters are designed to have a calming effect on the body and support blood circulation. Later, head to the Zen garden for a moment of contemplation and gratitude.

PORTUGAL

557 Feel the therapeutic benefits of seawater and volcanic mud

Madeira's pure air, mild climate, and calm, clear waters offer plenty of health benefits, and extracts from its algae and plants offer therapeutic properties. One of its traditional treatments uses natural sea pools carved out of lava rocks along the island's coastline to provide a holistic hydrotherapy spa experience. This is often complemented by baths and wraps using volcanic mud, which promise to detoxify the body and increase relaxation.

BELGIUM

560 Connect with nature through silent time and nature ceremonies

Solitude and silence take on a whole new meaning in the Belgian Ardennes—a paradise for outdoor enthusiasts. Brimming with forested areas and rivers that wind through the valleys, the charming village of Hodister is home to various nature retreats and ceremonies. Many of them prioritize silent time and solo exploration in the thick forests to help individuals cleanse unwanted energies, set intentions without any distractions, and manifest new desires in life.

LUXEMBOURG

561 Visit a chateau that marries history and modernity

Château d'Urspelt is living proof that enchanting, romantic, fairy-tale castles can have a place in modern society. As well as being a national monument, it is now a hotel with a spa, which offers a flotation tank where you can experience the closest feeling there is to being weightless. Alternatively, you can escape to a red cavern-inspired swimming pool.

THE NETHERLANDS

562 Movement and mindfulness retreat for couples

Discover relationship bliss and develop a deeper, more intimate relationship with your partner by attending a couples retreat that prioritizes movement and mindfulness in Maastricht. Let nature and movement nurture your relationship since they are natural antidotes to improved well-being.

THE NETHERLANDS

563 Stroll among blooms at the world's largest flower garden

A floral wonderland located 16 mi. (26 km) southwest of Amsterdam, the gardens at Keukenhof pack a powerful visual punch, with over seven million flowers including daffodils, hyacinths, and some eight hundred varieties of tulip. It's only open to visitors for an eight-week spring-to-summer season so you'll have to book accordingly, but you'll be glad you did. Stroll the gardens slowly and deliberately, taking time to take in the colors and breathe in the intoxicating fragrances, and you'll feel in tune with the joys of the natural world.

563 Keukenhof tulips

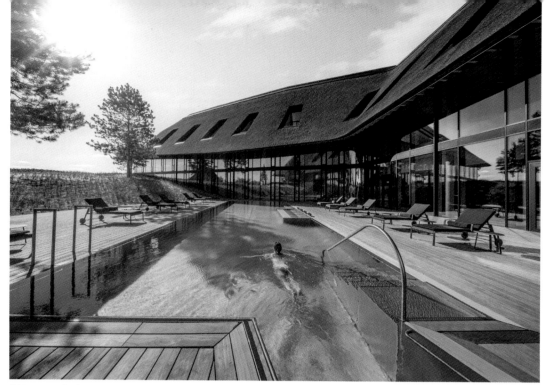

564 Lanserhof Sylt

564 Escape from your allergies at an innovative, holistic coastal resort

Constructed from sustainable, nonemitting materials, and shaped in curves to mirror the landscape, Lanserhof Sylt is built on a UNESCO site, between sand dunes and the Wadden Sea. In its healing climate, allergy and respiratory sufferers find respite thanks to the restorative sea air and programs designed for acute and chronic illnesses by a specialist in cardiological rehabilitation. Therapies combine cutting-edge diagnostics with natural healing methods.

565 Discover health secrets through DNA screening

There's a solid offering of high-tech medi-spas in Germany, and Lanserhof Tegernsee is one of the best. Come here for an extensive menu of diagnostic treatments from cardiology examinations to endoscopy to a gene-testing program designed to discover your predisposition to a range of serious illnesses, from dementia to diabetes.

566 Find peace with the kids on a car-free island

You'll feel like you've gone back to a simpler time when you reach the East Frisian island of Juist, a narrow, 11-mi.-long (18-km) strip of land with wild beaches on either side. There are only two ferry crossings a day, and motor vehicles aren't allowed so you'll need to get around the old-fashioned way: on foot, by bike, or on horseback. It's the ideal place for families to bond and step back from their daily lives—there's little to do but run along the beaches, splash in the waves, and revel in wide, open spaces.

567 Unwind in an extravagant spa hotel, complete with concert hall

You can mix music with your meditation at Schloss Elmau, an exquisite castle hotel, spa, and cultural hideaway that extols the therapeutic benefits of music on mental health. Originally developed as an artists' and writers' retreat, it has its own performance hall, where you can catch live classical music and the occasional reading, when you're not trying out the hammam or working on your mindful movement. The hotel offers a range of retreats including ones based on Chinese medicine. You can also enjoy wild swimming in the lake.

568 Try hydrotherapy at the town where it was rediscovered

Hydrotherapy was enjoyed by the Romans, but as time passed its health benefits were lost. In the nineteenth century, a priest and a naturopath in Bad Wörishofen realized that short increments of cold water exposure strengthens the immune system, stimulates the nervous system, and improves circulation. The town continues to offer the treatment for those who want to discover it.

569 Cruise the rivers of Germany on a wellness riverboat

Float down the Rhine or the Danube on a cruise offering a mindful wellness trip. Join in with yoga at the bow, a stretch class at the stern, a session on the treadmill, or a massage in the spa, and then choose from a menu of healthy dishes. On dry land there are guided excursions to expand the mind and explore towns and villages along the way. Alternatively, borrow a bicycle and find your own adventure.

569 Cycle along the Rhine

GERMANY

570 Visit the spa town of Baden-Baden

The great and the good have been coming to soak in Baden-Baden's thermal waters for centuries. The Roman Emperor Caracalla came here to cure his arthritis, Mark Twain was a fan of Friedrichsbad bathhouse, and Marlene Dietrich, Victor Hugo, and even Napoléon III took to the waters here. The remaining public bathhouses are the primary reason most visitors come here today. Try Friedrichsbad, a palatial venue with a strict no-clothes-allowed policy, and Caracalla Spa, which has an outdoor pool and where nudity isn't required.

GERMANY

571 Take a traditional spa break with holistic treatments

Baden-Baden is home to the historic Villa Stéphanie, where celebrities and aristocrats enjoy recuperative, preventative, and luxurious treatments in splendid surroundings. While the hotel dates back to 1872, the spa—which takes up a whole house—was added in 2015. It offers an extensive menu including tailor-made body treatments, detoxes, and facials.

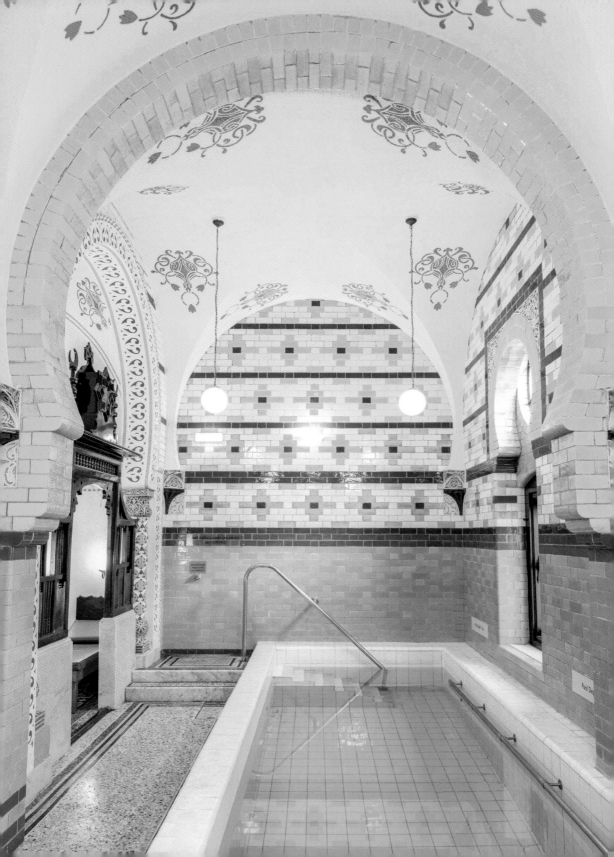

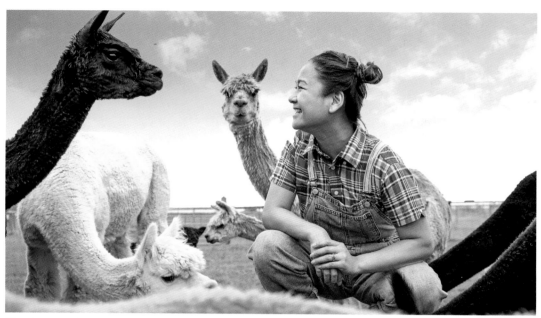

574 Alpaca walk

572 Visit Harrogate's Moorish-style Turkish baths

Harrogate is a historical spa town with a rich heritage as a fashionable resort, and its nineteenth-century Turkish baths are still in full working order. The baths' elaborate design features vibrant glazed brickwork and mosaic floors under decorated Islamic arches and arabesque painted ceilings. You can indulge in a unique regime of relaxation and rejuvenation: steam, plunge, heat, relax, and repeat.

573 Take a historic dip in Bath's Roman baths

Visit the town of Bath's steaming Great Bath where people bathed nearly two thousand years ago, marvel at the ruins of the temple of Minerva where Roman worshippers gathered, and then immerse yourself in the twenty-first-century Thermae Bath Spa. It has two large pools brimming with thermal water, including an iconic rooftop pool. You can also "take the waters" as visitors did in Jane Austen's time by drinking the thermal water at the Roman Baths or the Pump Room.

574 Take an alpaca for a walk to alleviate stress and anxiety

It's well documented that being with animals reduces blood pressure and helps alleviate feelings of stress and anxiety. So why not take an alpaca for a walk? Spending time with these gentle creatures, known for their calming presence, can help promote relaxation and increase energy levels and self-esteem. Plus you'll enjoy plenty of fresh air while you and your newfound, halter-trained companion spend time in the countryside.

572 Turkish bath

ENGLAND

575 Immerse yourself in London's ancient underground baths

In the heart of Westminster lies a labyrinth of underground tunnels lit by candles and lanterns and leading to seven thermal baths, a steam room, and nine treatment rooms for massages and body rituals. Housed in a restored historical building, the AIRE Ancient Baths feature Roman, Greek, and Ottoman bathing traditions.

ENGLAND

576 Give your sleep routine an overhaul

A good night's sleep and city life don't always go hand in hand. But sign up for the sensory sleep program at Pan Pacific London and you're guaranteed rest and relaxation. The main attraction is a customizable bed with a choice of pillows and a sheet that adjusts its temperature throughout the night to suit your body's needs. Then there are in-room yoga, sleep-inducing essential oils, and relaxing bath products.

ENGLAND

577 Join the outdoor swimmers at Hampstead Heath Ponds

Londoners have been coming to swim at the Hampstead Heath Ponds—which has a men's, ladies', and mixed pond—since Victorian times. You'll have to swim with the weeds, the mud, and the ducks, but the well-being benefits are undeniable: the feel of the cool, dark water on your skin, the conviviality of your fellow swimmers, and the sense of having escaped the city.

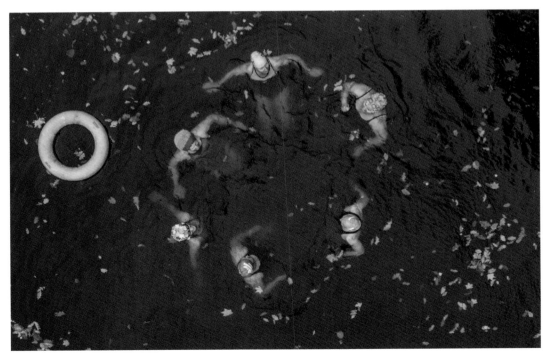

577 Hampstead Heath Ponds

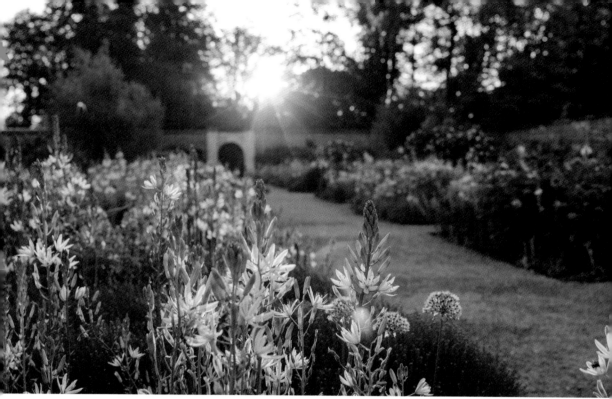

579 Walled garden

ENGLAND
578 Enhance your skin with a treatment in an infrared dome

It might look like you're about to have a scan in an MRI machine, but the MLX i3Dome in London's Claridge's Spa is actually part of a body detox session and uses far infrared technology to activate tissue metabolism and stimulate cellular repair. You'll spend thirty minutes inside, before continuing the rest of your treatment—a turmeric and ginger wrap and lymphatic-drainage body massage.

ENGLAND
579 Reset your circadian rhythm through eco-psychology

Feel out of sync with the time of day? At Heckfield Place you can reset your internal clock with bespoke treatments inspired by the universal principle of circadian rhythms to support recovery, healing, and balance. Treatments also include a therapeutic massage sequence using essential oil blends specifically formulated to the time of day. Aferward, enjoy a stroll through the flower-filled walled garden.

ENGLAND
580 Receive spiritual guidance at an abbey

If you need to escape your real life for a while, a stay at Quarr Abbey could be the silent haven you need. Set on the Isle of Wight, it's home to a small group of Benedictine monks who welcome visitors to stay in their guesthouse and encourage them to share in the monastic day. Guests are welcome to wander the grounds and use the chapel for prayer and meditation. If you feel the need to talk, one of the community will be available.

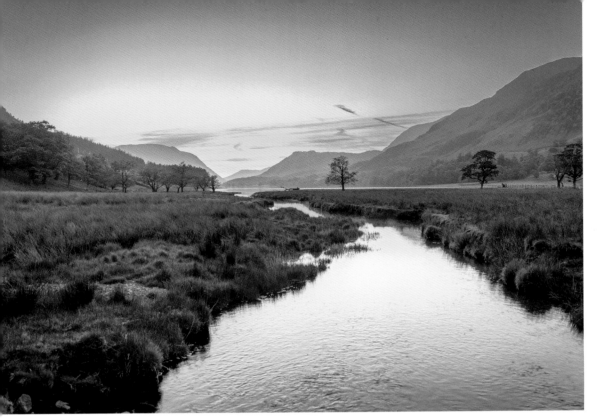

581 Buttermere

ENGLAND

581 Reflect and recharge on a walk along the shores of Buttermere

Enjoy the comradery of gentle strolls on the shores of Buttermere in the Lake District National Park with a solo or group walking trip to replenish diminished energy. Reconnect with new relaxation techniques, such as silent walking, learn to live in the moment, or participate in targeted activities to bond with your surroundings and unite with nature.

ENGLAND

582 Step back in time and off-grid

You'll feel as if you've traveled to a different century when you reach the Cottage in the Clouds. This old, atmospheric stone building sits in a remote corner of the Lake District National Park and comes without Wi-Fi, mains electricity, or plumbing. A visit here is about spending time outdoors, walking in the hills, swimming in lakes and rivers, and soaking up the sense of peace and self-reflection that this remote wilderness brings.

ENGLAND

583 Wellness therapy with animals

The restorative power of nature and wildlife is on full display during Armathwaite Hall's day-long rest, restore, and rewild program. You'll join a mindfulness coach for a forest bathing session on the hotel grounds, walk through the hotel's deer park, then finish with a visit to the Lake District Wildlife Park, where you'll observe the resident creatures during a mindfulness-with-animals session.

584 Soak up the coastal scenery from a hot tub

An adult-only eco-retreat perched on a cliff, the Scarlet Hotel is a quiet, low-key place from which to soak up Cornwall's coastal beauty, especially if you do so from its spa. You can catch the views from the outdoor natural reed pool, the cedarwood sauna, and the cliff-top hot tubs, where you can soothe your limbs to the sound and scent of the crashing waves below.

584 Hot tub

585 Rainforest walks at a Cornish wellness retreat

A Dirty Weekend at Cabilla Cornwall is much more wholesome than it sounds, and the only passion you'll develop is for the temperate English rainforest. You'll take part in a habitat restoration project, learn about species reintroduction, and go on a nature walk. Then crank the feel-good factor up even further with a sound bath, a yoga class, and a blissful session in the woodland sauna.

586 Stay at a magical luxury tree house

The eco-friendly tree houses at Chewton Glen have all the perks of being close to nature—views of the treetops, the sound of birdsong, magical walks on the doorstep—and all the perks you'd expect from one of England's best-loved country house hotels. They come complete with outdoor hot tubs, kitchenettes, huge freestanding baths, and a private concierge, who can arrange everything from private dinners to spa treatments.

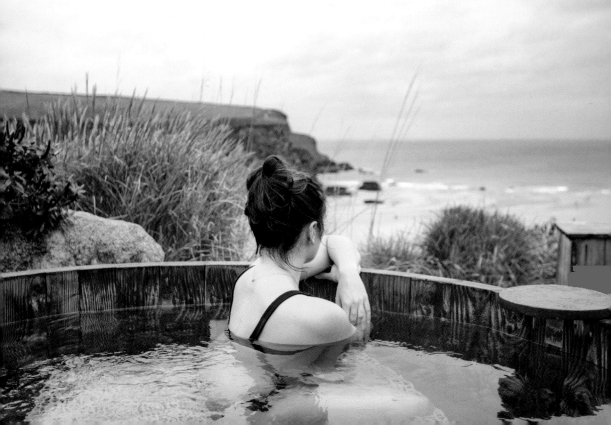

587 Experience nature-based mindfulness at the Sharpham Trust

The Sharpham Trust's year-round retreat program aims to connect you to the land and yourself, in beautiful, riverside surroundings. The nature-mindfulness charity—set within an eighteenth-century house and grounds—offers retreats in various venues, inviting you to learn meditation, awareness, and stress-management techniques.

588 Try the Wim Hof method at a country house hotel and spa

Channel your inner Wim Hof at Beaverbrook Hotel and Spa, where the half-day cold water exposure and breathwork workshop takes inspiration from the Iceman himself. The rewards are many and include increased energy, better sleep, and improved mood. Not to mention the smug feeling you'll get from completing this famous challenge.

589 Enjoy a weekend of vegan meals, yoga, and conversation

The phrase "detox retreat" might sound severe, but there's nothing restrictive about a weekend at the Detox Barn. The vegan food is delicious and plentiful, plus you'll learn how to make it yourself. No phones are allowed, but the relaxed atmosphere will provide all the connection you need—as will the yoga, meditation, and nature walks.

590 Experience emotional and spiritual healing with Fiona Arrigo

If you're struggling from stress, grief, or depression, book a one-on-one with the Arrigo Program, an intensive retreat run by psychotherapist and healer Fiona Arrigo on a farm in the West Country. The program includes therapy, healing, and clinical work, and you'll be alone, save for a housekeeper to cook your meals, stoke the fire, and light the candles.

587 Meditation

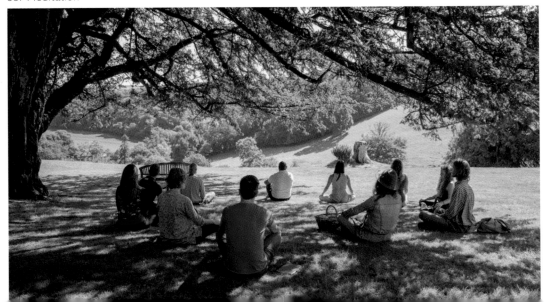

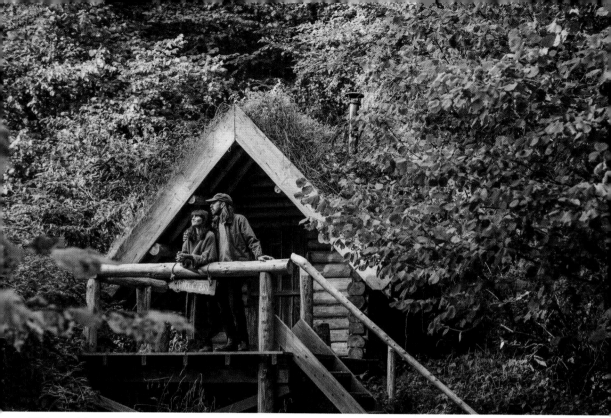

591 Log cabin

ENGLAND
591 Try your hand at rustic crafts

You'll find a range of restorative, creative workshops at Campwell, a wholesome, off-grid eco-camp near Bath, made up of log cabins, yurts, and bell tents. Learn foraging, fire building, and whittling at its bushcraft sessions, enjoy a challenge (and plenty of laughter) at its sheepherding lessons, or sing shanties around the campfire. It's the perfect opportunity to indulge your inner child and connect with nature.

ENGLAND
592 Learn to make healthy, balanced meals

In addition to eating well on a Daylesford Organic Eat to be Healthy cooking course, you'll also learn all the skills you need to cook your own meals once you're home again. The recipe demonstrations and cooking sessions—using fresh produce from Daylesford's farm and market garden in the picturesque Cotswolds—are shored up with plenty of expert advice about nutrition and well-being and what makes a balanced meal.

ENGLAND
593 Empower yourself at a holistic menopause retreat

You can take control of your menopause at this two-day retreat at Goodwood, designed to help you make sense of this overwhelming, emotional, and often isolating period in your life. Industry-leading experts will teach you how to manage your symptoms with clinical medicine and complementary therapies. You'll leave refreshed, empowered, and with all the advice you need to thrive.

ENGLAND
594 Detox from your devices at an off-grid cabin in the wilderness

Lock your phone away and recharge in nature without another soul in sight at one of Unplugged's digital detox cabins. There are twenty scattered around the country, and they come with everything you need for an immersive and restorative break, including lockboxes to shut away your devices, huge picture windows to connect you to the countryside, books and games for cozy nights inside, and a map to get you out exploring.

594 UNPLUGGED

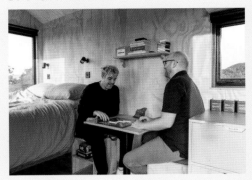

Board games

Lock away your cell phone

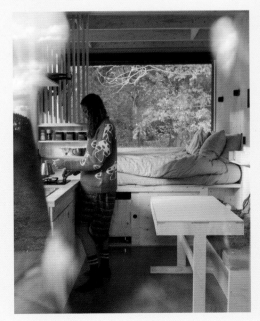

Space to relax

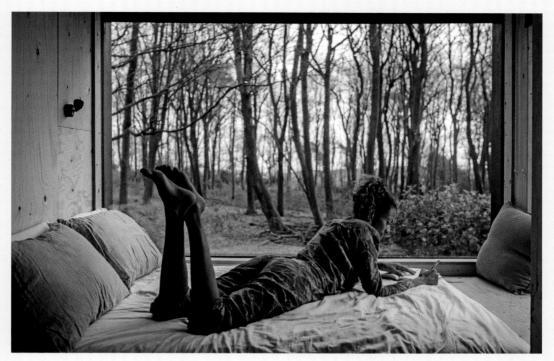

Time to journal

Cabin with a view

595 Reflect on the past year and manifest your dreams for the next

Get the new year off to a positive start by brushing off the stress and negativity of the past at the Centre for Alternative Technology. Embed yourself in a zero-hassle, immersive wellness retreat to slow down and reconnect. You'll tread paths on mindful nature walks and join daily yoga classes.

596 Go on a mindful walking weekend

Learn to let go of the distractions of everyday life on a mindful walking weekend with Adventure Tours UK. You'll learn how to use your senses to reconnect with yourself and nature. Lie on the grass in ancient woodland to focus on your breathing, examine the details in the moss, soil, and trees, and think about your impact on the environment by collecting any trash you see on the trails.

597 Join a meditation and hiking retreat for men

Described as a pilgrimage and a rite of passage, Menspedition is a journey of self-discovery built around nature, walking, and learning how to express emotions. You'll stay at an eco-retreat and bond with your fellow participants as you hike through the Snowdonian mountains, take part in meditations, and spend evenings around the fireside. It's a chance to discuss what it means to be masculine, the expectations placed on men, and how to change the picture.

598 Attend a nourishing wellness center

When that high-pressure modern lifestyle gets all a bit too much, head for the Dreaming, a countryside healing retreat set in the spectacular Elan Valley, owned by singer-songwriter Charlotte Church. Each retreat is different, offering guests activities such as stargazing, sound therapy, nighttime forest bathing, and joyful silent discos, but you could also choose to spend your days curled up comfortably in beautiful surroundings. And with a sliding price scale and pay-what-you-can places, it's something that everyone has the chance to experience.

597 Hiking in Snowdonia

598 Forest discovery

600 Fairy pool

599 Experience blue wellness by the waters of Loch Lomond

Understand the meaning of blue wellness in the tranquil setting of Loch Lomond. Spending time in close proximity to a body of water is positively related to health and, according to experts, induces a positive mood and reduces stress. And just meters away from the loch lies Cameron House, which offers restorative retreats that continue the blue theme including guided walks, cruises, and wild swimming.

600 Contemplate among magical fairy pools on the Isle of Skye

Hike or stroll to a place that will make you pause to breathe in the beauty and the light and magic of a natural phenomenon. The crystal-clear, blue and green fairy pools on the Isle of Skye have transfixed visitors for centuries. These rock pools of translucent mountain spring water, fed by a series of waterfalls, are perfect for wild swimmers tough enough to brave the icy water or for those who simply live in the moment.

602 Tune into the simple life on a car-free island

Spend time on Eilean Shona and it's easy to see why it inspired J. M. Barrie's *Peter Pan*. A car-free island off the west coast of Scotland, it's got the scenery you'd expect to find in a fantasy tale. Go for long walks, swim in the sea, and eat by candlelight—you'll see that the simple life can be a balm for the soul.

603 Swim in the shadow of oil rigs

On a calm day, the waters of the Cromarty Firth are flat, glassy, and inviting—the perfect setting for a mood-boosting swim. But while you might spot a seal or a dolphin, the real charm comes from the oil rigs that sit in this natural harbor, brought here for refurbishment or storage. Swim after dark as their lights reflect in the water and drink in their strange appeal.

604 Revive your spirit at a monastery retreat

You can sample the peace and solitude of monastic life at Pluscarden Abbey, an imposing building surrounded by the forest and moors of Blackburn Glen. On a retreat here, the days revolve around prayer, reading, and physical work. You'll spend much of your time in silence, learning to slow down, be patient, and appreciate the small things in life.

605 Visit the Centre for World Peace and Health

Hectic, modern life will fade away when you arrive at Holy Isle, a peaceful island off the southwest coast of Arran that's owned by the Samye Ling Tibetan Buddhist Community. Just 1.8 mi. (3 km) long, it's home to a monastery and the Centre for World Peace and Health—a secluded, spiritual retreat offering mindfulness, yoga, and meditation programs.

601 Recharge in nature on the Ardnish Peninsula

Accessible only by boat, with no electricity and next to no cell phone signal, Laggan Cottage on the Ardnish Peninsula gets you back to basics in a beautiful patch of Highland wilderness. The lack of neighbors, sound, and light pollution means you can focus on enjoying the surroundings in peace. Explore and you'll spot seals, red deer, and sea eagles.

SCOTLAND

606 Go on a well-being wander with a life coach in tow

Walking and well-being are a perfect match. Go on a wander with Wild Roots Highland Guiding and a life coach will join you to help you make the most of your environment. Walks last between five and eight hours, and you'll be taught to appreciate the natural beauty, history, and geology of the area, and learn some mindful exercises along the way.

SCOTLAND

607 Heal body and mind at a school of wild wellness and bushcraft

The private Glen Dye estate sits among 15,000 ac (6,000 ha) of wild forest and moorland, surveyed by the giant granite tor of Clachnaben. Time spent in the estate's simple cabins and cottages is restorative enough, but sign up for a class at the Glen Dye School of Wild Wellness and Bushcraft and you'll take the experience to another level. Options include cold water therapy, guided foraging, and for hardy souls, "twenty-four hours in the wild," during which you'll spend a night in the wilderness.

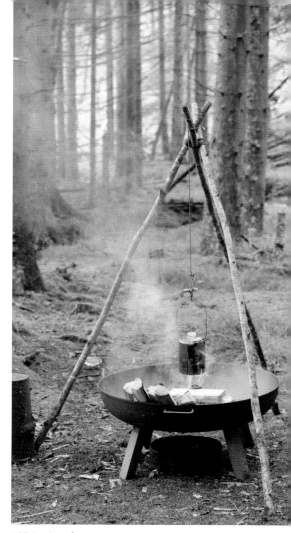

607 Bushcraft

NORTHERN IRELAND

608 Sample medically oriented therapies and a linear vitality pool

A partnership between the Culloden Estate and Spa and the Holywood Private Clinic has created a purpose-built medical facility that offers treatments ranging from chronic pain management to a menopause clinic. In contrast, the spa centers on relaxation, with rejuvenating therapies and a vitality pool, which looks out over the tranquil gardens and the hills overlooking the coastline.

NORTHERN IRELAND

609 Choose a mindful, restorative, or detox retreat

Let go of distraction and negative chatter to embrace mindfulness. Choose from a range of focused retreats in the peaceful lakeside setting with Lake Isle Retreats. Find spirituality on a women's relax and restore retreat featuring chants and a visit to the temple on Inis Rath, understand why silence is golden on a silent retreat, or nourish mind and soul on a detox retreat.

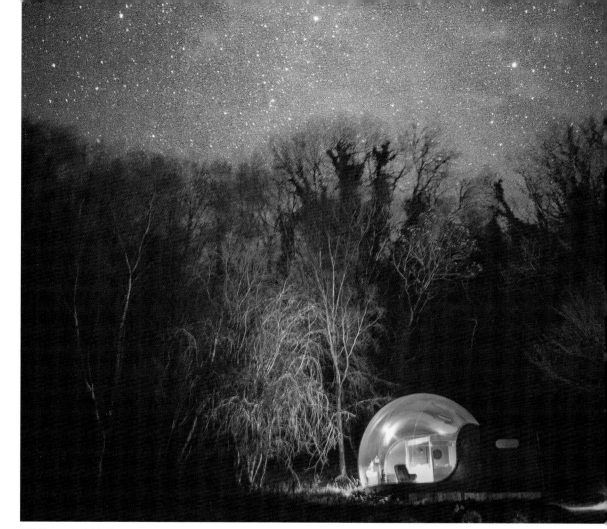

610 Forest Bubble Domes

610 Spend the night in a transparent forest dome

Tucked away in a private forest on the grounds of the Finn Lough resort are a handful of Forest Bubble Domes—luxury pods with 180-degree transparent walls, designed to bring the outside in. Fall asleep to the blaze of the night sky and be woken up by the light of a new dawn. And if the weather turns, lie in bed and listen to the rain crashing around you—it's a wonderful way to feel connected to nature even when you're wrapped up warm in bed.

611 Find serenity along the Glenbarrow Waterfall Loop

A riverside trail taking in a three-tiered waterfall, fairy-tale glens, and swathes of natural woodland, the Glenbarrow Waterfall Loop is the ideal place for a mindful countryside walk. Take in the scent of heather and bluebells, wander slowly through the cool, dark woods, and focus on the waterfall itself, listening to the roar of the water and feeling the spray on your skin.

IRELAND

612 Bathe in a tub full of seaweed

People have extolled the well-being properties of seaweed for decades, particularly when combined with hot salt water. It could help reduce inflammation, soothe your muscles, and leave your skin soft and glowing. Try Sneem Seaweed Baths in County Kerry, where you steep in wooden barrels overlooking the mountains. Or go for Voya Seaweed Baths in County Sligo, where cast-iron baths are filled with hot seawater and seaweed.

IRELAND

613 Join thousands of pilgrims at Croagh Patrick

Steeped in history, religion, and mythology, Croagh Patrick was a pagan pilgrimage route as far back as 3000 BC, and it's where Saint Patrick is said to have fasted for forty days before banishing all the snakes from Ireland. On the last Sunday of July, around twenty-five thousand pilgrims climb the peak in honor of Ireland's patron saint. Join them to reflect on your own life and faith, and to feel the power of shared experience as you tackle the summit.

IRELAND

614 Seek spiritual renewal in the mountains

High up in the Wicklow Mountains, Glendalough Hermitage Centre is an ancient site of pilgrimage and a Christian refuge. Nestled on the grounds of St. Kevin's Parish Church in the village of Laragh, it welcomes visitors of every faith who are on their own personal or spiritual journey. There's plenty of time for quiet contemplation, walks in the hills and valleys, and sessions in the prayer room and meditation garden.

615 Take a dip in Killary Fjord

If bathing in the chilly waters of Killray Fjord doesn't improve your mood, then the view surely will. Forming a natural border between Counties Mayo and Galway and surrounded by Connemara's dramatic mountains, it's one of the most spectacular places to swim. To push the health benefits to the max, sign up for the Great Fjord Swim, which includes three races of 2,460 ft. (750 m), 1.25 mi. (2 km), and 2.5 mi. (3.9 km).

615 Killary Fjord

616 Let go of negativity at an island yoga retreat

Off the west coast of Ireland sits Clare Island, home to mountains, megalithic ruins, bird colonies, and Macalla Farm, a yoga retreat and regenerative farm. Come for a sati yoga retreat and you'll learn to use meditation, breathwork, and asana practice to cultivate mindfulness and let go of negativity. You can also volunteer to help out at the farm.

617 Book a sauna session on the shores of Lough Ennell

Hidden in a forest on the shores of Lough Ennell is a wood-fired Finnish sauna. Run by the Sauna Society, it's perfect for a quick well-being boost if you're high on stress but low on time. Relax in the steamy sauna while taking in the views of the lake, then refresh with a dip in the lake or plunge pool.

618 Join a spiritual retreat at a monastery with an outdoor labyrinth

Labyrinths are a meditative tool that date back thousands of years. From above, the corridors create a stunning visual, but the true journey is the walk inward to build awareness. Enter the labyrinth at Manresa Jesuit Centre of Spirituality to let go of what's holding you back and exit with new insights.

4

AFRICA AND THE MIDDLE EAST

619 Experience age-old tradition at a hammam in Morocco

Once a place to socialize, today the hammam is revered as a health treatment, as its hot, steamy environment triggers the body to produce new cells, heal damaged ones, and detoxify the body. Rooted in ancient traditions, it dates back to the fifteenth century, but modern-day visitors can still experience this Moroccan tradition. Although the experience varies, the three-stage process involves a steam room and exfoliation, followed by a cold immersion.

619 Hammam

MOROCCO

620 Find calm and creativity

Royal Mansour hotel is known for its sumptuous spa, but you don't need to opt for a massage to boost your well-being—the resort's *atelier d'artiste* offers arts and crafts sessions as a stress-busting alternative. Sign up for everything from painting to beading to patisserie classes to help you slow down, remain present, and find peace of mind through creativity.

MOROCCO

621 Unwind in a traditional mud chamber

Rhassoul, a clay found in the Atlas Mountains that's rich in minerals, is used in spa treatments throughout Morocco. At Les Bains de Marrakech it's mixed with aromatics such as cloves and rose water, then slathered over your body before you sit in a steamy chamber. A shower followed by a rubdown with a rich oil leaves you with clean, supersoft skin.

MOROCCO

622 Go on a wellness tour across Morocco

A wellness tour of Morocco with Responsible Travel takes you to Marrakech, the Sahara desert, and the Atlas Mountains, with daily well-being activities to help you make the most of your journey. Yoga and meditation sessions and activities aimed at cultural connection, including a visit to a traditional Berber textile women's cooperative, will keep you feeling centered.

620 Art class

623 Kasbah du Toubkal

MOROCCO

623 Find peace, quiet, and dramatic views at a mountainside retreat

A secluded, sustainable resort cradled by the breathtaking Atlas Mountains, Kasbah du Toubkal is a place to escape, hide out, and soak up Morocco's natural beauty and culture. Use it as a base for mountain treks, spend time in the local Berber village, or just stay put, use the hammam and drink mint tea on the rooftop terrace, taking in one of the best views you'll ever see.

MOROCCO

624 Learn to cook traditional Moroccan food on a farm

The ingredients for a meal, and how they will benefit your health, come first at Farm to Table Marrakech. Join a cooking class at this family-owned farm and you'll start by shopping at the souk, then discover how to use traditional Moroccan spices to create a meal with a local chef. Finally, it's time to enjoy the food you have cooked with your fellow chefs.

MOROCCO

625 Hide out in luxury between the mountains and the desert

An hour's drive from Marrakech you'll find yourself in a magical kasbah, set in the foothills of the Atlas Mountains. Stays at Kasbah Tamadot are all about relaxation and the romantic atmosphere, courtesy of walled courtyards and candlelit roof terraces, as well as the spa. For maximum indulgence, book a Berber tent, where you'll have a private hot tub with a view.

638 Float in salt pools at Siwa Oasis

A small community near the Libyan border, Siwa Oasis is surrounded by limestone mountains and is home to hundreds of salt pools, whose striking blue and white colors stand out against the barren desert. Their high salt concentration allows you to float effortlessly above the surface and is said to provide relief for sinus and skin conditions.

638 Siwa Oasis

639 Simien Mountains

640 Lalibela

ETHIOPIA

639 Feel on top of the world with a night at the highest lodge in Africa

Just inside the entrance to Simien Mountains National Park is a collection of round thatch-roofed *tukels* that make up Simien Lodge, Africa's highest hotel at 10,700 ft. (3,300m). Get an energizing dose of fresh air and endorphins as you tackle the local trails, then relax in the hotel bar, where you can take in the sunsets in the company of geladas and thick-billed ravens.

ETHIOPIA

640 Embrace the spiritual pull of the rock-hewn churches of Lalibela

No matter what you've read or seen, nothing can prepare you for the impact of seeing Lalibela's rock-hewn churches in person. Buried deep in the highlands of northern Ethiopia, these monuments to Christianity were carved from a single rock in the twelfth and thirteenth centuries and remain a place of pilgrimage. It's impossible not to be moved by the atmosphere in this most spiritual of places.

ETHIOPIA

641 Experience the joy of Orthodox Christian Christmas celebrations

White-robed worshippers flock to Lalibela to celebrate Genna (Ethiopian Christmas). At the stroke of midnight on January 6, there's a candlelight ceremony to commemorate the birth of Jesus Christ, followed by singing, dancing, ululating, and drumming throughout the night, led by priests. It's a joyful, soul-stirring experience as well as a chance to connect with local culture in a meaningful way.

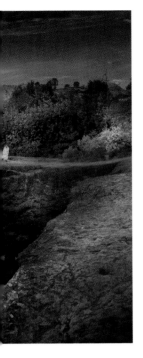
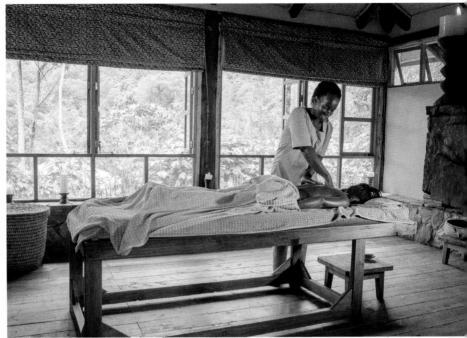

643 Bwindi Lodge massage

ETHIOPIA

642 Take a vegan food tour

Veganism has been part of Ethiopian life for centuries, linked to the Orthodox church and the wide observance of vegan fasting days. Join a food-focused tour with Ethiopian Trips and you'll tour markets, eat in local cafés and restaurants, and learn about a diverse, delicious, and healthy cuisine that includes spicy stews, pulses, and ever-present injera (sour, fermented flatbread). Highlights will include eating in local homes in Lalibela, joining a cooking class in Addis Ababa, and taking part in a traditional coffee ceremony.

UGANDA

643 Soak up dramatic views of primeval forest

Enveloped by the primeval Bwindi Impenetrable Forest, Bwindi Lodge is a wonderful place to escape the daily grind and recharge in nature, right from the comfort of your own banda (hut). Sit on your private deck and you can gaze across the forest canopy spotting birds and monkeys. Should you wish to venture out, unforgettable encounters with gorillas and chimpanzees await.

KENYA

644 Sleep alfresco at Loisaba Star Beds

Sleeping in the open air can calm your mind, reset your circadian rhythm, and boost your mood, especially if you do so at Elewana Loisaba Star Beds. A clutch of raised wooden platforms overlooking the Laikipia Plateau, they feature four-poster beds positioned to make the most of the views. Add the stars, some romantic lantern light, and the soothing sounds of the bush and you're in for a magical stay.

KENYA

645 Wellness and Swahili culture at a yoga festival

People from across Kenya and beyond flood into Lamu each October for the Lamu Yoga Festival, which offers breathing, meditation, and yoga workshops of all kinds, from the tranquil depths of Yin yoga to the invigorating flow of vinyasa. Classes are spread throughout the island, and there's plenty of chance to sample Swahili food and enjoy traditional music, dance, and drumming showcases.

644 Loisaba Star Beds

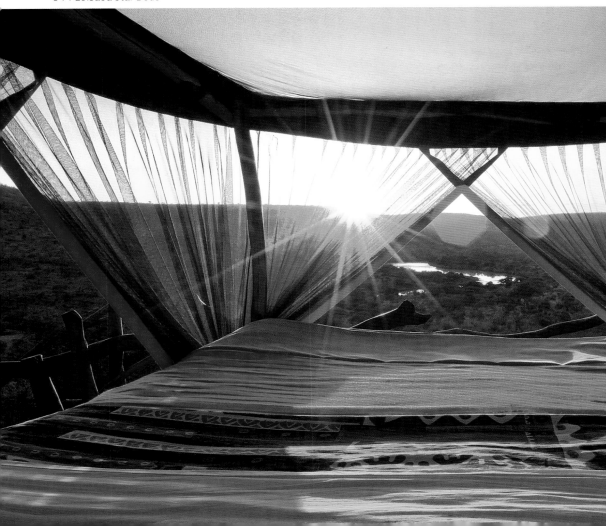

646 Wildlife watching and spa treatments

It's not surprising that the Amani Spa at Bushtops Camp is an award winner. Its massages and holistic treatments include luxury products made from native Kenyan plants, and it comes with a showstopping view. Both the open-air treatment rooms and the solar-heated infinity pool look out over the Maasai Mara hills and the reserve's natural salt lick, where game comes to graze and drink.

647 Find balance and peace at a retreat

Soothe your soul in a sanctuary with the Chyulu Hills as the backdrop at Finch Hattons. From couples getaways to luxury safaris to wellness retreats, its immersive wildlife experiences have something for everyone. The wellness retreat encompasses hikes to get the blood pumping, yoga classes to boost the mind-body connection, and signature spa treatments that incorporate age-old traditions and Indigenous ingredients.

648 Learn and connect with endangered wildlife

Luxury and wellness go hand in hand at Ol Jogi Wildlife Conservancy. Start the day with a contemplative walk through a tunnel that leads to a vantage point at a watering hole, then keep your voice low so you can hear the black rhinos or giraffe sipping some water. Later, unwind in a secluded cottage, then end the day with a complementary massage to alleviate muscle tension.

649 Yoga practice above a forest canopy

A whimsical tree house hotel rising above a forest canopy, Watamu Treehouse is an enchanting place to stay with a strong well-being focus. Yoga classes and retreats take place in a light-filled room on the top floor, which has 360-degree views over the coastline. If you'd rather be closer to the ground, classes also take place on the beach or on paddleboards on the ocean.

650 GIBB'S FARM

Garden walk

Coffee massage

Art class

Relaxing massage

Farm animals

650 Embrace slow living on a heavenly farm

Set on the forested outer slopes of the Ngorongoro Crater, Gibb's Farm is a place to slow down, de-stress, and experience the rhythms of local community life. Walk through the organic gardens, help with collecting the eggs and caring for the piglets, or join a morning art or baking class. If spas are more your style, you can have treatments using local Olkaria clay or freshly roasted arabica beans from the farm's coffee plantation.

651 Enhance your well-being through human connection

If you want authentic insight into a different way of being, arrange a stay at Original Maasai Lodge, owned by NGO Africa Amini Life and built and run by Maasai women. You'll stay in traditional mud and grass huts and spend time learning about the culture, land, and local life—for example, by taking a craft workshop, visiting a Maasai church, and going on guided walks in the surrounding countryside.

652 Heal through creativity at Zuri Zanzibar

A five-day well-being retreat at Zuri Zanzibar isn't just about perfecting your yoga poses. In between morning and afternoon yoga classes, there's a program of creative activities aimed at helping you achieve well-being through learning new skills. Classes on offer include everything from art therapy to mindful cooking and eating, to dance medicine.

652 Zuri Zanzibar

TANZANIA

653 Sleep beachside in a baobab tree

If you draw strength from being close to nature, you'll love Chole Mjini Lodge. Rustic, wild, and surrounded by tropical beauty, it merges seamlessly with the bush, mangroves, and medieval Swahili ruins on Chole Island. Its pièces de résistance are the tree houses, which sit on platforms built around the trunks of baobab trees. There are no walls between you and nature, so you're free to gaze out at forest and ocean and wake up to waves and birdsong.

TANZANIA

654 Feel the buzz of achievement as you tackle Africa's highest peak

Climbing Mount Kilimanjaro is no simple undertaking, and you'll have to train for three to four months to get your fitness, strength, and endurance up to snuff. Once you do, there are seven routes to choose from, which take anything between five and nine days to complete, with nights spent in basic campsites and scenery ranging from forests to moors to mountainous desert. It might be tough, but the sense of achievement knowing you've reached the highest point on the African continent will leave you on a high for days. What's more, if you make it to the summit at sunrise, you can see the curvature of the Earth—a beautiful, mind-bending experience.

654 Mount Kilimanjaro

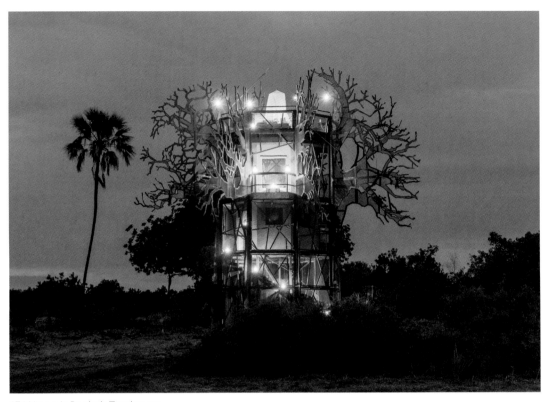

674 Xigera's Baobab Treehouse

674 Take in views of the Okavango Delta from a chic spa therapy pod

A sustainable safari lodge in the untamed Moremi Game Reserve, Xigera is home to a spa and wellness center, from which you can enjoy the restorative powers of the natural world. Its chic spa therapy pods can be opened to the elements, so you can lie back and enjoy a massage while catching all the drama from the floodplains.

675 Lie in an outdoor tub by lantern light

You can bathe by lantern light at Sanctuary Baines' Camp, a tiny lodge set above the Boro River. Each of its six suites comes with a "star bath" set on a private deck, so you can immerse yourself in the sounds and sights of nature while you soak. Wheel your bed onto the deck for a night in the open.

SOUTH AFRICA
676 Forge a connection with the land on a wilderness skills course

You'll learn how to survive in the wild and develop a deep connection with the land in EcoTraining's Wilderness Trails Skills Course in Kruger National Park. It's led by highly experienced wildlife guides, who'll teach you about bushlore and wilderness philosophy, as well as skills such as water purification, navigation, and how to keep your impact low.

SOUTH AFRICA
677 Express emotions through art

Set in a tiny beach town along South Africa's Garden Route, Stilbaai Art Retreat is a restorative hideaway designed to stimulate your senses through unconventional art techniques. During its joyful week-long program, you'll create art, sculpture, and jewelry using different materials and textures, drawing inspiration from the colors, sounds, and sights of the ocean. There's also plenty of time to dance, make music, and bond with your fellow artists.

SOUTH AFRICA
678 Find tranquility at the Buddhist retreat

KwaZulu-Natal's Buddhist Retreat Centre is celebrated for its strong environmentally friendly approach—so much so that former president Nelson Mandela awarded it national heritage status. Scheduled retreats cover everything from meditation to Vipassana to Japanese brush painting, or there's always the option of finding solitude on a "self-retreat" and exploring the 300 ac (121 ha) of rolling hills, parkland, and forest.

676 Wilderness course

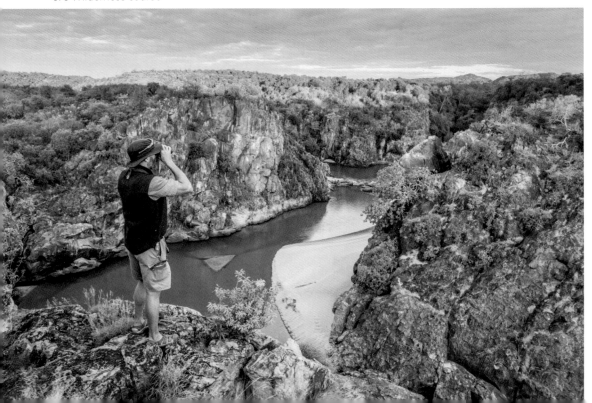

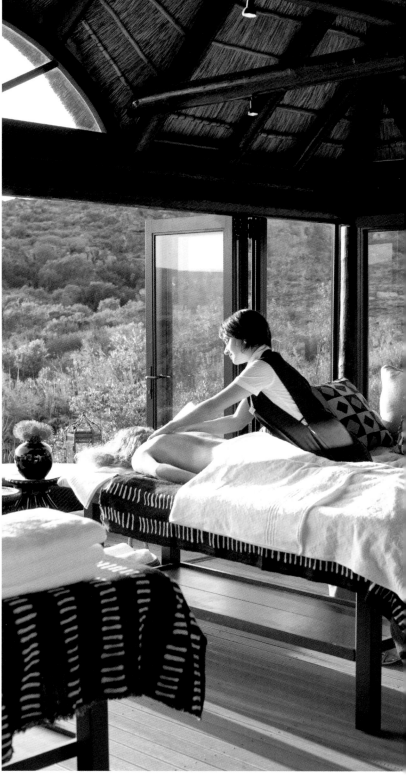

679 Wellness in the wilderness

Bushmans Kloof Wilderness Reserve prioritizes well-being through nature in the awe-inspiring landscape of the Cederberg mountains, which includes rock art sites dating back ten thousand years. Go on mindful walks through the wilderness, marvel at a bloom of color during wildflower season, visit the herb garden to learn about botanical remedies, or head for its spa, which opens onto the bush and uses natural products made from native plant extracts.

SOUTH AFRICA

680 Join a healing family arts retreat in the Karoo

You can spend quality time with your family in a peaceful wilderness far from sound, light, and air pollution at the Rest, a farm and retreat cradled by the Sneeuberg mountains. Family retreats focus on reestablishing bonds and strengthening relationships through group games, nature walks, fireside tales, and arts therapy, or simply spending time together without any digital distractions.

679 Spa treatment

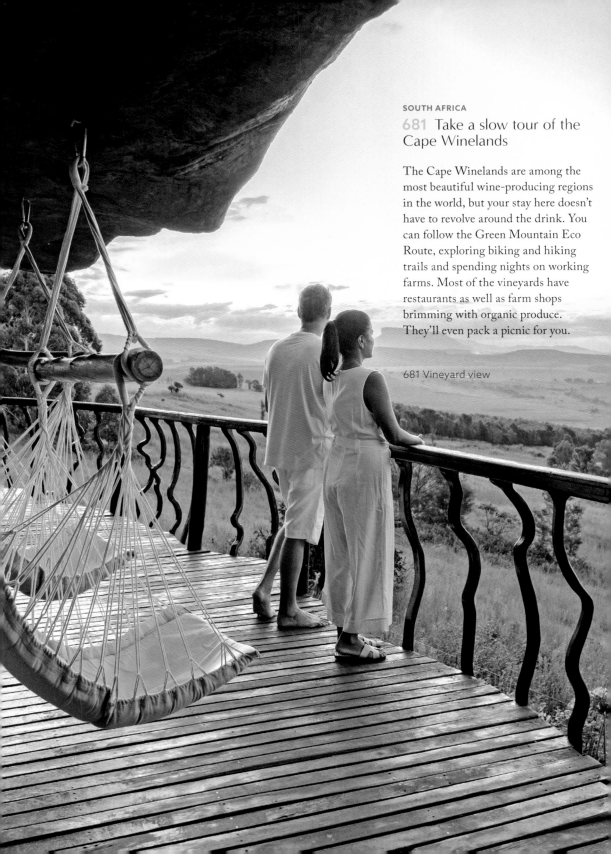

681 Take a slow tour of the Cape Winelands

The Cape Winelands are among the most beautiful wine-producing regions in the world, but your stay here doesn't have to revolve around the drink. You can follow the Green Mountain Eco Route, exploring biking and hiking trails and spending nights on working farms. Most of the vineyards have restaurants as well as farm shops brimming with organic produce. They'll even pack a picnic for you.

681 Vineyard view

682 Book a massage for your little people

Children can get in on the wellness action at Madikwe Safari Lodge, a stunning retreat set in malaria-free North West Province. Its thirty-minute Cubs Massage uses natural, fragrant oils such as hemp and evening primrose to soothe and nourish skin and muscles and promote feelings of relaxation—ideal to help the kids relax and sleep deeply after a busy day out in the wild.

683 Try out treatments using local ingredients

Surrounded by bushveld gardens in Sandton's Indaba Hotel, Mowana Spa is a serene sanctuary away from the big city noise. Signature treatments make use of baobab kernels, which produce a rich, golden oil with intense moisturizing properties that was traditionally used to protect the skin from the sun.

684 Learn what's best for your body

We all know that exercise is good for us, but are you doing the right exercise for your body type? Sign up for a private assessment with a certified biokineticist (clinical exercise specialist) at Newmark Hotel and they'll evaluate your body's movement and suggest exercises suitable for you and your lifestyle. Understanding how your own body works could be the tool you need to jump-start your health and fitness.

685 Get a body and mind overhaul

A retreat in the heart of South African wine country, the Hydro is a one-stop well-being shop that goes well beyond the standard massages, wraps, and cleansing treatments. Try movement therapies such as tai chi and aquacise, practice mindfulness in its maze or on daily guided walks, or choose from treatments including reflexology, craniosacral therapy, and shiatsu.

686 Take a deep level detox

"Clear your body to clear your mind" is the mantra of the detox and yoga retreat at Guinevere Guest Farm, which is set among mountains and nature in the Western Cape. During the fast, organized by Cape Town Retreats, guests drink fresh fruit juices and almond milk. The retreat is designed to clear the body of toxins and lead to clarity of mind, while daily walks, yoga, and Pilates build your strength.

687 Optimize health with high-tech holistic healing

Health is a balance of many things, from what we eat to how we live, and our genetics. The health optimizing concept at the Santé Wellness Retreat and Spa in Franschhoek gives you a thorough assessment using state-of-the-art equipment to identify and locate the causes of ill health. It then targets them using lifestyle coaching and by stimulating the body's self-regulating mechanisms.

NAMIBIA

688 Track elephants with like-minded women

An all-female expedition across the Namibian wilderness could be just the journey of self-discovery you're looking for. Sign up with the Matriarch Adventure and you'll spend ten days tracking desert elephants alongside a small group of women from around the world. Nights under the stars, sunrise yoga, and plenty of campfires sweeten the deal, and cell phones are not allowed so you can focus on connecting with yourself, the wilderness, and one another.

688 Matriarch Adventure

NAMIBIA

689 Wind down in nurturing silence on the Skeleton Coast

The remote Skeleton Coast is the kind of place that ignites a sense of childlike wonder in even the most blasé of travelers thanks to its dunes, shipwrecks, seal colonies, and desert-adapted wildlife including elephants and lions. Stay at Hoanib Camp—a handful of low-impact tented rooms that blend beautifully into their wild surroundings—and you'll feel the restorative power of this quiet, isolated landscape to your very core.

NAMIBIA

690 Tackle a hiking trail through the world's second-largest canyon

The multiday hiking trail through Fish River Canyon delivers some of Namibia's most alluring landscapes—and 1.5 billion years of geological history. Stretching 53 mi. (86 km), it takes seven days to complete, but the payoff is worth it. You'll walk along arid plateaus, weave past giant boulders, swim in sulfur pools, and spot antelope, hyrax, and even rare Hartmann's mountain zebras.

691 Wolwedans Dune Camp

691 Feel at one with nature at a sustainable desert camp

Lo-fi, low-impact, and surrounded by mile upon mile of desert, Wolwedans Dune Camp makes communing with nature simple. Watch the sunset from the decks, have a silent nature walk or yoga session, and open your eyes to a new world courtesy of Bushmen guides. The afterglow of this kind of trip will last much longer than your standard beach vacation.

692 Wonder at Southern Africa's brightest skies

You don't need a telescope to be wowed by the night sky in NamibRand Nature Reserve. This is one of the naturally darkest and quietest places on Earth, where the stars shine above dunes and mountains. As well as providing a beautiful show, it allows you to contemplate the vastness of the sky to help slow your mind and offer a sense of perspective about problems down here on Earth.

693 Watch the wildlife gather at night

Among the best places to see wildlife at night in the Etosha National Park is the dimly lit Okaukuejo Rest Camp. At the waterhole, zebras and antelopes still move about, giraffes take turns to drink and mount guard, before the elephants move out of the shadows, looking after their young. You may even spot a rhino. Commune with nature and reassess your life balance during this holistic experience.

ZAMBIA

694 Explore the prehistoric landscapes of Mutinondo Wilderness

Wander the granite whaleback hills and grasses of Mutinondo Wilderness and it's almost as if you've gone back to another era—one where you're free to wander the wild bushland without restrictions or a guide. The chance to swim in rivers, hike to waterfalls, and pick mushrooms in the forests without coming across another soul is a liberating and invigorating experience.

ZAMBIA

695 Take in the sights and sounds on a mindful boat trip

Traversing the Zambezi River is a wonderful way to get up close to Zambia's wildlife, especially if you do so by canoe. Your low-profile vessel will allow you to paddle close to wildlife in a minimal, low-impact way, and there's no engine noise to get in the way of the sounds of the wild. It's the perfect remedy for a frazzled, overloaded brain.

ZAMBIA

696 Embrace slow travel and see wildlife on foot

Getting off the beaten track and far away from the crowds can improve your physical and mental well-being, and there are few better places to do so than the Zambian wilderness. A walking safari is an immersive experience—breathe fresh air, explore wide, open spaces, and step in time with nature.

696 Wilderness walk

ZAMBIA
697 Visit the Bush-Spa

Wildlife viewing and pampering treatments go hand in hand at the Bush-Spa in South Luangwa National Park, which has open-air treatment rooms overlooking a wildlife-rich lagoon. Book a massage, a body wrap, or a soak in a wellness tub built into a wooden deck. Whatever you choose, listening to birdsong and the grunt of hippos as you decompress is an experience you won't forget in a hurry.

ANGOLA
698 Indulge in modern holistic treatments at a chic city spa

You can travel the globe at Sayanna Spa, a holistic sanctuary tucked away in Epic Sana Luanda Hotel. In addition to saunas, hydrotherapy sessions, and steam baths, its "around the world" treatments take you from Brazil to Polynesia to France, making use of traditional techniques and products.

NIGERIA
699 Support Nigerian beauty brands at a female-owned spa

There's nothing but organically grown botanical ingredients in ORÍKÌ's spa's lotions and potions. This female-owned, fast-growing wellness chain has three branches in Lagos and specializes in all-natural farm-to-skin products. Try them in a facial, body massage, or sea stone therapy. Then bag some products from the store to take home.

NIGERIA
700 Soothe aches and pains with a tailored wellness package for mothers

Find support on your motherhood journey at Bioviva, a holistic spa in Lagos. Soothing massages help you relieve the emotional and physical stresses of pregnancy, while postnatal treatments aim to reduce strain on the abdomen, lower back, and hips, as well as encourage better sleep.

697 Bush-Spa

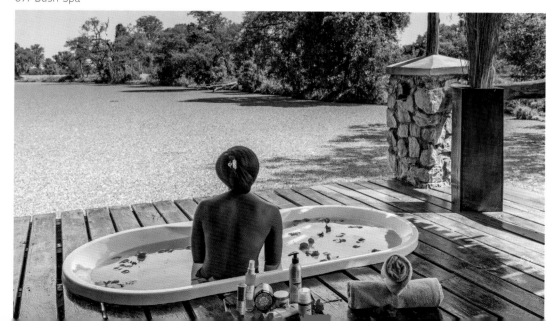

GHANA

701 Feel the therapeutic power of music at a drumming and singing workshop

The KASAPA Centre—a lodge and cultural exchange program on Ghana's west coast—is an excellent place to experience the joy and togetherness of communal music-making and movement. Its regular workshops focus on Ghanaian dance, drumming, xylophone, and singing and are led by experienced professionals.

GHANA

702 Slather yourself in nourishing shea butter

Extracted from the nut of the West African shea tree, organic, raw shea butter is known for its moisturizing properties and can help heal cuts and scrapes as well as soothe eczema. Local companies such as Celmar Travel and Tours take visitors to learn about its uses, see how it's harvested and processed, and buy products at the source.

GHANA

703 Feed your soul on an immersive cooking retreat

Drink in the warmth and colors of Ghana—the country, the people, and the food—on an Africana Retreat and Cooking Holiday. Join the renowned chef Lerato and prepare a sumptuous feast from fresh, local ingredients. The immersive nature and friendly atmosphere will feed your soul and body.

SIERRA LEONE

704 Feel the curative effect of nature on a rainforest island

Set in a dense rainforest, Tiwai Island is a wildlife sanctuary, research lodge, and traveler's haven, where you can slow down, unwind, and immerse yourself in a world that's home to chimpanzees, monkeys, and pygmy hippos. It's managed by the Environmental Foundation for Africa, and guides are drawn from local communities.

705 Saloum Delta National Park

GAMBIA/SENEGAL

705 Take in the beauty of Gambia and Senegal on a peaceful river cruise

You won't find any megaships in Gambia. Try a river cruise holiday organized by Explore Worldwide and you'll move at a gentle pace, absorbing the sounds of nature and passing through Gambia's and Senegal's most beautiful landscapes including bird sanctuaries, hippo country, and the oyster shell islands of Saloum Delta National Park.

706 Make music and new friends at a creative oceanside retreat

Dancing, kora playing, yoga, and communal singing are all part of the experience at an upbeat and restorative week-long retreat in Casamance, on the Senegalese coast. Jaliya Camp's intention is to create a second home where guests from all over the world come together to create, exchange ideas, and form bonds, accompanied by the sounds of the ocean.

707 Indulge in healing water therapies at an exclusive spa hotel

There's plenty of top-end spa action to be had at the Rhino Resort, one of Senegal's most exclusive hotels. But its forte is the balneotherapy area, where you can wash away your troubles with the help of water jets, whirlpool baths, a huge reproduction of a waterfall, and a balneotherapy basin, where the water remains around 86°F (30°C).

CAPE VERDE

708 Swim and soak in the medicinal salt water of the salt pans

Wind down with a natural spa treatment in the lagoon of Pedra de Lume, a surreal, lunar-like crater formed by an ancient volcano and surrounded by pink-hued salt beds. You can float in the medicinal salt water, said to soothe skin complaints and improve blood circulation, or have a massage, salt scrub, or mud treatment at the small on-site spa.

ISRAEL

709 Unplug in the biggest oasis in Israel

Found hidden in the Judaean Desert is a breathtaking oasis replete with natural wonders including verdant greenery, waterfalls, and views of the Dead Sea. Once upon a time, Ein Gedi Nature Reserve served as King David's refuge. Nowadays it welcomes visitors to unplug and create their own sanctuary by hiking the Arugot trail or pausing for a moment of reflection in Dudim Cave.

ISRAEL

710 Experience Holy Week

Jerusalem is the heartbeat of the world's three biggest religions: Christianity, Islam, and Judaism. This unique combination creates the city's powerful connective energy, which peaks once a year. During Holy Week, a Christian tradition, tourists and locals visit for reenactments of Jesus's crucifixion. Unite with others in the joyous ambience of Palm Sunday or spend time in prayer.

711 Make a pilgrimage to the Western Wall

The energy is electric at the Western Wall, Judaism's holiest prayer site. It has been a place of pilgrimage since Ottoman times, and worshippers come to recite scriptures and touch millennia-old stone. It's divided into sections for men and women, and modest dress is recommended, including a head covering for men. The plaza adjacent to the wall is a popular destination for Bar Mitzvahs, which are usually held on Monday and Thursday mornings, when the area is alive with celebratory processions.

712 Do yoga at sunrise at the top of an ancient desert fortress

Imagine this: it's around 6 a.m. in the Judaean Desert and you're reaching the summit of an ancient archaeological fortress as the sun slowly rises. As you climb this majestic complex, called the Masada—a UNESCO World Heritage Site—you can see the Dead Sea in the distance. Then stretch your hard-worked muscles with a yoga flow as you inhale the crisp desert air.

712 Masada

713 Experience the healing minerals of the Dead Sea

The Dead Sea should be on every wellness addict's bucket list. A shimmering blue lake with a salt concentration ten times that of seawater, it's been drawing visitors for thousands of years. Not only can you bob around like a cork, but the water also contains healing minerals such as bromine, zinc, and magnesium, which soothe aching muscles, beautify your skin, and help reduce inflammatory conditions such as psoriasis, acne, and arthritis.

714 Live the good life at a luxury spa hotel in the Negev desert

There's a sense of calm that comes with being in the desert, and Six Senses Shaharut exploits this to the max. After a drive through the desert you arrive at a chic boutique hotel built from honey-colored stone and perched on a dramatic cliff. Do your laps while gazing at the desertscape, watch sunset at cocktail hour, and spend time in the spa, which includes an alchemy bar where you can create your own mixture of soothing botanicals from local ingredients.

713 Dead Sea

PALESTINE

715 Join crowds of carolers in Bethlehem

Midnight Mass is an emotional and spiritual way to ring in the Christmas vacation, and you can join people from all over the world at the Church of the Nativity in Bethlehem, on the site where Christians believe Jesus was born. The standing-room-only service includes singing and organ music, and large crowds outside the church watch the service on a big screen.

PALESTINE

716 Stay in a pilgrim house in the Holy Land

Franciscan hospitality is on display at pilgrim houses owned by the Custody of the Holy Land, where guests can join a centuries-old tradition of pilgrims lodging at Christian guesthouses—spaces where they're welcome to stay, pray, and meditate. Try Casa Nova house, which dates to 1866 and sits in the old center of Bethlehem.

LEBANON

717 Meditate in the mountains

Take a break from the city and head for Lebanon's verdant mountains, where you can wake up to fresh air and the sound of birdsong. Days can be as busy or as quiet as you choose: join one of its daily guided hikes, blow off some steam at the sauna, or enjoy a rejuvenating scrub and foam massage in Bkerzay's traditional-style hammam, which sits under a skylight dome.

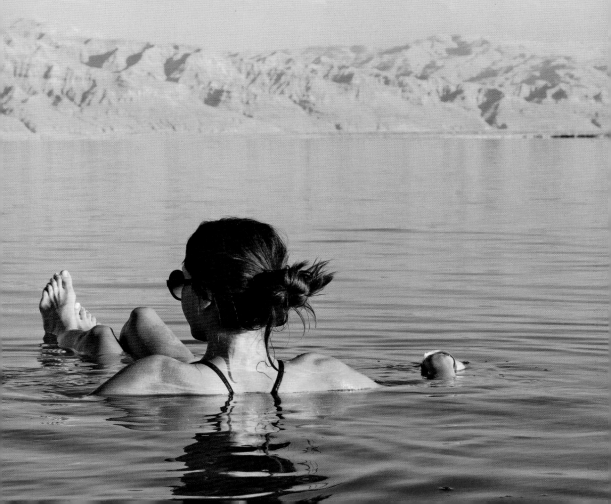

JORDAN

718 Take a desert bath in Wadi Rum

Desert bathing is similar to forest bathing, except it's practiced in, you guessed it, the desert. And what better way to grasp this concept than in the iconic Jordanian desert, Wadi Rum. The name of this UNESCO World Heritage Site means "valley of the moon." Meander through the Mars-like setting and tune into the desert to receive the mood-boosting effects of the landscape.

JORDAN

720 Connect with nature

A hidden site in the lush Jordan Valley showcases the beauty of the area while protecting its ecology. The Jordan EcoPark has a commitment to support the local community and planet through organic food, energy renewal, and ecological buildings. Attend a sustainable workshop where you can learn about ecological gardening and mud wall building, or go hiking to learn plant identification.

JORDAN

719 Eat, hike, and sleep beneath the stars with Bedouins

At a glance, the majestic, rugged beauty of Wadi Rum never ceases to amaze visitors, and they can get to know the desert's enchanting personality by embracing the Bedouin lifestyle. From eating home-cooked meals to traversing the canyons and sand, and sleeping beneath the moonlit sky, desert dwelling is the ideal way to discover this way of life.

JORDAN

721 Sign up for a mind detox program

Your emotional, spiritual, and mental health are a priority at Anayata Hotel's well-being center, set in the seaside city of Aqaba. Its mind detox program is designed to declutter your mind, encourage positive thoughts, and allow you to move forward with strength. You'll experience yoga, meditation, group talking sessions, and breathwork, as well as individual meetings with a well-being consultant.

718 Wadi Rum

722 Dead Sea mud treatment

724 Ma'in Hot Springs

722 Revitalize body and soul at a Dead Sea spa

Jordan's Dead Sea coast is lined with resorts offering restorative treatments using the area's salt and dense, black mud. Try the Mövenpick Resort, which has an enormous spa, or the Kempinski Hotel, whose grounds are fashioned after the Hanging Gardens of Babylon. Most hotels have direct access to the Dead Sea beaches, where you'll find pots of natural mud to cover yourself in.

723 Escape to a desert eco-resort

You'll find desert escapism at its best at Feynan Ecolodge, a community-centered hotel on the edge of the Dana Biosphere Reserve. Spend time drinking in the silence, discovering the hiking trails, and enjoying the company of the Bedouin people who make up the staff. The magic continues after dark, when the lodge is lit almost entirely by candles, and you can head up to the roof to sip mint tea and look up at the stars.

724 Wallow in the waters of Ma'in Hot Springs

A stunning set of hot springs and waterfalls set close to the Dead Sea, much of Ma'in has been cordoned off for guests of a fancy resort built on the premises, but everyone can access the public section for a fee. Several terraced pools are set against the cliffside and are filled by waterfalls and springs. These are some of the warmest waters in Jordan, and they're a natural remedy for joint pain and skin conditions, thanks to their mineral-rich content.

SAUDI ARABIA

725 Sink into traditional healing rituals at a desert spa hotel

Full desert immersion is on the cards at Habitas AlUla, which is surrounded by ancient sandstone cliffs in a box canyon in the Ashar Valley. Go for outdoor experiences such as stargazing or meditation on its outdoor yoga deck, or discover a traditional treatment in the spa. You can also try yoga, discover your inner child at the swing and trampoline art installations, and enjoy locally sourced food in the restaurants.

SAUDI ARABIA

726 Find positive energy at a wellness festival

Find spiritual connectedness at the annual AlUla Wellness Festival, where celebrity yogis and wellness luminaries focus on recreation and relaxation. Channel the rejuvenating power of the oasis with collective dance and inspirational art therapy while you enjoy the backdrop of the mountains and the enveloping stillness of the desert. It's the perfect setting for solitude and self-discovery where nature connects with ancient history.

Yoga

Guest villa

Local ingredients

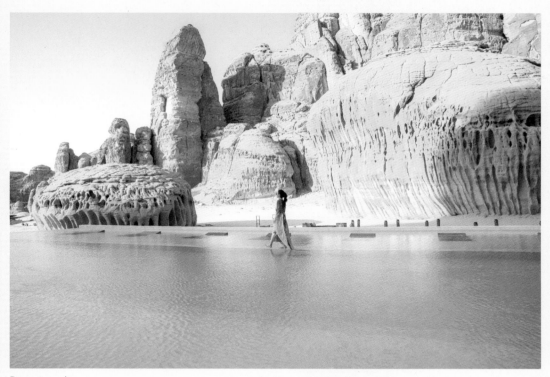

Desert pool

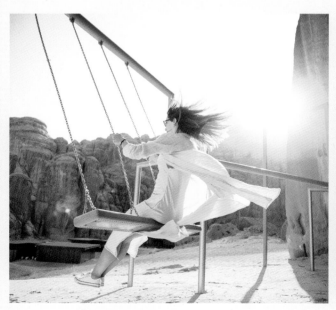

Swing art installation

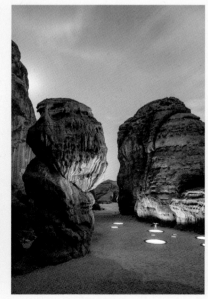

Desert trampolines

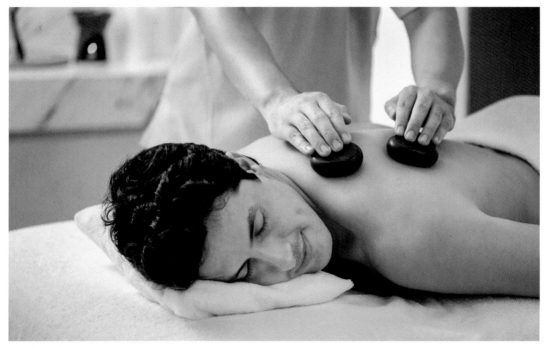

727 Heated stone massage

QATAR

727 Try traditional Qatari therapies

Inspired by traditional medicine, the treatments on offer at Zulal Wellness Resort aim to restore health using the skills of medicinal historians and herbalists. Experience *hijama* (cupping therapy), a body mask of camel milk, which delivers heat to enhance metabolic rate, or a traditional *hamiz*, a deeply relaxing massage using heated stones with *tadleek* oil infused with medicinal herbs.

UNITED ARAB EMIRATES

728 Stay at an oasis for holistic rejuvenation

Overlooking the mangrove reserve in the smallest emirate of the United Arab Emirates, guests seek peace and relaxation at Zoya Health & Wellbeing. The resort uses advanced diagnostic equipment to calculate body composition, posture alignment, and muscle strength to create customized programs to balance, heal, and enhance your health, while the pampering happens in an underground spa.

UNITED ARAB EMIRATES

729 Paint your feelings at a wellness art retreat

Painter Ibrahim Gailani has much to say about the link between art and wellness. He's the brains behind the wellness art retreats at the H Dubai hotel, which are open to everyone from newbies to experienced artists. Meditation, discussion, and visualization sessions help participants get in touch with their emotions, while mindful painting sessions help transfer these emotions onto canvas.

UNITED ARAB EMIRATES
730 Gaze at Dubai's skyscrapers from a spa

You don't have to stare out at greenery or hear birdsong for your spa experience to be rejuvenating, and at Dubai's Longevity Wellness Club, it's the views of the skyline that take center stage. Treatments such as hot stone massages and mud wraps take place in rooms with floor-to-ceiling windows, so you can look out at the skyscrapers and decide which part of the city to conquer next.

UNITED ARAB EMIRATES
731 Work on your mental health at a retreat

Emotional well-being retreats last anywhere between three and fourteen days at Rayya Wellness, which promotes self-care, healing, and fostering resilience through activities including neurolinguistic and sound therapy. Healthy, nutritious meals and smoothies promote healing from within, as do evening rituals designed to help you get the best night's sleep.

UNITED ARAB EMIRATES
732 Revel in an opulent spa

Pure opulence is the selling point of Emirates Palace spa, a marble-laden temple to well-being set in one of Abu Dhabi's most dazzling hotels, the Mandarin Oriental. It is decorated with dim lanterns and bubbling water features, and offers treatments inspired by ancient techniques. Try its aromatherapy based on the five elements: wood, fire, earth, metal, and water.

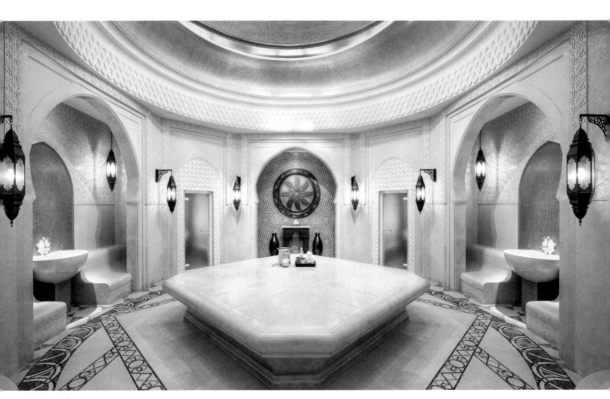

732 Marble spa

OMAN
733 Unwind with an Omani frankincense ritual

Mountainside Anantara Al Jabal Al Akhdar has a plethora of different treatments to help you shake the stress from your shoulders. The Omani frankincense ritual is a balancing and relaxation treatment, designed to soothe muscles and aid sleep. Try it and you'll understand why Oman has been known for its frankincense for thousands of years.

OMAN
734 Practice your asanas overlooking a canyon

You can practice yoga on a platform overlooking a canyon at Anantara Al Jabal Al Akhdar, an upscale hotel surrounded by the spectacular Hajar Mountains. Both group classes or one-on-one sessions are available, but for the most exhilarating experience, arrive at sunrise or sunset so that you can watch the mountains come aflame.

OMAN
735 Go luxury camping in Oman's Empty Quarter

There's wild camping, and then there's wild desert camping in Oman's Empty Quarter, where you can bed down far from artificial light, pollution, or people. At Empty Quarter Bedu Camp, the spacious tents, generous mattresses, and crisp cotton linen ensure maximum relaxation. Rise for sunrise walks and spend your evenings by the campfire.

OMAN

736 Work on your brain function

Tackle brain fog, lack of sleep, and mental fatigue with a workshop at Six Senses Zighy Bay. Its one-day Mind Your Brain program will teach you how to look after and get the best out of your brain, from eating the right foods to choosing activities that will maximize your mental capacity. Yoga, breathwork, and sleep tracking are on the menu, and guests leave with a plan to continue the good work.

OMAN

737 Boost energy and improve sleep at a five-night fitness retreat

Boosting your physical well-being is simple at Six Senses Zighy Bay—you just need to put your name down for its fitness program. This is not-scary boot camp, however. It's designed to kick-start a new regime to suit you and your lifestyle, regardless of how fit you already are. A personal consultation with a fitness coach will get you started, followed by a mixture of high- and low-intensity training with plenty of massage, meditation, and sleep thrown in.

YEMEN

738 Feel the thrill of traveling to off-the-beaten-track Socotra

If you get your kicks from adventure, escaping tourist crowds, and immersing yourself in out-of-this-world landscapes, a trip to Socotra will do you a whole lot of good. An island in the Arabian Sea, it's a zoological and botanical treasure trove, home to flora and fauna including alien-like dragon blood trees. Book a tour and explore the island's lagoons, caves, and forests, camping out at night underneath a blanket of the brightest stars. It's a trip that's short on modern comforts but big on wonder.

738 Dragon blood trees

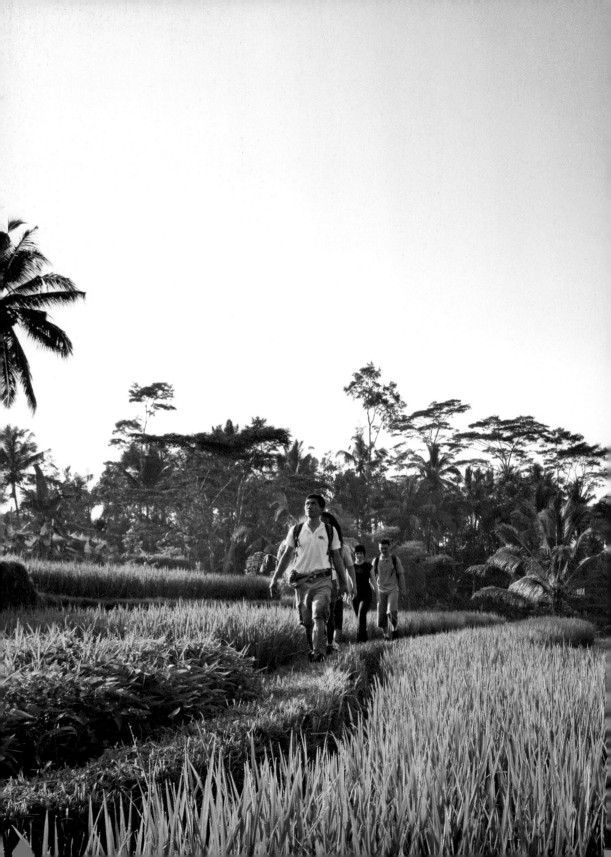

5

ASIA

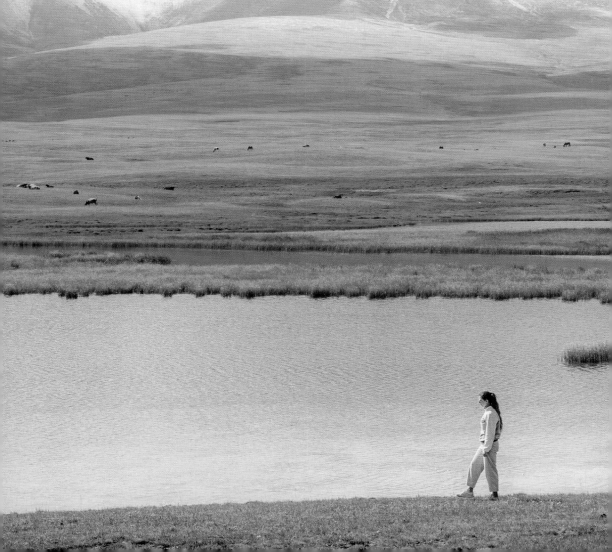

739 Be inspired by mountains and monasteries on the Transcaucasian Trail

Inaugurated in 2021, the Transcaucasian Trail is the first route to link the South Caucasus in one monumental path. Tackle it on foot or by bike and you'll take in desert canyons, mountains, Silk Road caravan sites, and ancient monasteries, as well as connect with some of Armenia's more remote communities. It's a trip with minimum impact on the environment but huge impact on body and soul.

740 Use art as meditation at a pottery workshop

The focus and patience involved in creating pottery forces you to slow down and live in the present moment—not to mention you have the sensory experience of handling a piece of clay. You can get in on the action at a pottery workshop in the city of Yerevan, including at Terracotta Studio, which will introduce you to the ancient tradition of Armenian ceramics.

AZERBAIJAN

741 Experience a mind and body detox with the Chenot Method

Whether you're committed to aging well, reducing stress, or improving fitness, the Chenot Palace hotel has a solution: the Chenot Method, which promotes harmony through a holistic approach to body, mind, and emotions. A team of medical professionals including cardiologists, osteopaths, nutritionists, and physiotherapists work alongside the spa therapists, so you'll get a comprehensive medical checkup as well as a fitness and healthy eating plan.

TAJIKISTAN

742 Go wild in the Pamir Mountains

The spectacular scenery and wildlife of the Pamir Mountains will make you press pause on your troubles and enjoy the moments as they unfold. A company such as Wild Frontiers can get you to Central Asia's least-visited destination, where you can look out for brown bears, wolves, and the elusive snow leopard while tackling challenging high-altitude hiking trails and building confidence and courage in the process.

742 Pamir Mountains

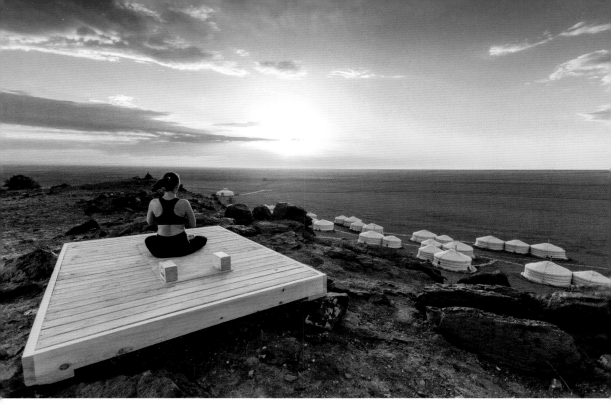

744 Sunrise yoga

MONGOLIA

743 Meet the shamans of the Bayangol Valley

Modern Mongolian shamans are thought of as fortune tellers, healers, and bridges between their communities and the spiritual world—and many people consult them before making an important decision. You can meet the shamans of eastern Mongolia on a cultural tour organized by Explore Mongolia, spending two days in their company at a shaman center and staying overnight in a a traditional dwelling.

MONGOLIA

744 Sleep in off-grid luxury in the desert

The sweeping landscape of the Gobi Desert is the setting for Three Camel Lodge, an eco-hotel that's stylish, sustainable, and utterly restorative. This is one of the most remote places on Earth, and the only sounds you'll hear are the wind, birds, animals, and the arrival of new guests. There are plenty of wow moments to be had, including riding Bactrian camels across the sand dunes, participating in a *ger* (traditional dwelling) raising, and standing atop the famous Flaming Cliffs.

MONGOLIA

745 Learn about cuisine in the Gobi Desert

A two-week food tour of Mongolia with Eternal Landscapes takes you to an off-the-beaten-track wilderness, allowing you to truly connect with the land, its people, and its traditions. You'll visit local markets and cook alongside your hosts, creating fresh, homemade meals such as *tsuivan* (stir-fried flour noodles) and *khuurshuur* (mutton pancakes). Spending time with rural families is unforgettable—and you'll make a contribution to their lives too.

CHINA

746 Climb a sacred Taoist mountain

The supernatural allure of Taishan—the most revered of China's five sacred Taoist peaks—draws millions of visitors annually. It takes four to five hours to climb the six thousand steps to the summit, and you'll pass by temples and hundreds of engraved stone tablets along the way. For maximum spiritual impact, spend the night on the peak in a tent or basic hotel, get up early, and bag a spot for a most spectacular sunrise.

CHINA

747 Visit a foot massage parlor in Shanghai

According to traditional Chinese reflexology, applying pressure to specific points on the soles of the feet can stimulate your vital functions, eliminate toxins, improve blood circulation, and reduce anxiety. Shanghai is full of spa retreats where you can give it a try, including many staffed by blind or partially sighted masseurs, for whom the massage industry is a vital employment lifeline.

CHINA

748 Try acupuncture in Beijing

Originating in China some three thousand years ago, acupuncture is the practice of penetrating the skin with thin needles for therapeutic or preventive purposes, such as treating back, neck, or joint pain or influencing energy flow. You can get this treatment at a host of places throughout Beijing, including traditional Chinese medicine hospitals and acupuncture houses, which operate along the lines of massage parlors.

748 Acupuncture

749 Find peace through cultural activity at Nan Shufang

At the heart of Shanghai's tranquil Amanyangyun resort is the Nan Shufang center, dedicated to Chinese art and culture and housed in a gorgeous antique building that mimics the style of a seventeenth-century scholars' studio. It's a place to study, contemplate, and immerse yourself in Chinese crafts, including playing the seven-stringed *guqin*, using incense to focus thought, and learning calligraphy, which is often used as a form of meditation in Buddhist culture.

750 Get to grips with quantum wellness at Sangha Retreat

A health and wellness space in Suzhou, Sangha Retreat by Octave is an advocate of quantum wellness—the belief that enhanced consciousness can positively impact all aspects of your life. Stays begin with a health assessment by a team of traditional Chinese medicine practitioners and Western doctors, after which you'll get involved in everything from sound healing to yoga to sessions in the subterranean spa, all with the aim of improving physical fitness and mental clarity.

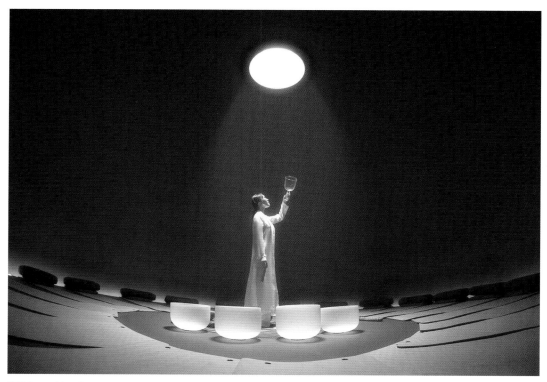

750 Sound healing

CHINA

751 Find serenity in the historic gardens of Huaqing Palace

Built during the Tang dynasty, the Huaqing Palace is a popular historic site in Xi'an. It's most notable for two things: the hot springs and the romantic tale of Emperor Xuanzong and his concubine Yang. Wander the palace to see historic artifacts, the mineral-rich hot springs, and the Pear and Lotus Garden. Find a quiet place to ponder your thoughts while relishing the view.

HONG KONG

752 Head off on a mental health vacation with the Happiness Factory

Mental and physical well-being is the priority of the Happiness Factory, which arranges talks, events, and retreats for those looking to reset and de-stress. Working alongside some of the island's top trainers, psychologists, and doctors, it combines science and holistic practice to get optimum results. Activities include yoga, journaling, and forest walks, and the food is wholesome and vegetarian.

HONG KONG

753 Find a peaceful sanctuary in the busy city

At the heart of busy Sheung Wan, step into Kadampa Meditation Center, a serene oasis where a deep breathing technique will guide you through Buddhist meditation. Focus on the present moment, and when body and mind unwind, you will achieve mental clarity and greater self-awareness.

HONG KONG

754 Explore alternative therapy at a training center for the soul

Break from the norm and head to Samadhi Training Centre for the Soul, the only place in Hong Kong where an active light matrix induces a higher level of consciousness. Add the healing sound of a crystal bowl and, as you awaken your soul, ultimate relaxation may lead to an out-of-body experience.

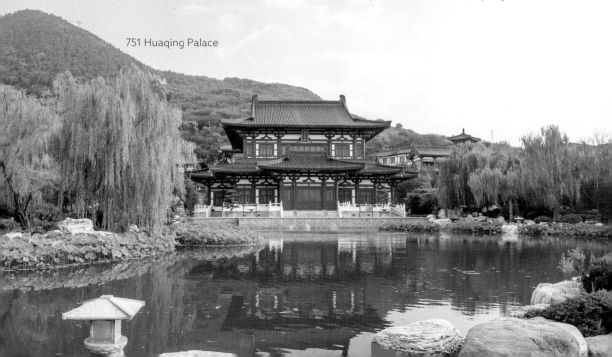

751 Huaqing Palace

755 Engage with traditional Korean culture

Perched on a hilltop, Bukchon Hanok Village is an ancient settlement that transports visitors back to the age of the Joseon dynasty. In this residential Seoul neighborhood, you'll find traditional homes called *hanoks*. Many of them are still in use and some offer immersive experiences such as calligraphy, black bamboo crafting, and natural dyeing to help you get to know the culture up close.

756 Bathe in an open-air hot spring

Pain relief, stress reduction, and an improvement in skin conditions are among the possible benefits of soaking in South Korea's volcanic hot springs. Try Hurshimchung, the largest hot spring spa in Asia, which can accommodate up to three thousand people and has indoor and outdoor baths. Or head to Seorak Waterpia, a hot spring spa and a waterpark.

757 Relive muddy childhood antics

You can unleash your inner child as you roll around in sludge at the Boryeong Mud Festival, an event that takes place every August and features mud slides, mud baths, mud fountains, and mud wrestling. It may sound like a free-for-all, but the mud here is renowned for its high mineral levels, which soften the skin, improve blood circulation, and balance pH levels—making your visit a fusion of wellness and fun.

758 Take your tea with a footbath

You can choose a tea to suit your well-being needs at Tea Therapy, a teahouse tucked away in a quiet corner of Seoul. Gongmi tea, for example, improves poor digestion and a weak stomach, while hyangtong tea will reduce the physical symptoms of stress and anxiety. To add to the healing experience, you can soak your feet in a footbath as you sip. Just like your tea, the water contains soothing medicinal herbs.

SOUTH KOREA
759 Take your skin on an intense ginseng journey

Sulwhasoo Heritage Spa makes full use of South Korea's traditional herbal ingredients, in particular ginseng. Its intensive ginseng journey purports to strengthen the vitality of your skin and relax neck and back muscles, while its signature treatment uses ginseng berry extract to enhance skin elasticity and reduce the signs of aging.

SOUTH KOREA
760 Revitalize your body at a water-based spa

Jeju Island is home to the We, a health and spiritual healing resort that promotes well-being through water and nature. Rooms are pumped with oxygen to enhance sleep, and the food is organic and nutritious, but the jewel in the crown is its hydrotherapy program. It uses mineral-rich volcanic bedrock water. Try aqua acupressure massage, the meditation pool, or even surf yoga.

SOUTH KOREA
761 Hike one of South Korea's sacred mountains

Taebaeksan is one of Korea's most sacred mountains, and there are five hiking trails from which to conquer the 5,140-ft. (1,568-m) summit. Here, you'll find Cheonjedan, a 10-ft.-high (3-m) stone altar connected with Korea's mythical founder, Dangun. For maximum atmosphere come here on New Year's Day or during the Taebaek folk festival in October, when moving ceremonies are performed.

761 Taebaeksan mountain

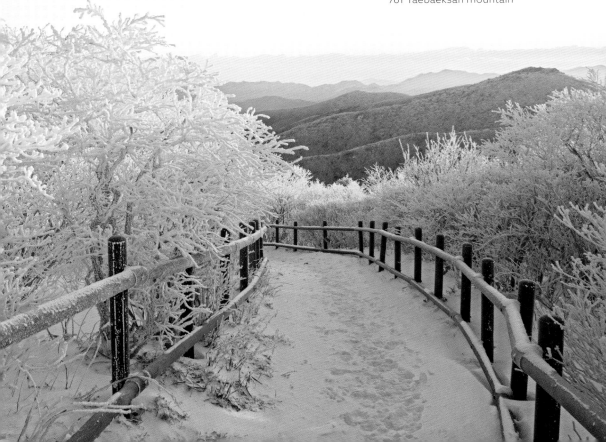

771 Relieve stress in the forest with *shinrin-yoku*

Shinrin-yoku or forest bathing is an important part of preventative healthcare in Japan, said to improve physical and mental health by reducing the effects of stress on the body. It's not about exercise but about connecting with nature and taking in the forest with all your senses. As little as an hour spent among trees will help you slow down, bring you into the present moment, and reduce your stress levels. Walking with a forest therapist can help you get the most from the experience, and organizations such as Iinan-cho Furusato-no-Mori offer planned sessions.

772 Follow the Kumano Kodo Trail

You'll walk through bamboo forest, past wide river valleys, and across soaring mountains when walking the Kumano Kodo Trail, a centuries-old pilgrimage route linking three sacred shrines and many other temples. Whether you complete it all or just a section, it provides a fascinating insight into Japan's spiritual history, and you'll feel moved by and connected to the beautiful landscapes and structures, no matter what your faith.

771 Forest bathing

773 Spend the night in a traditional inn

Staying at a traditional *ryokan* (inn) is the ultimate Japanese experience. Established as a place of sanctuary back in the Edo period, today they offer a chance to slow down and gain respite from the hectic outside world. For the full experience, choose a Japanese-style room, in which you'll find tatami mats, paper interior walls, sliding doors, and a *yukata*, a casual kimono set that can be worn when relaxing and eating in your room.

774 Attend a meditation retreat hosted by a monk

Experience the Japanese Zen lifestyle at Beppu Zen Retreat, a homestay in the tranquil village of Hiji, hosted by Zen Buddhist monk Yodo Kono and his family. During your stay you'll join the local community, practicing meditation each morning as well as other activities including calligraphy and a tea ceremony. There's time to bond with your fellow guests and build connections with your hosts.

775 Yoga, meditation, and Japanese culture on a wellness adventure

A peaceful temple in Kyushu is your base for a yoga adventure organized by Reclaim Yourself tours. There are morning meditation sessions with a Zen Buddhist priest, daily yoga classes with an experienced teacher, and regular discussions on Buddhist teachings and developing a mindful way of living. During your downtime you can soak in the *onsen* and explore the temple gardens.

773 Ryokan stay

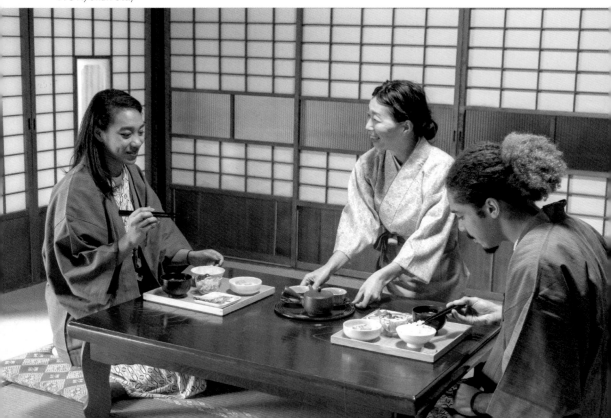

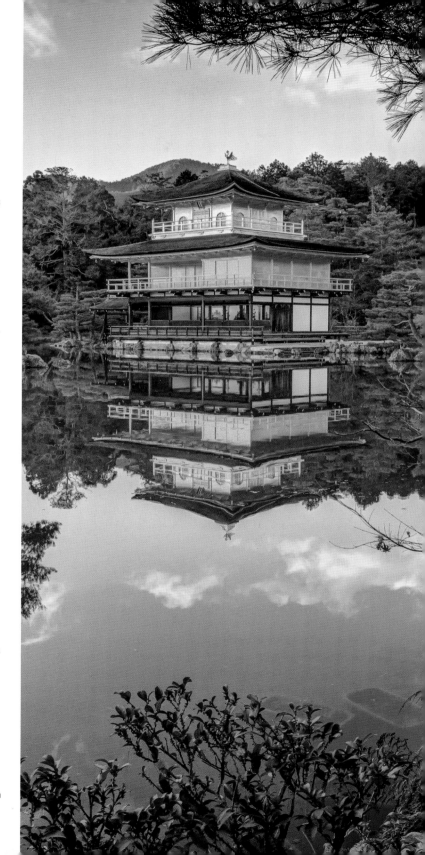

776 Feel the wisdom of Zen as you contemplate a golden temple

In a place devoted to Zen, you can see a mirror image of Kyoto's Golden Pavilion in a pond—pristine but beyond reach. Sit in the garden among flowers and trees and, as you count your breaths in and out, concentrate on the here and now. Once you are at peace, use the deep mindfulness to observe what you see, one thing at a time. Slow down and live in Zen; every minute is precious.

777 Personalize your experience at a restorative *onsen* resort

On the beautiful coastline by Ago Bay, the Amanemu Onsen Resort is fed by natural hot spring water that has been used to reduce fatigue and help with recovery from injury for thousands of years. Pair this with the herb-based healing practice of *kampo* and you can design a well-being experience that will leave you feeling balanced in body and mind.

776 Golden Pavilion

JAPAN
778 Learn the secrets of longevity in Okinawa

Located between the Pacific Ocean and the East China Sea, Okinawa is one of five blue zones, where people regularly live longer, healthier lives than average. In Okinawa this is said to be due to their healthy eating habits, a slower pace of life, a community-oriented mindset, and the subtropical marine climate of the islands, which are warm and stable year-round. Visit and you can experience this way of life firsthand. There's also the opportunity to discover the island's attractions including atmospheric caves and waterfalls, the marine life in the sea surrounding it, and try horseback riding in the countryside.

Underground cave

Horseback riding

Humpback whale

Waterfall

Traveling slowly

779 Calligraphy

779 Learn and practice calligraphy in silence in Fo Guang Shan

Listen to the gentle whisper of the teacher, then prepare to weave the feelings in your heart around the traditional threads of sutra scripts at Fo Guang Shan Monastery. Paper, brushes, and characters are provided at the calligraphy sessions, and when you copy your first icon, your body and mind will focus only on what you are doing.

780 Stay with a Tsou farmer to learn about local customs

Meet members of the Tsou tribe in Alishan to discover how they preserve their culture. Stay in a farmer's home, watch the slow ritual of pouring tea into thimble-sized cups, then learn about local tales and festivals. Afterward, visit the forest to wander along the trails, see the mist drifting across the hills, and feel the spirit of the land.

781 Go hard-core vegan at a yoga and raw food retreat

A holistic health and wellness resort, the Farm at San Benito puts on regular yoga and vegan food retreats, where daily yoga and meditation sessions go hand in hand with nutritious juices and farm-to-table raw vegan meals and workshops on how to prepare them. Fitness and nutritional assessments as well as health screenings round out the picture.

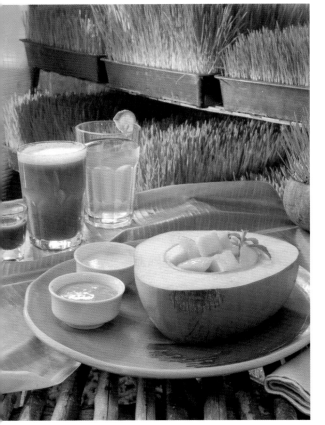

781 Raw food treats

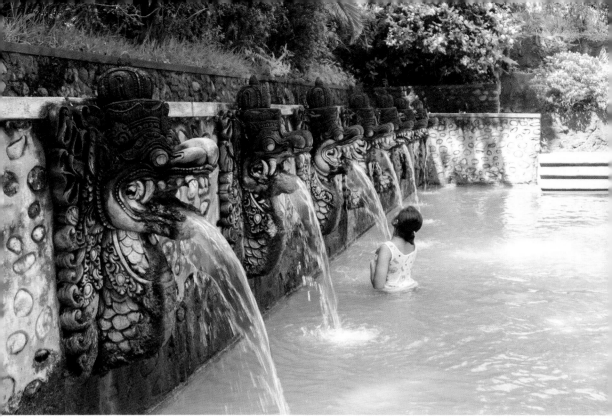

783 Banjar Hot Springs

INDONESIA
782 Get well in the wild on a spa safari

A lush island of palm-fringed beaches and limestone hills, Sumba is home to NIHI Spa Safari, a group of cliffside treatment pavilions reached by horseback, jeep, or a sunrise trek. Once there, you can swim in the sea, eat food cooked over an open fire, and enjoy treatments inspired by Indonesian culture and history.

INDONESIA
783 Bathe in Banjar Hot Springs

A complex of lush gardens, palm forest, and steaming waters, Banjar Hot Springs is a blissful tropical interlude that includes a central bathing pool and a family pool fed by intricately carved dragon spouts. The water's high-sulfur content makes for a relaxing, therapeutic experience, and it's thought to be a cure for a range of muscular and skin complaints.

INDONESIA, BALI
784 Get into ancient sound healing at the Pyramids of Chi

Sound and vibration have been hailed as powerful healing tools for centuries, and at the Pyramids of Chi—a wellness center in Bali set across two pyramids and based upon the Great Pyramid of Giza—sound healing is the specialty. You can lie back and relax while feeling the energy of ancient instruments including gongs, didgeridoos, and Tibetan bowls.

786 Alchemy Academy

785 Be inspired by the BaliSpirit Festival

A celebration of yoga, dance, music, and other wellness practices, the BaliSpirit Festival takes place in Ubud each spring, bringing in a diverse community of yogis, musicians, and artists. Boost your mood and energy through nightly world music performances, attend meditation sessions and spiritual workshops, and connect with like-minded people from across the world.

786 Get to grips with Bali's raw food scene

The raw food movement is big news in health-conscious Bali. Vegan restaurants abound, particularly in Ubud, and you'll find all sorts of tempting raw food treats on their menus— think smoothie bowls, rice paper rolls, and raw chocolate brownies. Among the best is Alchemy Academy, which also offers cooking classes at its raw vegan culinary school.

787 Choose from a plethora of activities at Ubud's famous Yoga Barn

One of Southeast Asia's most popular yoga hubs, Ubud is awash with studios. But none is more iconic than the Yoga Barn, a sprawling, jungly complex that has seven practice spaces, several cafés and juice bars, a spa, and a guesthouse. It runs an impressive 130 classes a week, from candlelit meditation sessions to ecstatic dance.

788 Decompress through quiet self-reflection on the Balinese day of silence

Balinese New Year is marked by a day of silence. During *Nyepi* the sound of construction, traffic, and beach bars evaporates for twenty-four hours as residents and visitors stay indoors for a day of self-reflection. Everything from the airport to supermarkets to beaches are closed so you can focus on the quiet and listen to the sounds of nature.

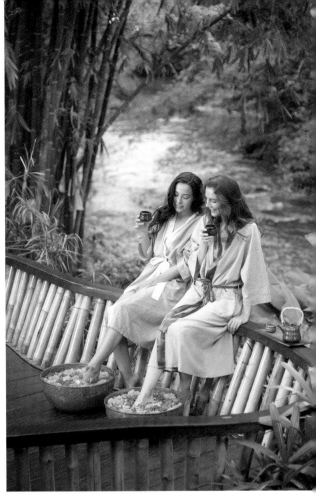

INDONESIA, BALI

789 Achieve better focus and resilience at an executive retreat

You can relax, refocus, and recharge at Fivelements Bali, where the executive performance retreat is designed to help frazzled city types enhance performance both in and out of the boardroom. The resort's setting—surrounded by jungle alongside the Ayung River—gets things off to a good start, while sunrise hikes, yoga, and teamwork sessions help to complete the picture. Add in a spa treatment or two and you're ready to get back to business.

789 Spa treatment

INDONESIA, BALI

790 Learn to prepare delicious and health-giving plant-based cuisine

Fivelements Retreat is a firm believer that a plant-based diet can boost your energy, immunity, and happiness, lead to improved sleep and greater focus, and benefit some health conditions. On its retreats, you won't just enjoy the benefits of a healthy diet, but also learn the recipes and techniques you need to create fabulous plant-based feasts at home.

790 Vegan meal

791 COMO SHAMBHALA ESTATE

Inspiring view

Raw tuna tacos

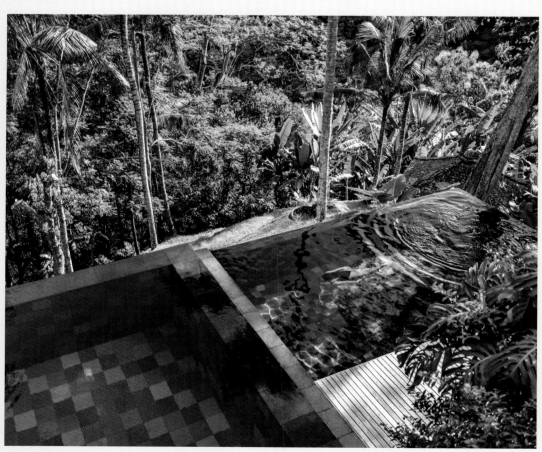

Swimming pool

INDONESIA, BALI
791 Slide into tropical luxury and spiritual development

A wellness resort beloved for its back-to-nature ethos, Como Shambhala Estate is a refuge for celebrities, wellness seekers, and burned-out execs eager to unwind in the jungle. Nestled in the sacred Ayung valley, it's enveloped in greenery and rice fields and has a soundtrack of birdsong and tropical insects. From the wholesome food to the serene spa to the elegant villas, it feels as if everything is designed to make you feel happier and healthier.

INDONESIA, BALI
792 Take part in a water purification ceremony

Water is a symbol of strength and purification in Indonesian culture, and you can experience *melukat* rituals (water purification ceremonies) at Hindu temples and spiritual sites across Bali. The purpose is to cleanse the body, mind, and spirit, as well as to rid yourself of negative influences. A priest guides you through a series of prayers and rituals. Places to start include the holy springs at Pura Tirta Empul, Sebatu Holy Water Spring, and Beji Selati springs.

INDONESIA, BALI
793 Get acquainted with contrast therapy

Contrast therapy requires you to submerge yourself in cycles of ice-cold and hot water—creating a muscle-tightening, circulation-simulating, and inflammation-reducing high. You can try it at Asa Maia, moving back and forth between a 45.5°F (7.5°C) cold pool and a 104°F (40°C) hot pool. The process should be repeated three to six times for a total of twenty minutes. A coach is available should you need someone to help you work up the courage to take the plunge.

INDONESIA, BALI
794 Learn healthy cooking techniques

Join a cooking class at the Spa Village Resort Tembok to discover techniques to nurture your health while learning about the healing properties of local ingredients. You'll get culinary insights, tips, and the principles required to prepare nourishing dishes as well as finding out how to transform them into healthy lifestyle habits. The resort's school of life program includes activities aimed at redesigning daily routines so that new skills become sustainable life practices.

INDONESIA, BALI
795 Unwind with traditional treatments and activities

Alongside meditation, massage, and chakra opening, a retreat at Balitrees is strong on different styles of yoga for holistic healing, including the unique Watukaru. Reflect in the lush tropical garden, visit the beach or waterfall, then join in authentic Balinese activities such as planting rice, preparing a herbal drink, making coconut oil, and more. On this spiritual island, you will be rejuvenated and achieve inner peace.

796 Hammam

INDONESIA, JAVA
796 Chill out at Southeast Asia's only authentic hammam

MesaStila Resort in Central Java is home to the only authentic hammam in Southeast Asia. Its intensive hammam ritual includes a steam session, body exfoliation, and soapy cleanse in the tepidarium (heated relaxation room), before moving to a private suite for a full-body massage using warm oil followed by a rosewater splash.

INDONESIA, JAVA
797 Feel your spine tingle at an iconic temple

Set on a remote hilltop in Central Java, Borobudur is the biggest Buddhist monument in the world. Visit during sunrise or sunset for the most magical experience, or for full spine-tingling impact, come after dark during the Buddhist festival of Vesak, when saffron-robed monks walk from Mendut temple to Borobudur carrying candles, then release lanterns into the sky.

SINGAPORE
798 Practice yoga at sunrise

Wave hello to the rosy sun ascending over the horizon and greet the day with *Tadasana* (Mountain pose) as you consciously fill your lungs at the Marina Bay Sands SkyPark observation deck. Yoga enthusiasts are invited to stretch their muscles, strengthen their core muscles, and build up heat on the outdoor deck for an invigorating experience.

799 Floral Fantasy

SINGAPORE

799 Breathe in the scent of thousands of flowers

Picture this: you walk into an enchanting space and are surrounded by flowers. Garlands sway above your head, and there are flowering plants and colorful arrangements ranging from fiery red to lilac blue. Your eyes are spoiled by the beauty, but your nose surrenders to the scents that perk up your mood and lower your stress levels. This whimsical garden—Floral Fantasy—is part of Gardens by the Bay.

SINGAPORE

800 Connect with nature in the Cloud Forest

Say hello to a magical world where the phrase "head in the clouds" takes on a physical and rewarding meaning. At the Cloud Forest, which is part of the Gardens by the Bay, you can embark on a journey of discovery that takes in a verdant mountain covered in plants from around the world and views from aerial walkways. When you finish exploring, relax by one of the world's tallest indoor waterfalls.

SINGAPORE

801 Visit a green island sanctuary

Did you know Singapore has several offshore islands? One of these, Coney Island, calls to anyone looking for a green sanctuary. It's connected via two red footbridges, so cycling is one of the best (and fastest) ways to access it. It's the perfect place to escape to as part of the Wellness Festival Singapore. Attend some workshops, then head off for some bird-watching and to cycle the rustic, lush terrain.

MALAYSIA

802 Benefit from plant-based spa treatments

Enveloped by the tranquil sights and meditative sounds and scents of the jungle, experience local rituals and herbal remedies made from rainforest ingredients. The Datai Spa Langkawi offers a range of *ramuan* treatments inspired by traditional healers who believed inner and outer beauty are interdependent. Indulge in a seven flowers ritual to harness the healing power of Indigenous plants.

MALAYSIA

803 Unplug and unwind in an ancient rainforest

At the ripe old age of 130 million years, Taman Negara rainforest is the largest national park in Malaysia and contains a myriad of ways to lose yourself in the natural world. Take a longboat ride along the Tembeling River, get a bird's-eye view of the treetops on a canopy walk, or explore the jungle after dark on a nighttime stroll.

MALAYSIA

804 Get some well-being action in a healing cave

Nestled in a forested valley full of geothermal hot springs, waterfalls, and limestone caves, the Banjaran is well-placed for a restorative escape. Try its crystal cave for energy healing treatments such as Reiki or the meditation cave for a secluded moment of contemplation. Then there's the thermal steam cave, which is transformed into a natural sauna by its geothermal hot spring.

MALAYSIA

805 Soothe your feet with a reflexology massage

The theory behind reflexology is simple: your feet mirror your organs, so when pressure is applied to specific areas of them, it may ease stress, alleviate constipation, improve back pain, and help with sinus pressure. Try out a reflexology massage experience in Malaysia as a trained professional rubs your feet in a serene atmosphere.

MALAYSIA

806 Relax with furry feline friends in Langkawi

The Bon Ton Resort's antique wooden villas, rural setting, and Malaysian cuisine might be the main attraction for some, but for others it's the chance to bond with some of its furry inhabitants. The resort's owners own the cat sanctuary next door, and guests will find friendly felines at the bar, around the pool, or even staking a claim to their villa. For animal lovers, it's a spirit-lifting treat.

MALAYSIA

807 Enjoy water slides and healing hot springs

Part water theme park, part hot spring spa, the Lost World of Tambun is best visited at night, after both the crowds and the temperatures have gone down, and you can enjoy a soak by starlight. Check out the hot spring infinity pools, foot spa, and hot tubs, then head for the thermal caves for a revitalizing steam.

806 THE BON TON RESORT

Wooden villa

Malaysian meal

Visiting cat

MALAYSIA

808 Feel on top of the world on a canopy walk

Up above the trees in Kinabalu National Park, you can explore one of the oldest rainforests on Earth thanks to its canopy walk. From this series of five suspension bridges lined with safety nets, you can see the tangled lianas and giant trees as well as look out for spiders, snakes, and colorful birds all within an arm's reach.

MALAYSIA

809 Relax in wetlands that are home to rare birds

Once a barren land, now a hidden paradise, Mangala Estate Boutique Resort is the perfect getaway from the bustling city. Serene and exuberant, it's a revitalized ecosystem dotted with wild areas and lakes, claiming more than one hundred species of birds. There are also stylish villas, some with private pools, a luxurious spa, and pristine scenery framed by emerald hills.

VIETNAM

810 Go on a wellness cruise down the Mekong

You can combine a wellness retreat with a luxury cruise around the towering limestone islands of Ha Long Bay. Book a trip with Au Co Luxury Cruise and in addition to swimming, kayaking, and jungle excursions, you'll enjoy daily yoga and meditation sessions, including Yin yoga under the stars and cave meditation on shore.

810 Ha Long Bay

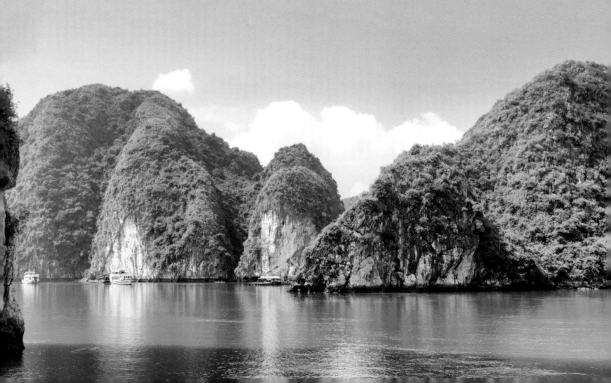

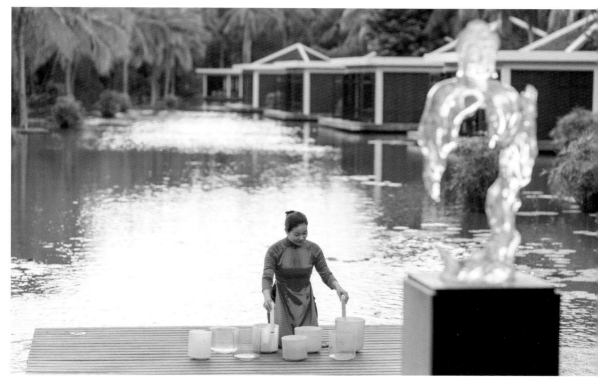

811 Singing bowls

811 Find your frequency with a singing-bowl artist

When a crystal singing bowl is struck by a gem-tipped metal tuning fork, it creates a subtle vibration that is believed to align the body with the harmonic rhythms of the Earth. Join the singing-bowl artist at Four Seasons Nam Hai to experience the sound of a complete octave of bowls. Relax in a treatment villa floating on a lotus-filled lagoon while listening to the sound of the bowls.

812 Feel a sense of community by living with an ethnic minority tribe

Homestays are all about genuine connection and exchange—you're learning about life in a different community while sharing a little about your own culture too. On a tour with Responsible Travel, you'll travel to little-known rural regions, staying with local families and ethnic minority tribes. It's a warm and immersive experience that will teach you more about the country than a hotel stay ever could.

VIETNAM

813 Do sun salutations by the ocean

Known for its stylish villas and stunning views, Six Senses Ninh Van Bay is one of the best yoga retreats in Vietnam. Its three-, five-, or seven-night Discover Yoga program is perfect for beginners. Daily practice of hatha yoga will help you tune in to your body and emotions while targeting the physical scars of stress and tension.

VIETNAM

814 Make cultural connections

Set in the hills along the Chinese border, Sa Pa offers fresh mountain air and hiking alongside terraced rice fields—but the real thrill is the chance to meet Vietnam's minority hill tribes. You can visit local markets, arrange a homestay, and listen to traditional folk music and dance. Choose a responsible operator so you'll be contributing in a positive way and supporting programs that help local communities.

VIETNAM

815 Sun, sand, and spa

After a day on the beautiful sands of Phuong Mai Bay, continue to immerse yourself in Vietnamese goodness with a coconut religion body massage at the Maia Resort's Vela Spa. The eco-focused beauty regimes here take a "jungle to jar" attitude, using handcrafted, locally sourced products from the Mekong Delta.

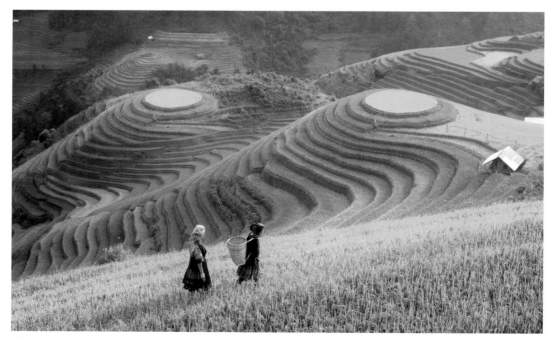

814 Terraced rice fields

VIETNAM
816 Hole up in a private wellness villa

Ensconced within the lush surrounds of Núi Chúa National Park, Amanoi is a coastal sanctuary known for its yoga pavilion and lakeside spa. Its offerings are certainly impressive, but book one of the resort's two private wellness villas and the fun really starts. Each has its own hot tub, steam room, cold plunge pool, and spa treatment room, complete with a dedicated therapist. All you'll have to worry about is choosing the setting—do you want to overlook the tranquil lake or be surrounded by rainforest?

816 Amanoi's central pavilion

CAMBODIA

817 Explore Buddhist teachings on a private island

The spa at Song Saa private island embraces the Buddhist tradition of *metta bhavana*, which blends the concepts of stillness, healing, and blessing. Daily yoga and meditation in a waterside studio are included, and you can arrange a monk blessing to enhance any spiritual intentions for your stay. These rituals involve chanting in a tranquil location.

CAMBODIA

818 Soak up serenity in the mountains

The vast tropical wilderness of the Cardamom Mountains is a spectacular location in which to unwind, decompress, and commune with nature. Its rugged landscape of mountains, marshes, and rivers is not only beautiful but also a stunning home to wildlife. Stay in Cardamom Tented Camp for a back-to-nature experience that will act as a natural antidote to the stresses of modern life.

818 Tropical wilderness

CAMBODIA

819 Chill in a waterfall pool at a riverside spa

A wilderness lodge deep in Cardamom National Park, Shinta Mani Wild has natural wellness down to a tee. Made from wood and stone, the spa's two treatment rooms sit among giant rocks perched in the forest, where you can have a foot massage while soaking in a waterfall pool.

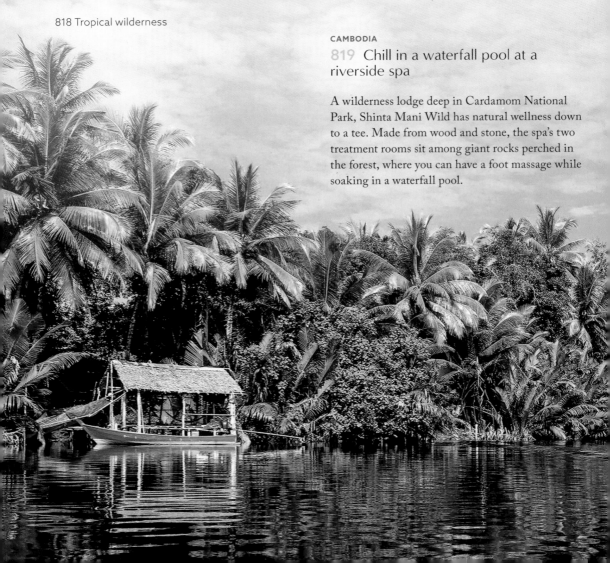

CAMBODIA

820 Try a massage at an island hotel

A back-to-nature tropical island is the setting for Six Senses Krabey Island, which makes use of Cambodian ingredients in its signature spa treatments. Try a Khmer salt and herb scrub, made with Kampot sea salt, local Khmer herbs, and aromatic essential oils; or go for a Khmer *kru thnam* herbal massage, where local therapeutic herbs are wrapped in a muslin cloth, tied into a ball, and used to stimulate pressure points. For a private stay book the two-villa beach retreat.

CAMBODIA

821 Join a midlife wellness retreat

Take a break from the mundane, reconnect to simple pleasures, and rediscover your enthusiasm for life on a midlife retreat with Red Road. You'll join a small group of like-minded women as you travel around Cambodia, with healthy meals, meditation, and yoga classes included. There's plenty of time to nurture yourself in nature too, from waterfall bathing to hiking in the jungle.

CAMBODIA

822 Practice mindfulness and concentration techniques

You can improve your focus and clear creative blockages at Anantara Angkor Resort, a sleek boutique hotel within striking distance of Angkor Wat. Its refocus program uses meditation, yoga, and breathing techniques to clear your mind, improve concentration, and chip away at the stress buildup that occurs throughout the course of everyday life.

CAMBODIA

823 Join a mindful cooking retreat

Let your senses come alive on a cooking retreat with Shojin Kitchen. Between the mindful preparation of plant-based meals, the retreat helps guests ponder such questions as "What am I really hungry for?" and "What do I need to nourish in my life?" Through mindful cooking, yoga, and meditation, you will be guided to explore the answers.

824 Exercise program

824 Optimise your health with a program based on genomic testing

Benefit from a program based on your genetic code. Chiva-Som International Health Resort Hua Hin offers genomic testing, which analyzes the way our genes interact with our environment, diet, and lifestyle, and how they affect our health. The spa interprets the test results and then curates a bespoke program that includes exercise, sleep protocols, treatments, and advice on optimizing nutrient intake as well as other lifestyle choices.

825 Focus on physical recovery at Chiva-Som

Want to regain your physical fitness? Check out Chiva-Som's optimal performance retreat. A bespoke week coordinated by fitness and physiotherapy experts focuses on pain management, recovery, and rehabilitation, as well as general well-being. Your program will include kinesthetic assessments, physiotherapy, and stress-relief therapy, all designed to get you feeling your best.

826 Witness regeneration on a forest walk

Take a forest walk through Krailart Niwate, the last remaining mangrove ecosystem on the edge of the city of Hua Hin, to witness the revival and regeneration of nature as part of a program with Chiva-Som. Then, follow the trail and stairway to the peak of the temple of Wat Khao Krailart for a unique meditation session and quiet contemplation as you enjoy the view of the Gulf of Thailand.

828 *Nuat thai* massage

827 Follow an itinerary based on traditional Eastern medicine

The ancient wisdom of Eastern medicine, naturopathy, and coaching are integrated into personalized wellness journeys at Banyan Tree Phuket. For those seeking a better night's sleep, snuggle up for a program that uses meditation rituals, sleep-inducing therapeutic massages, and a sleep workshop to leave you well rested and energized with the skills and knowledge you need when you return home.

828 Release tension with an ancient *nuat thai* massage

A massage routine that uses acupressure, reflexology, and gentle stretching, *nuat thai* should improve your flexibility and posture, relieve muscle tension, and help blood circulation. The practice is thousands of years old and is said to originate from the teachings of Buddhist doctor Shivago Komarpaj. You can try it at massage parlors and spa resorts throughout Thailand.

829 KHAO SOK NATIONAL PARK

Macaque monkey

Swing with a view

Bamboo forest

Sunset scene

829 Workout body and mind in the jungle

Escape the beach for lake swimming and jungle hikes in one of the oldest rainforests in the world. Khao Sok National Park is alive with monkeys and birds and home to rare creatures including clouded leopards. There is a bamboo forest as well as swings with views of the jungle and mountains. Visit during the dry season and hire a guide who can teach you to slow down and engage all your senses for an all-enveloping experience.

830 Attend a retreat at a monastery in the jungle

Suan Mokkh monastery welcomes visitors for a silent retreat, where living simply and devoting your time to study, meditation, and breathing exercises can be a life-changing experience. This is no pampering spa retreat, and you'll need to hand in digital devices, books, and notebooks before you begin. Meals are vegetarian and your private room will contain a hard bed with a simple straw mat, a blanket, and a mosquito net.

831 Improve the quality of your sleep

If you're having trouble getting some shut-eye, Kamalaya in Koh Samui might have the answer. Its sleep enhancement program explores your mental, emotional, and physical barriers to sleep and helps you overcome them. This could include nutritional guidance, massage therapy, oxygen therapy, or a personal mentor to provide counseling and meditation sessions.

832 Feel on top of the world

The very setting of Phu Chaisai Resort is restorative enough: it's a series of bamboo cottages set amid forested hills, complete with panoramic views, a river, and a fragrant rose garden. Add to that an exemplary spa and organic food and drink courtesy of the resort's own farms, orchards, and tea plantation, and you've got the wilderness refuge of your dreams.

833 Join a regenerative women's health retreat

Whether you're preparing for pregnancy, transitioning to perimenopause, or dealing with menopause itself, Kamalaya's Radiant Bliss program can help. Aimed at women aged eighteen and over, it combines traditional Chinese medicine and Ayurveda with nutrition and up-to-date medical research. Expect private health and fitness assessments, balanced nutrition, and plenty of restorative spa treatments.

834 Fine-tune your body at a sports resort

You'll get closer to your fitness goals at Thanyapura, a sprawling Phuket resort that has some of the best sporting facilities in the country—think swimming pools, tennis courts, a running track, performance gyms, and fitness studios. Sport packages include personal training, sports massage, and advice from nutritionists to help you on your way toward a healthier, happier lifestyle.

THAILAND
835 Boost your artistic skills in Chiang Mai

In the lovely city of Chiang Mai, learn to paint watercolors or improve your technique with a local artist at Three Owls Gallery. You can book for a few hours, or try an immersive full-day retreat, which offers three hours painting outdoors (when it is cool), often in temple grounds, and three hours after lunch in the studio. You can choose one-on-one sessions or join a small group of like-minded people.

THAILAND
836 Stretch yourself out at a Pilates boot camp

Hone your body with a five- or seven-day Pilates boot camp at Absolute Sanctuary, a retreat that's suitable for beginners and devotees alike. You'll receive two group reformer classes daily, as well as targeted one-on-one training sessions, and regular massages to knead away tense muscles. Vegetarian meals and fresh juices are included.

THAILAND
837 Try a traditional healing massage

Thai yoga massage is based on physical contact between the giver and the receiver, where the body is manipulated along its energy lines. It may be forceful at times, but the holistic approach will loosen your body, reduce stress, and boost well-being. For an authentic experience, visit Wat Po temple in Bangkok, where you keep your clothes on and the massage happens in the common therapy room.

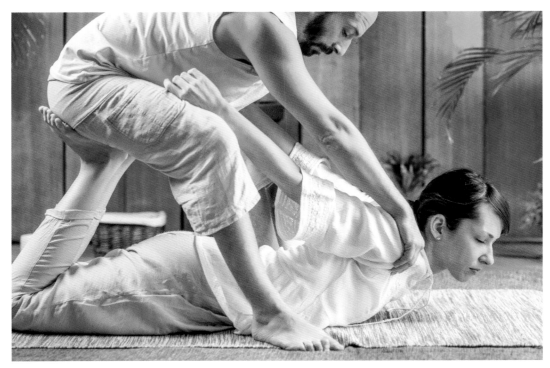

837 Thai yoga massage

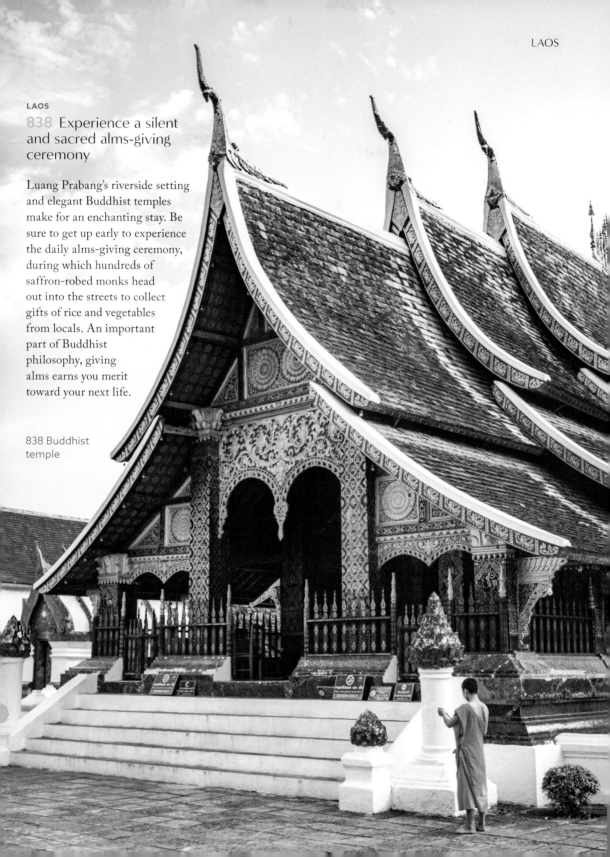

838 Experience a silent and sacred alms-giving ceremony

Luang Prabang's riverside setting and elegant Buddhist temples make for an enchanting stay. Be sure to get up early to experience the daily alms-giving ceremony, during which hundreds of saffron-robed monks head out into the streets to collect gifts of rice and vegetables from locals. An important part of Buddhist philosophy, giving alms earns you merit toward your next life.

838 Buddhist temple

BHUTAN

839 Learn from Buddhist masters in the land of happiness

Bhutan is the only country that has a gross national happiness measurement to evaluate the quality of life and ensure that "material and spiritual development happen together." It is the last Buddhist kingdom and often quoted as being one of the most blessed places to visit due to its holy sites. For the ultimate meditation experience, hike to the Tiger's Nest, the revered temple high on a mountainside shrouded in mist, to enjoy the serenity of this quiet, spiritual land of happiness.

839 Bhutan monastery

BHUTAN

840 Learn about monastic life

Reconnect with Six Senses is an invitation to disconnect from daily distractions and rekindle your connection with other people and the natural world. At Six Senses Punakha this takes the form of a visit to Chorten Nyingpo monastery. Guests hike to the monastery through the forest, eat a vegetarian breakfast, and meet with novice monks to learn about their everyday lives.

BHUTAN

841 Join a spiritual-cleansing session

Full immersion in the culture and natural environment of the Gangtey Valley is the route to well-being at Gangtey Lodge. You can join the monks at Gangtey Shedra (Buddhist college) for an early morning *thrusel* ritual, a self-cleansing ceremony when herbs are burned and holy water is poured over your head for purification, luck, and eradication of bad spirits.

BHUTAN

842 Wind down in a traditional hot stone bath

Hot stone baths are an ancient Bhutanese tradition, and you can experience one when you stay at Gangtey Lodge. A pinewood bath is filled with water that is sprinkled with herbs and warmed using large river stones, which have been heated over a fire. It's thought that minerals released from the stones and herbs have a number of medicinal benefits.

853 Climb though fragrant forests to the World Peace Pagoda

Take a boat across the lake at Pokhara, then follow the steep, forested trail up to the hilltop. Then walk clockwise around the World Peace Pagoda, where Buddhas gaze in every direction. Continue along the path for views across the Himalayas. From Dhaulagiri to Manaslu, past the mighty Annapurna, it's a dazzling scene with snow and ice peak after peak.

854 Join the Tibetans and walk seven times around Boudhanath

Buddhist flags, prayer wheels, alms bowls, gongs, and chanting monks are all part of the experience at Boudhanath—one of Nepal's largest stupa (place of meditation). Visit at dawn or dusk to see it at its most inspiring and join in the ancient traditions. Follow the locals as they keep count of the auspicious number as they walk around the stupa in a clockwise direction.

855 Rekindle your hidden self in a hilltop monastery in Kathmandu

In serene surroundings, high above the city, Kopan Monastery is the perfect escape for those seeking contemplation and personal reflection. Unwind in the beautiful garden, meditate in silence in the Tibetan temple, attend a course if you wish, or join the prayers and talks. Then when the monks begin to chant, sense the positive vibrations throughout your body and mind.

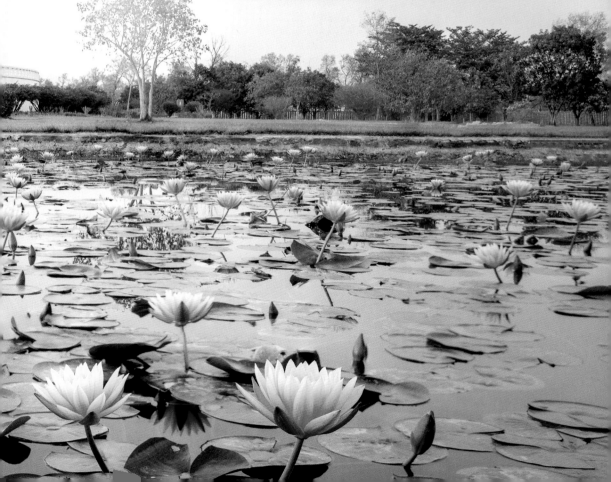

PAKISTAN

856 Go off-grid and up high in the glorious Hunza Valley

The mountain valley of Hunza is so spectacular that it's often described as the original Shangri-la. Its seven 23,000-ft.-high (7,000-m) peaks lie on the Karakoram Highway, once the ancient Silk Road to Kashgar, making for breathtaking views everywhere you turn. A tour company such as Wild Frontiers can get you there, taking you off-grid to mountain lodges, ancient forts, and dramatic glaciers in an unforgettable trip to excite even the worldliest of travelers.

856 Valley view

THE HIMALAYAS

857 Trek the passes of the Himalaya Trail

Are you active, healthy, and motivated? Then why not trek into areas very few have traveled before on the longest section of the Great Himalaya Trail. Challenge your mental and physical capabilities on a thirty-four-day journey across the highest and hardest passes in the mountains and across rugged terrain while marveling at the most majestic mountain scenery on the planet.

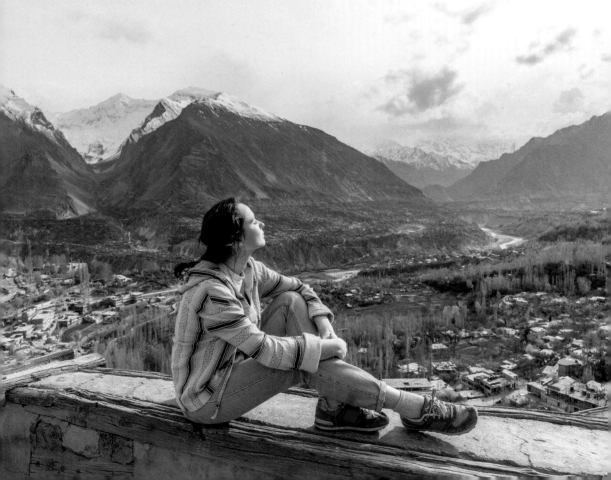

858 Visit the home of Mother Teresa

A destination sought by visitors for meditation and positive energy, visit the humble home of Mother Teresa in Calcutta, where she founded the Missionaries of Charity. Pay homage to this saintly woman, famous for focusing her life on love, happiness, and kindness. Experience a spiritual connection in the small museum, which houses artifacts and items she used in her daily life.

859 Enjoy hot springs with Himalayan views

It's an 8-mi. (13-km) hike through a pine forest and into the heart of the Parvati Valley to reach the sulfur springs at Kheerganga. If soaking your limbs in therapeutic hot water doesn't elevate your mood, the 360-degree view of the snowcapped Himalayas certainly will. Come at sunset to watch the valley change from orange to blood red to indigo. Then pitch a tent under a star-studded sky.

859 View from Kheerganga

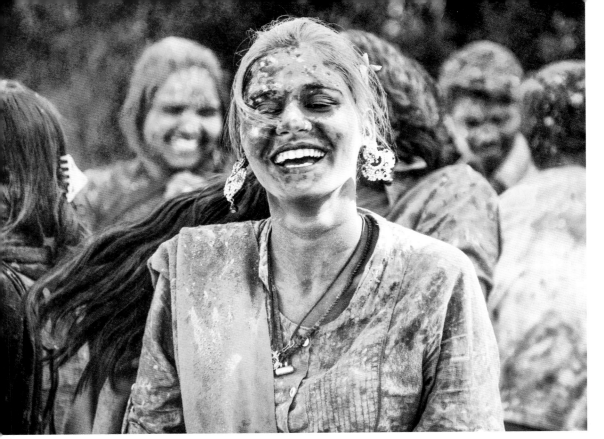

860 Holi festival

860 Find new beginnings at the festival of colors

Celebrated throughout India with infectious joy and enthusiasm, Holi is a famous Hindu festival that marks the arrival of spring. There are bonfires, folk musicians, and dancing, but it's best known as a festival of colors. Go outside and before long you'll be drenched as revelers throw dyed water and colorful powdered paint. It's fun, messy, and a massive mood enhancer.

861 Get acquainted with Tibetan healing at Six Senses Vana

Six Senses Vana is one of the few places in the world to offer the Tibetan medicine practice of Sowa-Rigpa, carried out by practitioners who have trained at the Dalai Lama's Tibetan Medical and Astro Institute. It's a practice that has its roots in Ayurveda, Chinese medicine, and Buddhism, and it places an emphasis on both the mind and the emotions.

862 Rediscover yourself at a traditional ashram

Expand your mind, open your heart, and leave behind the stresses of daily life at Sivananda, a traditional ashram in Tamil Nadu. Its yoga vacation program immerses you fully in the Yogic lifestyle. You'll follow the ashram's daily schedule, which includes two meals a day, silent meditation, and yoga practice. Morning and evening *satsang* are a time to meditate, chant, and listen to talks or readings.

INDIA
863 Learn the teachings of the Buddha

Travel to McLeod Ganj, Dharamshala—the seat in exile of the fourteenth Dalai Lama—for an introduction to Buddhism from the Tibetan Mahayana tradition. A retreat at the Tushita Meditation Centre is silent, and time is spent in spiritual study and meditation. It's a chance to shut out the distractions of everyday life and develop patience and stillness within yourself.

INDIA
864 Get a dose of luxury glamping

With mountains and monasteries as your only neighbors, Indus River Camp in Ladakh is a perfect slice of get-away-from-it-all chic. This is the kind of place where it's easy to do nothing but drink in the peace, take in the views, and swim in the river, but you could make things more active by bird-watching, exploring the forest, and trekking to nearby monasteries.

INDIA
865 Strengthen your mind and your muscles at Wildflower Hall

You can get your body and mind in shape at 8,250 ft. (2,514 m) above sea level at Wildflower Hall, a luxury resort in the Himalayas. Get your heart pumping with hill walking and off-road mountain-biking trails, or make use of its yoga and meditation instructors. Every class is one-on-one, so you'll get perfect personalized sessions. Have them in the yoga shala, or pick somewhere scenic on the grounds.

INDIA
866 Slip into the slow rhythm of safari life at Bagh Villas

You can sleep within roaring distance of Bengal tigers at Bagh Villas, an experiential safari lodge in Kanha National Park, which prizes sustainable tourism and wildlife conservation. You'll slip into a gentle rhythm during your stay, exploring the forest on foot or by bike, visiting nearby villages, getting treatments at the spa, and—if you're lucky—experiencing the incredible thrill of seeing a tiger in the wild.

864 Indus River Camp cottages

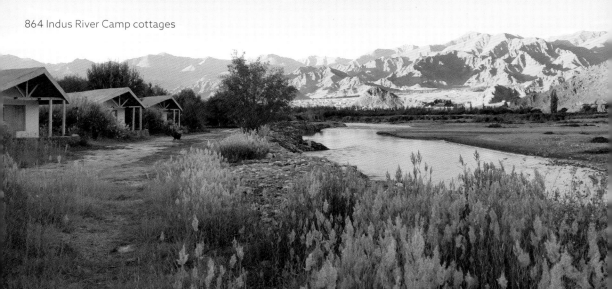

INDIA

867 Try a super immunity program

Whether you're looking for a postinfection boost, to better manage a comorbid condition, or you have digestion and gut concerns, Atmantan Resort's super immunity program can help. You'll build muscles and improve your core body strength, consume nutrition-dense meals and supplements, use nature as an immunity booster through mindful walks, and spend time in its calming sleep sanctuary.

INDIA

868 Load up on healing therapies in a palace

Sign up for a cleansing program of Ayurveda at Kalari Kovilakom, a treatment center and former maharaja's palace set in the lush southern Indian region of Kerala. In the name of Ayurvedic *panchakarma* (rebirth), you'll undergo an intensive diet and treatment regime, eat nourishing vegan food, do gentle yoga, and have massages and hot oil treatments. Each stay begins with a consultation with a doctor, who'll assess your needs.

INDIA

869 Attend a luxury Ayurvedic retreat in the mountains

Ananda in the Himalayas sits on a hillside overlooking the town of Rishikesh and the Ganges River valley. Its mission is to integrate traditional Ayurveda, yoga, and Vedanta (a form of spirituality) with international wellness practices. Yoga classes, stunning hikes, holistic treatments, and one-on-one meditation sessions are all part of the program.

INDIA

870 Visit Rishikesh, the yoga capital of the world

Crammed with ashrams, temples, and pilgrims and set alongside the sacred Ganges River in the Himalayan foothills, Rishikesh is the self-styled yoga capital of the world. Ease into this yoga heartland with a class at Parmarth Niketan Ashram, one of India's top yoga centers, which offers pranayama and Vedic healing for all abilities. Or try Rishikesh Yog Temple, which organizes retreats, teacher-training courses, and sound healing workshops.

870 Yoga in Rishikesh

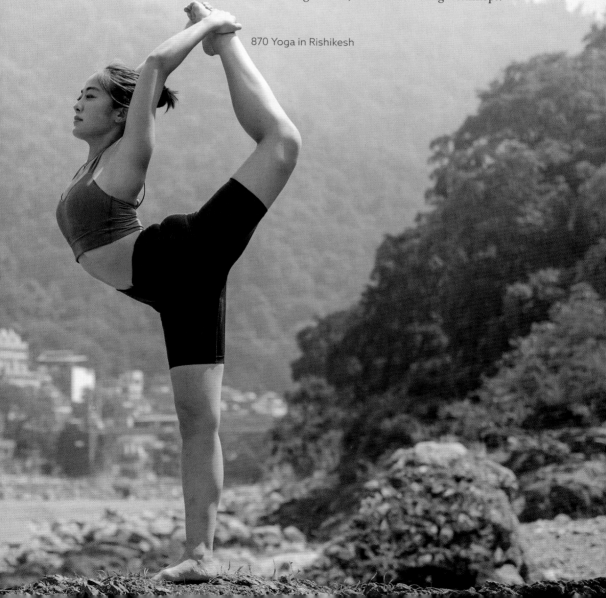

INDIA
871 Practice Vipassana meditation at Dhamma Giri

Dhamma Giri is one of the biggest Vipassana centers in the world, set around a golden pagoda that has over four hundred separate meditation cells. Join its intense ten-day retreat and you'll rise at 4 a.m. daily for ten hours of silent meditation, broken up by regular breaks and rest periods.

INDIA
872 Volunteer at a community canteen

For the Sikh community, helping others is part of daily life. And at the world's largest canteen, at the Golden Temple in Amritsar, everyone is welcome. Step in, join a queue—the food is free—then find a space and sit as the locals do. The food prep, cooking, and cleaning are done by volunteers. There is no pressure to join in, but give it a go and you will be enlightened by a new spiritual connection.

INDIA
873 Take a slow boat through the rural waterways of Kerala

Sail in a converted rice barge along canals and rivers and across lakes and past an island or two, as the world floats around you almost like a dream. Alternatively, if you canoe into a narrow channel and beyond the paddies, the pristine scenery greets you with flowers, exotic trees, and twittering birds.

873 Converted rice barge

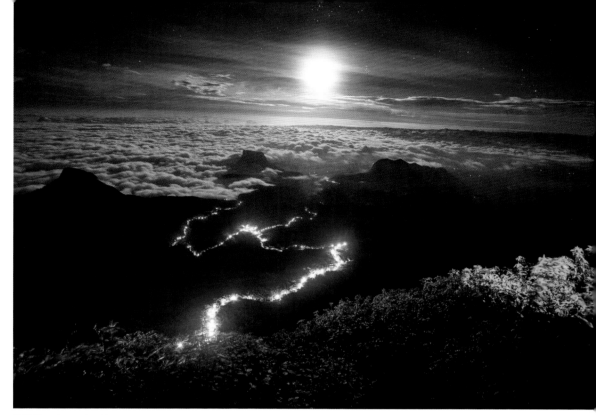

875 Illuminated pathway

874 Experience the feel-good factor of volunteering with wild elephants

You'll witness the intelligence and beauty of elephants firsthand on a week-long conservation vacation. Working with the Great Projects, you'll spend your time out in the wild, monitoring and tracking elephant activity from tree houses, as well as meeting with local communities who are affected by their presence.

875 Join pilgrims on the ascent of Adam's Peak

Adam's Peak is one of Sri Lanka's most dramatic natural landmarks and a celebrated pilgrimage spot, thanks to an unusual depression at its summit, the Sri Pada or "Sacred Footprint," supposedly left by the Buddha as he headed toward paradise. It has been an object of pilgrimage for over a thousand years, with the ascent up the illuminated pathways traditionally made at night, allowing you to reach the top in time for sunrise.

876 Relax to the max on a cinnamon plantation

Switch off in style at Tri, a secluded resort on an old cinnamon plantation by the shores of Lake Koggala. Each guest is given a bespoke plan of spa treatments and yoga classes—held in an airy treetop sala above a bamboo grove. Additional pampering comes in the form of a steam cavern and a sheltered relaxation area, with a gently trickling fountain and banks of scented white flowers.

879 Ulpotha retreat

877 Enjoy treatments at a stunning design hotel in Hill Country

A chic, modern design hotel enveloped by mist-soaked hills, Santani makes it easy to switch off. The views from the rooms are pure drama, and the hotel's elegant three-tiered spa is open to forest breezes. Choose from wellness packages including stress relief, improving sleep, and managing menopause. Or just chill out, book the occasional treatment, and luxuriate in the thermal salt pool or sauna.

878 Unplug and watch magnificent wildlife at an off-grid eco-resort

Set in blissful isolation in Gal Oya National Park, Gal Oya Lodge offers an uplifting combination of wildlife watching and relaxation. Bungalows made from natural, local materials blend beautifully into the landscape, and forest walks and boat trips make the most of the park's tranquility. Throw in magical elephant encounters and you've found the wilderness escape of your dreams.

879 Go off-grid in an agricultural community

An emotional, physical, and spiritual reset is in the cards at Ulpotha, a Buddhist agricultural community that welcomes guests. You can come for the yoga and Ayurvedic programs or just as a restorative getaway—either way you'll reap the calming effects of life surrounded by nature. Accommodation is in adobe huts that are open to the elements, and you can swim in the lake, go bird-watching, or relax in a hammock.

880 Practice self-love at a wellness retreat

Squeezed between a lagoon and a blissful beach, Sen Wellness Sanctuary is a place where rest, relaxation, and digital detox are encouraged. Days are aligned with the rhythms of the natural world—they begin at dawn with an energizing sunrise yoga session and end at 8 p.m. with lights out for a restorative night's sleep. In between, you'll fill your time with yoga, meditation, Ayurvedic treatments, and Buddhist rituals.

881 Join a revitalizing Ayurvedic retreat

You can meditate, practice yoga, and get involved in rural life at Plantation Villa, an Ayurvedic retreat set on a coconut, cinnamon, and black pepper plantation and run by the village community of Nehinna. You'll undertake a full Ayurveda plan, following consultation with its on-site doctor. Treatments include herbal medicines and yoga and meditation classes, as well as personalized farm-to-plate meals.

882 Visit a plantation to enjoy the health benefits of tea

Nuwara Eliya is at the heart of Ceylon tea country. Explore the trails with a guide, learn about the process and different varieties of tea, then taste it with an expert. These are health-giving teas, rich in antioxidants and trace minerals such as manganese. Ceylon tea can control blood sugar and cholesterol, keep your heart healthy, and improve your weight.

882 Tea plant

MALDIVES
883 Enjoy a massage with medicinal plants

Therapists at Sun Siyam Iru Fushi use Indigenous treatments, which draw on the wisdom of Dhivehi medicine, traditional herbalism, and age-old bodywork techniques. For example, guests may be covered in a paste made from freshly picked herbs and then wrapped in banana leaves to relieve body aches and joint pain. Following treatments they are invited to plant a coconut tree—a sustainable act to preserve the island.

MALDIVES
884 Go on a luxurious caviar journey

Caviar isn't just for fancy meals, it's also used in a signature treatment at St. Regis Maldives Vommuli. Its luxurious caviar journey is a mammoth three-hour session that uses caviar protein to firm, tone, and hydrate the skin. Once you're done being slathered in the stuff, you get to eat it too—while sitting in a lavender bath gazing out at an impressive ocean view.

MALDIVES
885 Get a star-studded high at a night spa

Performed on a candlelit terrace beneath a radiant night sky, the night spa at Four Seasons Maldives is both magical and restorative. Skin brushing, a body wrap, and a massage are followed by a relaxing beauty bath, all designed to lull body and mind into a meditative state. Add to this the soothing sounds of the ocean and you'll fall into a deep sleep the minute your head hits your pillow.

883 Bodywork

887 Overwater bungalow

886 Enjoy holistic therapies overwater at COMO Maalifushi

Follow in the perfectly pedicured footsteps of beauty editors and head to COMO Maalifushi resort, where warm breezes blow through the yoga studio, and overwater treatment rooms look out at a vast expanse of blue. Choose anything from marine-algae therapy to a hydrating facial to a deep tissue massage—it'll feel even better in the open.

887 Indulge in a massage from the comfort of your overwater bungalow

There are few more dreamy settings for a back massage or an herbal body wrap than above the impossibly clear waters of the Indian Ocean. At Anantara Kihavah the two-bed overwater villa comes with its very own spa suite, complete with glass panels below so you can gaze at colorful fish while you're having your treatment.

888 Indulge yourself on an island dedicated to your well-being

Bodufushi, one of the Maldives's 1,192 islands, is a little different from the others—the whole island is dedicated to the well-being offered by JOALI BEING. There is sound therapy in the forest, meditation, a hydrotherapy hall, herbal healing, and Watsu therapy. Succumb to your surroundings and let your mind and body feel free.

889 Wellness workshops for multigenerational travelers

Even the younger guests are encouraged to think about well-being at JOALI BEING. Families with children can discover the play zone, while older offspring can try their hand at making natural self-care products. The whole family can take part in well-being and sensory workshops, chat with marine biologists, and discover sound healing.

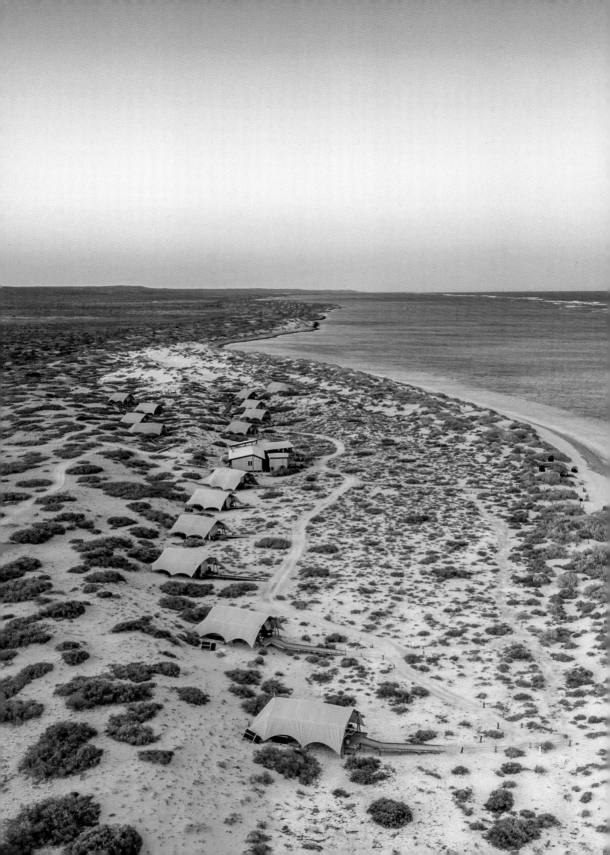

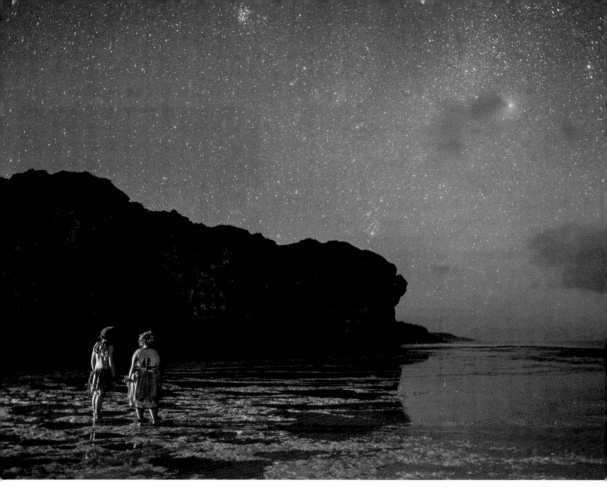

900 Dark Sky Nation

900 Magical stargazing at the world's first Dark Sky Nation

The tiny island nation of Niue is the world's first Dark Sky Nation—where the night sky isn't obscured by light pollution or other light sources. Guided stargazing tours are led by trained Niuean community members, who hold knowledge that has been passed down over centuries. Catch a breathtaking canvas of stars, including the Andromeda constellation and the Milky Way, and learn why the skies hold huge emotional, cultural, and spiritual meaning for the people of Niue.

901 Sign up for a stand-up paddleboard yoga session

If the sublime beauty of the Cook Islands isn't restorative enough, go that extra mile and sign up for a yoga session. The twist? Your classes will take place on a stand-up paddleboard. You'll first get your sea legs with a shore-based introduction, then paddle a short distance to a calm lagoon to practice your poses on the water. For maximum impact, try a class at sunset or a floating meditation session at dawn.

FRENCH POLYNESIA
902 Chill out in total luxury at a paradise private-island resort

Oozing unspoiled beauty out of every pore, the private atoll of Tetiaroa is where actor Marlon Brando fell in love with the South Pacific, buying the island group and setting it up as a personal retreat. Now it's home to the Brando, a resort that's the epitome of understated luxury. Everything here is designed to help you drift away from all your worldly concerns, from the secluded overwater bungalows to the intimate fine-dining restaurant, to the tropical copse that contains a flower-strewn lake and a spa.

FRENCH POLYNESIA
903 Engage with the Polynesian concept of a life force

Feel the life force at the Varua Te Ora Spa, a self-sustaining wellness sanctuary at the Brando on the island of Tetiaroa. Find spiritual healing on this atoll to connect with nature, culture, and the way of life on the land chosen by Tahitian chiefs and royalty for its beauty rituals. Indulge in treatment rituals, which include massages with Polynesian instruments to lead you to your mana—the Polynesian concept of a life force.

902 and 903 THE BRANDO

Massage

Hermit crab

Fine dining

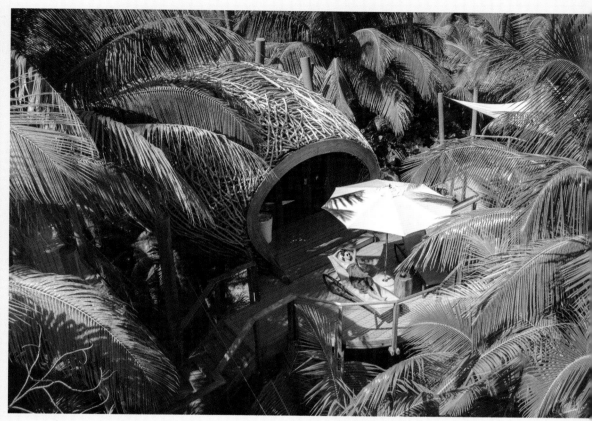

Overwater bungalow

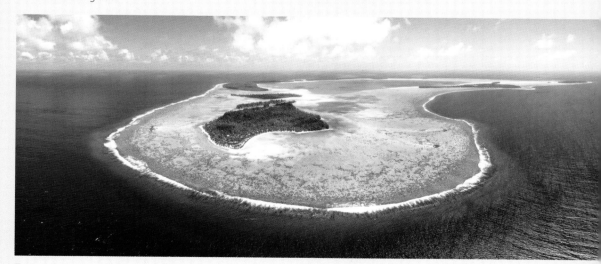

Tetiaroa

904 Massage

904 Have a massage with monoi oil

In French Polynesia, the word for a massage is
taurumi—*tau* means to pose, and *rumi* means to
smooth deeply. Using rhythmic movements and
locally made monoi oil—a blend of coconut oil and
the tiare flower—a *taurumi* will relax you both
physically and mentally. There are many spas on the
island, often sited in traditional buildings, and it's
the perfect way to soak up the island's culture.

905 Book an overwater bungalow with a sauna and well-being room

You'll barely need to move a muscle to have a spa
treatment at Conrad Bora Bora Nui. Its lavish
overwater presidential villas come complete with
their own well-being room with a sauna, as well
as a private host who can organize all the spa
treatments you need—from hot stone massages
to indulgent facials.

906 Heal yourself in seawater from below a Bora Bora resort and spa

Harness the healing power of the rich seawater
captured from the depths of the Pacific Ocean.
The pearl rain massage at the InterContinental
Bora Bora Resort involves a forty-minute massage
under a warm, deep-sea shower. The combination
of the falling water and the massage is bound to be
the ultimate in relaxation.

907 Take seawater therapy to a new level

Seawater therapy—or thalassotherapy—has been
taken to new levels at the InterContinental Bora Bora's
Deep Ocean Spa in French Polynesia. The products
used in treatments here are made with marine extracts
to remineralize the skin, but best of all the treatment
rooms are glass-bottomed so you can watch the fish
swim by as you relax.

908 Recharge your batteries Polynesian style

Where better to press the restart button than at the NIU Shack in the Tepuhapa valley. It's no coincidence that the name of this sustainable guesthouse plays on the pronunciation of "new," but also stands for "nature inspires us." Enjoy vegan food and treatments by the river in this remote, lush valley where you can appreciate the power of nature and the importance of responsible consumption—in your diet or your lifestyle.

909 Swim in a pool shrouded in legend

The three waterfalls of the Faarumai Valley come with the legend of a princess who persuaded a man to run away with her so that she could leave her lonely life behind. Their escape was aided by the waterfalls, and the couple are said to have lived behind one of them. You can swim in this peaceful spot, and let nature and the legends feed your soul.

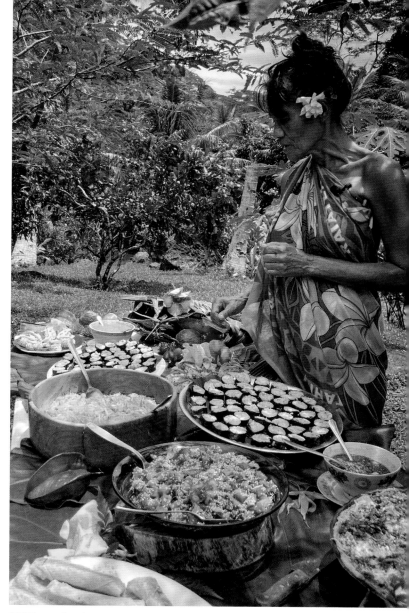

908 Vegan food

910 Let rituals guide you to the sacredness within

On a sacred-life retreat in Tahiti, guests are immersed in the spiritual side of local culture on a journey to connect them to the "sacredness within." Guests of Tahiti Islands Travel visit the hallowed Papenoo Valley, learn about local plants, and attend waterfall cleansing rituals and a fire ceremony.

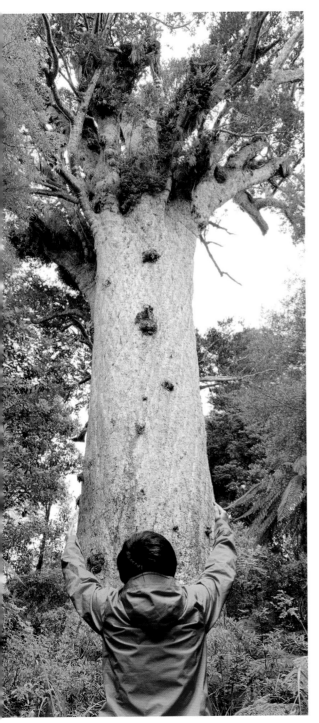

911 Have a spiritual encounter in the Waipoua Forest

Walking among the trees in the Waipoua Forest is an almost spiritual experience, and these giants are up to three thousand years old. Book a twilight tour with Footprints Waipoua and you'll feel the forest transition from day to night. Your guide will spin stories and legends about the forest before greeting the trees with bewitching songs.

912 Soak up the majesty of one of the world's oldest living trees

The restorative power of nature and the benefits of experiencing moments of awe are well documented. Combine both with a walk to Tāne Mahuta—the God of the Forest—the largest living kauri tree standing today. Tāne Mahuta has stood in this spot for at least one thousand years, possibly two thousand. Feel diminished by its great size.

913 Find clarity, compassion, and inner peace on a solitary retreat

Taking a few days away can bring a great clarity of mind. The Mahamudra Centre is a peaceful Tibetan Buddhist retreat surrounded by nature on the serene Coromandel Peninsula. Book a cabin for a solitary retreat knowing that you'll be surrounded by others who can support your goals.

912 Kauri tree

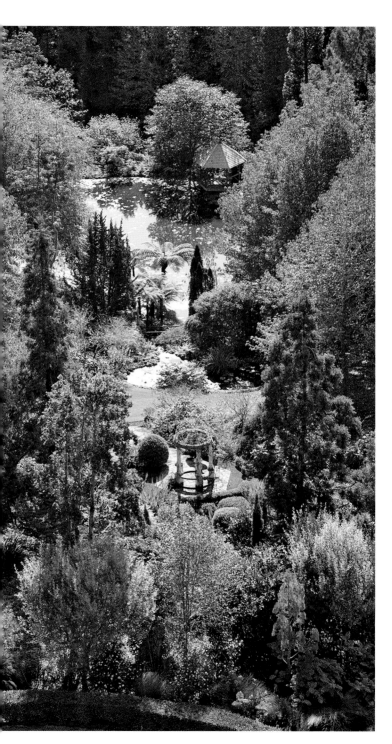

914 Enjoy the tranquility of a thoughtfully created garden

Every week of the year, one of the plants in Ayrlies Garden will be looking its absolute best. You can also stroll on the lawns or sit by one of the ponds and waterfalls to enjoy the sounds of nature. Whenever you visit, there will be color and vibrancy to make you smile and peace and tranquility to help you to relax.

915 Find peace in a Zen garden

Japanese *karesansui* gardens take gravel, stones, and a minimal amount of vegetation to imitate the essence of nature. Their simplicity is designed to aid with meditation, and while they are usually found in monasteries and temple grounds, you can seek out this refuge of calm at Hamilton Gardens where the *karesansui* garden forms part of the Japanese Garden of Contemplation. Sit, breathe, and let serenity in.

914 Ayrlies Garden

NEW ZEALAND

916 Connect to nature with some forest bathing

A ferry ride from Auckland is the beautiful Waiheke Island. Disembark and immerse yourself in a sensory forest walk with Terra & Tide, led by a qualified practitioner. Allow each of your senses the space to expand and explore the natural world. After a tea ceremony, you will leave feeling relaxed in body and mind and as if you'd just enjoyed a massage from nature.

NEW ZEALAND

917 Stimulate all your senses in nature

Whangārei Quarry Gardens is a labor of love created by volunteers over the last twenty years in a disused quarry. You only need to wander around the Five Senses Garden for a short while to let that love filter into your bones. Dotted with sculptures, the plants appeal to each of your senses, leaving you enamored with the power of nature.

NEW ZEALAND

918 Hit the reset button to find your best self

There is a wildness about Karioitahi Beach that hooks you in. It makes it the ideal location for a revive-and-reset retreat at the Castaways Resort, which aims to hit the reset button for your mind, body, and soul. You'll receive expert nutrition advice, and a personal trainer and a yoga instructor together will provide a balance of rest and movement.

918 Karioitahi Beach

919 Connect to the earth with a traditional Maori meal

There is something that speaks to our primal core when we use the elements of the earth to sustain us. And so it is with food cooked in a *hāngī*—the traditional Maori underground oven that infuses food with smoky, earthy flavors. There are many places that recreate a *hāngī* with a modern take, but at the Maori Kitchen in Auckland, they still use pits dug into the ground.

920 Join a men-only retreat to get into nature, rest, and reflect

Modern life has taken us a long way from our ancestors' ways of hunting and gathering, living life following the cycles of the seasons and the sun. Get back in touch with this way of life on a men's well-being retreat with Provider Retreats. The emphasis is on fishing and foraging for food, being active, and talking through your stories and your struggles in a nonjudgmental environment.

921 Enjoy barefoot sensory immersion

Our feet are connected to twenty-nine muscles, each of them working to help us to move and to balance. Our shoes often give us added comfort, but this can come at the cost of reducing our muscle use and strength, affecting our posture, and leading to aches and pains. Let your feet go free on a barefoot sensory immersion walk along the beach with Wellbeing Wanders to connect with nature and work on your posture.

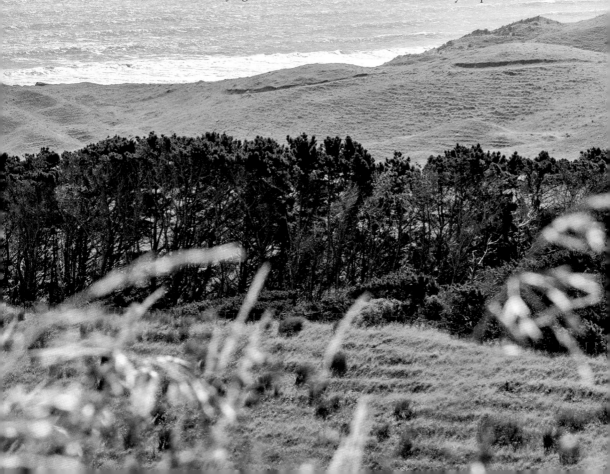

922 Dig your own spa on Hot Water Beach

You'll need a spade, a swimsuit, and some muscle to experience the healing powers of Hot Water Beach on the Coromandel Peninsula. Naturally heated mineral water bubbles up through the golden sand and is accessible two hours before and after low tide. Get digging and you can relax in your very own homemade hot tub, just paces from the ocean.

923 Get your balance back with a zero-balance therapy

Zero balancing is a form of therapy that uses touch and traction to clear chronic tension and help the body's energy to flow more freely. It combines a Western understanding of anatomy with an Eastern understanding of energy flows to create bone-deep relaxation. Experience a zero-balancing therapy at the Earth Energies Sanctuary in Mangatarata and feel decades-long aches and pains slip away.

924 Join a women-only weight loss, health, and wellness retreat

The key to a healthy body weight is a healthy diet and regular exercise. On a Resolution Retreats's women's weight loss, health, and wellness retreat, you can get that ball rolling with delicious, nutritious meals, yoga, meditation, and daily fitness sessions. The minibreak also includes expert speakers providing education on nutrition, exercise, and health, plus daily cooking classes, so you can keep that ball rolling when you're back home to make all the changes you need in your daily life.

922 Hot Water Beach

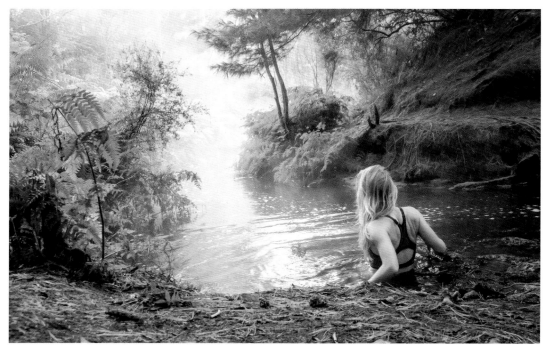

927 Kerosene Creek

925 Yoga, surfing, and plant-based food

Magical Raglan is the setting for Solscape, an eco-resort that emphasizes doing good for the community, your body, and the planet. You can sign up for lessons at the on-site surf school, take part in daily yoga classes, or book a massage or sauna session. Or for a really deep dive, there are workshops in holistic wellness. The on-site Conscious Kitchen serves up ethically sourced plant-based cuisine.

926 Bathe in geothermal mineral water in Rotorua

There's plenty of action for hot spring enthusiasts in Rotorua, New Zealand's most active geothermal area. Head for Hell's Gate Geothermal Reserve and Mud Spa, where you can try a mud bath or de-stress in a sulfur spa, then rinse off in a waterfall. The nutrient-rich waters can help ease inflammation and arthritis, as well as rejuvenate the skin.

927 Swim in a natural hot spring

It's invigorating to walk into the jungle and see steam rising before you. This is the view when you arrive at Kerosene Creek, around 19 mi. (30 km) from the center of Rotorua. A small waterfall drops into a tranquil hot pool where you can relax and feel the mineral-rich waters soak your troubles away.

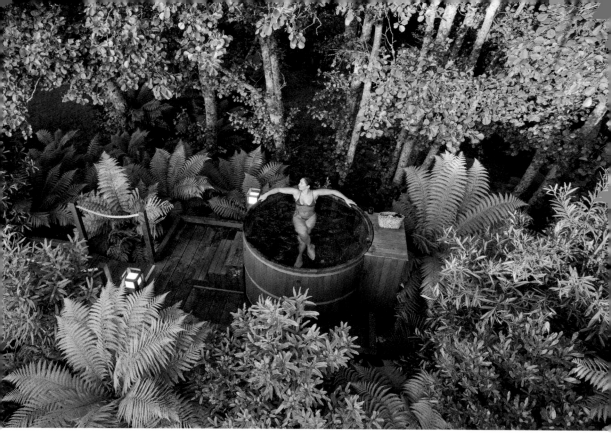

929 Secret Spot Hot Tubs

928 Stargaze from a mineral bath

Head out to the Waitangi Soda Springs, between Lake Rotoma and Lake Rotoehu, after dark to experience the pleasure of a hot mineral bath combined with fabulous stargazing. Light pollution here is minimal so you can feed your mind while allowing the iron-rich water to soak away your aches and pains.

929 Indulge in some hydrotherapeutic forest bathing

Hot and cold hydrotherapy—where you move between pools of two extreme temperatures—can improve blood circulation, ease muscle tension, and reduce fatigue. Do it in style at Secret Spot Hot Tubs, where the cedar hot tubs look out over the Whakarewarewa Forest and Puarenga Stream, and can be combined with a cold plunge cedar tub.

930 Be nurtured with slow food

A historic country house at the end of a winding lane, Wallingford Homestead combines classic luxury with good food. Spend the day relaxing in the house and gardens, then in the evening enjoy the best of what the slow-food movement has to offer. Discover the stories behind the feast of flavors on your plate, then meet the chef while he bakes your sourdough bread.

NEW ZEALAND

931 Find nature in the heart of a city

In the heart of downtown New Plymouth, find your way to the natural haven of Pukekura Park, where you can breathe air that is filtered by thousands of plants. Cross the lake on Poet's Bridge, wander into Kunming Garden through the circular Moon Gate, and listen to the sounds of water and birdsong. Nature is everywhere.

NEW ZEALAND

932 Lose yourself for a while in a peaceful encampment

Once a weedy valley, Te Kainga Marire—which translates as "peaceful encampment"—has been transformed into a tranquil and harmonious native Maori garden. Wander slowly to notice the many textures and colors of the native planting that is a tiny microcosm of New Zealand.

NEW ZEALAND

933 Enjoy the healing power of a sound bath

The vibrations of a sound bath ripple through your whole body, producing a deep sense of relaxation and also releasing stagnant energy and negative emotions. Join one of Resonant Sound Healing's events in Wellington's Botanic Gardens to immerse yourself in the natural world, self-love, and discovery.

NEW ZEALAND

934 Give your feet a treat with reflexology

Put your feet in the hands of an expert with a reflexology session at Westhaven Retreat in Golden Bay—a beautifully designed lodge set on a hill surrounded by nature. Reflexology uses pressure points to stimulate the feet. You can use it to address particular concerns or to produce an all-around sense of relaxation.

NEW ZEALAND

935 Sip and sample award-winning organic wines on a wine tour in Marlborough

From glaciers to lakes, hiking, and cruising the Marlborough Sounds, this country has plenty to offer—including organic wines. Marlborough is the largest wine-growing region, and its vineyards are set in stunning landscapes with valleys of vines leading to open stretches of rolling countryside. Here, winegrowers work with nature to boost the biodiversity of their vineyards to produce heartier skins and higher concentrations of anthocyanins and antioxidants, including polyphenols and cardio-friendly resveratrol.

935 Marlborough vineyard

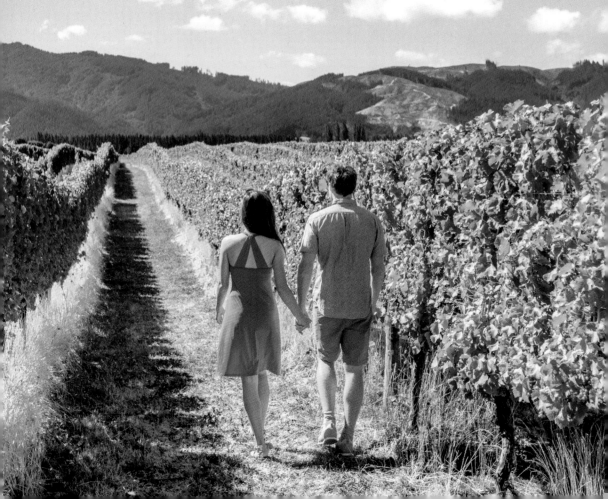

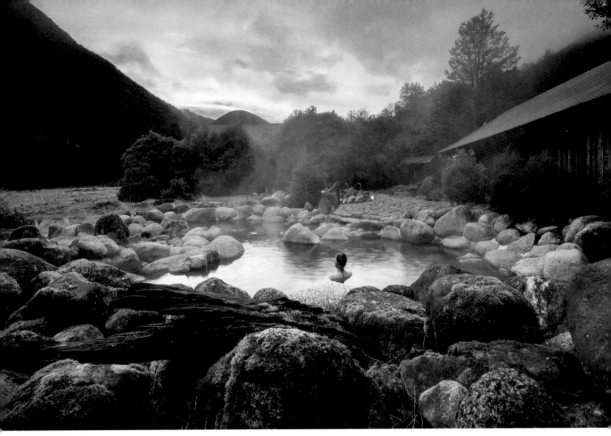

936 Maruia hot spring

NEW ZEALAND
936 Get some TLC for your skin and muscles

You can bathe in the shadow of the snowcapped Southern Alps at Maruia, a natural hot spring, day spa, and wellness destination. The water is full of minerals including sulfur, boron, and hydrogencarbonate, which can help increase circulation, soothe muscles, and ease eczema. It also contains black algae, which you can rub on your skin for a beautifying effect.

NEW ZEALAND
937 Feel revitalized at a family-friendly spa

Which of the twenty-two pools at Hanmer Springs will you visit first? In addition to geothermally heated pools, there are water slides, an activity pool, and a lazy river where you can swim against the current. It's truly a thermal spa for the whole family, meaning you can benefit from the relaxing qualities of the water and the smiles of your nearest and dearest at the same time.

NEW ZEALAND
938 Visit the happiest garden on earth

If ever you are in need of injecting a little joy into your life, a visit to the Giant's House in Akaroa is sure to do the trick. Created by gardener and artist Josie Martin, the place is full of multicolored, larger-than-life mosaic sculptures. There are elegant cats, twirling ballerinas, and a mosaic grand piano hiding a garden within. Time spent here is a little foray into happiness.

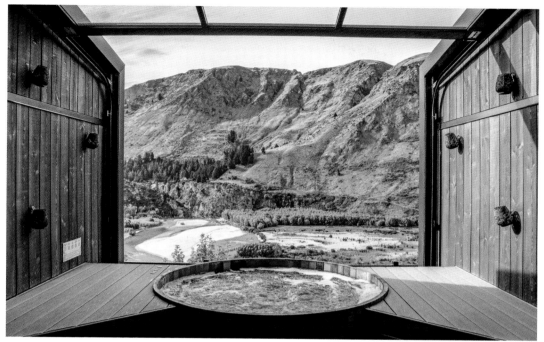

941 *Onsen* at Shotover River

NEW ZEALAND
939 Feel the high of completing the Routeburn Track

There are few better ways to get the endorphins flowing than to head outdoors, get active, and take in beautiful landscapes. Add the challenge of a long-distance hiking route (and the euphoria once you're done) and you've got a major well-being boost. The three-day Routeburn Track takes you across the mountains and valleys of two national parks: Fiordland and Mount Aspiring.

NEW ZEALAND
940 Explore nature on an e-bike

New Zealand's largest private conservancy, Mahu Whenua (the name translates as "healing the land"), is a beautiful area of mountains, rivers, and valleys. Once extensively farmed, it is now being regenerated to flourish with native flora and fauna and opened up for people to enjoy. Take an e-bike ride through the area and open your mind to the opportunities that a vision for change can bring.

NEW ZEALAND
941 Explore Japanese-style *onsen* hot pools

The magical relaxation properties of *onsen* are so well known that there isn't a Japanese town without one. But few Japanese *onsen* can boast quite the view of the one ten minutes outside Queenstown. Onsen's cedar hot pools look out over the Shotover River and mountains beyond. The bathing waters are personalized with scents and salts to complement the massage that follows.

942 ARO HĀ

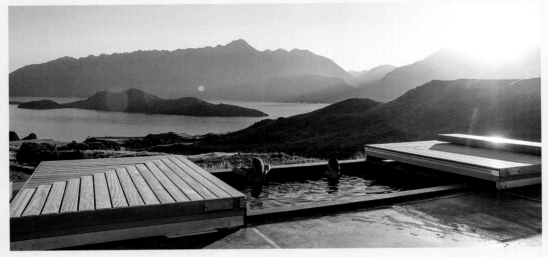

Outdoor pool

Balanced meals

Yoga

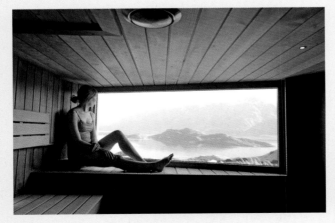

Sauna

Food from the garden

942 Slow down aging at a luxury retreat

What's the secret to slowing down biological aging? With the help of nutrition and health coach Ben Dessard, a retreat at the Aro Hā Wellness Retreat aims to achieve it through contemplative silence, mindful movement, and a plant-based menu. The architecture here is designed to foster the connection between nature and wellness—making it easy to let the pristine landscapes wash over you.

943 Reconnect with your breath

Today's constant use of technology can lead to feelings of stress and an inability to switch off and enjoy the moment. At Aro Hā, swap Instagram images for views of snowcapped mountains framed by the sauna window, and your morning alarm clock for the sound of a Tibetan bowl. It's easy to tune back into yourself and your breathing with these stunning surroundings, sunrise yoga, and massages.

944 Enhance your health with nutritional teachings

There is a growing awareness of the importance of nutrition for our long-term health. On a retreat at Headwaters Eco Lodge, health coach Sian Leigh shares the latest research so that guests feel empowered to make the dietary changes that suit them. There's also the chance to enjoy yoga, mountain walks, and massage.

945 Slow down and enjoy the process

Cooking with your heart not your head is the focus of a plant-based cooking program at Te Whenua retreat center. As well as giving you recipes, nutrition, and wellness tips, the retreat puts the focus firmly on exploring and connecting. Cooking isn't just about the joy of the results, it's about savoring the smells and the sensations along the way.

946 Watch waves crash on the Moeraki Boulders

Nature itself is often enough to offer us moments of reflection. Take a walk along Koekohe Beach and contemplate the clusters of spherical boulders that lie along this shore. Such perfect forms, combined with the gentle sound of lapping waves on a calm day or a thunderous sky on a stormy one, will give you plenty to feel good about.

946 Koekohe Beach

AUSTRALIA

947 Enjoy a Finnish sauna at the beach

Sweat out your body's impurities while watching the rolling ocean through the sauna window at the Neighbourhood Sauna in South Beach, Fremantle. You can pop down to the water to cool off or use its dedicated showers. Either way, the hot then cold experience improves circulation and gives you that va-va-voom feeling.

AUSTRALIA

948 Breathe in the sea air as you indulge in a Swedish-style massage

Throw the glass doors open wide at Injidup Spa Retreat in Yallingup and you can soak in the fresh air and sounds of the ocean while one of the beauty specialists massages away your stresses and strains. The Swedish massage here includes essential oils so that you leave feeling calm and rejuvenated.

AUSTRALIA

949 Go off-grid glamping among the dunes

There's no Wi-Fi or cell phone reception at Sal Salis, an upscale camp set among dunes by the Indian Ocean and overlooking Ningaloo Reef. A stay here is all about putting aside routines and connecting with the landscape and wildlife. You can swim with whale sharks or green turtles and explore the World Heritage–listed Ningaloo Reef, which is within swimming distance.

AUSTRALIA

950 Feel connected to the earth in the Olive Pink Botanic Garden

Wander up Tharrarletneme (Annie Meyers Hill) in the Olive Pink Botanic Garden in Alice Springs and reflect on the Dreamtime Yeperenye story that explains how the MacDonnell Ranges came into being. Let your mind wander as you look out for wallabies and colorful birdlife and feel that sense of connection to the earth.

AUSTRALIA

951 Gaze at the Milky Way

To see the Milky Way, and the thousands of galaxies each dot of light represents, is to understand our place in the universe. It's a humbling experience. At Earth Sanctuary's carbon-neutral venue outside Alice Springs, you can be guided around the night sky with the use of a powerful telescope and leave feeling educated and in awe.

AUSTRALIA

952 Hike yourself to health on a women-only exploration

The Larapinta Goddess Walk offers the chance to experience the beauty of the Northern Territory—and to unwind with a group of like-minded women and a female guide. You'll walk for four to five hours a day along the Larapinta Trail, with time in between for yoga and meditation. Evenings are spent around the campfire, taking in the stars.

AUSTRALIA

953 Feel the connection at Uluru

No matter how many pictures you've seen, your first glimpse of Uluru will make you catch your breath. At 1,141 ft. (348 m) high, this six-hundred-million-year-old monolith stands proud on the vast red plains of Anangu land, shifting in color and mood according to the time of day. It's one of Australia's most sacred sites, and a pilgrimage here will make you feel part of something big and indefinable.

AUSTRALIA

954 Luxury, culture, and Uluru views

The views of Uluru from Longitude 131° are so good you could spend hours just taking them in. But this sustainable tented camp encourages cultural connection too. Walk with Anangu guides who have an extensive knowledge of this ancient land, visit the Aboriginal artists in residence, and get some downtime in the spa, which reflects the design of a traditional Aboriginal *wiltja* (shelter).

954 Longitude 131°

AUSTRALIA

955 Rediscover your purpose

Remove any stigmas around mental health as you enjoy the journey to happiness at Living Valley. With a mission to provide holistic approaches to mental health, its Mind Wellness Program enables guests to craft a life path filled with purpose and fulfillment. Bask in the rolling hills of Queensland and expect to walk away with emotional support, lifestyle tools, and fitness plans.

AUSTRALIA

956 Feel the benefits of cow cuddling

An animal rescue farm and therapy center all in one, Queensland's Cow Cuddling Co. invites adults and children to meet, sit with, and—of course—cuddle their hand-raised therapy cows. The idea is that a cow's slower heart rate and warm body temperature can make us feel calmer, lowering stress and releasing oxytocin, our feel-good bonding hormone.

AUSTRALIA

957 Meditation and mindfulness

The Vipassana Centre Queensland promotes one of the world's oldest Buddhist meditation practices. Join a ten-day retreat and you'll spend the entire time in silence, meditating for about twelve hours a day, and learning to be aware of your body and what is happening in the moment. It's emotionally and physically challenging, but improves mental clarity.

AUSTRALIA

958 Recharge on the waters of the Great Barrier Reef

Lizard Island National Park comprises six beautiful islands that lie on the Great Barrier Reef—Lizard, South, Osprey, Eagle, and Palfrey Island and Seabird Islets. While each one is rich in biodiversity, Lizard Island is a haven for wellness enthusiasts. Its seclusion grants downtime for meditation, while the reefs and clear water offer the chance to connect with the marine wildlife through snorkeling and diving.

958 Lizard Island

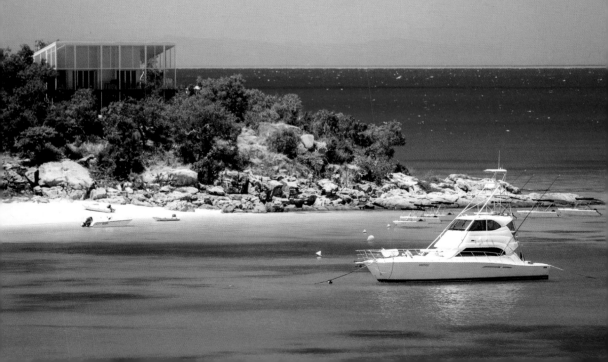

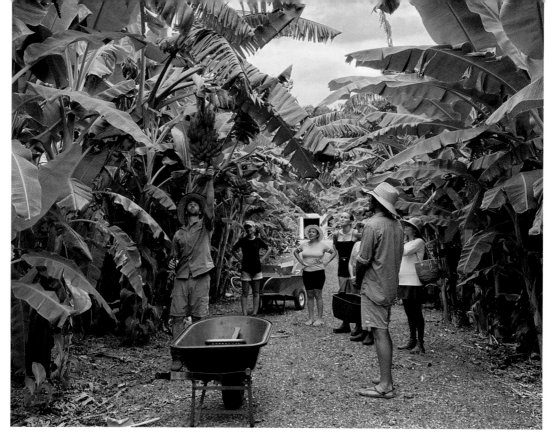

961 Growing produce

AUSTRALIA

959 Take a sunrise class of Qigong at Gwinganna Lifestyle Retreat

Start the day watching the sun rise above the ocean as your body slowly flows from one movement to another during a Qigong session at Gwinganna Lifestyle Retreat on Queensland's Gold Coast. Follow this with a prebreakfast walk through the rainforest listening to the sounds of the animals and birds to feel perfectly set up for the day.

AUSTRALIA

960 Break the sleep, sugar, and stress cycle

Have you fallen into an unhealthy pattern of trying to cope with stress and insomnia by eating high-sugar foods? The Triple-S (sleep, sugar, and stress) program at Gwinganna Lifestyle Retreat aims to help break this cycle by showing participants how to manage stress, become more resilient, and use the body's natural rhythms to improve performance and productivity.

AUSTRALIA

961 Learn how to grow your own food

A connection to the earth is key for the earth to sustain us. And you can find that connection through growing fruits and vegetables, practicing yoga, and other events at Shambhala Living in Queensland. Join the team on this organic family farm to learn about growing your own produce, rewilding, and foraging. The sanctuary space offers services to grow and nourish the connection between body, mind, and spirit.

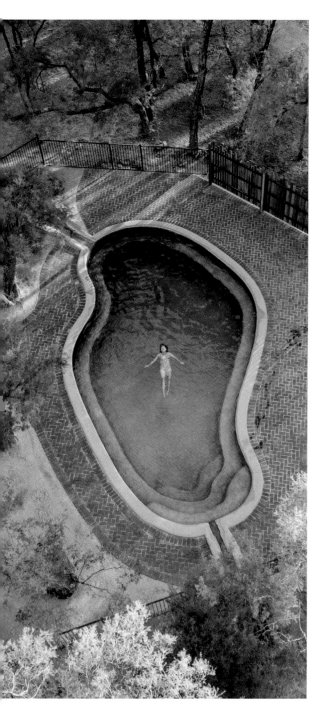

962 Reconnect with yourself and your route to health

Spend six days on a yoga and wellness retreat at Mission Beach in Queensland and you will feel as if you've been away for six months. Set between the rainforest and the beach, a stay here may include boot camps, healthy vegetarian food, art therapy, and a healing massage.

963 Experience the world's oldest living rainforest with a traditional custodian as your guide

Thought to be twice as old as the Amazon, the Daintree Rainforest is a thriving wilderness squeezed between mountains and tropical sea. Join a walk with a guide from the Kuku Yalanji community and you'll learn about native plant use, sample seasonal bush tucker, and get the chance to connect with both nature and the traditional custodians of this land.

964 Relax in a private soaking pool

Owned and managed by the Ewamian people, Talaroo Hot Springs is a geological wonder millions of years in the making, full of terraces, steaming pools, and radiant colors. Book a guided hot springs discovery tour to explore further, then try out the therapeutic waters in a soaking pool. For maximum atmosphere, book a private pool and gaze out at the surreal landscape in utter peace and privacy.

964 Talaroo Hot Springs

AUSTRALIA

965 Attend a men's mental and physical health retreat

Living Valley Men's Cleanse gives you valuable time away from the stresses of work and everyday life. Alongside organic, wholesome meals, you can take part in boxercise, breath and relaxation classes, attend healthy lifestyle lectures, and join sharing circles around a fire. Naturopathic consultations and life-planning sessions are also part of the offering.

AUSTRALIA

966 Make time for contemplation in every season of the year

Japanese culture places a great emphasis on connecting with nature and taking the time to reflect. *Kisetsukan* is the practice of appreciating and respecting what nature offers at different times of year. Revisit the Cowra Japanese Garden—and its serene teahouse—in each season to feel the gift of colors in fall, mists in winter, rebirth in spring, and abundance in summer.

AUSTRALIA

967 Nourish body and soul on a yoga retreat

Let the power of yoga, meditation, drumming, connection, and laughter lead you to feelings of joy and clarity on a Happy Buddha Retreat at Wentworth Falls in the Blue Mountain National Park. They call it the inner joy retreat, and you'll leave not only having found yours, but knowing that you deserve it too.

966 Teahouse

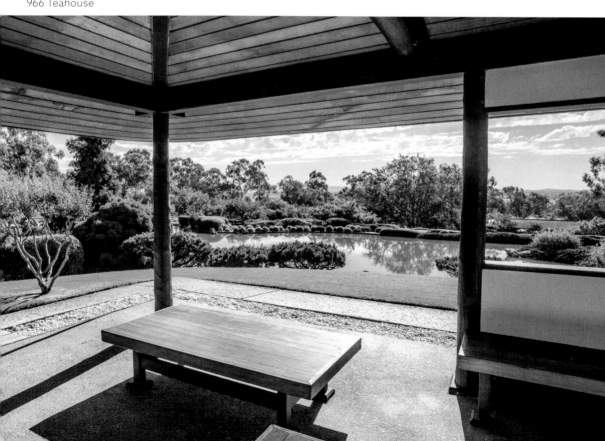

970 Bush tucker tour

968 Feel the mindfulness of playing with clay

Byron Bay is often called Australia's healing heartland: its pristine beaches and ozone-rich rainforests have been a destination for spiritual and wellness retreats for many years. One, the Gaia Retreat, sits at the highest point in the area, offering spectacular views as well as holistic, restorative treatments whether you choose to come for two days or a whole week.

969 Create your perfect blend of essential oils

A drop of bergamot, a dash of ylang-ylang, a splash of geranium—what will your personal blend of essential oils smell like? Join an aromatherapist at Synthesis Organics who will guide you through a meditation and body awareness exercise that will lead you to discover the blend that brings you the greatest sense of well-being.

970 Connect with the land and the plants that have sustained us for centuries

To be Indigenous to a land is to understand that we need to live in harmony with the earth. On an Aboriginal Bush Tucker Tour around Sydney's Royal Botanic Gardens, learn about the traditional uses of Indigenous bush foods and how they are employed today.

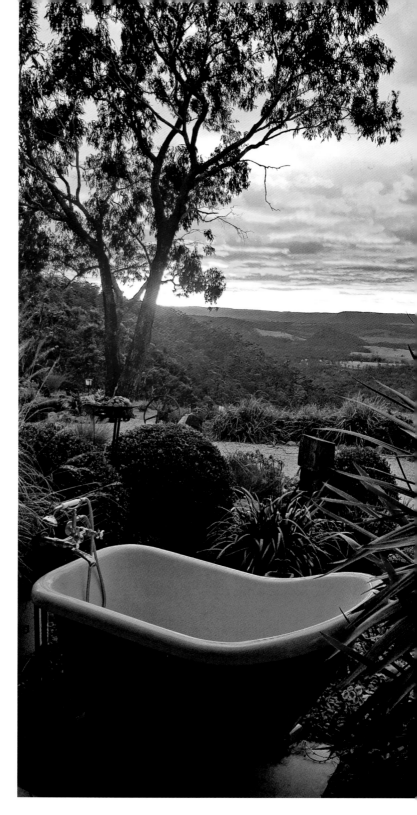

971 Reduce the impact stress has on your life

It's one thing to know that stress is bad for you, but learning how to reduce its presence in and impact on your life can be a different matter. On the stress less, thrive more retreat at the Billabong Retreat in northwest Sydney, you'll learn relaxation techniques and small changes you can make to reduce stress. Each night you can retreat to a cabin in a tree house or on a cliff.

972 Drink in the beauty of the Blue Mountains from a secluded outdoor soaking tub

The epic, bush-clad scenery of the Blue Mountains could be all the therapy you need, especially if you take it all in from the comfort of an outdoor bath. At Kookawood rural retreat—a characterful farmhouse crammed full of antiques—a claw-foot tub sits among the shrubs in the front garden, overlooking mountain peaks and well-placed for magical sunsets.

972 Outdoor soaking tub

973 Let heat and cold work their magic

You might think it takes a certain power of the mind to sit in an ice bath. In fact, ice baths improve brain function, so each time you take one, you improve that power. At the Life Centre Holistic Health and Wellness in Bewong, you'll mix ice baths with saunas, flotation therapy, breathwork, and personal training to increase your body's ability to heal and endure. And you'll emerge feeling full of health and happiness.

974 Bathe in natural mineral water surrounded by nature

The geothermal waters of Metung Hot Springs are full of natural minerals and trace elements, and a bath in them is said to detoxify the body. As you do so, you can look out over the Gippsland Lakes, alternate a dip with a cold plunge, and enjoy the site's geothermal showers and reflexology walk.

975 Experience a Himalayan ritual at one of Australia's oldest spas

Hepburn Bathhouse & Spa has been standing in the same spot since 1895, offering clients the relaxing benefits of its mineral-rich waters. Enhance the experience with a Himalayan salt ritual that includes a heated salt-stone massage, which loosens your muscles as it relaxes them, and a natural salt-stone exfoliation, which leaves your skin feeling soft and purified.

973 Ice bath

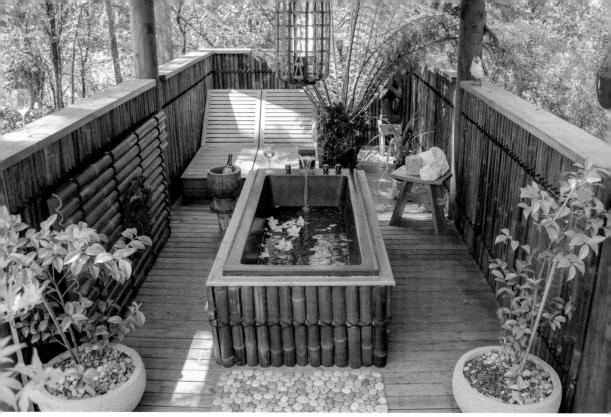

978 Japanese-inspired hot tub

AUSTRALIA

976 Feel the freedom that a sound-healing session brings

Let the resonance of sound-healing instruments wash over and through you, to leave you feeling utterly relaxed, centered, and ready for the world. This is just one of the techniques a well-being retreat at the Great Ocean Road Resort offers to help you feel relaxed and replenished. There are also nature walks, yoga sessions, saunas, and meditation.

AUSTRALIA

977 Connect with your teen daughter

On the great journey that is parenthood, it's vital to take the time to connect with your child. The aim of a Rise Up mother and teen retreat at the Great Ocean Road Resort is to empower, build confidence, and foster independence. Moms and daughters spend time together on a beach walk and take part in fitness sessions, but they also get some alone time—in the spa for moms while their daughters learn about nutrition and kinesiology.

AUSTRALIA

978 Take the Zaborin Walk—a certified forest therapy trail

Allowing each of your senses to connect with nature is a wonderful way to relax, and it also has many benefits for your health. Qii House eco-retreat in Lorne is not only a wonderful, quirky building surrounded by trees, but it also has a certified forest therapy trail on its grounds—the Zaborin Walk. Wander it alone or with a guide to enjoy the experience of wild meditation.

979 Take a thermal bath in a darkened room

Have you ever wondered why it feels so good to soak in a hot bath? It's the heat relaxing your muscles. At Alba Thermal Springs and Spa, the heat of its twenty-two geothermal baths is enhanced by the sulfur, calcium, magnesium, and potassium content of the water that not only relaxes muscles but can also alleviate aches and pains from stiffness or rheumatism and rid you of feelings of fatigue.

980 Find your own way

At various times in our lives, we all might need that extra bit of guidance to find our way. A wholeness retreat at Samadhi Spa & Wellness Retreat will help you look inside yourself and find that path. Through healthy eating, meditation, and discussion, you can find the direction to take to help you live a full and wholesome life.

981 Make your thermal bath a sensory journey

It's not just the geothermal, mineral-rich waters that will give you a boost at the Deep Blue in Warrnambool; your mind is also invited to explore while you're here. There's a sensory cave, an aroma pool, a rainforest cave, and a reflection bay so you can engage all your senses while soaking in the thermal baths.

AUSTRALIA

982 Relax in communal hot springs

A sanctuary for frazzled Melbournians escaping the city, Peninsula Hot Springs sits on the peaceful Mornington Peninsula and can meet all your well-being needs. There are wet and dry saunas, hammams, an ice cave, and a hydrotherapy pool, but most people come for the shared geothermal pools. The star of the show is the beautifully placed hilltop pool, which has wide-ranging views of rural Fingal.

982 Shared pool

AUSTRALIA

983 De-stress in an off-grid eco–tree house

Your accommodation alone will make you take a deep, slow breath—a modern-day tree house with floor-to-ceiling windows, designed to bring as much of the outside in as possible, with a bedroom set at treetop level. There are four units at Aquila Eco Lodges, a sustainable, off-grid retreat within the bushland of the Southern Grampians, within easy reach of some of the best walks in Australia.

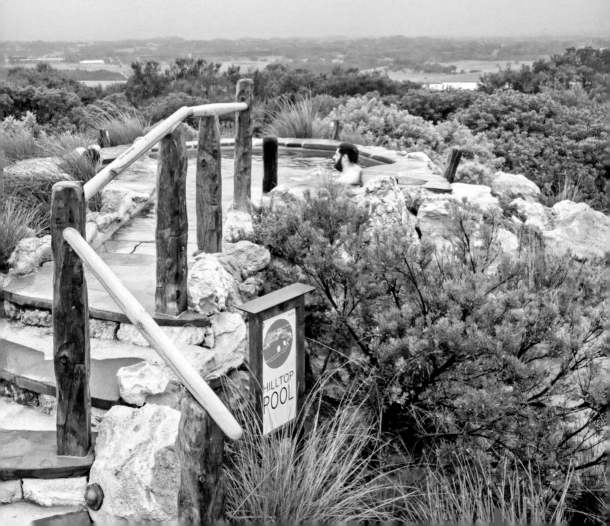

AUSTRALIA

984 Take yourself away from it all to a private island

Off the coast of Tasmania lies the wild and beautiful Satellite Island. There's something about staying on an island that gives you an instant feeling of adventure. Add to this the peace and the wildlife, the lapping waves, and the sunset from a private beach, and you can hardly imagine a better way to feel recharged.

AUSTRALIA

985 Take a fire and ice walk

Walk through the mountains, plunge into icy streams, sit around a fire, and indulge in some journaling on a Wild Wellness Method fire and ice walk that offers a feast for all the senses. Your guides will connect you with the local mountain, its stories and its wildlife, as well as coaching you through the Wim Hof method for breathwork prior to your icy plunge.

AUSTRALIA

986 Feel the spirit of Tasmania on the Wukalina Walk

An Aboriginal-owned and guided hiking experience, the four-day Wukalina Walk leads you through the bushland and windswept coastline of Wukalina and Larapuna—the cultural homeland of the Palawa people. This experience isn't just about immersing yourself in the coastlines, including the Bay of Fires, it's also a chance to connect with Tasmania's Aboriginal community.

986 Bay of Fires

987 Create a mindful mandala

Mandala is a sanskrit word that translates as "circle," and a circle has no beginning and no end. That is what attracted Cathy Gray to the art form, creating intricate works out of pen and ink that can take hours to produce. Join her in a Mindful Mandala workshop to harness your creativity. At the end of the session you destroy your artwork, freeing you to explore without any restrictions.

988 Take a mindful stand-up paddleboard session

Mindfulness is the art of being in the moment and letting other cares fall away. On a Mindfulness in the Mangroves session, after paddling to a quiet spot in the mangroves, you will lie down on your paddleboard, close your eyes, and listen to the sounds of nature around you, feeling the gentle movement of the water below. Take the time to slow down.

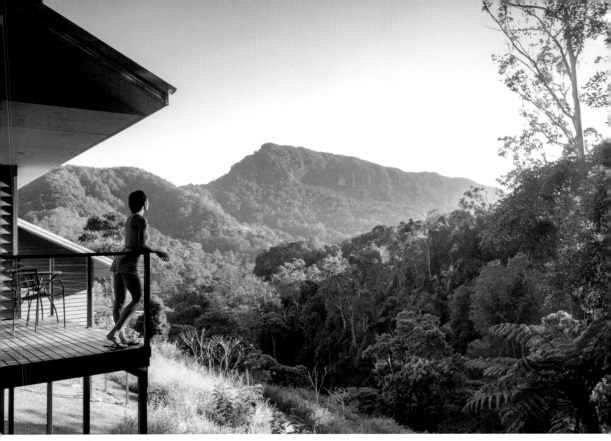

989 Valley view

989 Find your own preference for stress removal

Relaxing is an essential part of removing stress from your life, but not everyone enjoys the same techniques. At the Eden Health Retreat in the Currumbin Valley, you can take a mindfulness walk in the labyrinth, feel a sense of awe on a glow-worm walk, fly through the jungle on a zipline, or simply enjoy the views. It's all backed up with fabulous food and a wealth of spa treatments.

990 Learn the ancient principles of Ayurveda

You don't have to spend long in the Ayurveda Village in the Adelaide Hills to start to feel more relaxed. There is a garden with areas for contemplation and a deep respect for the powers of Ayurvedic treatment. Come for a detox, support for your mental health, or to seek help with physical ailments. Through yoga, meditation, and massage you can find what you're looking for.

991 Surround yourself with well-being

For three days in October the city of Adelaide is focused on its well-being with WellFest, a festival that celebrates fitness, nutrition, self-care, sleep, mindfulness, and connection. Join in with forest bathing at the zoo, a vegan picnic in the park, or an Aboriginal dance workshop. Rarely will you see so many different approaches to well-being in one place.

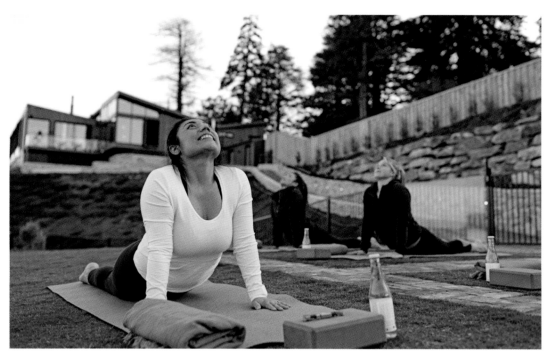

992 Yoga session

992 Enjoy yoga or soak in spring-fed pools

Connect with the land and your fellow guests at Sequoia Lodge in the Adelaide Hills. Together you can enjoy early morning yoga sessions and discover the benefits of thermal pools. The lodge has three spring-fed pools so you can find whichever one suits you the best. Keep an eye out for wallabies hopping by or koalas in the trees at this beautiful lodge where nature is all around.

993 Join kangaroos for morning tai chi

There are no strict schedules or restrictive diets at Elysia Retreat. Just healthy food, fresh air, and a choice of activities and spa treatments. Rise early for morning tai chi or a sunrise walk and you could find an extra visitor or two joining you for your session. The curious resident kangaroos are frequent bystanders at guests' morning activities.

994 Connect with land and sea while foraging

Experiences that bring a true connection are those that you really learn from in life. When you join the Indigenous Hunter family to explore Cygnet Bay, on the Dampier Peninsula, you'll hear centuries' worth of stories of the Bardi people and share their knowledge of bush food, medicinal plants, and sustainable fishing practices. The oysters you forage may be the goal on the day, but the cultural knowledge you pick up will stay forever.

AUSTRALIA

995 Discover your self-expression on a creativity retreat

Creative pursuits are essential for humans to feel fulfilled. Whether it's cave art, traditional dances, or stories passed down through generations, we are a creative species. Find the creativity inside you on a retreat with Edgewalkers. After walks in nature there is personal exploration through theater, writing, movement, and play, as well as a three-hour painting workshop in the bush.

AUSTRALIA

996 Feel in sync with the landscape on the Dampier Peninsula

The vast, silent spaces of the Dampier Peninsula are the perfect foil to a busy and noise-polluted modern life. Base yourself at Pender Bay, a four-and-a-half-hour drive by 4WD from the nearest town, and you've got a dreamy spot for whale watching, snorkeling, and fishing, as well as opportunities to join Indigenous cultural tours. Book a cliff-top camping pitch or make a campfire on the beach.

AUSTRALIA

997 Take the slow train

Eliminate the stress of itineraries and planning with a slow train journey across the outback. Travel on the Ghan—a vintage train that runs between Adelaide and Darwin—and you'll have time to watch the landscape change from rich red plains to rugged mountains to tropical forest. Similar options include the Indian Pacific sleeper train from Sydney to Perth, and the Spirit of the Outback, which runs on the route from Brisbane to Longreach.

AUSTRALIA

998 Nourish body and mind on a foraging walk

Traverse wild coastline and learn about bush tucker on a foraging tour of Hearson Cove, known as Murujuga by the area's traditional custodians, led by an Aboriginal guide. You'll collect berries, roots, leaves, and bush potatoes, and maybe even catch a mud crab. The next step is to prepare them and taste some of the goods. It's the ultimate in sustainable eating and a way to get to know a piece of Aboriginal history and culture.

AUSTRALIA

999 Learn about Aborginal traditions in the forest

Connect with the bush and its people with a Walk on Country tour of the forests in Canberra's National Arboretum. The arboretum's Indigenous Tourism Officer will lead you though the forests where you'll become immersed in the landscape and gain a deeper respect for Aboriginal traditions and culture. You will hear stories about the use of stones and clapsticks, and learn how to throw a boomerang.

AUSTRALIA

1000 Experience the healing power of the didgeridoo

Probably the oldest wind instrument in the world, the *yidaki*, or didgeridoo, produces a pulsating, hypnotic sound that can be felt as well as heard. Living Culture in Victoria offers individual *yidaki*-healing sessions, during which the instrument is played close to your body. The powerful sound vibrations move through you, helping you to enter a deep state of relaxation.

996 Campfire on the beach

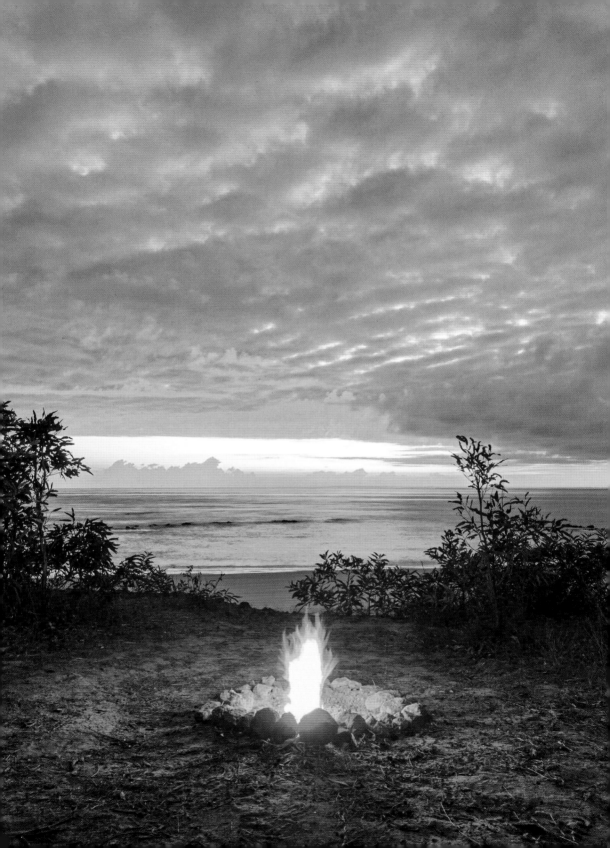

INDEX

A

Algeria
 desert trek 264
 Hoggar Mountains 264
 Tassili n'Ajjer 264
Argentina
 Buenos Aires 149
 Cacheuta hot springs 152
 hammam and spa 152–3
 heritage ranch 154
 horseback tour 149
 horse-whispering show 154
 Iguazu River 152
 Japanese Garden 149
 La Paya 152
 Margay Natural Reserve
 149
 Patagonia 149
 puna 149
 Salinas Grandes 150–1
 Santiago del Estero 152
 star gazing 388
 Torres del Paine National
 Park 154
 treetop bath 152
 Uritorco mountain 153
 wine lodge 148, 149
 yoga retreat 149
Armenia
 mind and body detox 307
 Pamir Mountains 306–7
 pottery workshop 306
 Transcaucasian Trail 306
Australia
 Aboriginal dance workshop
 402
 Adelaide 402
 Adelaide Hills 401, 402,
 403
 Alba Thermal Springs 398
 Alice Springs 388
 animal rescue center 390
 art workshop 401
 Ayurvedic treatment 402
 bathhouse and spa 396
 Bewong 396
 Blue Mountain National
 Park 393, 395
 bush tucker tour 394, 404
 Byron Bay 394

Canberra 404
cow cuddling 390
creativity retreat 404
Currumbin Valley 402
Cygnet Bay 403
Daintree Rainforest 392
Dampier Peninsula 403,
 404, 405
didgeridoo therapy 404
essential oils exercise 394
Finnish sauna 388
fire and ice walk 400
forest therapy trail 397
Fremantle 388
geothermal shower 396
Ghan, The 404
Gold Coast 391
Great Barrier Reef 390
Great Ocean Road 397
Hearson Cove 404
hot springs 399
ice bathing 396
Indian-Pacific 404
Indigenous cultural tour
 404
Japanese garden 393
Japanese hot tub 397
labyrinth mindfulness walk
 402
Larapinta Trail 388
Lizard Island National
 Park 390
meditation retreat 390
men's retreat 393
Metung Hot Springs 396
mindful paddleboarding
 401
mind wellness program 389
Mission Beach 392
Mornington Peninsula
 398–9
mother and teen retreat
 397
National Arboretum 404
Ningaloo Reef 388
Northern Territory 388
off-grid glamping 388
organic family farm 391
outdoor bathtub 395
Queensland 389–2

Qigong class 391
rainforest walk 392
reflexology walk 396
Royal Botanic Gardens 394
Satellite Island 400
sensory cave experience
 398
snorkeling 390, 404
Southern Grampians 399
spa retreat 388
Spirit of the Outback 404
star gazing 388
sustainable tented camp
 389
Sydney 394, 395
tai chi 403
Talaroo Hot Springs 392
Tasmania 400–1
treehouse cabin 395
Uluru 389
Victoria 404
Warrnambool 398
WellFest 402
Wentworth Falls 393
wholeness retreat 398
Yallingup 388
yidaki-healing session 404
yoga retreat 392
Austria
 El Camino de Santiago 204
 forest bathing 202
 hay bath 203
 healthy aging 202
 immunity program 202
 Lake Worth 202
 Leogang Mountains 201
 Otztal Valley 203
 saltwater spa 204

B

Bahamas
 Andros Island 110
 animal rescue ranch 114
 British Virgin Islands 114
 East Bimini's Healing Hole
 110
 mindful eating 110
 silent retreat 114
Barbados
 railway hike 118

Qigong class 391
Belgium
 Ardennes 235
 Hodister 235
 thermal baths 235
Belize
 alfresco massage 128
 eco-spa 127
 kayak trip 127
 Maya Mountains 128
 medicinal garden 127
 Moho River 127
 Mountain Pine Ridge 127
 Pook's Hill 128
 San Antonio 127
 transformative hike 126
 wildlife expedition 127
Bhutan
 Chorten Nyingpo
 monastery 346–7
 Gangtey Shedra 346
 Gangtey Valley 346
 Haa Valley 347
 hot stone bath 346
 sand mandala art 347
 Tiger's Nest hike 346
Bolivia
 Charazani 158
 Isla Suasi 159
 Lake Titicaca 159
 Polques Hot Springs 158
 Salar de Uyuni 159
 salt hotel 159
 star gazing 159
Botswana
 Boro River 281
 Kalahari Desert 280
 Makgadikgadi Pans
 National Park 280
 Moremi Game Reserve
 281
 Okavango Delta 281
 spa therapy pod 281
 star bath 281
Brazil
 Amazon rainforest 140
 ashram sanctuary 144
 Baía de Golfinhos 144
 beachside spa 140
 canine companionship 142
 Chocolate Coast 140

Cruzeiro do Sul 140
Desengano State Park 140
dolphin watching 144
Fazenda Catuçaba 143
Fernando de Noronha 144
healing ceremony 140
Human Design System
 140
local oils massage 143
nature immersion 142
Ojo de Mar lake 145
paddleboard excursion 142
Saltos del Monday
 waterfall 145
São Paulo 140
Serra do Mar State Park
 142
snorkeling 144
star gazing 140
Terra Preta 144
Trancoso 143
waterfall watching 145
Ypoá National Park 145
Bulgaria
 Lake Atanasovsko 189
 mineral hot springs 189
 Rhodope Mountains 189
 Rila Mountains 189
 walking and spa tour 189
 Zornitza village 189

C
Cambodia
 Angkor Wat 339
 Cardamom Mountains
 338–9
 cooking retreat 339
 Krabey Island 339
 Song Saa 338
 wilderness lodge 338
 women's wellness retreat
 339
Canada
 Alberta
 glass-floored skywalk 20
 Indigenous cooking 20
 Jasper National Park 20,
 21
 Kananaskis Country 20
 Arctic Circle 10

British Columbia
 Great Bear Rainforest 23
 Haida Nation 25
 hiking retreat 25
 Kootenay Rockies 23
 Mount Seymour Park 24
 Pacific Rim National
 Park Reserve 22
 Rocky Mountaineer 22
 Vancouver Island 24
 West Coast Trail 22
 Whistler 23
cross-country night train
 17
ice roads 10
New Brunswick
 Bay of Fundy 14
 Metepenagiag Heritage
 Park 14
 spa retreat 14, 15
Newfoundland
 Fogo Island 12, 13
Northwest Territories
 Kraus Hot Springs 10
 South Nahanni River 10
 wilderness kayak 10
Nova Scotia
 hydrothermal spa 12
Ontario
 Algonquin Provincial
 Park 18
 Bruce Peninsula National
 Park 18
 Chalice Lake 17
 eco-cabin 17
 Georgian Bay 18
 meditation course 11
 Montebello 11
 Niagara Falls 18
 off-grid cabin 16, 17
 snorkeling 18
Prince Edward Island
 Cedar Dunes Provincial
 Park 14
 Northumberland Strait
 14
Québec
 art and food retreat 11
 creative workshop 11
 design hotel 12

Gatineau Hills 11
ice hotel 11
Les Jardins de Quatre-
 Vents 12
monastery retreat 12
Old Québec 12
silence retreat 12
Saskatchewan
 clay-hike-breathe-sauna
 retreat 19
 equine retreat 19
 Wanuskewin Heritage
 Park 19
 sound healing 10–11
Cape Verde
 Pedra de Lume 292
Chile
 Atacama Desert 158
 Elqui Valley 156
 Isla Grande de Chiloé 156,
 157
 Pucón 155
 Rapa Nui (Easter Island)
 156
 Torres del Paine 155
China
 Beijing 309
 Shanghai 309, 310
 Suzhou 310
 Taishan 309
 Xi'an 311
Colombia
 Blue Apple Beach 138
 El Peñón de Guatapé 139
 Las Islas 138
Cook Islands
 paddleboard yoga 369
Costa Rica
 Ayurveda cooking retreat
 135
 Ayurveda wellness retreat
 132
 eco-lodge 133
 hot springs 132
 Nayara Springs 134–135
 Nicoya Peninsula 133
 Osa Peninsula 131
 surf retreat 132
 treetop dining 134
 Watsu retreat 135

yoga retreat 131
Croatia
 Losinj 198
 medicinal spa 198
 Plitvice Lakes National
 Park 198, 199
 Vis 198
Curacao
 herbalist treatment 119
 writing retreat 119
Cyprus
 Aphrodite's Rock 192
 Ayia Napa 192
 hot springs 192, 193
Czech Republic
 Grandhotel Pupp 182, 183
 hot springs 185
 Karlovy Vary 183

D
Denmark
 Arhus 175
 Copenhagen 174
 Nordic health sanitorium
 173
 open-air living 174
 winter swimming festival
 173
Dominica
 sulfur spa 115
 wellness retreat 115
Dominican Republic
 eco-lodge 110
 island retreat 110

E
Ecuador
 Amazonian journey 165
 Chocó rainforest 164
 traditional healing
 ceremonies 165
 Wilderness Quiet Park 164
Egypt
 Cairo 266
 Hurghada 266
 Nile riverboat 266
 Siwa Oasis 266–7
 snorkeling 266
England
 alpaca walk 241

ancient baths 242
Bath 241, 247
Cornwall 245
country house hotel 245
creative workshop 247
detox retreat 246
digital detox cabin 248–9
Hampstead Heath Ponds 242
Harrogate 241
Heckfield 243
infrared treatment 243
Isle of Wight 243
Lake District 244
London 242
menopause retreat 247
mindfulness retreat 246
off-grid cottage 244
organic cooking course 247
rainforest walk 245
sensory sleep program 242
spiritual healing 246
wildlife park 244
Wim Hof workshop 246
Estonia
 Lahemaa National Park 182
 smoke sauna 183
Eswatini
 traditional healer 280
Ethiopia
 Lalibela 268
 Simien Mountains National Park 268
 vegan food tour 269

F
Fiji
 bobo massage 366
 breath work and yoga 367
 coral gardening 366
 natural healing remedies 368
 Savusavu 366
Finland
 ice pool swimming 181
 midnight sun 179
 Oulanka National Park 180, 181
 Oulujoki 181

Tampere 179
France
 Ardeche 219
 artists' landscapes 218
 Ax-les-Thermes 221
 Bordeaux 221
 detox cuisine 223
 Dordogne 219
 Evian water spa 218
 hot springs 221
 Italian maze 222
 kayak exploration 219
 Limousin 219
 Loire Valley 222
 Mont Saint-Michel 222
 nature walks 223
 plant-based cuisine 221
 postnatal yoga retreat 219
 Pyrenees 221
 sleep and reset massage 221
 thalassotherapy 22
 Val Thorens 221
 Vichy 221
 vinotherapy treatment 221
 weight-loss program 218
French Polynesia
 Bora Bora 372
 Faarumai Valley 373
 Papenoo Valley 373
 pearl rain massage 372
 Polynesian massage 370, 372
 Tahiti 373
 Tepuhapa Valley 373
 Tetiaroa 370–1
 thalassotherapy 372
 waterfall pool swim 373

G
Gambia
 river cruise 290
Germany
 Bad Wörishofen 238
 Baden-Baden 239
 coastal resort 237
 Danube 238
 Juist 237
 medi-spa 237
 music spa 238
 Rhine 238–239

thermal spa 239
Ghana
 cooking retreat 290
 drumming workshop 290
 shea butter guide 290
Greece
 art retreat 197
 Ayurveda center 197
 creative workshops 197
 Crete 196
 Meteora 195
 Peloponnese 196
 Rhodes 194
 Skyros 195
 sleep program 195
 thalassotherapy 194
 Vikos Gorge 194
Greenland
 kayak expedition 170
 Uunartoq Island 170
Guatemala
 Antigua 124
 Finca el Paraiso 126
 hot springs 124
 Lake Atitlán 124–5
 mountain forest yoga 125
 Tikal National Park 124

H
Honduraas
 Roatán 128
Hong Kong
 happiness retreat 311
 Sheung Wan 311
 soul training 311
Hungary
 Budapest 186
 cave bathing 186
 Lake Hévíc 187
 Széchenyi Baths 187

I
Iceland
 Blue Lagoon 168
 Fljót Valley 168, 169
 horse ranch 168
 Kársnes Harbor 170
 Lake Urrioavatn 170
 sea safari 170
India

Amritsar 358
ashram retreat 354
Ayurvedic cleansing program 356
Ayurvedic retreat 356
Calcutta 353
Dharamshala 355
Ganges River valley 356
glamping 355
Golden Temple 358
Himalayas 355
Holi 354
Indus River 355
Kanha National Park 355
Kerala 356, 358
Kheerganga sulfur springs 353
Ladakh 355
meditation center retreat 355
Mother Teresa's home 353
Parvati Valley 353
rice barge trip 358
Rishikesh 356–7
safari lodge 355
Sowa-Rigpa 354
super immunity program 356
Tamil Nadu 354
Tibetan healing 354
Vipassana meditation 358
Indonesia
 Ayung Valley 329
 Bali 325–9
 Balinese New Year 327
 Banjar Hot Springs 325
 contrast therapy 329
 cooking class 326, 329
 executive retreat 327
 hammam 330
 holistic healing 329
 Java 330
 plant-based cooking 327
 sound healing 325
 Sumba 325
 Ubud 326
 Vesak 330
 water purification 329
Ireland
 Clare Island 257

Connemara National Park 257
County Kerry 256
Croagh Patrick 256
Galway 257
Glenbarrow Waterfall walk 255
Killray Fjord 257
labyrinth walk 257
Lough Ennell 257
Mayo 257
monastery retreat 257
pagan pilgrimage 256
seaweed bath 256
spiritual retreat 257
Wicklow Mountains 256
wood-fired Finnish sauna 257
yoga retreat 257
Israel
Arugot trail 292
crucifixion reenactment 292
Dead Sea 294–5
Dudim cave 292
Holy Week 292
Jerusalem 292
Judaean Desert 292–3
Masada 292–3
Midnight Mass 295
Negev Desert 294
pilgrim house stay 295
sunrise yoga 293
Western Wall pilgrimage 293
Italy
Alpine infinity pool 208–9
Amalfi coast 212
Assisi 211
Basilica of Saint Francis 211
Castrocaro Terme 205
catamaran vacation 207
Chianti Hills 212
Dolomites 206
equine therapy 212
foraging and cooking 205
garden walk 212
gut health program 210
hay bath 207

hut-to-hut hike 206
Mount Etna 212
mud therapy 205, 212
Plose mountain 205
red-wine bathing 210
Sacro Bosco 212
San Damiano 211
Saturnia hot springs 210
South Tyrol 206
Tuscany 212, 213
Villa d'Este 212

J
Jamaica
Blue Mountains 120
bush bath 120
Negril 120
Oracabessa Bay 120, 121
seawater salt bath 120
yoga retreat 120
Japan
Ago Bay 321
Awaji Island 316
forest bathing 319
head spa 317
hot springs 321
Ibusuki 316
kampo treatment 321
Kumano Kodo Trail 319
Kyoto 321
Kyushu 320
meditation retreats 316, 320
misogi retreat 318
monastery stay 318
Mount Koya 318
Okinawa 322–3
onsen 317
tea ceremony 316
Tokyo 318
traditional inn 320
volcanic sand treatment 316
yoga adventure 320
Jordan
Aqaba 296
Dana Biosphere Reserve 297
Dead Sea 297
desert bathing 296

desert eco-resort 297
Jordan Valley 296
Ma'in hot springs 297
mind detox program 296
sustainability workshop 296
Wadi Rum 296

K
Kenya
alfresco sleeping 268
Chyulu Hills 271
Laikipia Plateau 270
Lamu 270
Lamu Yoga Festival 270
Maasai Mara 271
Ol Jogi Wildlife Conservancy 271
tree house yoga 271
wildlife watching 271
Kiribati
Abaiang 366
snorkeling 366

L
Laos
alms-giving ceremony 345
Lebanon
Chouf mountains 295
Lithuania
Curonian Spit 182
Luxembourg
spa hotel 236

M
Madagascar
Antsirabe 276
Malawi
art safari 278
Lake Malawi 278
Mumbo Island 278
Malaysia
Kinabalu National Park 334
Langkawi 332, 333
reflexology massage 332
Taman Negara rainforest 332
Tambun 332
thermal steam cave 332

Maldives
Bodufushi 363
caviar journey 362
family wellness workshop 363
Indigenous treatments 362
night spa 362
overwater villa 363
Mauritius
Ayurvedic detox 276
ocean immersion therapy 277
personal wellness chef 276
snorkeling 277
Tibetan yoga 277
Mexico
Ayurvedic menu and music 104
eco-resort 106–107
Maya rituals 109
Maya sweat lodge 103
Monarch Butterfly Reserve 105
nature hideaway 105
Nayarit 104
Playa del Carmen 109
San Miguel de Cozumel 109
Shamanic session 109
tented resort 104
Tulum 108
Yucatán cenote 108
Monaco
Monte Carlo 214
Mongolia
Bayangol Valley 308
food tour 308
Gobi Desert 308
Montenegro
Adriatic Coast 198
healing spa 198
Morocco
Anima gardens 263
art class 261
cooking class 262
hammam 260
Marrakech 261
mountains kasbah 262
singing vacation 263
surf therapy 263

wellness tour 261
Mozambique
 Anantara Bazaruto Island
 279
 Gorongosa National Park
 279
 safari 27
 Tofo Beach 279
 underwater world 279

N
Namibia
 desert camp 287
 Etosha National Park 287
 Fish River Canyon 286
 hiking trail 286
 NamibRand Nature
 Reserve 287
 Skeleton Coast 286
 star gazing 287
 sustainable desert camp
 287
 wildlife watching 287
 women's expedition 286
Nepal
 Annapurna 351
 Boudhanath 351
 hilltop monastery 351
 homestay hiking 349
 Kathmandu 351
 Kopan Monastery 351
 Lumbini 350
 Mustang 349
 Pokhara 350–1
 sound-massage retreat 349
 Tibetan singing bowls 349
 World Peace Pagoda 350–1
Netherlands
 couples retreat 236
 Keukenhof gardens 236
New Zealand
 Akaroa 384
 Auckland 377
 Ayrlies Garden 375
 barefoot walk 377
 cooking retreat 387
 Coromandel Peninsula 374,
 379
 Fiordland National
 Park 385

forest bathing 376, 381
Golden Bay 382
Hamilton Gardens 375
Hanmer Springs 384
hot spring 384
Hot Water Beach 379–80
Karioitahi Beach 376–7
Kerosene Creek 380
Koekohe Beach 387
Mahamudra Centre 374
Mahu Whenua 385
Maori meal 377
Marlborough Sounds
 382–3
Maruia 384
men's well-being retreat
 377
Mount Aspiring National
 Park 385
New Plymouth 382
nutritional retreat 387
Pukekura Park 382
Queenstown 385
Raglan 380
reflexology session 382
Rotorua 380
Routeburn Track 385
sculpture garden 384
sound bath 382
Southern Alps 384
sunrise yoga 386–7
surf lesson 380
Te Kainga Marire 382
twilight forest tour 374
Waiheke Island 376
Waipoua Forest 374
Waitangi Soda Springs 381
Wellington 382
Whakarewarewa Forest
 381
Whangarei Quarry
 Gardens 376
wine tour 383
women's retreat 379
zero balancing 379
Nicaragua
 Cerro Negro 130
 Jicaro Island 130
 Little Corn Island 129
 surf spa 130

Nigeria
 holistic spa 289
 Lagos 280
Niue
 stargazing tour 369
Northern Ireland
 forest dome 255
 medicinal therapies 254
 mindfulness retreat 254
Norway
 aurora borealis 171
 fjord farm 172
 Frozen Lake Marathon 172
 Polar Park 172
 sea safari 171
 wellness center 172
 women's weekends 172

O
Oman
 brain-health program 303
 Empty Quarter 302
 fitness retreat 303
 frankincense ritual 302
 Hajar Mountains 302

P
Pakistan
 Great Himalaya Trail 352
 Hunza Valley 352
 Karakoram Highway 352
 mountain trekking 352
Palau
 Milky Way Cove 366
Palestinian Territories
 Bethlehem 295
 pilgrim house 295
Panama
 El Totumo volcano 137
 Isla Palanque 136
 Isla Secas 137
 Tatacoa Desert 136–137
Papua New Guinea
 Goroka 366
Peru
 Ahuashiyacu Waterfall 161
 Amazon eco-lodge 162
 Andes spa 163
 Cocalmayo hot spring 161
 food tour 163

Iquitos 161
Madre de Dios River 162
Ñape center 162
Pacaya-Samiria National
 Reserve 163
Sacred Valley 161
Philippines
 yoga and raw food retreat
 324
Poland
 Holy Mount of Grabarka
 183
 Wieliczka salt caves 183
Portugal
 Alentejo 230
 Algarve 230
 Alvor 233
 Areias do Seixo 232
 Ayurvedic detox 234
 Azores 230
 CBD massage 231
 digital detox 234
 Douro Valley 232
 gay and queer retreat 231
 Lagos 233
 Madeira 235
 Parque Terra Nostra 231
 sculpting and yoga retreat
 233
 Sintra 232
Puerto Rico
 bomba workshop 113
 eco-lodge 112
 El Yunque National Forest
 113
 Mosquito Bay 113
 personalized retreat 112
 rooftop cacao 112

Q
Qatar
 wellness resort 300

R
Romania
 outdoor yoga 188, 189
 Transylvania 188, 189
Rwanda
 African potato massage 275
 craft workshop 275

Denis Private Island 275
Kigali 275
wilderness retreat 275

S
Saint Lucia
 fitness resort 116
 Gros Piton 116–17
 Labrelotte Bay 117
 Marigot Bay 117
 Sulphur Springs 117
Saint Vincent and the
 Grenadines
 wellness cruise 118
Saudi Arabia
 desert spa hotel 298–9
 wellness festival 298
Scotland
 Ardnish Peninsula 253
 Blackburn Glen 253
 blue wellness 252
 bushcraft class 254
 Centre for World Peace
 and Health 253
 Clachnaben 254
 Cromarty Firth 253
 Eilean Shona 253
 fairy pool swimming 252
 forest dome 255
 Glenbarrow Waterfall 255
 Holy Isle 253
 Inith Rath 254
 Isle of Skye 252
 Loch Lomond 252
 mindful walking 254
 monastery retreat 253
 relax and restore retreat 254
 riverside trail 255
Senegal
 Casamance 291
 Saloum Delta National
 Park 290–1
 spa hotel 291
Sierra Leone
 Tiwai Island 290
Singapore
 Cloud Forest 331
 Coney Island 331
 Floral Fantasy garden 331
 sunrise yoga 330

Slovakia
 geothermal spa 185
 Tatra Mountains 185
Slovenia
 beehive hotel 200
 honey massage 200
 Kolpa River 200
South Africa
 art retreat 282
 biokinetic assessment
 285
 Buddhist retreat 282
 Cape Winelands 284
 Capetown 285
 Cederberg mountains 283
 detox and yoga retreat 285
 family retreat 283
 Franschhoek 285
 Garden Route 282
 Green Mountain Eco
 Route 284
 kids' massage 285
 Kruger National Park 282
 KwaZulu-Natal 282
 lifestyle coaching 285
 mindful walks 283
 North West Province 285
 Sandton 285
 Sneeuberg mountains 283
 Western Cape 285
 wilderness skills course 282
South Korea
 Boryeong Mud Festival
 312
 Bukchon Hanok Village
 312
 Changdeokgung
 (Changdeok Palace) 315
 gingseng journey 313
 hot springs 312
 Jeju Island 313
 Seoul 312, 314–5
 Taebaeksan 313
 temple retreat 315
Spain
 Alhambra 226
 Andalucia 225
 Burgas springs 223
 Camino de Santiago 224
 Formentera 227

Galicia 223
gastro workshop 223
Granada 225
hammam 225
hot springs 223
Ibiza 227, 228–9
integrative wellness 224
leadership wellness 224
lifestyle workshop 223
Mallorca 227
Menorca 226
Migjorn Beach 227
movement and meditation
 228
Ourense 223
painting vacation 225
Pontevedra 223
Sencelles 227
water therapy 227
well-being boot camp 227
Sri Lanka
 Adam's Peak 359
 Ayurvedic retreat 361
 conservation vacation 359
 design hotel 360
 Gal Oya National Park 360
 Lake Koggala 359
 Nuwara Eliya 361
 Ulpotha 360
 wellness retreat 361
Suriname
 eco-lodge 139
Sweden
 Arctic Circle swim race
 178
 eco-lodge 178
 Fjallraven Classic hike 175
 floating spa 176–7
 forest and yoga retreat 175
 Sormland 178
Switzerland
 Andermatt 215
 ashram spa 217
 Bad Ragaz 217
 botanical art 217
 goat yoga 216
 Gstaad 216
 Lake Geneva 215
 Lake Lucerne 214–5
 Les Bains de Lavey 215

Pontresina 215
wellness retreat 216
Zermatt 215

T
Taiwan
 Alishan 324
 calligraphy workshop 324
 Fo Guang Shan Monastery
 324
 Tsou home stay 324
Tanzania
 Chole Island 274
 Maasai lodge 271
 Mount Kilimanjaro 274
 Ngorongoro Carer 272, 273
 Zanzibar 273
Thailand
 Bangkok 344
 Chiang Mai 344
 forest walk 340
 Hua Hin 340
 Khao Sok National Park
 342-3
 Koh Samui 343
 Krailart Niwate 340
 monastery retreat 343
 nuat thai massage 341
 painting retreat 344
 performance retreat 340
 Phuket 341, 343
 Pilates boot camp 344
 rainforest hike 343
 Suan Mokkh monastery
 343
 Thai yoga massage 344
 wilderness refuge 343
 women's health retreat 343
Tibet
 hot spring spa 348
 Mount Kailash 348
Tobago
 Bon Accord Lagoon 118
 tree house yoga 119
Tonga
 survival vacation 368
Tunisia
 cooking class 265
 Jebil National Park 265
 Sousse 265

Turkey
 Afyonkarahisar 190
 Bodrum 191
 Cappadocia 191
 immunity-boost program
 190
 Istanbul 190
 Pamukkale hot springs 191
Turks and Caicos
 Pine Cay 110–111

U
Uganda
 Bwindi Impenetrable
 Forest 269
United Arab Emirates
 Abu Dhabi 301
 Ajman 300
 art retreat 200
 Dubai 200, 201
 wellness retreat 301
United States
 Alabama
 Mentone Mountains 71
 Alaska
 cruise 26–7
 Denali National Park 29
 Fox Island 27
 freshwater fishing 28
 geothermal spring 29
 hot spring 29
 Iditarod Trail 29
 Kachemak Bay 26
 Nordic spa 28
 northern lights 27
 Skilak Lake 27
 Tutka Bay 27
 wilderness lodge 27
 Arizona
 Bradshaw Mountains
 88–89
 copper treatments 86
 horse therapy 87
 Native American
 treatments 84
 new parent retreat 86
 Oracle State Park 84
 Sanctuary Camelback
 Mountain 87
 Sedona 84

Sonoran Desert 87
 Tucson 86
 VIP retreat 86
 Wupatki National
 Monument 84
 yoga and hiking retreat
 84–5
Arkansas
 Hot Springs National
 Park 72–3
Baja California
 fitness program 102
 Mount Kuchumaa 102
Baja California Sur
 San José del Cabo
 Mountains 103
California
 Bhakti Fest 97
 creative play workshop 94
 family retreat 101
 French dining 98
 gut health class 94
 hypnotherapy 97
 Joshua Tree National
 Park 96–7
 Mendocino coast 94
 mineral hot springs 95
 mono-diet 101
 Mount Shasta 99
 mud treatment 101
 Palm Springs 99
 Santa Clarita 94
 Santa Lucia Mountains
 98
 Santa Monica Mountains
 101
 Save the Redwoods 101
 tree houses 98
 wilderness retreat 97
 Yosemite National Park
 94–5
Colorado
 aqua yoga 76
 Crestone 78
 Gem Lake Trail 78
 Glenwood Springs 77
 horsemanship clinic 76
 Pinecliffe 76
 San Juan Mountains 77
 Willow Creek 77

Connecticut
 South Berkshires 57
 Wickham Park 57
Delaware
 equine therapy 58
 LED light therapy 58
Florida
 Biscayne National Park
 66
 dog-friendly spa 64, 65
 medicinal retreat 64
 preventative spa 64
 red light therapy 64
 Shy Wolf Sanctuary 64
 snorkeling 66
 yoga yacht 66
Georgia
 Blue Ridge Mountains
 66–7
 Golden Isles 68
 Okefenokee Swamp 68
Hawaii
 aroma and color therapy
 82
 experiential learning 82
 Kauai 82–83
 Lanai 81
 lomi massage 83
 Mauii 81
 pohaku hot-stone therapy
 83
 relationship retreat 81
 wild food and farm tour
 83
Idaho
 Craters of the Moon 32
 Feathered Pipe Ranch 33
Illinois
 Chicago 42
 farm retreat 42
Indiana
 Crown Point country
 retreat 43
 Indiana Dunes National
 Park 43
Iowa
 Ayurvedic menopause
 program 39
 labyrinth meditation 39
 Rock Creek 32

Sawtooth National
 Recreation Area 32
Kansas
 Hays 73
 life coaching and yoga 73
Kentucky
 ranch retreat 43
 salt cave yoga 43
Louisiana
 New Orleans Museum of
 Art 72
 yoga detox retreat 72
Maine
 cliff-top sanctuary 53
 coastal retreat 52–3
 milk and honey ritual 53
 yoga retreat 53
Maryland
 aerial yoga 59
 Assateague Island 59
 Deep Creek Lake 58
Massachusetts
 Berkshire Hills 54
 Cape Cod 54
 holistic retreat 54
 meditation and hiking 54
Michigan
 bio-electromagnetic
 therapy 42
 Mackinac Island 43
Minnesota
 forest bathing 39
 Minneapolis 38
Mississippi
 Mississippi Aquarium 71
 women's retreat 71
Missouri
 Lake Pomme de Terre 40
 natural building
 workshop 40
 spiritual retreat 40
Montana
 Glacier National Park 33
Nebraska
 Mountain Pine Ridge
 Forest Reserve 38
 treetop walk 38
Nevada
 body scrubs 93
 Lake Tahoe 92–93

New Hampshire
mountain spa 52
White Mountains 52
New Jersey
Laurelwood Arboretum
56, 57
sobriety retreat 57
New Mexico
Bandelier National
Monument 80
desert retreat 79
Ghost Ranch 79
Japanese massage 80
Santa Fe 80
Taos County 79
New York
Adirondack Mountains
48–9
Ayurvedic restaurant 46
Catskills 48
Finger Lakes 48
Hamptons 46
mama-child retreat 47
mountain boot camp 49
postnatal retreat 47
Russian oak leaf
treatment 47
Saratoga Springs 48
stress-management
program 48
North Carolina
couples retreat 62
happiness retreat 62
young adult retreat 62
North Dakota
bird-watching 36
crafting retreat 36
Ohio
Cedar Falls 45
Hocking Hills 45
Oklahoma
Arbuckle Mountains 74
Tulsa 74
Oregon
Breitenbush Hot Springs
31
Headlands Coastal
Lodge 31
Portland's Grotto 31
Pennsylvania

creative class 45
culinary retreat 45
float therapy 45
Himalayan salt spa 44, 45
Rhode Island
Newport Harbor 55
wilderness inn 55
South Carolina
Hilton Head Island
62–3
Springbank 63
South Dakota
Badlands National Park
37
Moccasin Springs 37
Tennessee
Ayurveda treatments 71
Blackberry Mountain 69
emotional wellness
workshop 70, 71
Great Smoky Mountains
National Park 69
Memphis 69
Texas
customized wellness 75
Fort Worth 75
Hamilton County 75
Hill Country 75
women's retreat 74
Utah
Amangiri 91
chakra-balancing
massage 90
Homestead Caldera 92
iridology reading 90
mental health retreat 92
Moab desert 90
Mount Timpanogos 91
running retreat 91
snorkeling 92
Snow Canyon State Park
92
Vermont
Bingham Falls 50
lifestyle coaching 50
massage and skin
treatments 50
relaxation room 50
Twin Farms 50, 51
Woodstock 50

Washington
Hoh Rain Forest 30
Moran State Park 31
North Cascades
National Park 30
Obstruction Pass State
Park 31
Orcas Island 31
whale-watching tour 31
West Virginia
Appalachian Mountains
60
Berkeley Springs State
Park 60
Blue Ridge Mountains
60, 61
equine adventure 60
Hot Springs 60
Kumbrabow State Forest
60
Wisconsin
folk school 40
Newport State Park 40,
41
off-grid wilderness
retreat 40
Wyoming
Gros Ventre mountains
34
Jackson Hole 34
skiing and snowboarding
34
Wind River Mountain
Range 34, 35
Yellowstone National
Park 34
Uruguay
Cabo Polonio 147
health spa 146
hot spring 147
hotel pool with a view 147
Maldonado 147
Rosedal del Prado 146

V
Venezuela
Los Roques National Park
138
Orinoco Delta 138
Vietnam

Ha Long Bay 334
homestay tour 335
Núi Chúa National Park
337
Phuong Mai Bay 336
singing bowl therapy 335
yoga retreat 336

W
Wales
Elan Valley 250, 251
men's hiking retreat 250
mindful walking 250
wellness retreat 250

Y
Yemen
Socotra 302–3

Z
Zambia
Mutinondo Wilderness
288
South Luangwa National
Park 289
wilderness walk 288
Zambezi River 288
Zimbabwe
Hwange National Park 280
Zambezi River 280

House; 113r Ciara Turner-Ewert / wellnesstraveldiaries.com; 114l, r Aerial BVI; 115 Jungle Bay Dominica; 119 Castara Retreats; 121t, bl, br GoldenEye; 130 Jicaro Island Lodge; 132tl Courtesy of The Retreat Costa Rica; 134-135 Image Courtesy of Nayara Springs; 136t, b Isla Palenque; 138 Blue Apple Beach; 141 Matias Ternes; 142 Itamambuca Eco Resort - Dimitri Matoszk; 143 Uxua Casa; 144-145 Andre Klotz; 148tl, tr, b Michael Feher & Cavas Wine Lodge; 152-153 Entre Cielos Wine Hotel Spa; 154 EcoCamp Patagonia; 157t, cl, bl, br Tierra Chiloé/Tierra Hotels; 160 Willka Ti'ika Wellness Retreat; 162 www.rainforestexpeditions. com; 163 Inkaterra Hotels: https://www. inkaterra.com/media/image-gallery/ inkaterra-hacienda-urubamba/; 169t, cr, bl, br Eleven Experience; 171 Katie Farr Photography; 172-173 TheIngalls_62°NORD(11); 174t Company: CopenHot Instagram: @ copenhot Facebook: @CopenH0T; 175 Alissa Lalita; 176tr Emil Wallin; 176br Daniel Holmgren; 177t, b Daniel Holmgren; 181 Rock and Lake/Finland; 184tl, tr, bl, br Grandhotel Pupp; 188t, cr, bl, br Akasha Wellness Retreat - Transylvania; 190tr Six Senses Kaplankaya; 193tl, tr, b Secret Forest; 194 Photo #12 by Vangelis Paterakis for Aristi Mountain Resort and Villa; 196 Giorgos Sfakianakis; 197 Artful Retreats; 201 Naturhotel Forsthofgut; 202-203 Copyright AQUA DOME – Tirol Therme Längenfeld; 205 Forestis Hotel; 206tr Hotel Engel Ayurpura https://ayurpura.hotel-engel.com/ +39 0471 614 245/Tiberio Sorvillo; 207tr Sailing 2 Wellness, Sardinia, July, 2023; 207br Hotel Heubad/Helmuth Rier; 208-209 Alpin Panorama Hotel Hubertus/© Manuel Kottersteger; 213tl, tr, bl, br © Vegan Agrivilla I Pini Tuscany; 214-215 Waldhotel Health and Wellbeing/© Switzerland TourismAndre; 216 Le Grand Spa at Le Grand Bellevue/Nick Hopper; 217tl Grand Resort Bad Ragaz; 217tr CERVO Mountain Resort; 218 Patrick Locqueneux; 220tl, tr, bl, br Sophia Van Den Hoek; 225 Hammam al Andalus; 228tr, br Six Senses Ibiza; 229t, b Six Senses Ibiza; 231 Rainbow Men/Ofer Danziger; 232 Daniel Espírito Santo; 233 Longevity Health & Wellness Hotel; 237 Lanserhof Sylt; 243 Heckfield Place; 245 Scarlet Hotel; 246

The Sharpham Trust; 247 Felix Russell-Saw; 248tr, cr Unplugged, Adam Firman; 248br Unplugged, Pasco Photography; 249t Unplugged, Pasco Photography; 249b Unplugged, Adam Firman; 250 Menspedition; 251 Elliot Cooper/@cooperexplores; 254 Glen Dye School of Wild Wellness and Bushcraft; 255 Christina Kruse; 261 Image Courtesy of Royal Mansour; 262 Travelling Buzz/Maria Stoyanova www. travellingbuzz.com; 269tr Black Bean Production and Volcanoes Safaris; 270-271 Elewana Collection; 272tl, tr, cl, bl, br Natalie Mulvaney - Tails of a Mermaid; 273 Kozanow Productions; 275 One&Only Nyungwe House; 276 Le Jadis Beach Resort & Wellness Mauritius; 278bl Katie Kendall; 281 XigeraSafariLodge; 282 Scott Ramsay; 283 Red Carnation Hotels/Bushmans Kloof; 286 © The Matriach Adventure; 287 Wolwedans.com; 289 The Bush Spa Retreats Ltd by Johan Elzenga; 298tr, cr, br Our Habitas Al Ula/Kleinjan Groenewald; 299bl, br Tanveer Badal; 300 Image Courtesy of Zulal Wellness Resort by Chiva-Som; 301 The Spa at Mandarin Oriental, Emirates Palace Abu Dhabi; 304-305 COMO Hotels & Resorts; 310 SANGHA Retreat by OCTAVE; 324bl The Farm at San Benito, Philippines; 328tr, c, b COMO Hotels & Resorts; 330 MesaStila Resort and Spa; 335 Four Seasons Nam Hai/ Ken Seet; 340 Courtesy of Chiva-Som International Wellness Resort; 349 Elise Hassey; 355 The Indus River Camp; 360 © Ulpotha - Jesper Anhede; 362 The Spa by Thalgo France, Sun Siyam Iru Fushi, Maldives; 363 Anantara Kihavah Maldives Villas; 364-365 Sal Salis; 367 Koro Sun Resort and Rainforest Spa – Fiji; 369 Mark Russell/Niue Tourism; 370tr, cr, br Courtesy of The Brando; 371t, b Courtesy of The Brando; 373 NIU Shack; 375 Ayrlies - Garden and Wetlands; 376-377 Castaways Resort; 381 Supplied by Secret Spot Hot Tubs Rotorua, www.secretspot.nz; 385 Onsen Hot Pools; 386t, cl, cr, bl, br Aro Ha Wellness Retreat; 390 Lizard Island Resort; 391 Shambhala Farm; 392 Talaroo Hot Springs; 394 Botanic Gardens of Sydney; 395 fionabruyn@ bigpond.com; 396 Natalie Childs/@ barefootandoffgrid; 397 Gareth Yago; 402 Eden Health Retreat; 403 Sequoia Lodge.

While every effort has been made to credit photographers, The Bright Press would like to apologize should there have been any omissions or errors, and would be pleased to make the appropriate correction for future editions of the book.

ABOUT THE AUTHORS

Nana Luckham

Nana Luckham is a writer, editor, and guidebook author who has lived all over the world including Australia, Ghana, France, and the United States. She has coauthored guidebooks for Lonely Planet and Rough Guides, and contributed to *The Family Bucket List* titles and *The Eco Experiences Bucket List*. Now based in southeast London with her husband and two children, Nana likes to escape the city whenever she can—and finds her biggest wellness boost by spending time in nature.

Ciara Turner-Ewert

Ciara Turner-Ewert is a certified travel coach, health and wellness writer, and travel writer who has visited more than thirty-five countries. She's passionate about learning mindful ways to support well-being, and is on a mission to inspire others to pursue wellness. Ciara's expertise has led her to write for publications including *USA Today*, *Fodor's*, *Essence*, *Health Digest*. When she's not writing for publications, she writes for her blog, Wellness Travel Diaries, where she shares inspiration for adventurous and wellness pursuits.

Jane Wilson

Jane Wilson specializes in wellness travel, an area which has moved beyond the spa and yoga mat. She considers travel as an investment in health and well-being for the ultimate makeover for mind, body, and soul. You will always discover that healthy twist laced into her writing—think slow travel, rituals, retreats, Indigenous therapies, and destination medispas. Jane writes for a range of media and is the founder and editor of **www.thewellnesstraveller.co.uk**.

Kath Stathers

Kath Stathers is a writer, editor, and Forest School Leader who has contributed to a number of books in the Bucket List series including the original *Bucket List: 1000 Adventures Big and Small*, *Bucket List North America*, *Bucket List Wild*, and *The Family Bucket List*. She lives in London with her family and dog, and believes the best route to wellness is nature immersion—although she does also love hot springs and sound baths.

Solange Hando

Solange Hando is an award-winning travel writer and photographer, a member of the British Guild of Travel Writers and International Travel Writers Alliance. Her features on destinations worldwide cover culture, adventure, local life, exotic holidays or city breaks, river cruises, reviews and more. Her books include *Be a Travel Writer* and *Berlitz Pocket Guide to Bhutan*, and she has contributed to *National Geographic* and *Reader's Digest*. **https://travelwriters.co.uk/personal-pages/solange-hando/**

Colleen O'Neill Mulvihill

Colleen O'Neill Mulvihill is a certified health coach, wellness travel coach, and travel writer. On her website and blog, The Holistic Health Traveler, Colleen shares wellness travel destinations, outdoor adventures, spa reviews, healthy restaurant finds, and other health- and travel-related articles. She specializes in the East Coast of the United States, from the majestic New England mountains to the serene coastal beach towns.